IN HIS
FOOTSTEPS

FAMOUS FATHERS & CELEBRITY CHILDREN
PÈRES CÉLÈBRES & ENFANTS CÉLÈBRES
BEROEMDE VADERS & BEKENDE KINDEREN

TECTUM
PUBLISHERS

"Books may well be the only true magic."

Alice Hoffmann

© 2011 Tectum Publishers
 Godefriduskaai 22
 2000 Antwerp
 Belgium
 info@tectum.be
 + 32 3 226 66 73
 www.tectum.be

ISBN: 978-90-79761-65-4
WD: 2011/9021/04
(126)

Author: Birgit Krols
Design : Gunter Segers
Translations: Thom Morrell (English),
Anne Balbo (French)

Printed in China

hael & Marco **Andretti** + John & Jennifer **Aniston** +
ette + Franz & Stephan **Beckenbauer** + Zulfikar Ali
olan + Duncan Jones & David **Bowie** + Pierre, Claude
& Sean **Brosnan** + Tim & Jeff **Buckley** + George
Clijsters + Nick & George **Clooney** + Nat King & Natalie
ola + Johan & Jordi **Cruijff** + Tony & Jamie Lee **Curtis** +
& Anthony **Delon** + John Sr., John Jr. & Linda **De Mol**
e **Sica** + Kirk & Michael **Douglas** + Willem & Willem Jr.
e fils **Dumas** + Jacques & Thomas **Dutronc** + Sunil &
Jr. **Earnhardt** + Clint & Alison **Eastwood** + Harry
Flynn + Henry & Jane **Fonda** + Peter & Bridget
Alessandro **Gassman** + Rein & Richard **Groenendaal**
& Christie **Hefner** + Graham & Damon **Hill** + Bobby &
glesias + Maurice & Jean-Michel **Jarre** + Laurent Désiré
King & Joe **Hill** + Klaus & Nastassja **Kinski** + Arthur
Brandon **Lee** + John, Julian & Sean **Lennon** + Roger &
Ziggy **Marley** + Tomáš Garrigue & Jan **Masaryk** + Paul
mes **Murdoch** + Louis & Günther **Neefs** + Jawaharlal **Nehru**,
lly **Osbourne** + Pablo & Paloma **Picasso** + Nelson &
& Lisa Marie **Presley** + Michael & Vanessa **Redgrave**
i + Michel & Davy **Sardou** + Ravi Shankar & Norah
nk & Nancy **Sinatra** + Will & Jaden **Smith** + Wlodi
& Zak **Starkey** + Jerry & Ben **Stiller** + Sting &
Tyler + Gilles & Jacques **Villeneuve** + Jon **Voight** &
Andrew & Jamie **Wyeth** + Frank & Dweezil **Zappa**

Muhammad & Laila **Ali** + Martin & Kingsley **Amis** + Mari

Bernard & Delphine **Arnault** + Lewis, Rosanna & Patricia A

& Benazir **Bhutto** + Niels & Aage **Bohr** + Marc & Rol

& Alexandre **Brasseur** + Lloyd, Jeff & Beau **Bridges** +

H.W.& George W. **Bush** + John & David **Carradine** + Lei &

Cole + Sean & Jason **Connery** + Francis Ford & Sofia C

Billie Ray & Miley **Cyrus** + Jan & Jenne **Decleir** +

+ Gérard & Guillaume **Depardieu** + Vittorio & Christian

Drees + Hans & Candy **Dulfer** + Alexandre père & Ale

Sanya **Dutt** + Bob & Jakob **Dylan** + Ralph, Dale Sr. &

& Stefan **Everts** + Gaston & Marc **Eyskens** + Errol

Fonda + Serge & Charlotte **Gainsbourg** + Vittori

+ Johnny & David **Hallyday** + Tom & Colin **Hanks** +

Brett **Hull** + John & Anjelica **Huston** + Julio & Enric

& Joseph **Kabila** + John F. & John F. Jr. **Kennedy** + St

& Roger D. **Kornberg** + Lenny & Zoë **Kravitz** + Bru

Romelo **Lukaku** + Cesare & Paolo **Maldini** + Bo

& Stella **McCartney** + Eddy & Axel **Merckx** + Rupe

Indira & Rajiv **Gandhi** + Ryan & Tatum **O'Neal** + Ozzy

Nelson Jr. **Piquet** + Ferdinand & Ferry **Porsche** +

Lionel & Nicole **Richie** + Roberto & Isabella **Ross**

Jones + Martin & Charlie **Sheen**, Emilio **Estevez**

& Ebi **Smolarek** + Aaron & Tori **Spelling** + Ringo S

Coco **Sumner** + Donald & Kiefer **Sutherland** + Steven

Angelina **Jolie** + Loudon & Rufus **Wainwright** +

Content / Sommaire / Inhoud

"A famous father means that in order to prove yourself you have to work three times harder than the guy who comes in off the street."

Frank Sinatra Jr. (born 1944)

Intro

Being born as the son or daughter of a famous father has its ups and downs. Sure, everyone would love growing up in luxury, having the world at his feet, being treated like a VIP and being able to hang out in celebrities' homes. But surviving the spotlights from day one, having to live up to unrealistic expectations and always being compared to 'the old man' can not always be so pleasant. Still, some celebrity fathers are so inspirational, they intentionally or unintentionally entice their brood to choose very similar career paths.

But simply being the son or daughter 'of' is no guarantee for success, and in order to step out of the shadow of your well-known dad, you have to muster up more than good genes alone. Because even the most famous father cannot provide his offspring with much more than an instant celebrity status and the necessary connections. That's where talent, dedication, perseverance and vision kick in and turn out to be just as important - if not more important - than for people trying to make it without famous backgrounds.

In His Footsteps offers an international collection of some of the most famous and successful father-son and father-daughter combinations in the worlds of sport, politics, entertainment, business, science, art and literature.

Être le fils ou la fille d'un père célèbre présente des avantages et, bien sûr, des inconvénients. Grandir dans le luxe, avoir le monde à ses pieds, être accueilli partout en VIP et être l'enfant chéri des grandes personnalités de son époque, tout cela semble pour le moins tentant, voire enviable. Toutefois, être en permanence sous les feux de la rampe, nourrir des attentes irréalistes et se voir sans cesse comparé à "son géniteur" n'est sans doute pas toujours des plus agréables. Quoiqu'il en soit, certains pères célèbres se révèlent un exemple tellement inspirant qu'ils encouragent leur progéniture, inconsciemment ou non, à embrasser une carrière similaire à la leur.

Être le fils ou la fille "de" n'est pas une garantie de succès. Pour sortir de l'ombre d'un père adulé, il faut effectivement posséder des qualités autres que l'hérédité, car même un père célèbre ne pourra jamais conférer à ses héritiers une renommée éternelle, ni leur fournir toutes les relations nécessaires pour qu'ils atteignent leur propre rêve. Et c'est là que le talent, la motivation, la persévérance et la clairvoyance s'avèrent des qualités essentielles pour qui veut réussir dans la vie, sans tirer profit d'une illustre paternité.

Dans les pas de mon père présente quelques-unes des combinaisons père-fils / père-fille les plus célèbres au monde, dans les domaines du sport, de la politique, du divertissement, des affaires, de la science, de l'art et de la littérature.

Geboren worden als zoon of dochter van een beroemde vader heeft zo zijn voor- en nadelen. Opgroeien in weelde, de wereld aan je voeten hebben, overal als een vip behandeld worden en kind aan huis zijn bij de groten der aarde zou iedereen wel leuk vinden. Maar vanaf dag één in de *spotlights* staan, onrealistische verwachtingen moeten inlossen en altijd met 'de ouwe' vergeleken worden kan toch niet altijd even prettig zijn. Nochtans vormen sommige bekende vaders blijkbaar zo'n inspirerend voorbeeld dat ze hun kroost bewust of onbewust aanzetten tot het kiezen van een gelijkaardige loopbaan in het voetlicht.

Zoon of dochter zijn 'ván', is echter geen garantie op succes en om uit de schaduw van een beroemde vader te treden, moet je over meer beschikken dan goeie genen alleen. Want meer dan een instant celebrity status en de nodige connecties kan zelfs de beroemdste pa zijn nageslacht niet bezorgen. En dan blijken talent, inzet, doorzettingsvermogen en een visie even belangrijk - zoniet belangrijker - als bij mensen die het zónder beroemde achtergrond proberen te maken.

In His Footsteps geeft een internationale bloemlezing van enkele van de bekendste en meest succesvolle vader-zoon en vader-dochter combinaties uit de wereld van de sport, politiek, entertainment, zaken, wetenschap, kunst en literatuur.

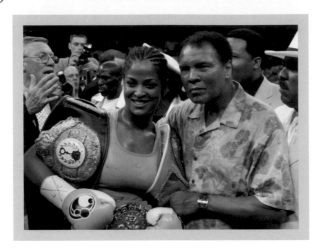

Muhammad & Laila
Ali

Cassius Marcellus Clay (17 January 1942, USA) is considered the greatest heavyweight championship boxer the world has ever seen. 'The Greatest' won the world champion belt three times and took home the gold medal in the 1960 Olympic games. He won 56 of his 61 professional fights, 37 of which by knockout. In 1964 he changed his name to Muhammad Ali after joining the Nation of Islam.
Laila Ali (30 December 1977, USA) began her boxing career in 1999 and went on to win 24 consecutive fights, 21 of which by knockout. In 2008, she began to focus on other activities, like writing her autobiography *Reach!* and TV programmes such as *American Gladiators* and *Dancing With the Stars*.
Father & daughter: Muhammad said about himself: "I float like a butterfly, sting like a bee." Subsequently, Laila was nicknamed She Bee Stingin'. • Adidas made a commercial using footage of both boxers to produce a fight that made it seem as though they were taking each other on in the ring. The message was: *"Nothing is impossible."* • Besides looking very much alike and sharing the same charisma, the amount of self-confidence Laila possesses is second only to her father's. • In 2007 Laila featured in the documentary *Daddy's Girl.*

Cassius Marcellus Clay (17 janvier 1942, États-Unis) est considéré comme le plus grand boxeur de tous les temps dans la catégorie poids lourds. Triple champion du monde, *The Greatest* a également remporté l'or olympique en 1960. Sur 61 combats professionnels, il en a remporté 56, dont 37 par KO. En 1964, après avoir rejoint la Nation de l'Islam, il se rebaptise "Mohammed Ali".
Laila Ali (30 décembre 1977, États-Unis) devient boxeuse professionnelle en 1999 et remporte 24 matchs consécutifs (dont 21 par KO).
En 2008, elle entreprend l'écriture de l'autobiographie *Reach!* et devient présentatrice à la télévision ("*American Gladiators*", "*Dancing With the Stars*").
Père & fille : Mohammed Ali disait de lui-même : "Je flotte tel un papillon et pique telle une abeille" ; Laila sera surnommée "*She Bee Stingin*'". • Dans une publicité pour Adidas, les images ont été retravaillées pour donner lieu à un combat les opposant sur le ring. Le message : "*Nothing is impossible*". • Leur ressemblance physique et charismatique est étonnante. En termes de confiance en soi, Laila n'a rien à envier à son père. • En 2007, un documentaire a été consacré à Laila : "*Daddy's Girl*".

Cassius Marcellus Clay (17 januari 1942, VSA) wordt beschouwd als de beste zwaargewicht bokser aller tijden. 'The Greatest' werd driemaal wereldkampioen en won in 1980 Olympische goud. Van zijn 61 gevochten profpartijen, won hij er 56, waarvan 37 op knock-out. In 1964 veranderde hij zijn naam in Muhammad Ali, toen hij lid werd van de Nation of Islam.
Laila Ali (30 december 1977, VSA) besloot in 1999 om profbokser te worden en won 24 duels op rij, waarvan 21 na knock-out. In 2008 begon ze zich aan andere bezigheden te wijden, zoals het schrijven van de autobiografie Reach! en tv-programma's als *American Gladiators* en *Dancing With the Stars*.
Vader & dochter: Muhammad zei van zichzelf: *"I float like a butterfly, sting like a bee"*. Daardoor kreeg Laila de bijnaam She Bee Stingin'. • In een reclamespot voor Adidas werd beeldmateriaal van beiden op zulke manier gemanipuleerd dat het leek alsof ze elkaar in de ring bekampten. De boodschap: *"Nothing is impossible"*. • De gelijkenis wat gelaatstrekken en uitstraling betreft, is verbluffend en ook op het vlak van zelfvertrouwen moet Laila niet onderdoen voor haar vader. • Laila was in 2007 het onderwerp van de documentaire *Daddy's Girl.*

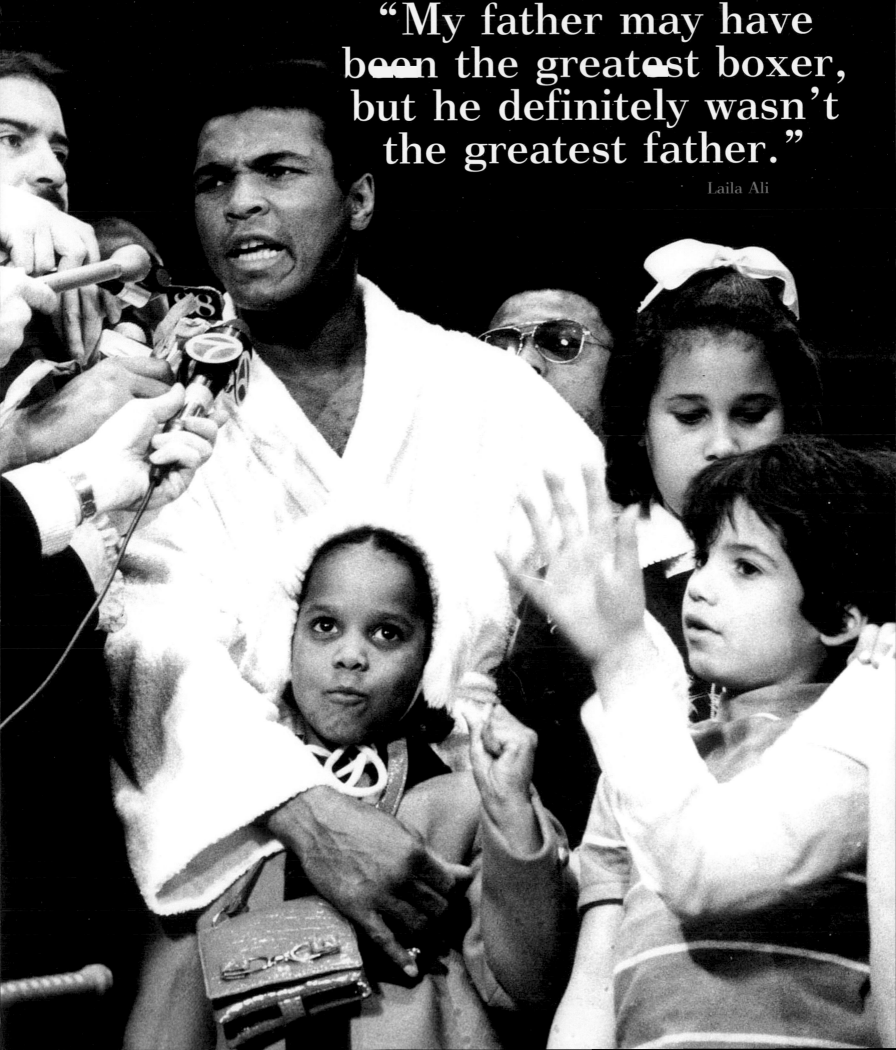

"My father may have been the greatest boxer, but he definitely wasn't the greatest father."

Laila Ali

Kingsley & Martin
Amis

Sir Kingsley William Amis (16 April 1922 - 22 October 1995, Great Britain) was a prominent representative of the British literary *Angry Young Men*-movement in the 1950s. He wrote more than twenty (mainly humorous) novels, six poetry collections and several short stories, scenarios and reviews. A few of his most famous pieces of work are *Lucky Jim*, *Take a Girl like You*, *The Green Man* and *The Old Devils*.
Martin Louis Amis (25 August 1949, Great-Britain) is said to be one of the most important British post-war authors. 'The master of the new unpleasantness' has a very distinctive style of writing, typically containing both moral and psychological violence. His work inspired a whole new generation of writers with books such as *The Rachel Papers*, *Dead Babies*, *Money* and *London Fields*.
Father and Son: After Kingsley's death, Martin fired his father's self-appointed biographer and wrote Experience, a sharp and humorous biography about him. • In 2008, the biographical book *Amis and Son: Two Literary Generations* came out about the two authors. • When Kingsley's second marriage ended in 1983, Martin arranged that his father moved in with his ex-wife Hilary (Martin's mother) and her third husband until his death in 1995.

Sir Kingsley William Amis (16 avril 1922 - 22 octobre 1995, Grande-Bretagne) fut un éminent représentant du courant littéraire britannique *Angry Young Men* apparu dans les années 50. Il a écrit une vingtaine de livres – principalement comiques –, six recueils de poésies et quelques nouvelles, scénarios et critiques. Ses œuvres les plus célèbres sont : *Lucky Jim*, *Take a Girl Like You*, *The Green Man*, *The Old Devils*, etc.
Martin Louis Amis (25 août 1949, Grande-Bretagne) est considéré comme l'un des principaux auteurs britanniques d'après-guerre. Le maître du "nouveau désagréable" possède un style très personnel, d'une vivacité morale et psychologique extrême. Ses ouvrages *The Rachel Papers*, *Dead Babies*, *Money* ou encore *London Fields* ont inspiré toute une jeune génération d'auteurs.
Père & fils : Après la mort de Kingsley, Martin limogea le biographe de son père et dressa un portrait cynique et amusant de Sir Kingsley dans *Experience*. • La biographie *Amis and Son: Two Literary Generations* est parue en 2008. • Quand le second mariage de Kingsley se révéla être un échec en 1983, Martin s'arrangea pour que son père puisse loger jusqu'à sa mort auprès de son ex-femme Hilary (la mère de Martin) et du compagnon de celle-ci.

Sir Kingsley William Amis (16 april 1922 - 22 oktober 1995, Groot-Brittannië) was een vooraanstaand vertegenwoordiger van de Britse literaire Angry Young Men-stroming uit de jaren 50. Hij schreef een twintigtal - vooral humoristische - boeken, zes dichtbundels en een aantal kortverhalen, scenario's en kritieken. Een aantal van zijn bekendste werken zijn *Lucky Jim*, *Take a Girl Like You*, *The Green Man* en *The Old Devils*.
Martin Louis Amis (25 augustus 1949, Groot-Brittannië) wordt beschouwd als een van de belangrijkste naoorlogse Britse auteurs. 'De meester van de nieuwe onplezierigheid' heeft een zeer persoonlijke stijl, gekenmerkt door moreel en mentaal geweld, en inspireerde met boeken als *The Rachel Papers*, *Dead Babies*, *Money* en *London Fields* een volledig nieuwe generatie schrijvers.
Vader & zoon: Na de dood van Kingsley ontsloeg Martin de door zijn vader aangeduide biograaf en schetste hij in *Experience* een scherp en grappig portret van zijn vader. • Over vader en zoon verscheen in 2008 het biografische boek *Amis and Son: Two Literary Generations*. • Toen Kingsleys tweede huwelijk in 1983 op de klippen liep, zorgde Martin ervoor dat hij tot aan zijn dood kon inwonen bij zijn ex-vrouw Hilary (Martins moeder) en haar derde echtgenoot.

> **"I think that if anyone's reading us both in fifty or a hundred years' time, we shall seem like very much the same kind of writer."**
>
> Kingsley Amis

Mario, Michael & Marco
Andretti

Mario Gabriele Andretti (28 February 1940, Italy) is one of the most successful American racing drivers of all time: he secured more than 109 victories in diverse disciplines, is the only man ever to win the Indianapolis 500, the Daytona 500 and the Formula 1 world championship, and is also the only racer whose career spanned five decades.

Michael Mario Andretti (5 October 1962, USA) was a commendable CART and Formula 1 racing driver. He became the IndyCar world champion in 1991 and ten years later founded the IndyCar race team Andretti Green Racing (later renamed Andretti Autosport).

Marco Michael Andretti (13 March 1987, USA) became the youngest IndyCar racer ever when he started out in 2006 for Andretti Green Racing. He was named the newcomer of the year and secured the runner-up spot that same year in the Indianapolis 500 race.

The Andretti family: Also in the racing business: Mario's brother Aldo, Michael's brother Jeff and Aldo's sons John and Adam Andretti.
• Michael, John en Mario were the first to share all three places on the victory stage, as a family, in the 1991 Milwaukee Mile IndyCar race. Jeff came in 11th place. • The unexplainable bad luck that the Andretti racing family has experienced in their efforts to win on the Indianapolis Motor Speedway has been attributed to the 'Andretti Curse'.

Mario Gabriele Andretti (28 février 1940, Italie) est, avec plus de 109 victoires au compteur dans diverses catégories, l'un des plus grands pilotes automobiles américains de l'histoire. Il est le seul à avoir remporté des courses pendant cinq décennies, notamment le triplé des 500 miles d'Indianapolis, le Daytona 500 et le championnat du monde de Formule 1.

Michael Mario Andretti (5 octobre 1962, États-Unis) fut un grand pilote de kart et de Formule 1. Il est devenu champion du monde d'IndyCar en 1991 et a lancé l'écurie d'IndyCar Andretti Green Racing en 2001 (devenue aujourd'hui Andretti Autosport).

Marco Michael Andretti (13 mars 1987, États-Unis) s'est distingué en 2006 comme le plus jeune pilote d'IndyCar de tous les temps. Il fut élu meilleur débutant de l'année et parvint à se classer second aux 500 miles d'Indianapolis.

La famille Andretti : Autres pilotes automobiles, Aldo (frère de Mario), Jeff (frère de Michael), John et Adam (fils d'Aldo). • Michael, John et Mario ont été les premiers à rafler le podium complet en 1991 sur le Milwaukee Mile (IndyCar). Jeff finissait quant à lui à la 11e position. • Les nombreuses déconvenues des Andretti sur l'Indianapolis Motor Speedway seraient le fruit de la "malédiction des Andretti".

Mario Gabriele Andretti (28 februari 1940, Italië) is een van de meest succesvolle Amerikaanse racers ooit. Hij behaalde meer dan 109 overwinningen in uiteenlopende disciplines, is de enige ter wereld die erin slaagde om de Indianapolis 500, de Daytona 500 én het Formule 1-wereldkampioenschap te winnen, en is ook de enige die gedurende vijf decennia races won.

Michael Mario Andretti (5 oktober 1962, VSA) was een verdienstelijk CART- en Formule 1-chauffeur. In 1991 werd hij IndyCar-wereldkampioen en tien jaar later startte hij het IndyCar-raceteam Andretti Green Racing, later omgedoopt tot Andretti Autosport.

Marco Michael Andretti (13 maart 1987, VSA) lanceerde zich in 2006 voor Andretti Green Racing als jongste IndyCar-racer ooit. Hij werd nieuwkomer van het jaar en pakte nog datzelfde jaar de tweede plaats van de Indianapolis 500-race.

De familie Andretti: Zitten ook nog in de racesport: Mario's broer Aldo, Michaels broer Jeff en Aldo's zonen John en Adam Andretti. • Michael, John en Mario waren de eersten die er in 1991 in slaagden om als familie het volledige winnaarspodium in te palmen tijdens de Milwaukee Mile IndyCarrace. Jeff eindigde elfde. • Het feit dat veel familieleden al pech hebben gehad op de Indianapolis Motor Speedway wordt geweten aan de 'Andrettivloek'.

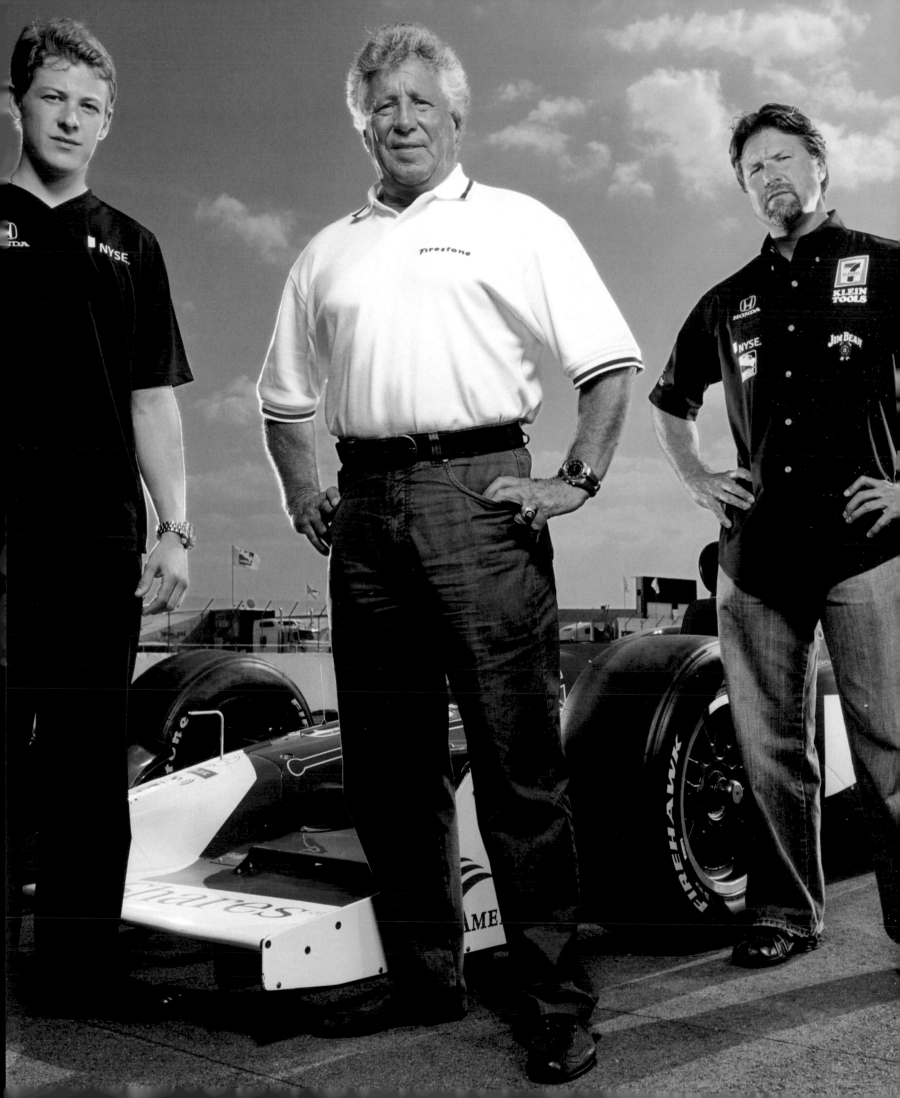

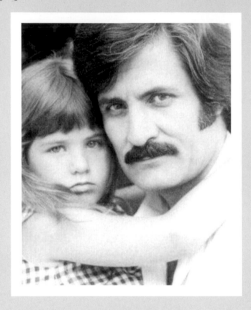

John & Jennifer
Aniston

Yannis Anastasakis (24 July 1933, Greece) moved from Crete to the United States along with his parents at the age of 10. As John Aniston, he came to fame after consecutively appearing in the popular soap operas *Love of Life*, *Search for Tomorrow* and *Days of our Lives*.
Jennifer Joanna Linn Aniston (11 February 1969, USA) became a household name thanks to her role in the popular sitcom *Friends*, in which she played Rachel Green for 10 years. She went on to appear in commercially successful films like *Bruce Almighty*, *Along Came Polly* and *He's Just Not That into You*. She received great critical acclaim for films like *She's The One* and *The Good Girl*. Her love life has received an enormous amount of attention from tabloid magazines.
Father & daughter: At a young age, Jennifer's parents divorced. During one of her visits, John found his fifteen-year-old daughter in his dressing room on the phone with his manager discussing film roles. • The Joey character in *Friends* played in the sitcom *Days of Our Lives*, an obvious reference to the program that her father had acted in for such a long time. • In 2009, Jennifer and her father recorded a listening version of the book *Loukoumi's Good Deeds* for charity.

Yannis Anastasakis (24 juillet 1933, Grèce) quitta la Crète avec ses parents pour s'installer aux États-Unis ; "John Aniston" connut ensuite la gloire auprès des amateurs de feuilletons en jouant successivement dans "*Love of Life*", "*C'est déjà demain*" et "*Des jours et des vies*".
Jennifer Joanna Linn Aniston (11 février 1969, États-Unis) conquiert le monde avec la série "*Friends*", dans laquelle elle joue le personnage de Rachel Green pendant dix ans. Elle enchaîne les succès commerciaux au cinéma (*Bruce tout puissant*, *Polly et moi*, *Ce que pensent les hommes*) et reçoit des critiques élogieuses pour *Petits Mensonges entre frères* et *The Good Girl*. La presse people raffole des potins relatifs à sa vie privée.
Père & fille : Les parents de Jennifer ont divorcé lorsqu'elle était enfant. En visite chez son père à l'âge de 15 ans, John la retrouva dans sa loge au téléphone avec son manager, discutant de rôles pour le cinéma. • Dans "*Friends*", Joey est acteur pour la série "*Des jours et des vies*" ; un clin d'œil au feuilleton dans lequel John Aniston jouait lui-même. • En 2009, Jennifer et John ont prêté leur voix pour la bonne cause dans une version audio du livre *Loukoumi's Good Deeds*.

Yannis Anastasakis (24 juli 1933, Griekenland) verhuisde op zijn tiende met zijn ouders van Kreta naar de States. Daar verwierf hij als John Aniston vooral roem bij soapliefhebbers, door achtereenvolgens mee te spelen in *Love of Life*, *Search for Tomorrow* en *Days of our Lives*.
Jennifer Joanna Linn Aniston (11 februari 1969, VSA) veroverde de wereld dankzij de sitcom *Friends*, waarin ze tien jaar lang de rol vertolkte van Rachel Green. Daarna scoorde ze commerciële successen met films als *Bruce Almighty*, *Along Came Polly* en *He's Just Not That into You*; en oogstte ze lovende kritieken voor prenten als *She's The One* en *The Good Girl*. De roddelbladen hebben bovendien een vette kluif aan haar liefdesleven.
Vader & dochter: Jennifers ouders scheidden toen ze nog klein was. Tijdens een van de bezoekjes aan haar vader op haar vijftiende, vond John haar in zijn kleedkamer terwijl ze met zijn manager aan het telefoneren was over filmrollen. • In *Friends* speelde Joey mee in de serie *Days of Our Lives*, een verwijzing naar de serie waarin Jennifers vader zolang meespeelde. • In 2009 spraken Jennifer en haar vader voor het goeie doel samen een luisterversie in van het boek *Loukoumi's Good Deeds*.

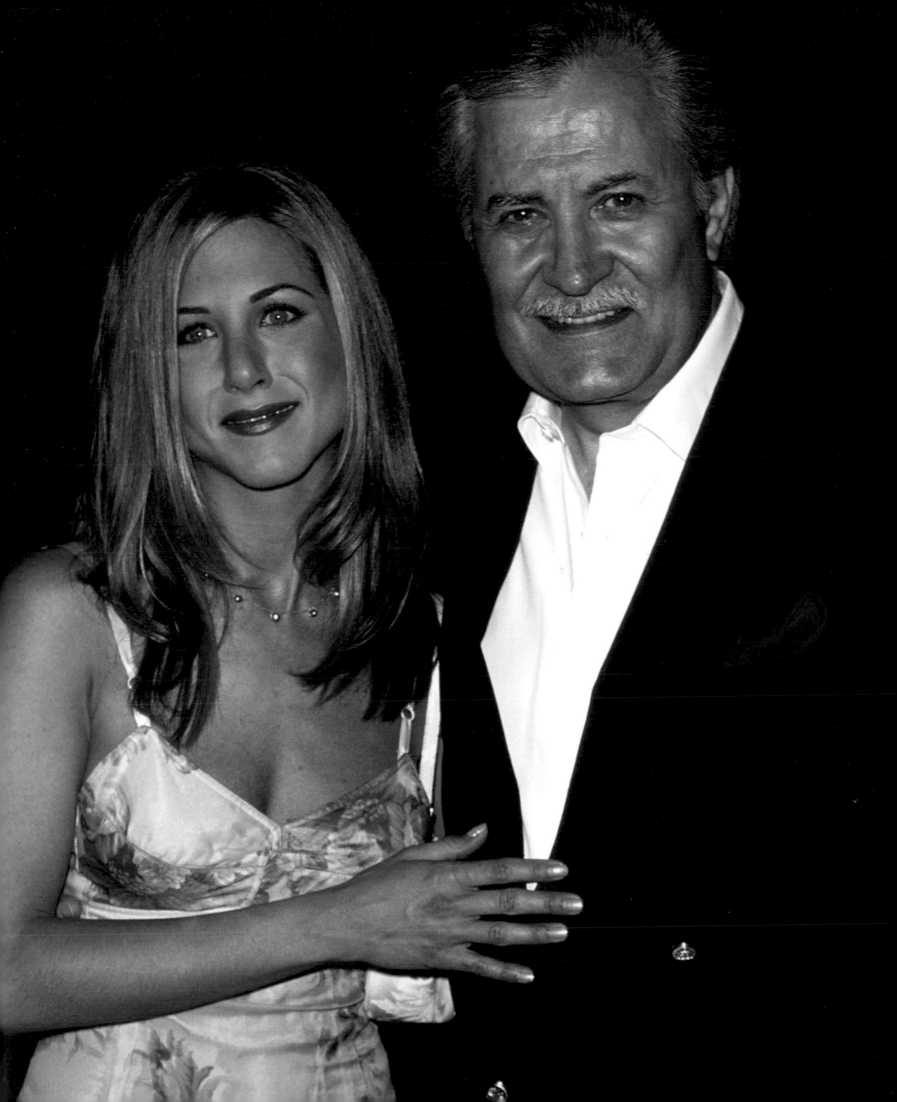

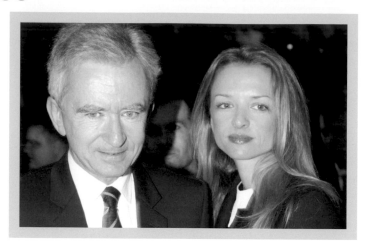

Bernard & Delphine
Arnault

Bernard Arnault (5 March 1949, France) is the founder and CEO of LVMH, which is a world leader in the luxury industry with its fifty-odd brands like Louis Vuitton, Dior, Veuve Cliquot, Moët & Chandon, Givenchy, Donna Karan and Fendi. According to Forbes Magazine, he is the world's seventh richest person.

Delphine Arnault Gancia (4 April 1975, France) worked her way up in McKinsey & Company and at the age of 28, became the youngest and first woman ever to be named director of LVMH. Due to her being the second most important shareholder and heir of LVMH and her marriage to Alessandro Gancia (heir to the Gancia Wine emporium and director of Christian Dior), Delphine has become one of the richest women in the world.

Father & daughter: Bernard is sometimes called the 'pope of fashion', while his daughter Delphine is known in France as 'the Napoleon of the luxury goods industry' or 'the wolf in a cashmere coat'. • Over the course of Delphine's three-day wedding, Bernard oversaw every single detail and even took care of some of the photography and filming of the event. • Delphine and her father are often spotted together at society events. The Arnault family: Delphine's younger brother Antoine is director of communications at Louis Vuitton.

Bernard Arnault (5 mars 1949, France) est le fondateur et PDG du groupe de luxe LVMH, englobant une cinquantaine de marques prestigieuses, dont Louis Vuitton, Dior, La Veuve Cliquot, Moët & Chandon, Givenchy, Donna Karan et Fendi. Selon le magazine *Forbes*, il est détenteur de la septième fortune mondiale.

Delphine Arnault Gancia (4 avril 1975, France) a travaillé chez McKinsey & Company avant de devenir la première femme à occuper la fonction de directeur chez LVMH. Âgée alors de vingt-huit ans, elle s'imposa à cette occasion comme le plus jeune directeur de toute l'histoire de la maison. Deuxième actionnaire principal et héritière de LVMH, l'épouse d'Alessandro Gancia (héritier de l'empire Gancia et directeur de la marque Christian Dior) est l'une des femmes les plus riches au monde.

Père & fille : Bernard est surnommé "le pape de la mode", Delphine "le Napoléon de l'industrie des produits de luxe" ou "le loup en manteau de cachemire". • Durant les trois jours de célébration du mariage de sa fille, Bernard a supervisé chaque détail et s'est lui-même chargé de filmer et de photographier l'événement. • Delphine et son père sont souvent présents lors des événements mondains.

La famille Arnault : Antoine, le frère cadet de Delphine, est directeur de la communication chez Louis Vuitton.

Bernard Arnault (5 maart 1949, Frankrijk) is de stichter en topman van LVMH, dat wereldleider is in de luxe-industrie dankzij een vijftigtal merken als Louis Vuitton, Dior, Veuve Cliquot, Moët & Chandon, Givenchy, Donna Karan en Fendi. Volgens Forbes Magazine is hij de zevende rijkste persoon ter wereld.

Delphine Arnault Gancia (4 april 1975, Frankrijk) werkte zich op bij McKinsey & Company voor ze op haar 28e de jongste én de eerste vrouw werd die erin slaagde directeur te worden bij LVMH. Als tweede belangrijkste aandeelhouder en erfgename van LVMH én echtgenote van Alessandro Gancia (erfgenaam van het wijnimperium Gancia en directeur van Christian Dior) is ze een van de rijkste vrouwen ter wereld.

Vader & dochter: Bernard wordt ook wel 'de paus van de mode' genoemd, terwijl zijn dochter Delphine in Frankrijk bekend staat als 'de Napoleon van de luxeproductenindustrie' of ook 'de wolf in de kasjmier jas'. • Tijdens het drie dagen durende huwelijksfeest van Delphine waakte Bernard als een wolf over alle details en hield hij zich zelfs bezig met filmen en fotograferen. • Delphine en haar vader worden vaak samen gespot op society-evenementen.

De familie Arnault: Delphines jongere broer Antoine is directeur communicatie bij Louis Vuitton.

"My father was often angry when I was most like him."

Lillian Hellman (1905-1984),
American playwright

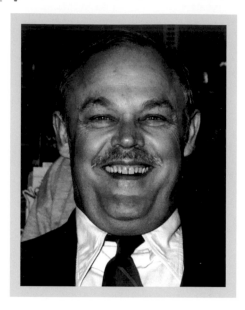

Lewis, Rosanna & Patricia
Arquette

Lewis Michael Arquette (14 December 1935 - 10 February 2001, USA) came to fame when he portrayed J.D. Pickett in the television series *The Waltons*. He played numerous character roles in films and television series, worked as a director, musician and stand-up comedian.
Rosanna Lauren Arquette (10 August 1959, USA) appeared in *Desperately Seeking Susan* and confirmed her success by playing in big films like *Pulp Fiction*, *Le Grand Bleu* and *Crash*. At the moment, she is mostly directing and producing.
Patricia T. Arquette (8 April 1968, USA) has built up a much acclaimed film career due to films such as *True Romance*, *Ed Wood*, *Beyond Rangoon*, *Lost Highway* and *Bringing Out the Dead*. Since 2005, she has played the lead character in the successful television series *Medium*.
The Arquette family: Lewis is the son of actor Cliff Arquette en the grandson of the vaudeville team Arquette & Clark. He is also the father of *Scream* actor David, actor Richmond and the transsexual actress Alexis. Patricia's son Enzo is also pursuing a career in acting. • Patricia ran away from home at the age of fifteen and moved in with her sister Rosanna so she could work on developing an acting career. • Both Rosanna and Richmond made guest appearances on *Medium* and David directed two of its episodes.

Lewis Michael Arquette (14 décembre 1935 - 10 février 2001, États-Unis) est célèbre pour avoir tenu le rôle de J.D. Pickett dans la série "La Famille des collines". Il a joué un nombre incalculable de grands rôles dans des séries comme au cinéma. Il fut également réalisateur, musicien et humoriste.
Rosanna Lauren Arquette (10 août 1959, États-Unis), révélée par *Recherche Susan désespérément*, confirma son succès en jouant dans *Pulp Fiction*, *Le Grand Bleu* et *Crash*. Actuellement, elle travaille avant tout comme réalisatrice et productrice.
Patricia T. Arquette (8 avril 1968, États-Unis) connaît, elle aussi, une très belle carrière cinématographique (*True Romance*, *Ed Wood*, *Rangoon*, *Lost Highway*, *À tombeau ouvert*). Depuis 2005, elle tient le rôle principal de la série "Medium".
La famille Arquette : Lewis est le fils de l'acteur Cliff Arquette et le petit-fils du duo de vaudeville Arquette & Clark. Il est le père de David (*Scream*), de Richmond et de l'actrice transsexuelle Alexis. Le fils de Patricia, Enzo, aspire aussi à une carrière cinématographique. • Patricia a quitté la maison familiale à l'âge de 15 ans pour s'installer chez sa sœur Rosanna et démarrer une carrière d'actrice. • Rosanna et Richmond ont joué dans "Medium", alors que David a réalisé deux épisodes de la série.

Lewis Michael Arquette (14 december 1935 - 10 februari 2001, VSA) werd bekend door zijn rol van J.D. Pickett in de tv-serie *The Waltons*. Hij speelde ontelbare karakterrollen in films en tv-series, werkte als regisseur, muzikant en stand-upcomedian.
Rosanna Lauren Arquette (10 augustus 1959, VSA) brak door met *Desperately Seeking Susan* en bevestigde haar succes met grote films als *Pulp Fiction*, *Le Grand Bleu* en *Crash*. Momenteel houdt ze zich vooral bezig met regisseren en produceren.
Patricia T. Arquette (8 april 1968, VSA) bouwde een gelauwerde filmcarrière uit dankzij prenten als *True Romance*, *Ed Wood*, *Beyond Rangoon*, *Lost Highway en Bringing Out the Dead*. Sinds 2005 speelt ze de hoofdrol in de succesvolle tv-serie *Medium*.
De familie Arquette: Lewis is de zoon van acteur Cliff Arquette en de kleinzoon van het vaudevilleteam Arquette & Clark. Hij is ook de vader van *Scream*-acteur David, acteur Richmond en de transseksuele actrice Alexis. Ook Patricia's zoon Enzo streeft een acteercarrière na. • Patricia liep op haar vijftiende van huis weg om bij haar zus Rosanna te gaan wonen en een acteercarrière uit te bouwen. • Zowel Rosanna als Richmond speelden een gastrol in *Medium* en David regisseerde er twee afleveringen van.

Franz & Stephan
Beckenbauer

Franz Anton Beckenbauer (11 September 1945, Germany) is generally considered to be one of the greatest football players of all time. While playing with Bayern Munich, he won the European Cup three times, the national championship four times and the German Cup four times. He appeared 103 times for the national team and is the only person in history to succeed in winning the World Cup trophy both as captain and as manager. In 1994, he took on the role of club president at FC Bayern Munich, which he held for 15 years.
Stephan Beckenbauer (1 December 1968, Germany) played for Bayern Munich, like his father, before transferring to rivals FC Saarbrücken. After a knee injury forced him to quit playing football, he went on to become coach of Bayern Munich's under-17 team and won the German championship in 2001 as well as in 2007.
Father & son: Franz was nicknamed 'Der Kaiser' because of his dominance on the football pitch, while Stephan had to settle for 'Der kleine Franz'.

Franz Anton Beckenbauer (11 septembre 1945, Allemagne) est considéré comme l'un des meilleurs footballeurs de tous les temps. Avec le Bayern de Munich, il a remporté trois Coupes d'Europe des clubs champions, quatre titres nationaux et quatre Coupes de la RFA. Il affiche 103 sélections en équipe nationale et est le seul à avoir conduit une équipe à la victoire en Coupe du monde, d'abord comme capitaine, puis comme entraîneur. À partir de 1994, il est devenu président du FC Bayern, poste qu'il occupera pendant 15 ans.
Stephan Beckenbauer (1er décembre 1968, Allemagne) joua comme son père au Bayern de Munich avant de passer au TSV Munich 1860 puis au FC Saarbruck. Une blessure au genou le contraint ensuite d'arrêter le football ; il devint entraîneur de l'équipe des moins de dix-sept ans du Bayern de Munich, avec laquelle il s'imposa comme champion d'Allemagne en 2001 et 2007.
Père & fils : Franz fut surnommé "Le Kaiser" en raison de sa domination sur le terrain. Stephan a quant à lui hérité du surnom de "Petit Franz".

Franz Anton Beckenbauer (11 september 1945, Duitsland) wordt beschouwd als een van 's werelds beste voetbalspelers aller tijden. Met Bayern München won hij driemaal de Europacup I, vier keer de landstitel en vier keer de Duitse beker. Hij trad 103 keer aan in het Duitse nationale elftal en is de enige die erin slaagde een ploeg tijdens het WK achtereenvolgens als kapitein en als coach naar de overwinning te leiden. Vanaf '94 was hij vijftien jaar lang president van FC Bayern München.
Stephan Beckenbauer (1 december 1968, Duitsland) speelde net als zijn vader bij Bayern München, stapte vervolgens over naar rivaal TSV 1860 München en tenslotte naar FC Saarbrücken. Na een knieblessure zag hij zich gedwongen te stoppen met voetballen en werd hij coach van het onder 17-team van Bayern München, waarmee hij in 2001 en 2007 Duits kampioen werd.
Vader & zoon: Franz werd vanwege zijn heersende aanwezigheid op het veld 'Der Kaiser' genoemd. Stephan moet het stellen met de bijnaam 'Der kleine Franz'.

"Withstanding the comparison
was simply impossible.
He was just too good."
Stephan Beckenbauer

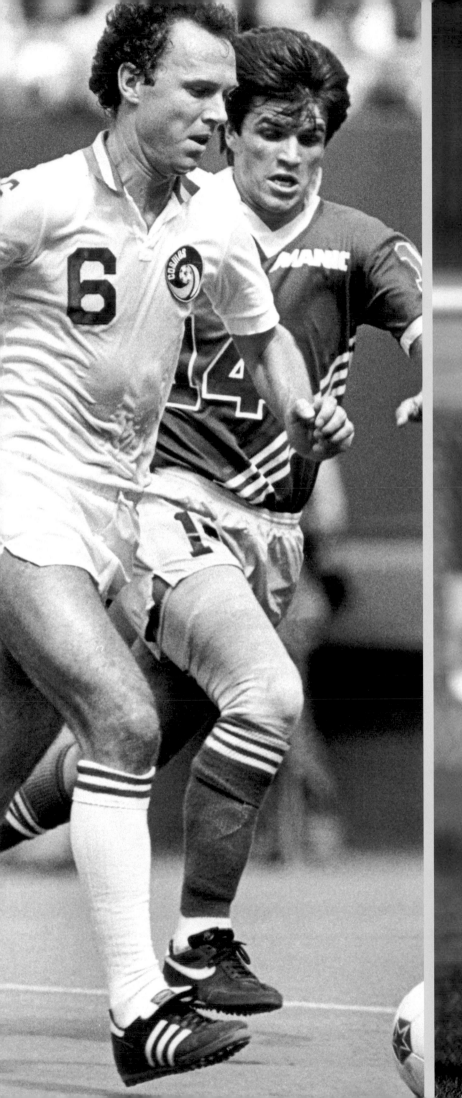

Zulfikar Ali & Benazir
Bhutto

Zulfikar Ali Bhutto (5 January 1928 - 4 April 1979, Pakistan) founded the largest and most influential political party of the country in 1967: the Pakistan Peoples Party (PPP). He became President and later Prime Minister but was removed after his third electoral victory in 1977 by the opposition and the army. He was arrested and accused of murdering a political rival and eventually hung 2 years later, despite much international protest.

Benazir Bhutto (21 June 1953 - 27 December 2007, Pakistan) was the first woman elected to lead a Muslim state and the only one to have ever become Prime Minister of Pakistan. After being removed from office twice on grounds of alleged corruption, she went into a self-imposed exile to Dubai. She was the opposition leader for the PPP in the run-up to the 2008 elections, when she was assassinated during a suicide attack.

Father & daughter: Zulfikar named his first daughter Benazir, which means incomparable. • While he was in prison, he urged his daughter to continue his political career.

The Bhutto family: Zulfikar's second wife, Nusrat Bhutto, became her husband's successor as the chairman of the PPP after his death. Benazir's husband, Asif Ali Zardari, is de current President of Pakistan.

Zulfikar Ali Bhutto (5 janvier 1928 - 4 avril 1979, Pakistan) fonde en 1967 le parti du peuple pakistanais (PPP), le parti le plus influent du pays. Il devient président puis Premier ministre, mais en 1977, après une troisième victoire aux élections, il est renversé par l'opposition et l'armée. Il est condamné pour "conspiration au meurtre" sur la personne d'un rival politique et pendu deux ans plus tard, malgré une vive protestation internationale.

Benazir Bhutto (21 juin 1953 - 27 décembre 2007, Pakistan) fut la première femme élue à la tête d'un État musulman et la seule à endosser la fonction de Premier ministre du Pakistan. Destituée à deux reprises sur la base d'accusations de corruption, elle s'est exilée à Dubaï. Puis, de retour à la tête du parti d'opposition durant la campagne électorale de 2008, Benazir fut victime d'un attentat suicide.

Père & fille : Zulfikar prénomma sa première fille Benazir, ce qui signifie "incomparable". • Même en prison, il exhortait sa fille à poursuivre son combat politique.

La famille Bhutto : la seconde épouse de Zulfikar, Nusrat Bhutto, prit la direction du PPP après la mort de celui-ci. L'époux de Benazir, Asif Ali Zardari, est l'actuel président du Pakistan.

Zulfikar Ali Bhutto (5 januari 1928 - 4 april 1979, Pakistan) stichtte in 1967 de grootste en meest invloedrijke politieke partij van het land: de Pakistan Peoples Party (PPP). Hij schopte het tot president en eerste minister maar werd in 1977 na een derde verkiezingszege door oppositie en leger ten val gebracht. Hij werd gearresteerd op beschuldiging van moord op een politieke rivaal en twee jaar later opgehangen ondanks groot internationaal protest.

Benazir Bhutto (21 juni 1953 - 27 december 2007, Pakistan) was de eerste vrouw die verkozen werd om een Moslimstaat te leiden en de enige vrouw die het schopte tot eerste minister van Pakistan. Nadat ze tweemaal afgezet was op beschuldiging van corruptie, trok ze in een zelfopgelegde ballingschap naar Dubai. Tijdens de aanloop naar de verkiezingen van 2008 werd ze als oppositieleidster van de PPP slachtoffer van een zelfmoordaanslag.

Vader & dochter: Zulfikar noemde zijn eerste dochter Benazir, wat 'onvergelijkbaar' betekent. • Vanuit de gevangenis spoorde hij zijn dochter aan om zijn politieke loopbaan voort te zetten.

De familie Bhutto: Zulfikars tweede vrouw Nusrat Bhutto volgde haar echtgenoot na zijn dood op als voorzitter van de PPP. Benazirs echtgenoot Asif Ali Zardari is de huidige president van Pakistan.

> "My father always would say, 'My daughter will go into politics. My daughter will become prime minister', but it's not what I wanted to do."
>
> Benazir Bhutto

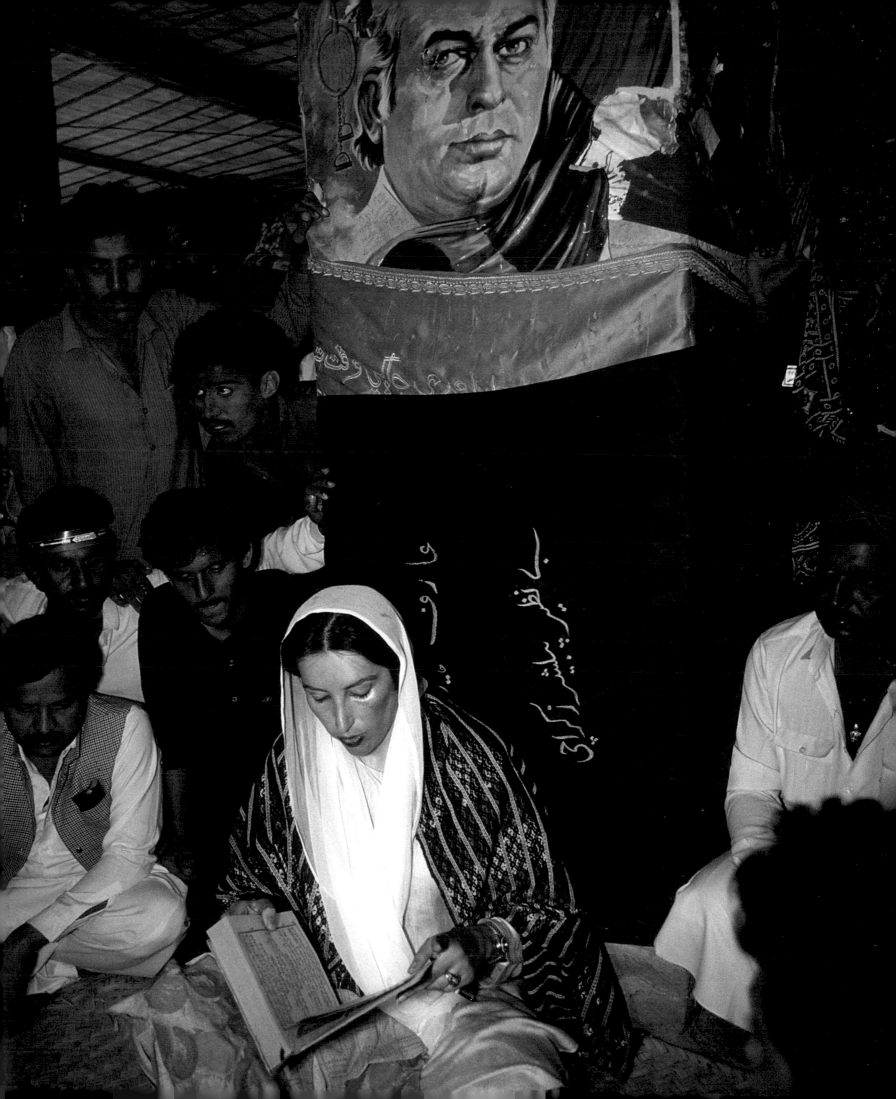

"Every father should remember that one day his son will follow his example instead of his advice."

Anonymous

23

Niels & Aage
Bohr

Niels Hendrik David Bohr (7 October 1885 - 18 November 1962, Denmark) is one of the most influential physicists of the 20th century. Due to his formulation of a theoretical foundation for the new atomic structure, he became one of the founders of atomic physics and made a major contribution to the most controversial branch of physics in the 20th century: quantum mechanics.

Aage Niels Bohr (19 June 1922 - 8 September 2009, Denmark) was a nuclear physicist, professor at the University of Copenhagen and director of the Niels Bohr Institute. Together with two colleagues, he made important discoveries in the research of the quantum mechanic description of nuclear particles.

Father & son: During WWII Niels worked on the Manhattan Project with his son Aage as assistant and secretary. This was a project conducted to develop the first atomic bomb. • In 1922, the year in which his son was born, Niels received the Nobel Prize in Physics for his work. Fifty-three years later it was Aage's turn, along with his colleagues Mottelson and Rainwater, to receive the same Nobel Prize.

Niels Hendrik David Bohr (7 octobre 1885 - 18 novembre 1962, Danemark) est considéré comme l'un des physiciens les plus influents du 20e siècle. Grâce à sa formulation du principe théorique pour le nouveau modèle de la structure atomique, il devint l'un des fondateurs de la physique atomique et posa les bases d'une branche sensationnelle de la physique contemporaine : la mécanique quantique.

Aage Niels Bohr (19 juin 1922 - 8 septembre 2009, Danemark) était un physicien nucléaire. Il enseigna à l'université de Copenhague avant de travailler comme chercheur au sein de l'Institut Niels Bohr. Avec deux collègues, il obtint d'importants résultats relatifs à la description de la mécanique quantique des nucléons.

Père & fils : Durant la Seconde Guerre mondiale, Niels – avec son fils Aage comme assistant et secrétaire – a travaillé au Manhattan Project portant sur le développement de la bombe nucléaire. • En 1922, Niels a reçu le prix Nobel de physique récompensant l'ensemble de ses travaux. Cinquante-trois ans plus tard, c'est au tour d'Aage et de ses collègues Mottelson et Rainwater de décrocher la prestigieuse récompense.

Niels Hendrik David Bohr (7 oktober 1885 - 18 november 1962, Denemarken) wordt beschouwd als een van de meest invloedrijke natuurkundigen van de 20e eeuw. Dankzij zijn formulering van een theoretische grondslag voor het nieuwe atoommodel werd hij een van de grondleggers van de atoomfysica en leverde hij meteen ook een grote bijdrage aan de meest spraakmakende tak van de fysica in de 20e eeuw: de kwantummechanica.

Aage Niels Bohr (19 juni 1922 - 8 september 2009, Denemarken) was een kernfysicus, hoogleraar aan de Universiteit van Kopenhagen en een tijdlang bestuurder van het Niels Bohr-instituut. Samen met twee collega's bereikte hij belangrijke resultaten in het onderzoek naar de kwantum-mechanische beschrijving van kerndeeltjes.

Vader & zoon: Tijdens WOII werkte Niels, met zijn zoon Aage als assistent en secretaris, aan het Manhattan Project, dat zich bezighield met de ontwikkeling van de atoombom. • In 1922 - het jaar waarin zijn zoon geboren werd - ontving Niels voor zijn werk de Nobelprijs voor Natuurkunde. Drieënvijftig jaar later was het de beurt aan Aage om samen met zijn collega's Mottelson en Rainwater dezelfde Nobelprijs in ontvangst te nemen.

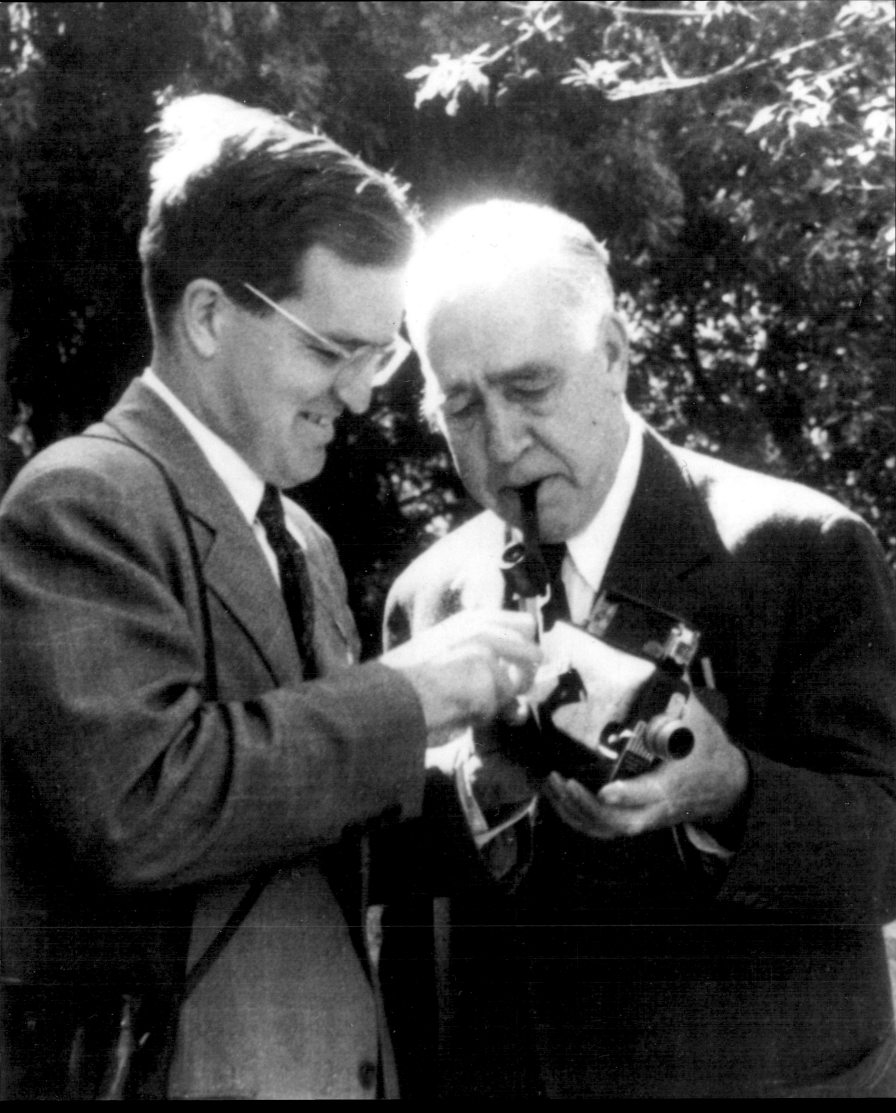

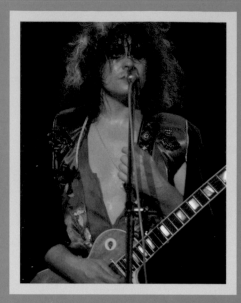

Marc & Rolan
Bolan

Mark Feld (30 September 1947 - 16 September 1977, Great Britain) became immortal as Marc Bolan due to the music he made with T.Rex. Songs like *Hot Love*, *Get It On*, *20th Century Boy* and *Children of the Revolution* turned him into the king of glam rock and the grandfather of punk. He died in a car crash at the age of 29.

Rolan Seymour Feld Bolan (26 September 1975, Great Britain) has been performing as a musician for live shows, television and radio shows and documentaries since 1998. His music is an eclectic mix of rock and hip hop.

Father & son: David Bowie, Tony Visconti and Marc Bolan once agreed that they would name their future sons Zowie, Monty and Rolan. The only one not to honour that agreement was record producer Visconti. • At the moment of the accident, Rolan alledgedly started crying harrowingly. Minutes later the police were standing at the door to inform Marc's parents about the accident. • Rolan only inherited a trifle of his father's fortune: over 20 million pounds disappeared in a negligently set up trust fund. To this day, no one knows who the beneficiaries are. • An hour and a half after Bolan's death, his house was looted. As a result of this, Rolan has few tangible memories of his father.

Mark Feld (30 septembre 1947 - 16 septembre 1977, Angleterre), alias Marc Bolan, entra dans la légende grâce à la musique qu'il composa avec le groupe *T.Rex*. Des morceaux comme "*Hot Love*", "*Get It On*", "*20ᵗʰ Century Boy*" et "*Children of the Revolution*" ont fait de lui le roi du glam-rock et le précurseur du punk. Il décéda à l'âge de 29 ans dans un accident de voiture.

Rolan Seymour Feld Bolan (26 septembre 1975, Grande-Bretagne), musicien, se produit en concert depuis 1998. Il participe à des émissions de radio et de télévision. Sa musique est un mélange éclectique de rock et de hip hop.

Père & fils : David Bowie, Tony Visconti et Marc Bolan avaient convenu ensemble d'appeler leurs fils respectifs Zowie, Monty et Rolan. Seul Visconti n'a pas tenu parole. • On raconte que, lors de l'accident de ses parents (dont il n'était pas au courant), le petit Rolan aurait commencé à pleurer. Peu après, la police arrivait chez les parents de Marc pour annoncer la mauvaise nouvelle. • Rolan n'a perçu qu'une infime part de la fortune de son père ; plus de 20 millions de livres ont disparu dans de mystérieux fonds de placement. • 1h30 après la mort de Bolan, sa maison était vide. Rolan ne possède ainsi que très peu de souvenirs de son père.

Mark Feld (30 september 1947 - 16 september 1977, Groot-Brittannië) werd onsterfelijk dankzij de muziek die hij als Marc Bolan maakte met T.Rex. Liedjes als *Hot Love*, *Get It On*, *20th Century Boy* en *Children of the Revolution* maakten van hem de koning van de glamrock en de grootvader van de punk. Hij kwam op zijn 29e om het leven in een auto-ongeluk.

Rolan Seymour Feld Bolan (26 september 1975, Groot-Brittannië) treedt al sinds 1998 aan als muzikant voor live-optredens, tv- en radioshows en documentaires. Zijn muziek is een eclectische mix van rock en hiphop.

Vader & zoon: David Bowie, Tony Visconti en Marc Bolan spraken ooit af dat ze hun zonen later respectievelijk Zowie, Monty en Rolan gingen noemen. Enkel muziekproducent Visconti hield zich niet aan de afspraak. • Op het moment van het ongeluk begon Rolan naar verluidt hartverscheurend te huilen. Minuten later stond de politie aan de deur om Marcs ouders te vertellen over het ongeval. • Rolan heeft maar een habbekrats geërfd van zijn vaders fortuin: ruim 20 miljoen pond verdween in een slordig opgezet trustfund waarvan nog altijd niemand weet wie de begunstigden zijn. • Anderhalf uur na Bolans dood werd zijn huis volledig leeggeplunderd. Als gevolg hiervan heeft Rolan weinig tastbare herinneringen aan zijn vader.

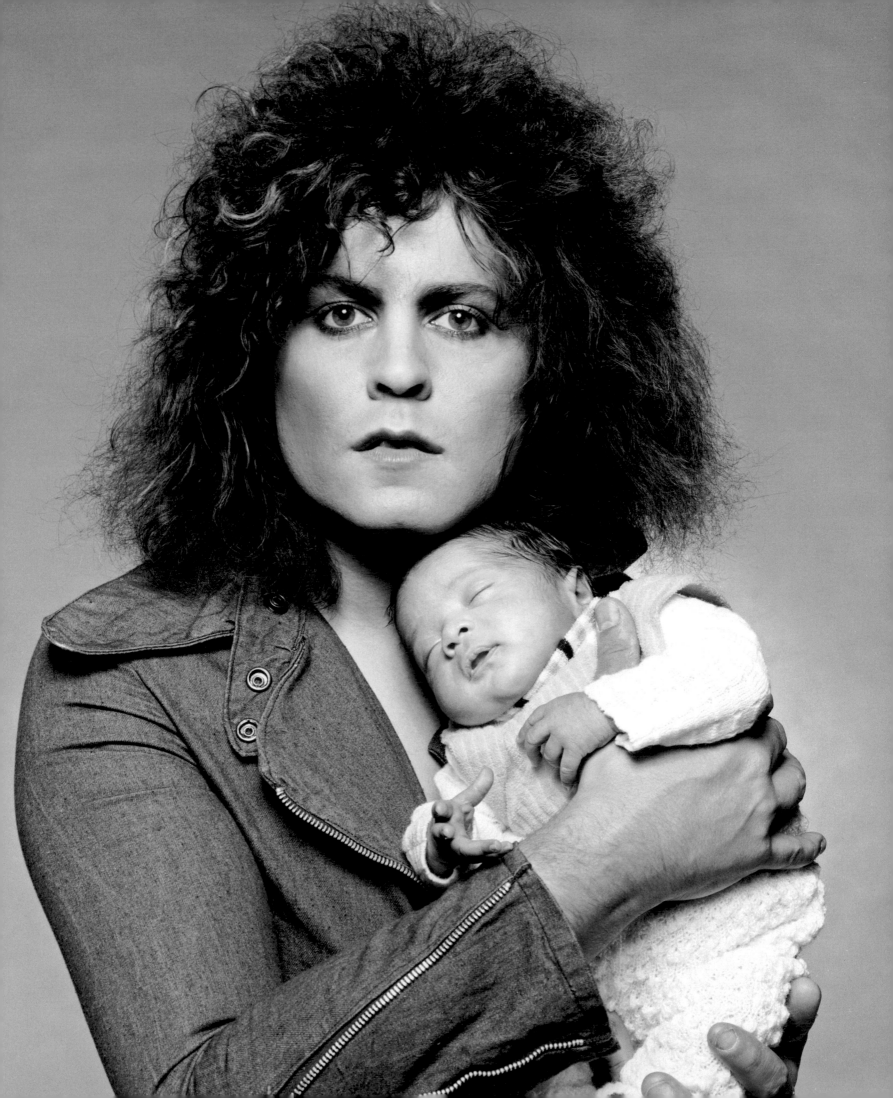

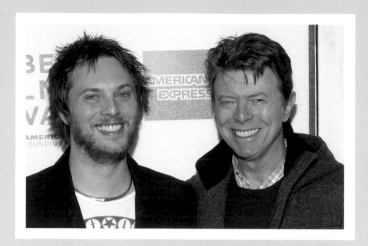

David
Duncan
Bowie & Jones

David Robert Jones (8 January 1947, Great Britain) was one of the most innovative musicians of the seventies. He became world famous thanks to his eccentric alter egos and he continued to score hits in five decades with songs like *Ziggy Stardust*, *Let's Dance*, *Dancing in the Street*, *Heroes* and *Under Pressure*.

Duncan Zowie Haywood Jones (30 May 1971, Great Britain) studied directing and came to the general public's attention in 2006 when he directed a violent advertisement for *French Connection*. His directorial debut *Moon* won several prizes for being the most original science fiction film in years. A sequel and several other films are in the making.

Father & son: David wrote the song *Kooks* for Zowie. • Zowie changed his name to Joey at the age of twelve and to Duncan Jones at the age of twenty. • After their divorce, David gained custody and Duncan's mother got 500 000 pounds. • Duncan first set foot on a film set when David played in *Labyrinth* and picked up a camera during the recording of the television series *The Hunger*. • He dedicated his first short film *Whistle* to 'dads everywhere'. • Duncan shares his love for science fiction with his father, who wrote songs like *Space Oddity*, *Life on Mars* and *Starman*, and starred in *The Man Who Fell to Earth*.

David Robert Jones (8 janvier 1947, Grande-Bretagne) est l'un des musiciens les plus prolifiques des seventies. Son excentricité et ses tubes planétaires s'étalant sur plus de quatre décennies ("*Ziggy Stardust*", "*Let's Dance*", "*Dancing In The Street*", "*Heroes*", "*Under Pressure*") lui valent une renommée internationale.

Duncan Zowie Haywood Jones (30 mai 1971, Grande-Bretagne) a étudié la réalisation et s'est fait remarquer en 2006 avec un spot publicitaire pour l'enseigne de mode French Connection. Son premier long-métrage, *Moon* (2009), est considéré comme le film fantastique le plus original produit depuis des années. Un second opus de *Moon* ainsi que d'autres films sont en projet.

Père & fils : David a écrit la chanson "*Kooks*" pour Zowie. • Zowie a changé de nom pour devenir "Joey" à l'âge de 12 ans. Depuis ses vingt ans, il se fait appeler Duncan Jones. • Duncan foula un plateau de cinéma pour la première fois lorsque David joua dans *Labyrinthe* ; il se familiarisa avec la caméra durant les prises de la série télévisée "Les Prédateurs". • Il dédia son premier court-métrage, *Whistle*, à son père. • Duncan partage avec son père une passion pour la science-fiction ; David composa notamment les chansons "*Space Oddity*", "*Life on Mars*" et "*Starman*", et triompha dans le film *L'Homme qui venait d'ailleurs* (1976).

David Robert Jones (8 januari 1947, Groot-Brittannië) was een van de meest vernieuwende muzikanten van de jaren 70. Hij werd wereldberoemd dankzij zijn excentrieke imago's en bleef vijf decennia lang hits scoren met nummers als *Ziggy Stardust*, *Let's Dance*, *Dancing In The Street*, *Heroes* en *Under Pressure*.

Duncan Zowie Haywood Jones (30 mei 1971, Groot-Brittannië) studeerde regie en liet zich in 2006 opmerken met een gewelddadige reclamespot voor *French Connection*. Zijn regiedebuut *Moon* werd in 2009 gelauwerd als de meest originele scifi-film sinds jaren. Een sequel en verscheidene andere films zijn in de maak.

Vader & zoon: David schreef de song *Kooks* voor Zowie. • Zowie veranderde zijn naam op zijn twaalfde in Joey en liet zich vanaf zijn twintigste Duncan Jones noemen. • Na hun scheiding kreeg David de voogdij en Duncans moeder 500.000 pond. • Duncan betrad voor het eerst een filmset toen David meespeelde in *Labyrinth* en pakte een camera vast tijdens de opnames van diens tv-serie *The Hunger*. • Hij droeg zijn eerste kortfilm *Whistle* op aan 'dads everywhere'. • Duncan deelt zijn voorliefde voor scifi met zijn vader, die songs schreef als *Space Oddity*, *Life on Mars* en *Starman*, en schitterde in *The Man Who Fell to Earth*.

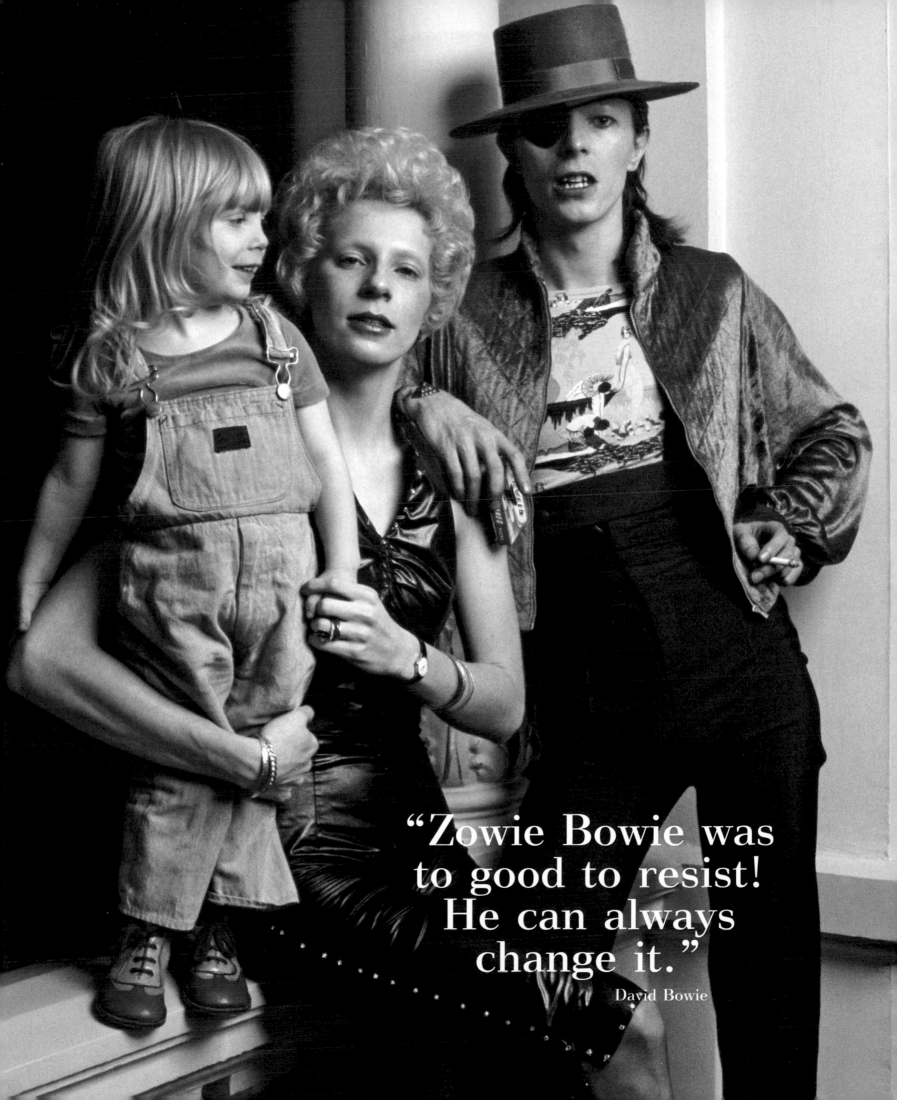

"Zowie Bowie was to good to resist! He can always change it."

David Bowie

Pierre, Claude & Alexandre
Brasseur

Pierre-Albert Espinasse 'Brasseur' (22 December 1905 - 16 August 1972, France) had a theatre and film career that extended over 50 years and more than 80 films. His most famous ones were *Le quai des brumes*, *Lumière d'été*, *Les enfants du paradis* and *Les yeux sans visage*.
Claude-Pierre Espinasse 'Brasseur' (15 Juni 1936, France) rose to fame thanks to the television series *Les Nouvelles Aventures de Vidocq* and launched his film career with *Un éléphant ça trompe énormément* and *Nous irons tous au paradis*. Other famous films he starred in are *La guerre des polices*, *La boum*, *Taxi boy* and *Camping*.
Alexandre Espinasse 'Brasseur' (29 March 1971, France) was first noticed in television series such as *Maigret* and *Le Juge est une femme*. He portrayed popular roles in films such as *Malabar Princess* and *Quand les anges s'en mêlent*, and directed theatre and short films like *La Voix de mon fils*.
Father, son & grandson: Claude appears aside his father in *Les yeux sans visage*. • In 2007 Alexandre and Claude played grandfather, father and son in the play *Mon père avait raison*.
The Brasseur family: The Brasseurs are part of a famous acting dynasty, which started in 1847 when great-grandfather Jules Dumont took on the artist name Brasseur, and includes grandfather and grandmother Albert and Germaine.

Pierre-Albert Espinasse "Brasseur" (22 décembre 1905 - 16 août 1972, France) fit carrière comme comédien et acteur durant 50 ans. Il joua dans plus de 80 films, dont *Le Quai des brumes*, *Lumière d'été*, *Les Enfants du paradis* et *Les Yeux sans visage*.
Claude-Pierre Espinasse "Brasseur" (15 juin 1936, France) fut révélé par la série "Les Nouvelles Aventures de Vidocq". Il lança ensuite sa carrière cinématographique avec *Un Eléphant ça trompe énormément* et *Nous irons tous au paradis*. Il tourna également dans *La Guerre des polices*, *La Boum*, *Taxi Boy* et *Camping*.
Alexandre Espinasse "Brasseur" (29 mars 1971, France) s'est distingué dans les séries "Maigret" et "Le Juge est une femme". Récemment, il a interprété des rôles savoureux dans les films *Malabar Princess* et *Quand les anges s'en mêlent*. Il joue également au théâtre et réalise des courts-métrages.
Père, fils & petit-fils : Claude joua aux côtés de son père dans *Les Yeux sans visage*. • En 2007, Alexandre et Claude se sont donnés la réplique en interprétant les rôles du grand-père, du père et du fils dans la pièce *Mon Père avait raison*.
La famille Brasseur : Les Brasseur sont une célèbre famille d'acteurs. En 1847, c'est l'arrière-grand-père Jules Dumont qui prit comme nom de scène : Brasseur.

Pierre-Albert Espinasse 'Brasseur' (22 december 1905 - 16 augustus 1972, Frankrijk) had een theater- en filmcarrière die 50 jaar overspant en ruim 80 films omvat, met als uitschieters *Le quai des brumes*, *Lumière d'été*, *Les enfants du paradis* en *Les yeux sans visage*.
Claude-Pierre Espinasse 'Brasseur' (15 juni 1936, Frankrijk) brak door dankzij de tv-serie *Les Nouvelles Aventures de Vidocq* en lanceerde zijn filmcarrière met *Un éléphant ça trompe énormément* en *Nous irons tous au paradis*. Andere bekende prenten zijn *La guerre des polices*, *La boum*, *Taxi boy* en *Camping*.
Alexandre Espinasse 'Brasseur' (29 maart 1971, Frankrijk) liet zich opmerken in tv-series als *Maigret* en *Le Juge est une femme*. Hij vertolkt gesmaakte rollen in films als *Malabar Princess* en *Quand les anges s'en mêlent*, maakt theater en regisseert kortfilms als *La Voix de mon fils*.
Vader, zoon & kleinzoon: Claude speelde naast zijn vader in *Les yeux sans visage*. • In 2007 speelden Alexandre en Claude grootvader, vader en zoon in het toneelstuk *Mon père avait raison*.
De familie Brasseur: De Brasseurs vormen een beroemde acteursdynastie die in 1847 van start ging toen overgrootvader Jules Dumont de artiestennaam Brasseur aannam, en die ook nog grootvader en -moeder Albert en Germaine omvat.

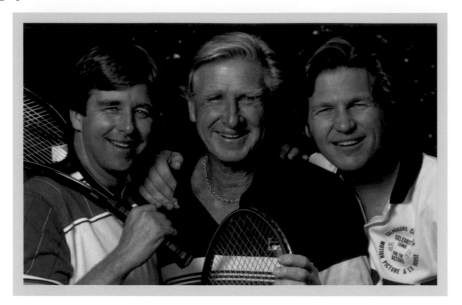

Lloyd, Jeff & Beau
Bridges

Lloyd Vernet Bridges Jr. (15 January 1913 - 10 March 1998, USA) starred in over 180 films and television series, but remains best known for his role in the 60s top series *Sea Hunt* and his contributions to film satires like *Airplane* and *Hot Shots*.

Lloyd Vernet 'Beau' Bridges III (9 December 1941, USA) received two Golden Globes and three Emmy Awards for his roles in television films, but reached his largest audience with the film *The Fabulous Baker Boys*, in which he appeared aside his brother Jeff.

Jeffrey Leon 'Jeff' Bridges (4 December 1949, USA) received four Oscar nominations for *The Last Picture Show*, *Thunderbolt and Lightfoot*, *Starman* and *The Contender*, before finally really winning the Academy Award for his leading role in *Crazy Heart*. His most unforgettable part is that of 'the Dude' in *The Big Lebowski*.

Father & sons: Beau and Jeff often appeared in the television series *Sea Hunt* and *The Lloyd Bridges Show*. • Lloyd played with his son Jeff in the films *Tucker* and *Blown Away*, and starred beside Beau in the series *Harts of the West* and the film *Meeting Daddy*.

The Bridges family: Four of Lloyd's eleven grandchildren are also actors (Jordan, Casey, Dylan en Emily).

Lloyd Vernet Bridges Jr. (15 janvier 1913 - 10 mars 1998, États-Unis) joua dans plus de 180 films et séries télévisées. Il fut avant tout célèbre pour son rôle dans la série culte des années 60 "Remous" et les parodies *Hot Shots* et *Y a-t-il un pilote dans l'avion*?

Lloyd Vernet "Beau" Bridges III (9 décembre 1941, États-Unis) a reçu deux Golden Globes et trois Emmy Awards pour des rôles dans des téléfilms. Il a connu son plus grand succès avec le film *Susie et les Baker Boys*, où il jouait aux côtés de son frère Jeff.

Jeffrey Leon "Jeff" Bridges (4 décembre 1949, États-Unis) fut nominé quatre fois aux Oscars pour les films *La Dernière Séance*, *Le Canardeur*, *Starman* et *Manipulations*, avant de remporter l'Oscar du meilleur acteur en 2010 pour son rôle dans *Crazy Heart*. Son personnage le plus marquant est sans conteste "Le Duc", dans la comédie *The Big Lebowski*.

Père & fils : Lloyd joua avec Jeff dans les films *Tucker* et *Blown Away*, et brilla aux côtés de Beau dans la série "*Harts of the West*" et le film *Meeting Daddy*.

La famille Bridges : Quatre des onze petits-enfants de Lloyd sont acteurs (Jordan, Casey, Dylan et Emily).

Lloyd Vernet Bridges Jr. (15 januari 1913 - 10 maart 1998, VSA) speelde mee in meer dan 180 films en tv-series, maar is nog het best gekend voor zijn rol in de jaren 60-topserie *Sea Hunt* en zijn bijdrage aan filmsatires als *Airplane* en *Hot Shots*.

Lloyd Vernet 'Beau' Bridges III (9 december 1941, VSA) ontving twee Golden Globes en drie Emmy Awards voor zijn rollen in tv-films, maar bereikte zijn grootste publiek met de film *The Fabulous Baker Boys*, waarin hij acteerde naast broer Jeff.

Jeffrey Leon 'Jeff' Bridges (4 december 1949, VSA) kreeg vier Oscarnominaties voor *The Last Picture Show*, *Thunderbolt and Lightfoot*, *Starman* en *The Contender*, alvorens het beeldje in 2010 ook echt te winnen voor zijn hoofdrol in *Crazy Heart*. Zijn meest onvergetelijke rol is die van 'the Dude' uit *The Big Lebowski*.

Vader & zonen: Beau en Jeff doken als kinderen geregeld op in de tv-series *Sea Hunt* en *The Lloyd Bridges Show*. • Lloyd speelde met zoon Jeff in de films *Tucker* en *Blown Away*, en schitterde naast Beau in de serie *Harts of the West* en de film *Meeting Daddy*.

De familie Bridges: Vier van Lloyds elf kleinkinderen zijn ook acteurs (Jordan, Casey, Dylan en Emily).

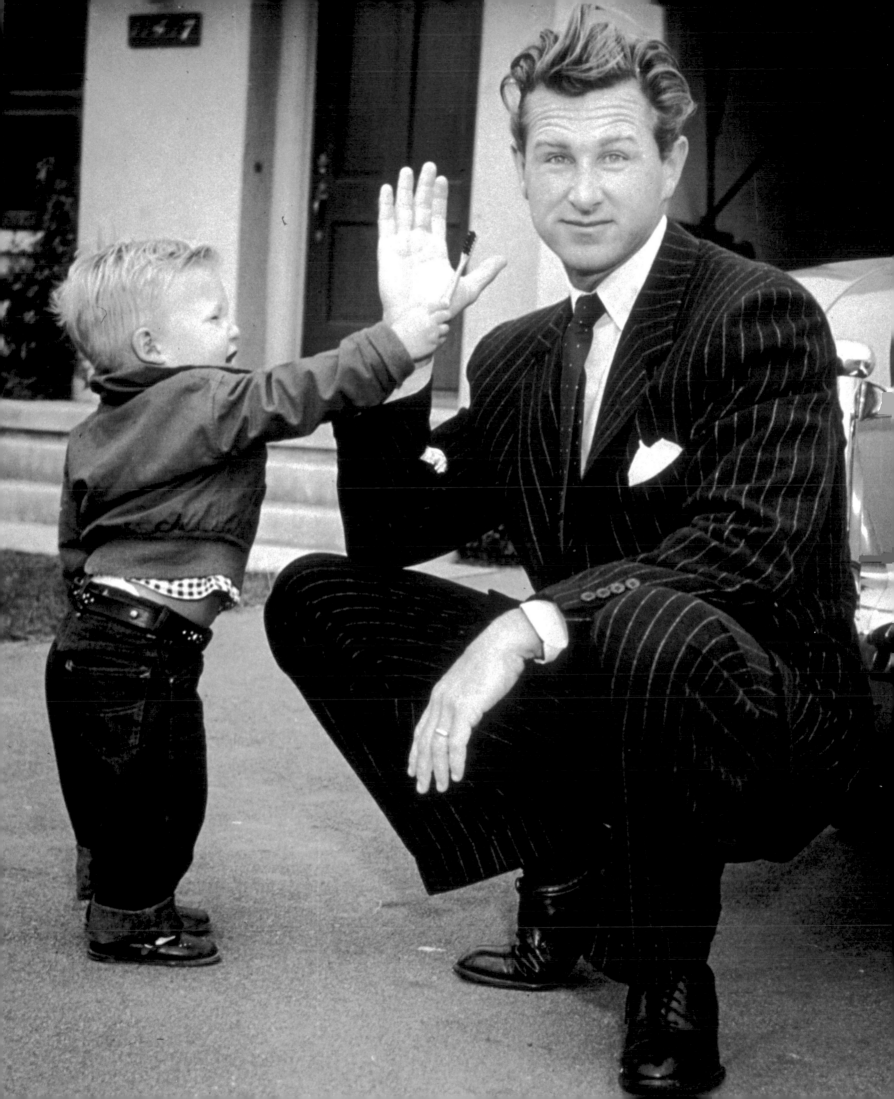

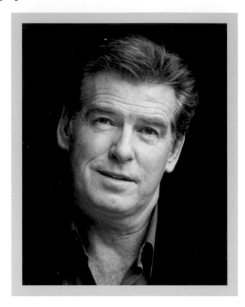 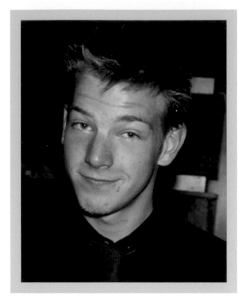

Pierce & Sean
Brosnan

Pierce Brosnan (16 May 1953, Ireland) rose to popularity in the 1980s when starring in the television series *Remington Steele*. He appeared in television mini-series like *Noble House*, films like *The Thomas Crown Affair* and portrayed the world's most famous secret agent in four consecutive *Bond* films. He went on to star in box office sensations like *The Matador* and *Mamma Mia!*

Sean Brendan Brosnan (13 September 1983, USA) appeared in such films as *Laws of Attraction*, *Surveillance 24/7*, and *Old Dog*, the television series *Dubplate Drama*, and the mini-series *Generation Kill* and *When Evil Calls*.

Father & son: After the death of Sean's mother in 1991, Pierce was left to raise his son on his own. • Sean made his television debut at the age of twelve in the film *Robinson Crusoe*, in which his father played the title role, and appeared in his second film seven years later, aside his father, in *Laws of Attraction*. • A severe car accident in 2000 left a critically injured Sean clinging to life by a thread. Pierce later said that caused him to have a difficult time during the production of *Remember Me*, a film about a couple that tries to deal with the premature death of their son. • Both father and son play police officers in the thriller *Bonded*.

Pierce Brendan Brosnan (16 mai 1953, Irlande) a acquis sa notoriété dans les années 80 avec la série "Les Enquêtes de Remington Steele". Il a joué dans des mini-séries ("*Noble House*") et des films comme *Thomas Crown*, avant d'incarner à quatre reprises l'espion de sa majesté, James Bond. Depuis, il a enchaîné les succès au box-office, avec notamment *The Matador* et *Mamma Mia*.

Sean Brendan Brosnan (13 septembre 1983, États-Unis) a joué dans les films *Une Affaire de cœur*, *Surveillance 24/7*, *Les 2 font la "père"*, la série télévisée "*Dubplate Drama*" et les mini-séries "*Generation Kill*" et "*When Evil Calls*".

Père & fils : Après la disparition de la mère de Sean en 1991, Pierce s'est occupé seul de l'éducation de son fils. • Sean a fait ses débuts au cinéma à l'âge de 12 ans dans le film *Robinson Crusoé*, où son père tient le rôle-titre. Sept ans plus tard, les deux hommes se retrouvent pour tourner *Une Affaire de cœur*. • En 2000, Sean frôle la mort dans un accident de voiture. Pierce avouera d'ailleurs que le tournage de *Remember Me* – film dans lequel le fils d'un couple décède prématurément – fut à cet effet éprouvant. • Dans le thriller *Bonded*, père et fils interprètent des agents de police.

Pierce Brendan Brosnan (16 mei 1953, Ierland) verwierf in de jaren 80 de nodige faam dankzij de tv-serie *Remington Steele*. Hij speelde mee in miniseries als *Noble House* en films als *The Thomas Crown Affair*, en kroop vier maal in de huid van topspion James Bond. Sindsdien duikt hij op in kassuccessen als *The Matador* en *Mamma Mia!*.

Sean Brendan Brosnan (13 september 1983, VSA) speelde mee in films als *Laws of Attraction*, *Surveillance 24/7* en *Old Dog*, de tv-serie *Dubplate Drama* en de miniseries *Generation Kill* en *When Evil Calls*.

Vader & zoon: Na de dood van Seans moeder in 1991 stond Pierce alleen in voor de opvoeding van zijn zoon. • Sean maakte op zijn twaalfde zijn debuut in de film *Robinson Crusoe*, waarin zijn vader de titelrol vertolkte. Zeven jaar later volgde zijn tweede rol aan diens zijde in *Laws of Attraction*. • Sean raakte in 2000 betrokken bij een auto-ongeval waarbij zijn leven aan een zijden draadje hing. Pierce zei later dat hij het daardoor moeilijk had tijdens de opnames van *Remember Me*, een film over een ouderpaar wiens zoon voortijdig sterft. • In de thriller *Bonded* spelen vader en zoon twee politieagenten.

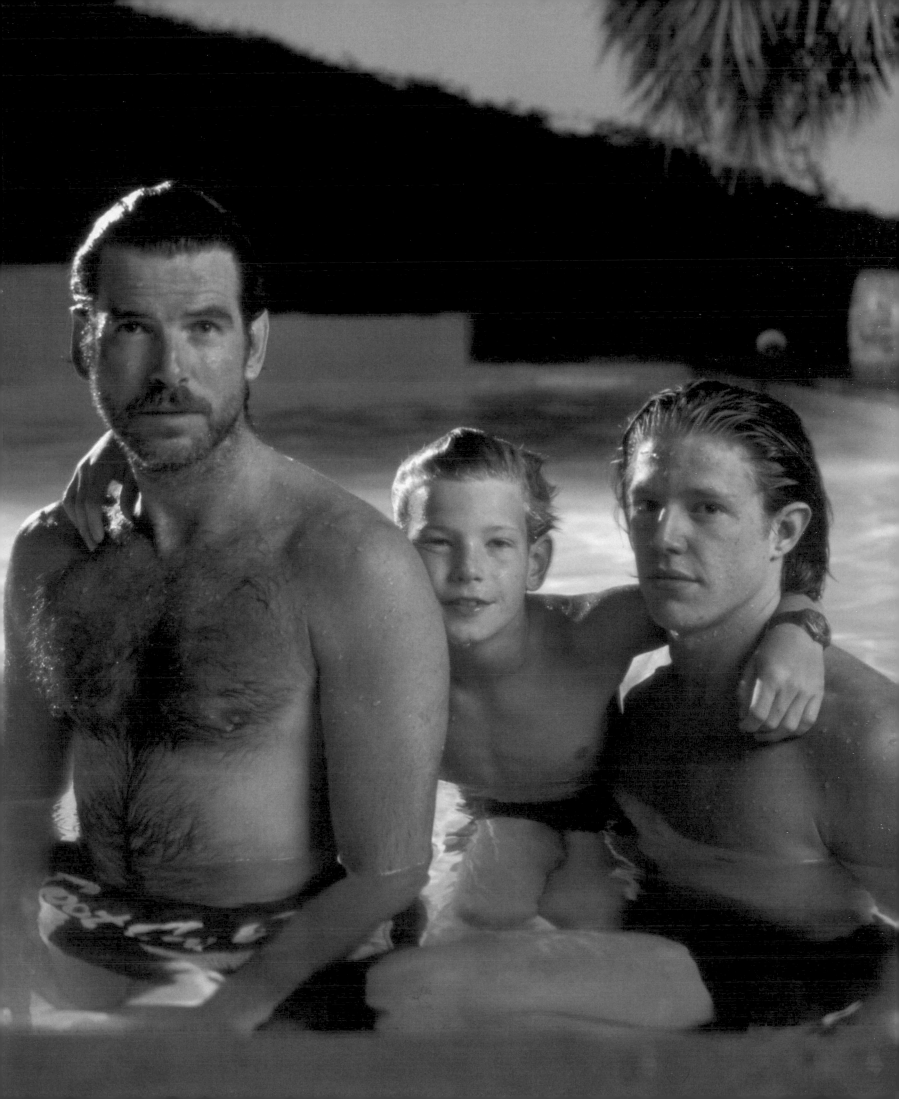

George H.W. & George W. Bush

George Herbert Walker Bush (12 June 1924, USA) was the director of the CIA, 43rd Vice President of the United States under Ronald Reagan and in 1989 he became the 41st President of the United States. Under his leadership, America fought the Persian Gulf War against Saddam Hussein. The Republican hoped to get re-elected but lost to Bill Clinton.

George Walker Bush (6 July 1946, USA) was the 46th Governor of Texas and succeeded Clinton in 2001 as the 43rd President of the United States. After the terrorist attacks of 11 September 2001, he announced a global war on terrorism and Osama Bin Laden and ordered the invasion of Afghanistan and Iraq. After his re-election, he received heavy criticism over his indecisive handling of Hurricane Katrina and the 2007 financial crisis.

Father & son: An Iraqi attempt on the life of Bush Sr. was thwarted in 1993. His son George W. Bush mentioned this incident in a speech as a personal motivation to overthrow Hussein. *"After all, this is the guy who tried to kill my dad at one time."*

The Bush family: Three generations of this American dynasty include bankers, businessmen, two senators, a high court judge, two governors, a vice-president and two presidents.

George Herbert Walker Bush (12 juin 1924, États-Unis) a été directeur de la CIA et 43ᵉ vice-président sous Ronald Reagan, avant de devenir le 41ᵉ président des États-Unis en 1989. Durant son mandat, l'Amérique entra en guerre contre Saddam Hussein. Le Républicain espérait être réélu, mais il s'inclina face à Bill Clinton.

George Walker Bush (6 juillet 1946, États-Unis), 46ᵉ gouverneur du Texas, succède à Clinton en 2001 et devient le 43ᵉ président des États-Unis. Après les attentats du 11 septembre 2001, il déclare la guerre au terrorisme et à Oussama Ben Laden. L'armée américaine envahit l'Afghanistan et l'Irak. Durant son second mandat, il est vivement critiqué pour son manque de réactivité face au désastre de l'ouragan Katrina et à la crise financière de 2007.

Père & fils : En 1993, un attentat irakien contre Bush père a pu être déjoué. Son fils déclara un jour que cet incident le motivait personnellement à destituer Saddam Hussein : "Après tout, il s'agit du gars qui a essayé de tuer mon père."

La famille Bush : Sur trois générations, on y dénombre, outre des banquiers et des hommes d'affaires, pas moins de deux sénateurs, un juge à la Cour Suprême, deux gouverneurs, un vice-président et deux présidents.

George Herbert Walker Bush (12 juni 1924, VSA) was directeur van de CIA, 43e vicepresident onder Ronald Reagan en vanaf 1989 de 41e president van de Verenigde Staten. Onder zijn aanvoering voerde Amerika de Golfoorlog tegen Saddam Hoessein. De Republikein hoopte op een herverkiezing maar verloor van Bill Clinton.

George Walker Bush (6 juli 1946, VSA) was de 46e gouverneur van Texas en volgde Clinton in 2001 op als de 43e president van de Verenigde Staten. Na de aanslagen van 11 september 2001 kondigde hij de Oorlog tegen het terrorisme en Osama Bin Laden aan en liet hij Afghanistan en Irak binnenvallen. Na zijn herverkiezing kreeg hij felle kritiek op zijn weinig daadkrachtige reactie op orkaan Katrina en de financiële crisis van 2007.

Vader & zoon: In 1993 wist men een Iraakse aanslag op Bush sr. te verijdelen. Zoon George W. Bush noemde dit incident in een toespraak een persoonlijke motivatie om Hoessein af te zetten. "Uiteindelijk is dit de kerel die mijn vader ooit probeerde te vermoorden."

De familie Bush: Drie generaties van deze Amerikaanse dynastie omvatten naast bankiers en zakenmannen ook twee senatoren, een rechter aan het hooggerechtshof, twee gouverneurs, een vice-president en twee presidenten.

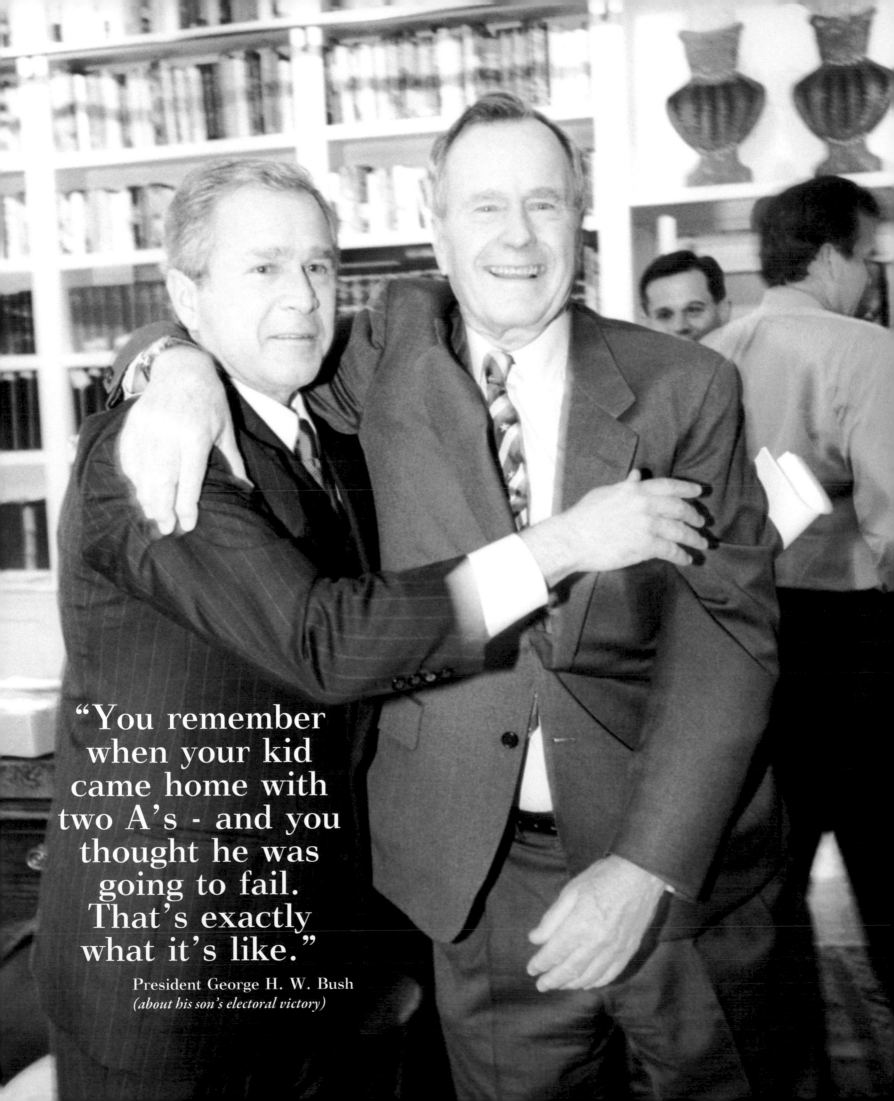

"You remember when your kid came home with two A's - and you thought he was going to fail. That's exactly what it's like."

President George H. W. Bush
(about his son's electoral victory)

"My father was not a failure. After all, he was the father of a president of the United States."

Harry S. Truman (1884-1972),
33rd President of the United States

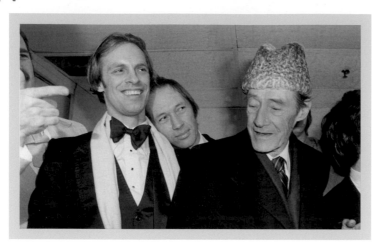

John & David
Carradine

Richard Creed 'John' Carradegna (5 February 1906 - 27 November 1988, USA) was a legendary character actor who appeared in over 200 films that ranged from horror classics like *The Black Cat* and *Bride of Frankenstein* to John Ford gems like *Drums Along the Mohawk*, *Stagecoach* and *The Grapes of Wrath*.
John Arthur 'David' Carradine (8 December 1936 - 3 June 2009, USA) became an icon in the 70s thanks to his role as a fighting monk in the western series *Kung Fu*. As a character actor, he starred in numerous television series and more than 100 films like T*he Serpent's Egg* and *The Long Riders*. In 2004 he made a remarkable comeback in *Kill Bill*.
Father & son: When his parents got divorced at the age of seven, David moved in with his father. • John appeared regularly in *Kung Fu* as reverend Serenity Johnson.
The Carradine family: John is the patriarch of an acting dynasty that includes four of his sons (David, Keith, Robert, Bruce) and five of his grandchildren (Martha Plimpton, Ever, Calista, Kansas, Cade). • The role of the younger Kwai Chang Caine in *Kung Fu* was portrayed by David's half-brother Keith. • David was known for the fact that he regularly arranged roles for family members.

Richard Creed "John" Carradine (5 février 1906 - 27 novembre 1988, États-Unis) est une légende du cinéma. Il a tourné plus de 200 films, depuis des classiques du cinéma d'horreur (*Le Chat noir*, *La Fiancée de Frankenstein*) à des perles de John Ford, telles que *Sur la piste des Mohawks*, *La Chevauchée fantastique* et *Les Raisins de la colère*.
John Arthur "David" Carradine (8 décembre 1936 - 3 juin 2009, États-Unis) est devenu une icône dans les années 70 grâce à un rôle de moine Shaolin dans la série américaine "Kung Fu". Cet acteur de talent a également joué dans de nombreuses séries et une centaine de films, dont *L'Oeuf du serpent* et *Le Gang des frères James*. En 2004, il fit un come-back remarqué dans *Kill Bill*.
Père & fils : John apparaît à plusieurs reprises dans la série "Kung Fu", où il incarne le Révérend Serenity Johnson.
La famille Carradine : John est le patriarche d'une véritable dynastie d'acteurs comprenant quatre de ses fils (David, Keith, Robert, Bruce) et cinq de ses petits-enfants (Martha Plimpton, Ever, Calista, Kansas, Cade). • Le rôle du jeune Kwai Chang Caine dans "Kung Fu" fut interprété par Keith, le demi-frère de David.

Richard Creed 'John' Carradegna (5 februari 1906 - 27 november 1988, VSA) was een legendarische karakteracteur die meespeelde in ruim 200 films, gaande van horrorklassiekers als *The Black Cat* en *Bride of Frankenstein* tot John Ford-pareltjes als *Drums Along the Mohawk*, *Stagecoach* en *The Grapes of Wrath*.
John Arthur 'David' Carradine (8 december 1936 - 3 juni 2009, VSA) groeide in de jaren 70 uit tot een icoon dankzij de rol van vechtende monnik in de westernserie *Kung Fu*. Als karakteracteur speelde hij mee in talloze tv-series en meer dan 100 films, zoals *The Serpent's Egg* en *The Long Riders*. In 2004 maakte hij een opmerkelijke comeback met *Kill Bill*.
Vader & zoon: Na de scheiding van zijn ouders ging de zevenjarige David bij zijn vader wonen. • John dook meermaals op in *Kung Fu* als eerwaarde Serenity Johnson.
De familie Carradine: John is de patriarch van een acteursdynastie die vier van zijn zonen (David, Keith, Robert, Bruce) omvat en vijf van zijn kleinkinderen (Martha Plimpton, Ever, Calista, Kansas, Cade). • De rol van de jongere Kwai Chang Caine in Kung Fu werd vertolkt door Davids halfbroertje Keith. • David stond erom bekend dat hij zijn familieleden geregeld aan rollen hielp.

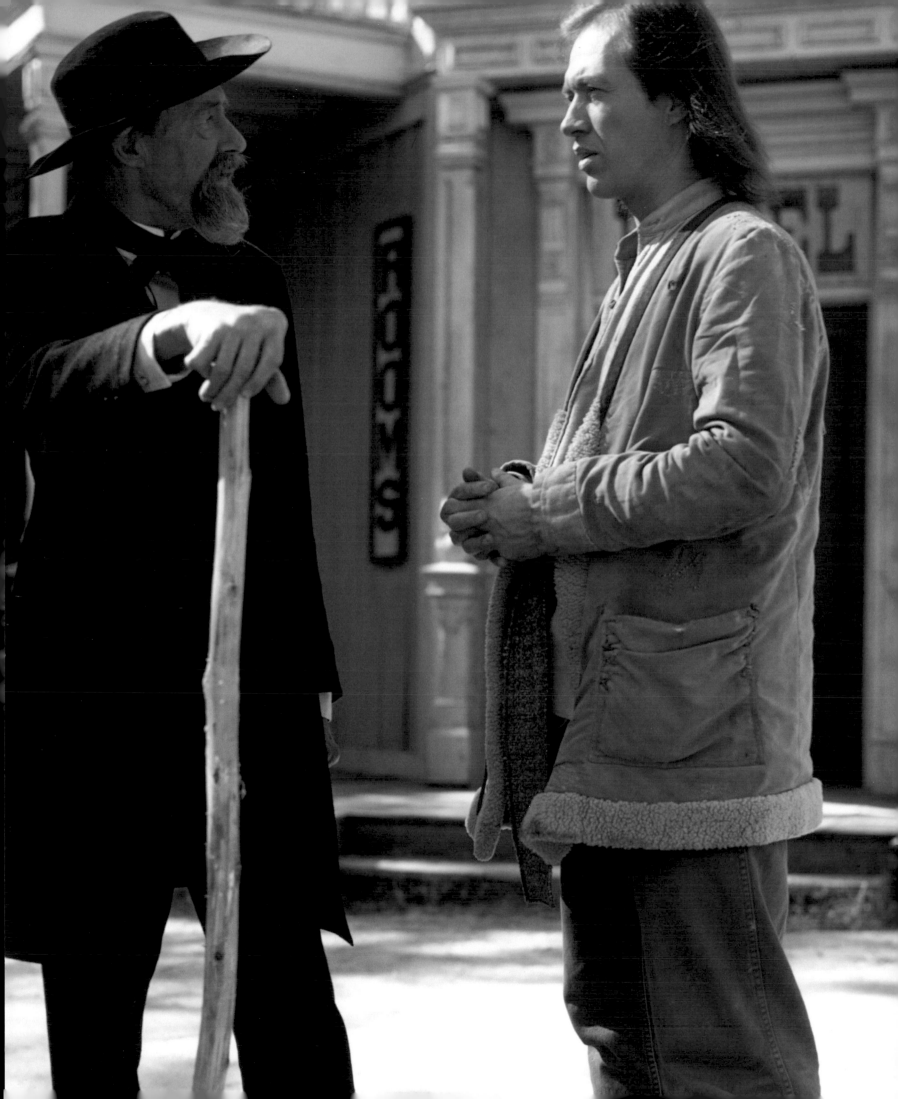

Lei & Kim
Clijsters

Leo 'Lei' Clijsters (9 November 1956 - 4 January 2009, Belgium) was a football player who played for several teams, including Club Brugge, KV Mechelen and Club Luik. During the time that he was captain of KV Mechelen, he won the Golden Shoe and was an asset to the Belgian national team. Afterwards, he worked as a trainer for different clubs.
Kim Antonie Lode Clijsters (8 June 1983, Belgium) won her first WTA title in 1999, played her first Grand Slam final two years later and in 2003 became the first Belgian ever to be ranked number 1 in the world. In 2007 she retired from professional tennis and gave birth to her daughter Jada Ellie a year later. In 2009 she made an unexpected but successful comeback.
Father & daughter: Kim has always claimed that she inherited her father's 'football legs' and her gymnast-mother's flexibility. • Lei acted as Kim's manager from the moment she began playing professionally at the age of 15. • Kim wears a necklace containing a small amount of her deceased father's ashes, which gives her the feeling that he is always with her.
The Clijsters family: Kim's sister Elke was also a worthy tennis player.

Leo "Lei" Clijsters (9 novembre 1956 - 4 janvier 2009, Belgique) joua comme footballeur professionnel au Club de Bruges, au FC Malines et au RFC de Liège. Durant la période où il endossa le maillot de capitaine du FC Malines, il remporta le Soulier d'or et s'imposa comme une valeur sûre des "Diables Rouges". Il devint ensuite entraîneur dans différents clubs.
Kim Antonie Lode Clijsters (8 juin 1983, Belgique) remporte en 1999 son premier titre WTA et dispute en 2001 sa première finale de Grand Chelem. En 2003, elle devient la première joueuse belge à se classer à la première place mondiale. En 2007, elle annonce sa retraite et accouche l'année suivante d'une petite fille, prénommée Jada, avant de faire en 2009 un come-back aussi fabuleux qu'inattendu.
Père & fille : Kim dit avoir hérité des jambes de footballeur de son père et de la souplesse de sa mère, ancienne gymnaste. • Lei devient le manager de sa fille lorsqu'elle commence le tennis professionnel à l'âge de 15 ans. • Kim porte une chaîne contenant des cendres de son père ; elle a ainsi l'impression qu'il est toujours à ses côtés.
La famille Clijsters : Elke, la sœur de Kim, est également une joueuse de tennis talentueuse.

Leo 'Lei' Clijsters (9 november 1956 - 4 januari 2009, België) speelde als voetballer onder andere bij Club Brugge, KV Mechelen en Club Luik. Tijdens zijn periode als aanvoerder bij KV Mechelen won hij de Gouden Schoen en was hij een vaste waarde in het Belgische elftal. Nadien werkte hij als trainer bij diverse clubs.
Kim Antonie Lode Clijsters (8 juni 1983, België) won haar eerste WTA-titel in 1999, speelde twee jaar later haar eerste grandslamfinale en werd in 2003 de eerste Belgische nummer 1 op de Wereldranglijst. In 2007 nam ze afscheid van het tennis, om een jaar later te bevallen van dochtertje Jada Ellie en in 2009 een even onverwachte als succesvolle comeback te maken.
Vader & dochter: Kim heeft altijd beweerd dat ze de voetbalbenen van haar vader geërfd heeft en de lenigheid van haar moeder, die turnster was. • Lei trad op als Kims manager vanaf het moment dat ze op haar vijftiende proftennis begon te spelen. • Een halsketting die een kleine hoeveelheid as van haar vader bevat, geeft Kim het gevoel dat hij altijd bij haar is.
De familie Clijsters: Ook Kims zusje Elke was een verdienstelijk tennisspeelster.

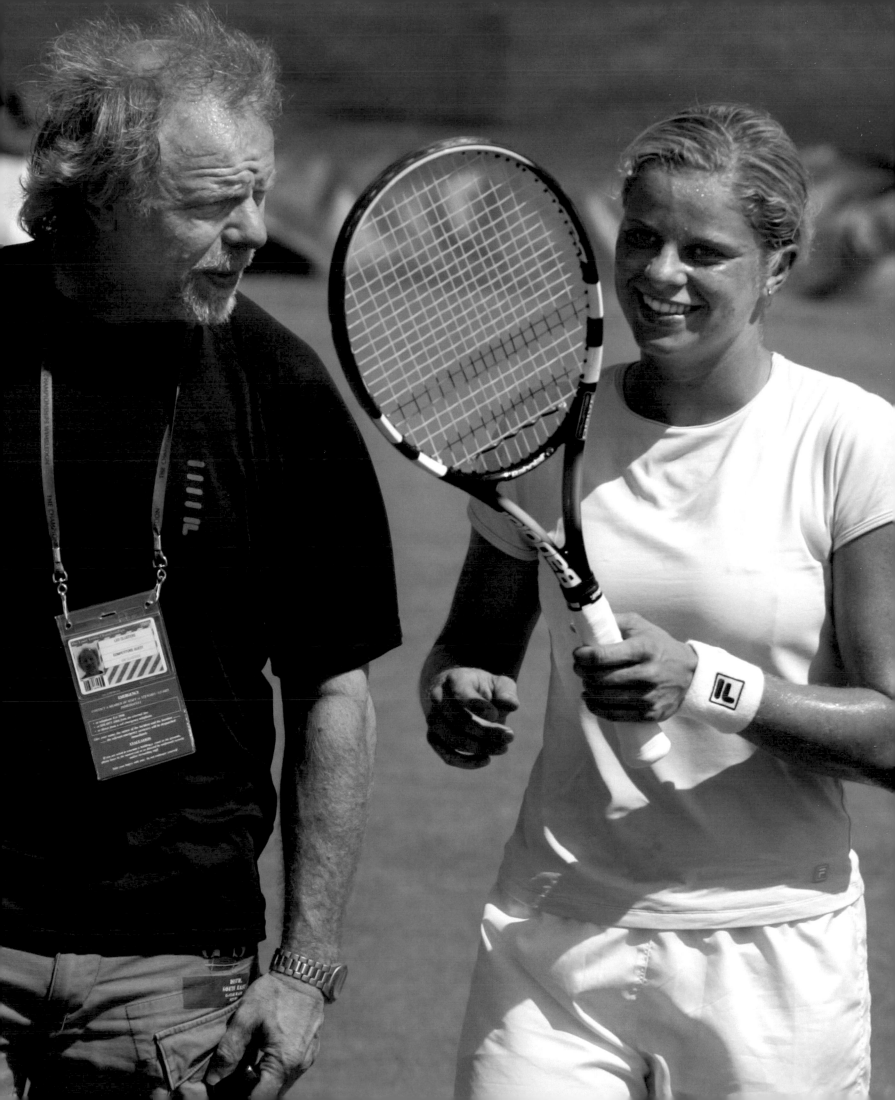

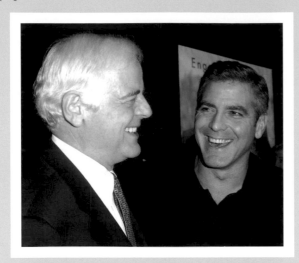

Nick & George
Clooney

Nicholas Joseph 'Nick' Clooney (13 January 1934, USA) is a journalist, news anchor, presenter and columnist. He rose to popularity in the United States due to television programmes such as *The Nick Clooney Show* and *The Money Maze* and as a presenter for the cable channel *American Movie Classics*. In 2002 he published the book *The Movies That Changed Us*.

George Timothy Clooney (6 May 1961, USA) is an actor, director, screenwriter and producer and has received over 30 awards and nominations for his work in the film business. He first came to fame when portraying Dr. Ross in the television series *E.R.* and became known around the world for his roles in films like *The Peacemaker*, *Batman & Robin* and *Ocean's Eleven*. He received a great deal of acclaim for his directing, producing, writing and acting in *Good Night and Good Luck* and *Leatherheads*.

Father & son: George is well known for his humanitarian work. He visited Darfur with his father in 2006 to raise public awareness about the crisis in Sudan. • Father and son not only have the same charm and charisma, but also share the same sense of humour. When being interviewed together, they often burst out laughing.

The Clooney family: Actress Rosemary Clooney is Nick Clooney's sister.

Nicholas Joseph "Nick" Clooney (13 janvier 1934, États-Unis) est à la fois journaliste, présentateur à la télévision (notamment du JT) et éditorialiste. Grâce aux programmes "*The Nick Clooney Show*" et "*The Money Maze*", et à ses talents d'animateur sur la chaîne *American Movie Classics*, il est devenu célèbre aux yeux du public américain. En 2002, il a publié l'ouvrage *The Movies That Changed Us*.

George Timothy Clooney (6 mai 1961, États-Unis) est à la fois acteur, réalisateur, scénariste et producteur. Titulaire de plus de 30 récompenses et nominations, il fut révélé par le rôle du Dr. Ross dans la série "Urgences". Il s'est imposé comme vedette internationale grâce aux films *Le Pacificateur*, *Batman & Robin* ou encore *Ocean's Eleven*. Son travail de réalisateur, producteur, scénariste et acteur dans *Good Night and Good Luck* et dans *Jeu de dupes* a été largement salué.

Père & fils : George est célèbre pour son engagement politique en faveur de nombreuses causes. Il s'est rendu au Darfour en 2006 avec son père pour sensibiliser l'opinion publique. • Père et fils partagent non seulement le même charisme, mais aussi le même sens de l'humour : leurs interviews en duo sont souvent mémorables.

La famille Clooney : L'actrice Rosemary Clooney est la sœur de Nick.

Nicholas Joseph 'Nick' Clooney (13 januari 1934, VSA) is een journalist, nieuwsanker, presentator en columnist. Dankzij programma's als *The Nick Clooney Show* en *The Money Maze* en zijn presenteerwerk voor de *American Movie Classics*-zender werd hij bekend bij het Amerikaanse publiek. In 2002 publiceerde hij het boek *The Movies That Changed Us*.

George Timothy Clooney (6 mei 1961, VSA) is een acteur, regisseur, scenarist en producer met meer dan 30 filmprijzen en nomaties op zijn naam. Hij brak door dankzij zijn rol van Dr. Ross in de tv-serie *E.R.*, werd wereldberoemd dankzij zijn rollen in films als *The Peacemaker*, *Batman & Robin* en *Ocean's Eleven*, en oogstte bakken lof voor zijn regie-, productie-, schrijf- en acteerwerk in *Good Night and Good Luck* en *Leatherheads*.

Vader & zoon: George staat bekend voor zijn sociaal engagement. Samen met zijn vader bezocht hij in 2006 Darfur in Sudan om de crisis daar onder de aandacht te brengen. • Vader en zoon delen niet alleen dezelfde charme en charisma, maar ook hetzelfde gevoel voor humor. Tijdens dubbelinterviews liggen ze dan ook geregeld dubbel van het lachen.

De familie Clooney: Actrice Rosemary Clooney is Nick Clooney's zus.

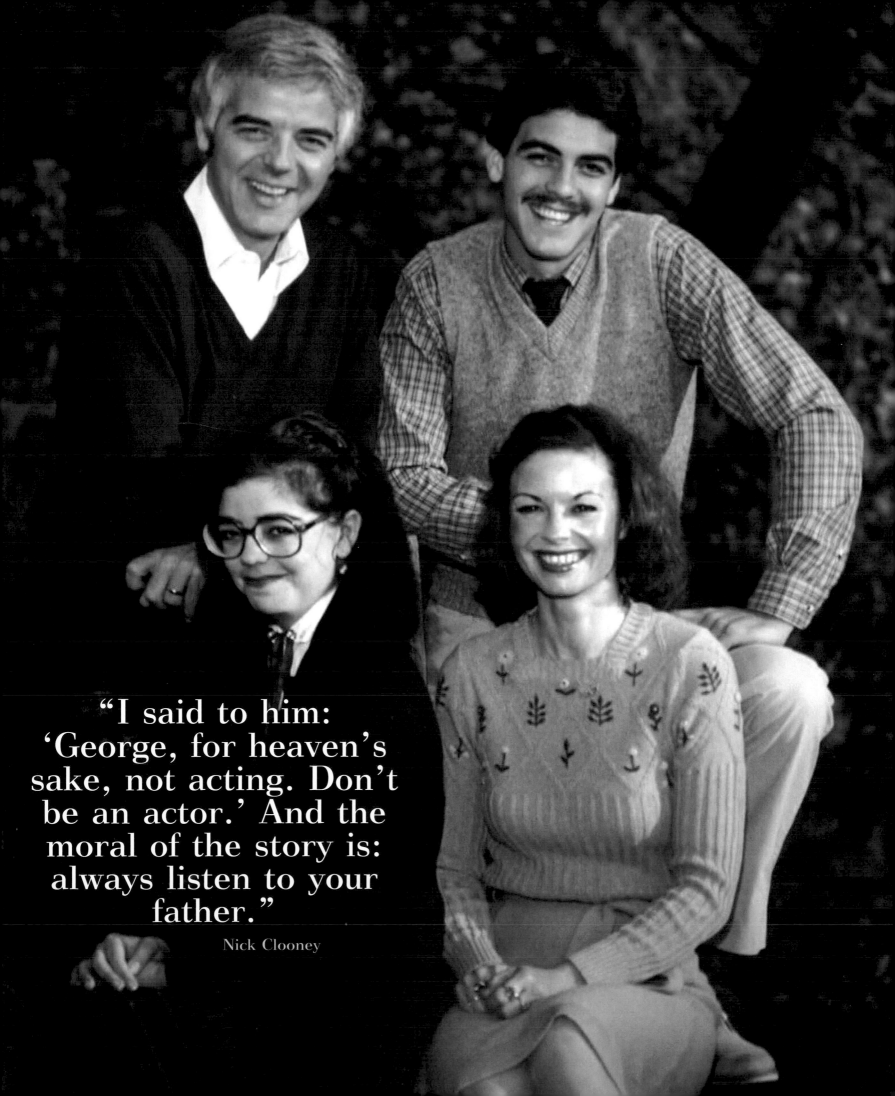

"I said to him: 'George, for heaven's sake, not acting. Don't be an actor.' And the moral of the story is: always listen to your father."

Nick Clooney

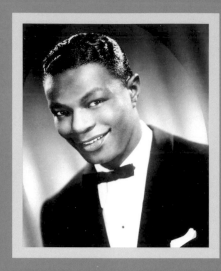
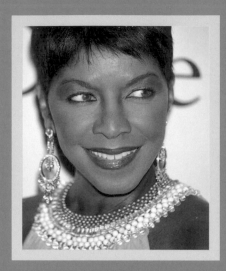

Nat King & Natalie
Cole

Nathaniel Adams Coles (17 March 1919 - 15 February 1965, USA) came to prominence with his recognisable baritone voice with world hits like *Unforgettable*, *Darling Je vous aime beaucoup*, *Mona Lisa* and *When I Fall In Love*. In the 40s he presented his own radio show and in 1956 he even hosted a television show. He was also an actor and appeared in films such as *St. Louis Blues*, *China Gate* en *Blue Gardenia*.
Natalie Maria Cole (6 February 1950, USA) started out her career as an R&B singer but successfully redirected her repertoire towards a more pop and jazz oriented style in the 90s. She regularly played small roles in television series and films. Despite being addicted to drugs and alcohol for many years, she also won nine Grammy Awards for her music.
Father & daughter: The 1991 song *Unforgettable*, on which Natalie's singing was combined with old recordings of her father's voice, led to a rediscovery of his work and a rise to world stardom for her. She later repeated this process with other songs like *When I Fall in Love*. • Natalie acknowledges initially shunning the music genres that made her father famous - big band and jazz music - to avoid being compared to her father.

Nathaniel Adams Coles (17 mars 1919 - 15 février 1965, États-Unis), chanteur à la voix de baryton, est l'interprète des tubes planétaires "*Unforgettable*", "*Darling je vous aime beaucoup*", "*Mona Lisa*" et "*When I Fall In Love*". Dans les années 40, il anime sa propre émission de radio et, en 1956, il est aux commandes d'un show télévisé. Il tournera également dans quelques films au cinéma (*St. Louis Blues*, *China Gate*, *Blue Gardenia*).
Natalie Maria Cole (6 février 1950, États-Unis) débute sa carrière comme chanteuse de R&B, avant d'étendre son répertoire, avec succès, au jazz et à la pop dans les années 90. Elle apparaît régulièrement à la télévision et au cinéma, où elle tient de petits rôles. Malgré son addiction aux drogues et à l'alcool, elle a remporté 9 Grammy Awards.
Père & fille : Natalie devient mondialement célèbre en 1991 avec le morceau "*Unforgettable*", mêlant sa voix à celle de son père défunt. Elle réitèrera ensuite ce procédé avec d'autres chansons comme "*When I Fall In Love*". • Natalie reconnaît avoir rejeté au départ les genres musicaux ayant fait le succès de son père – big band et jazz –, car elle voulait éviter toute comparaison avec celui-ci.

Nathaniel Adams Coles (17 maart 1919 - 15 februari 1965, VSA) scoorde met zijn herkenbare bariton wereldhits als *Unforgettable*, *Darling Je Vous Aime Beaucoup*, *Mona Lisa* en *When I Fall In Love*. In de jaren 40 presenteerde hij zijn eigen radioprogramma en in '56 had hij zelfs een tv-show. Daarnaast trad hij aan als acteur in films als *St. Louis Blues*, *China Gate* en *Blue Gardenia*.
Natalie Maria Cole (6 februari 1950, VSA) startte haar carrière als R&B-zangeres maar stuurde haar repertoire in de jaren 90 met succes meer de pop- en jazz-kant op. Ze speelde regelmatig kleine rollen in tv-series en films. Hoewel ze jarenlang verslaafd was aan drugs en alcohol, won ze ook negen Grammy Awards voor haar muziek.
Vader & dochter: Natalie werd in 1991 wereldberoemd en haar vader herontdekt dankzij de song *Unforgettable*, waarop haar zang gecombineerd werd met oude opnamen van zijn stem. Later herhaalde ze het proces met andere songs zoals *When I Fall in Love*. • Natalie geeft toe dat ze de muziekgenres waar haar vader bekend voor stond - big band en jazzmuziek - aanvankelijk schuwde omdat ze de vergelijking uit de weg wilde gaan.

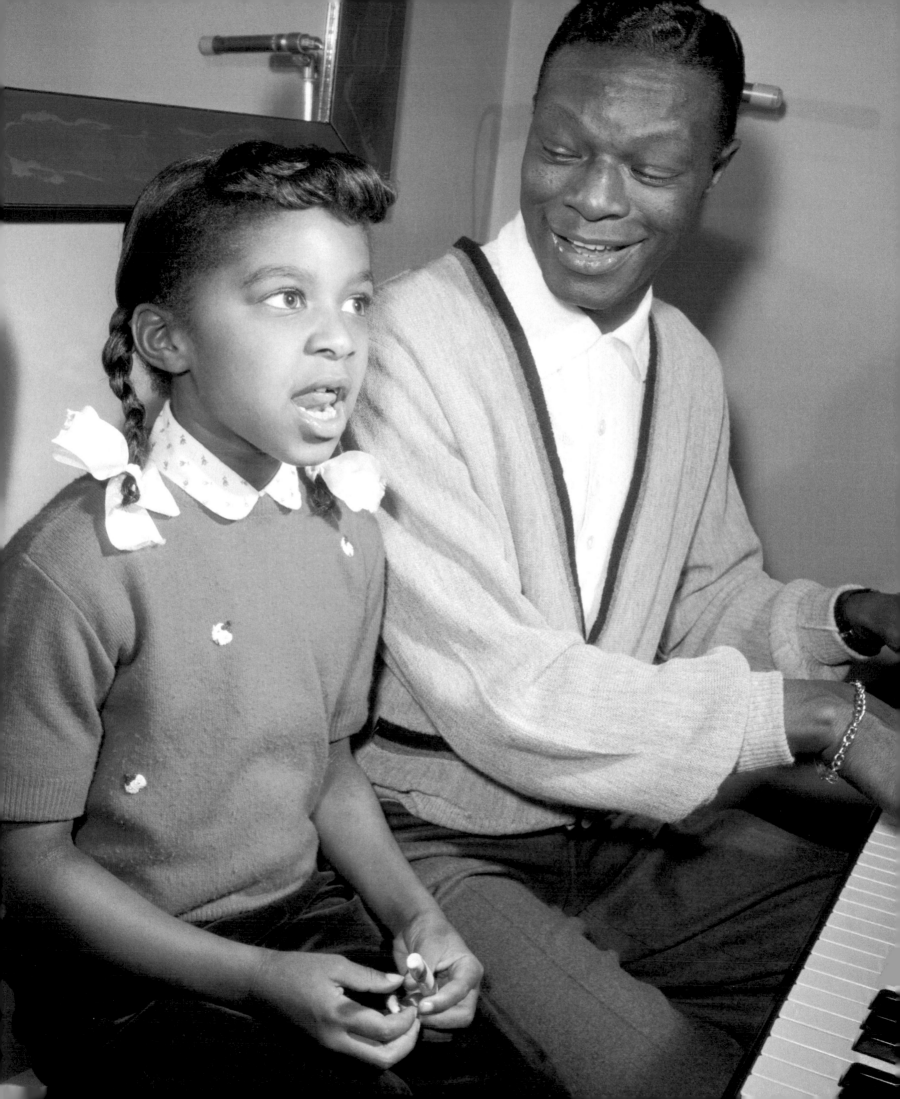

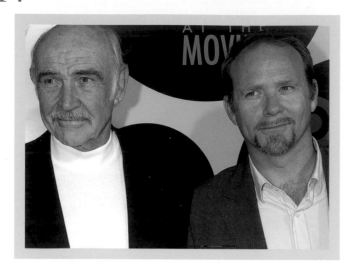

Sean & Jason
Connery

Sir Thomas Sean Connery (25 August 1930, Scotland) is best known for portraying the character James Bond in seven films between 1962 and 1983. He won an Oscar for his role in *The Untouchables* and appeared in many commercially successful films like *Indiana Jones and the Last Crusade*, *The Hunt for Red October*, *Highlander* and *The Rock*. In 2009 he was voted 'The Greatest living Scot'.
Jason Joseph Connery (11 January 1963, Great Britain) is an actor who appeared in over 30 films and series since he achieved national popularity with the title role in the television series *Robin of Sherwood*. He has performed many roles in theatre, works as a voice actor and has been directing since 2007.
Father & son: Both father and son have portrayed the role of Robin Hood, Jason in the television series *Robin of Sherwood* and Sean in the film *Robin and Marian*. • Jason portrayed the creator of the James Bond character (the role that had made his father famous) in the television drama *Spymaker: The Secret Life of Ian Fleming*. • Jason stores the Oscar that Sean won at his home in New York.

Sir Thomas Sean Connery (25 août 1930, Écosse) est mondialement célèbre pour avoir incarné à sept reprises l'espion de sa majesté, James Bond, entre 1962 et 1983. Il a remporté un Oscar pour son rôle dans *Les Incorruptibles* et a enchaîné par la suite les succès commerciaux avec des films tels qu'*Indiana Jones et la Dernière Croisade*, *À la poursuite d'Octobre Rouge*, *Highlander* et *Rock*. En 1999, il fut élu "l'homme le plus sexy du siècle".
Jason Joseph Connery (11 janvier 1963, Grande-Bretagne) a déjà joué dans plus de 30 films et séries depuis 1985, année où il fut révélé par le feuilleton télévisé "Robin des Bois". Présent également au théâtre, il s'occupe de doublage et est même récemment passé derrière la caméra.
Père & fils : Tous deux ont incarné le personnage de Robin des Bois, Jason dans la série "Robin des Bois" et Sean dans le film *La Rose et la Flèche*. • Dans le drame télévisé *La Vie secrète de Ian Fleming*, Jason joue le rôle du père spirituel de James Bond, le personnage qui fit le succès de Sean.

Sir Thomas Sean Connery (25 augustus 1930, Schotland) werd wereldberoemd dankzij zijn vertolking van topspion James Bond in zeven films tussen 1962 en 1983. Hij won een Oscar voor zijn rol in *The Untouchables* en scoorde commerciële successen met prenten als *Indiana Jones and the Last Crusade*, *The Hunt for Red October*, *Highlander* en *The Rock*. In 2009 werd hij verkozen tot 'Grootste Levende Schot'.
Jason Joseph Connery (11 januari 1963, Groot-Brittannië) is een acteur die in meer dan 30 films en series meegespeeld heeft sinds hij in 1985 in eigen land doorbrak met de titelrol in de tv-serie *Robin of Sherwood*. Hij is ook actief in het theater, werkt als stemacteur en houdt zich sinds 2007 bezig met regisseren.
Vader & zoon: Zowel vader als zoon vertolkte ooit de rol van Robin Hood, Jason in de tv-serie *Robin of Sherwood* en Sean in de film *Robin and Marian*. • In het tv-drama *Spymaker: The Secret Life of Ian Fleming* vertolkte Jason de rol van de geestelijke vader van James Bond, het personage dat vader Sean indertijd wereldroem bezorgde. • De Oscar die Sean won, bewaart Jason thuis in New York.

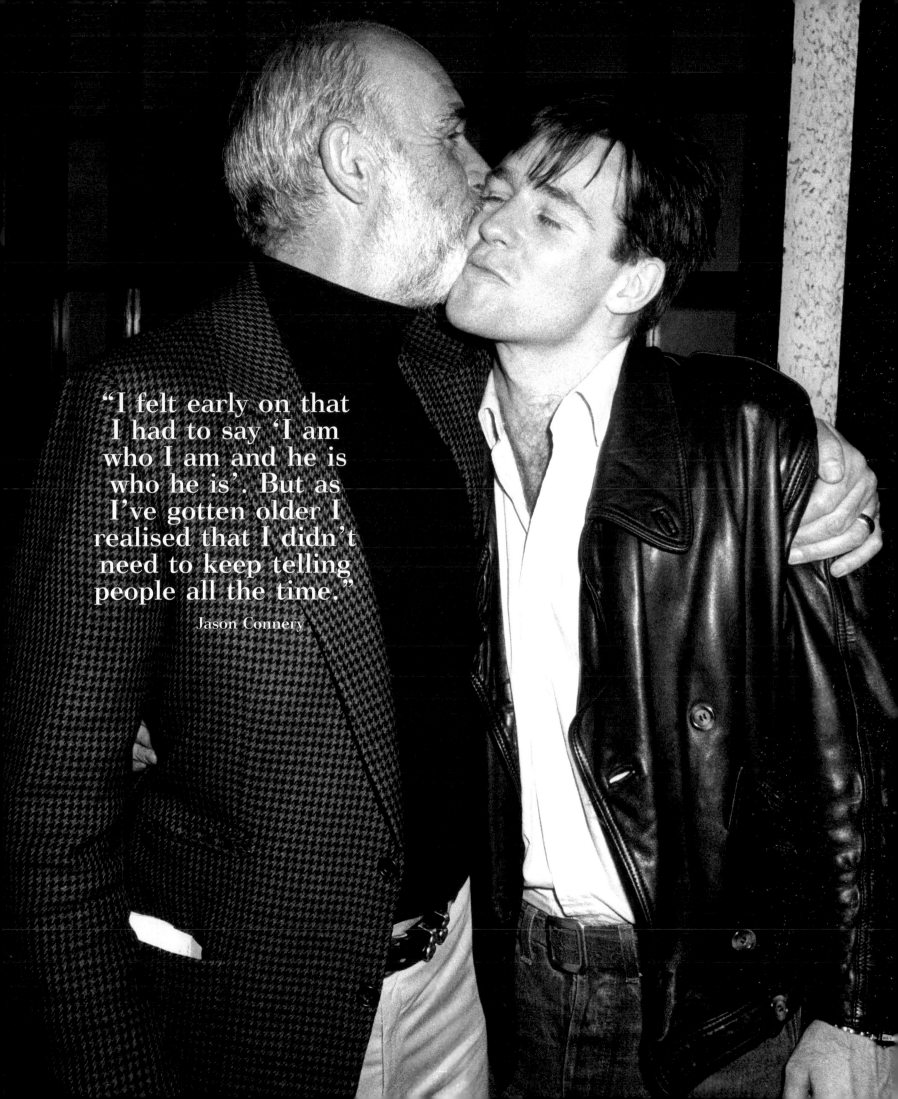

"I felt early on that I had to say 'I am who I am and he is who he is'. But as I've gotten older I realised that I didn't need to keep telling people all the time."

Jason Connery

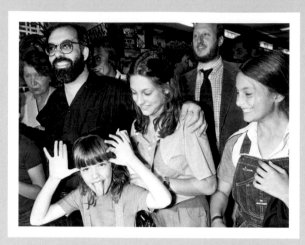

Francis Ford & Sofia
Coppola

Francis Ford Coppola (7 April 1939, USA) is one of the world's most honoured and controversial directors, producers and screenwriters. He won 2 Palme d'Or awards, and 5 Oscars with films like *Apocalypse Now*, *The Godfather*, *Patton*, *Dracula* and *The Conversation*. He also received an honorary Oscar for his whole career.
Sofia Carmina Coppola (14 May 1971, USA) started her acting career as a baby when she appeared in *The Godfather*. She went on to act in several other of her father's films. Sofia attracted the attention of the world with her directing debut *The Virgin Suicides* and later confirmed her talent and success with films like *Lost in Translation*, *Marie Antoinette* and *Somewhere*.
Father & daughter: Francis says that he felt certain his daughter would become a director, at three years old, she shouted 'cut' from the backseat of the car when he was quarrelling with his wife.
The Coppola family: Francis's mother Italia Pennino was an actress and his father Carmine was a composer. His son Roman is an assistant director, his sister Talia Shire is an actress and his cousins Nicolas Cage and Jason Schwartzman are actors. • Not including the Huston family, they are the only family to have three generations of Oscar winners: grandfather Carmine (best music), father Francis (best director, best film and three times best script) and Sofia (best script).

Francis Ford Coppola (7 avril 1939, États-Unis) est l'un des réalisateurs, producteurs et scénaristes les plus encensés et controversés au monde. Il a notamment remporté 2 Palmes d'or, 6 Oscars et 4 Golden Globes avec des films tels qu'*Apocalypse Now*, *Le Parrain*, *Patton*, *Dracula* et *Conversation secrète*.
Sofia Carmina Coppola (14 mai 1971, États-Unis) fait son baptême au cinéma, encore bébé, dans *Le Parrain*. Elle joue ensuite dans d'autres films de son père. Ses débuts de réalisatrice avec *The Virgin Suicides* sont salués ; elle confirme son succès avec trois nouveaux films remarqués : *Lost in Translation*, *Marie-Antoinette* et *Somewhere*.
Père & fille : Francis savait que sa fille deviendrait réalisatrice quand, à l'âge de 3 ans, celle-ci criait déjà "Coupez !" depuis la banquette arrière de la voiture lorsque ses parents se querellaient.
La famille Coppola : La mère de Francis, Italia Pennino, était actrice ; son père, Carmine, compositeur. Le fils de Francis, Roman, est assistant-réalisateur ; sa sœur, Talia Shire, actrice ; et ses neveux Nicholas Cage et Jason Schwartzman sont acteurs. • Avec les Huston, les Coppola sont la seule famille à compter trois générations oscarisées : Carmine (meilleure musique), Francis (meilleur film, meilleur scénario et meilleur réalisateur) et Sofia (meilleur scénario).

Francis Ford Coppola (7 april 1939, VSA) is een van 's werelds meest gelauwerde en controversiële regisseurs, producers en scenarioschrijvers. Hij verzamelde onder andere 2 Gouden Palmen, 5 Oscars, 4 Golden Globes dankzij films als *Apocalypse Now*, *The Godfather*, *Patton*, *Dracula* en *The Conversation* én kreeg een ere-Oscar voor zijn carrière.
Sofia Carmina Coppola (14 mei 1971, VSA) kreeg als baby haar filmdoop in *The Godfather* en speelde mee in verscheidene andere films van haar vader. Ze trok wereldwijd de aandacht met haar regiedebuut *The Virgin Suicides* en bevestigde haar succes met *Lost in Translation*, *Marie Antoinette* en *Somewhere*.
Vader & dochter: Francis beweert dat hij al wist dat zijn dochter regisseur zou worden toen ze drie jaar oud was en vanop de achterbank van de auto 'Cut!' riep terwijl hij aan het bekvechten was met zijn vrouw.
De familie: Francis' moeder, Italia Pennino, was actrice, zijn vader Carmine componist. Zijn zoon Roman is regie-assistent, zijn zus Talia Shire actrice, en zijn neven Nicholas Cage en Jason Schwartzman zijn acteurs. • Samen met de Hustons zijn ze de enige familie met drie generaties oscarwinnaars: grootvader Carmine (beste muziek), vader Francis (beste regie, beste film en driemaal beste script) en Sofia (beste script).

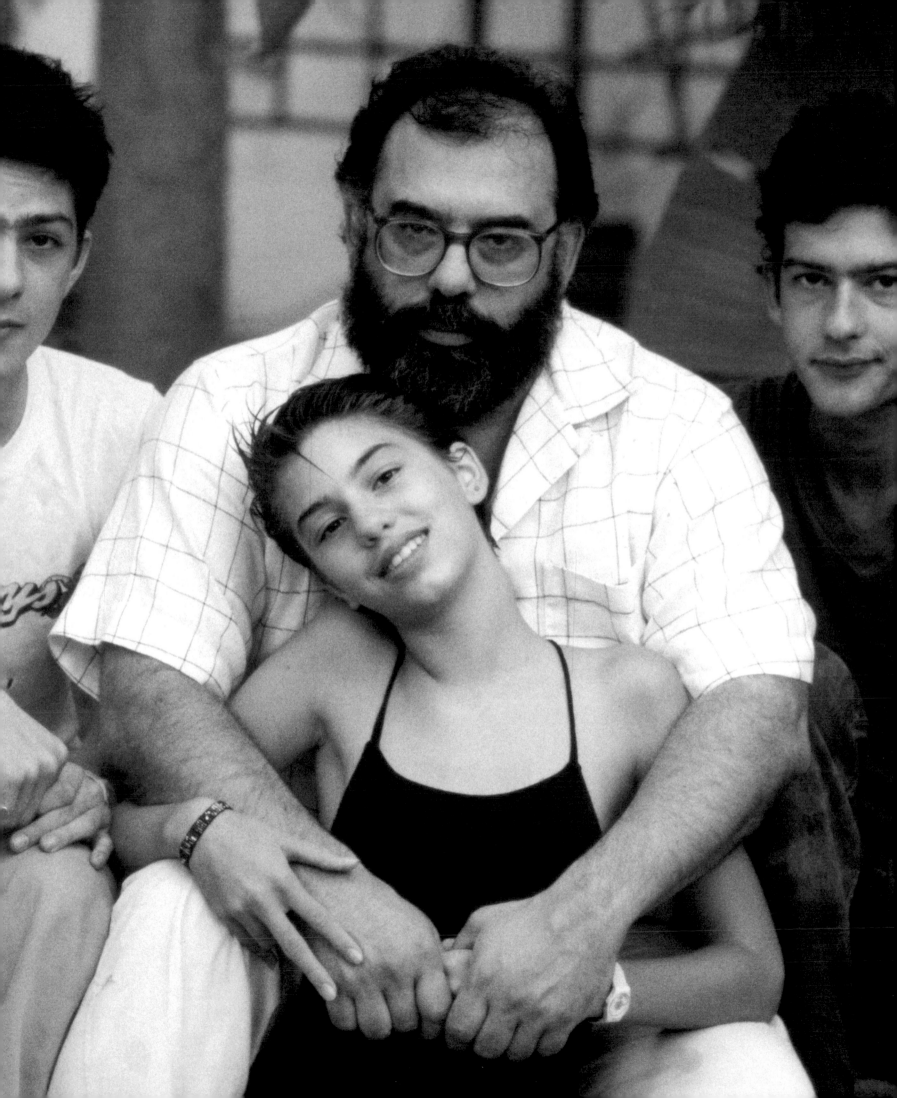

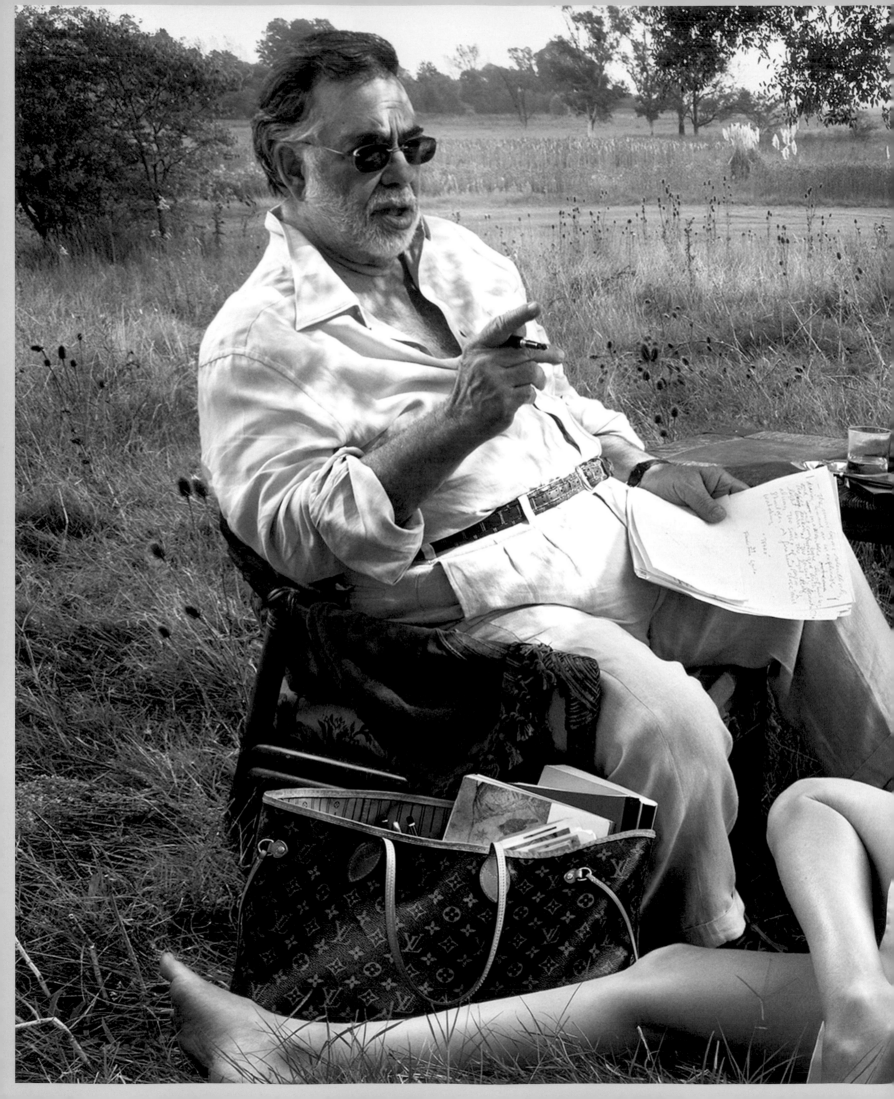

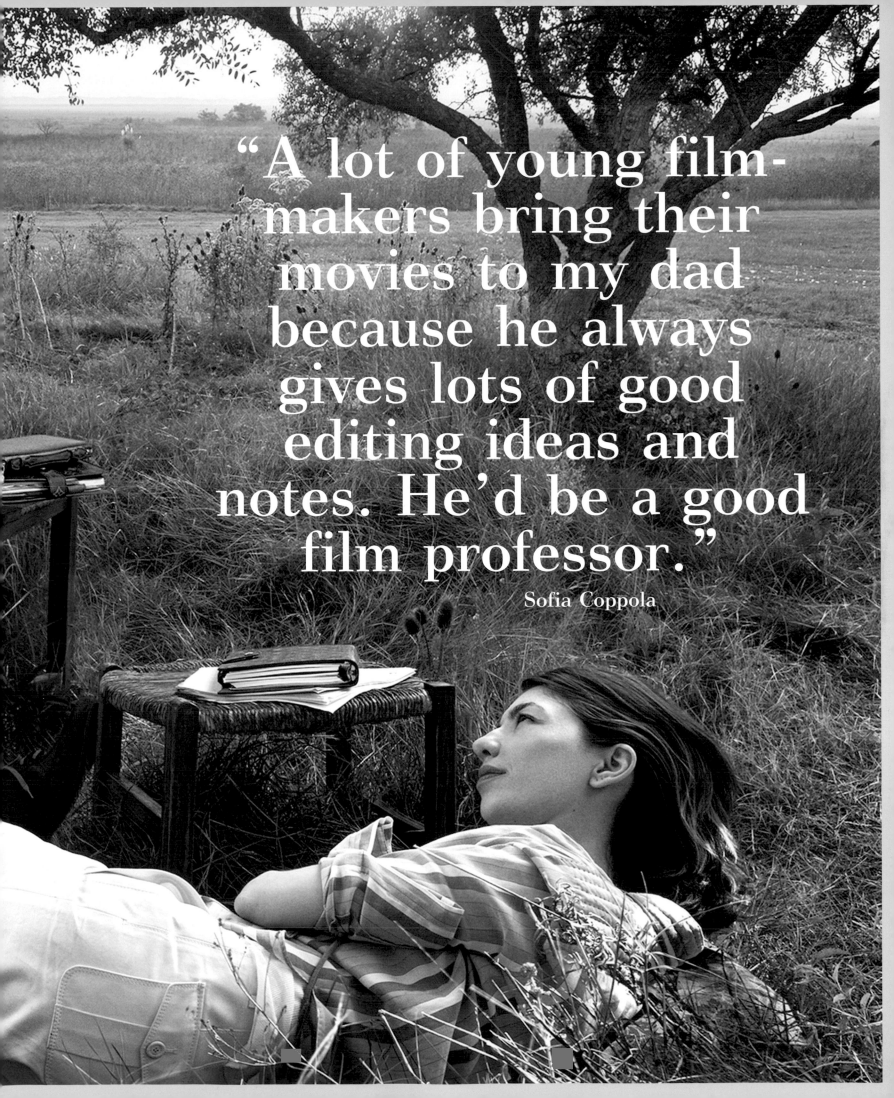

"A lot of young film-makers bring their movies to my dad because he always gives lots of good editing ideas and notes. He'd be a good film professor."

Sofia Coppola

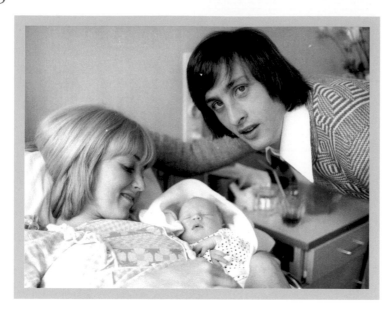

Johan & Jordi
Cruijff

Hendrik Johannes 'Johan' Cruijff (25 April 1947, Netherlands) was voted best European football player of the 20th century in 1999. He was an attacker for clubs like Ajax, FC Barcelona and Feyenoord and played 48 international matches with the Dutch national team. As manager of FC Barcelona, he put together a team that later became known as the Dream Team. Currently, he is manager of the Catalonia national team and works as a football analyst, columnist and advisor.
Jordi Cruijff (9 February 1974, Netherlands) played for international teams like FC Barcelona and Manchester United, and played for both the Dutch and Catalonian national squads. In 2010 he joined AEK Larnaca in Cyprus as technical director.
Father & son: Coach Rinus Michels chose Jordi's birth date because it had to be a day that fit into FC Barcelona's schedule. • Jordi made his debut in 1984 with FC Barcelona under his father's watchful eye. • After some time, he had his first name printed on his shirts to distinguish himself from his famous father. • The 'Jordi Cruijff-syndrome' is a Dutch term used to describe someone who tries to achieve the same as, but is always compared with, his father.

Hendrik Johannes "Johan" Cruijff (25 avril 1947, Pays-Bas) a été élu "meilleur footballeur européen du 20e siècle" en 1999. Il a évolué comme attaquant à l'Ajax Amsterdam, au FC Barcelone et au Feyenoord Rotterdam, et compte 48 sélections en équipe nationale. En tant qu'entraîneur, il a façonné l'équipe du FC Barcelone, devenue la célèbre *Dream Team*. Il est actuellement sélectionneur de l'équipe de Catalogne et travaille comme chroniqueur footballistique, éditorialiste et conseiller.
Jordi Cruijff (9 février 1974, Pays-Bas) a joué pour le FC Barcelone et Manchester United, ainsi qu'au sein du Onze néerlandais et catalan. En 2010, il est devenu directeur technique du club chypriote AEK Larnaca.
Père & fils : La date de naissance de Jordi fut choisie par l'entraîneur Rinus Michels : il fallait en effet que celle-ci s'accorde avec l'agenda du FC Barcelone. • Jordi a débuté en 1984 au FC Barcelone, sous la houlette de son père. • Jordi décida d'inscrire son prénom sur son maillot pour pouvoir être distingué de son illustre père. • "Le syndrome de Jordi Cruijff" se dit de quelqu'un qui essaie de marcher sur les traces de son père, mais qui demeure toujours comparé à celui-ci.

Hendrik Johannes 'Johan' Cruijff (25 april 1947, Nederland) werd in 1999 verkozen tot beste Europese voetballer van de 20e eeuw. Hij was aanvaller voor onder meer Ajax, FC Barcelona en Feyenoord en speelde 48 wedstrijden in het Nederlandse elftal. Als coach vormde hij bij FC Barcelona een ploeg die bekend kwam te staan als het Dream Team. Momenteel is hij bondscoach van het Catalaanse elftal en werkt hij als voetbalanalist, columnist en adviseur.
Jordi Cruijff (9 februari 1974, Nederland) speelde voor internationale ploegen als FC Barcelona en Manchester United, en kwam zowel uit voor het Nederlandse als het Catalaanse elftal. In 2010 ging hij als technisch directeur aan de slag bij het Cypriotische AEK Larnaca.
Vader & zoon: Jordi's geboortedatum werd gekozen door trainer Rinus Michels omdat het een dag moest zijn die in de agenda van FC Barcelona paste. • Jordi debuteerde in 1984 onder Johans vleugels bij FC Barcelona. • Hij liet na verloop van tijd zijn voornaam op zijn voetbalshirt drukken om zich te onderscheiden van zijn beroemde vader. • De term 'Jordi Cruijff-syndroom' wordt gebruikt voor iemand die op een bepaald gebied hetzelfde tracht te bereiken als zijn vader, maar daar altijd mee vergeleken wordt.

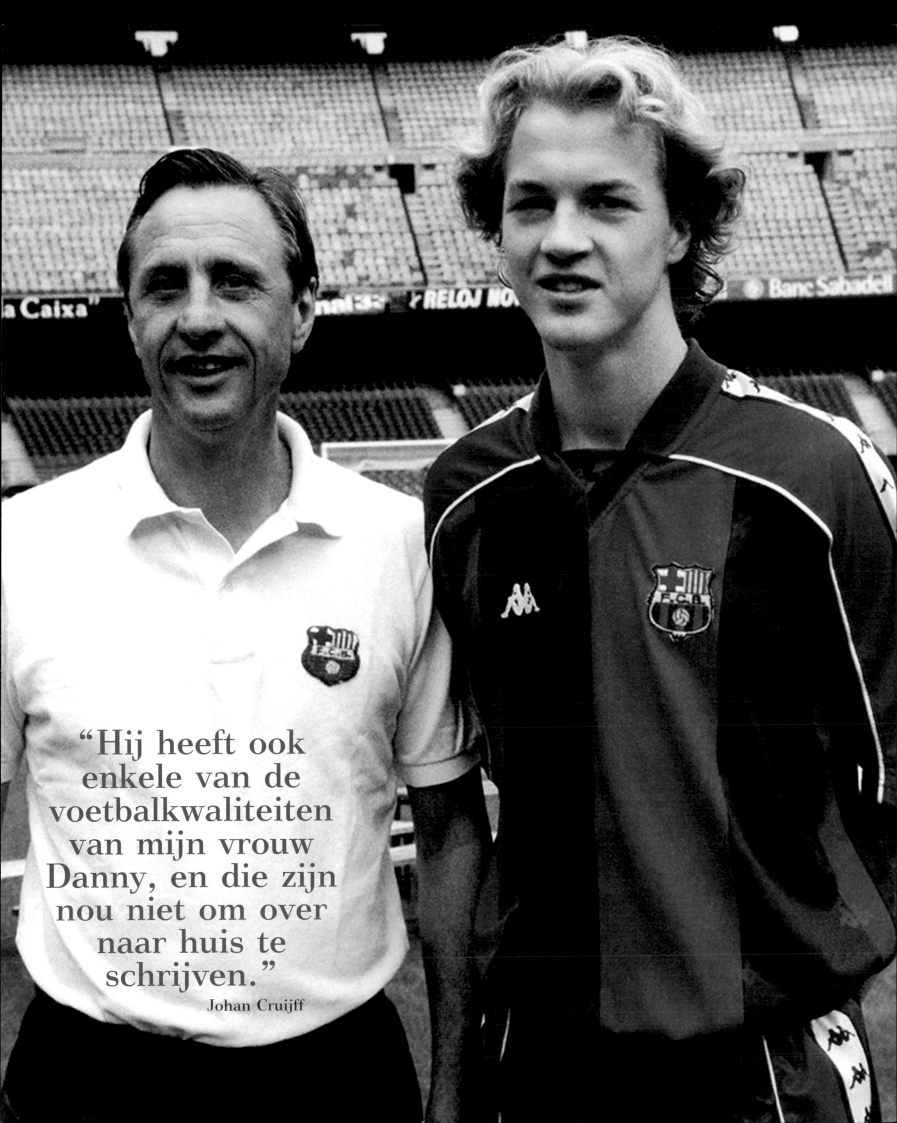

"Hij heeft ook enkele van de voetbalkwaliteiten van mijn vrouw Danny, en die zijn nou niet om over naar huis te schrijven."

Johan Cruijff

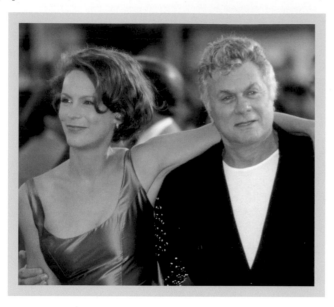

Tony & Jamie Lee
Curtis

Bernard Schwartz (3 June 1925 - 29 September 2010, USA), better known as Tony Curtis, appeared in over 100 films covering a wide range of genres. He was successful in television shows like *The Persuaders* and films like *Some Like it Hot*, *Taras Bulba*, *The Defiant Ones* and *Spartacus*. He also developed a second career as a painter.

Jamie Lee Curtis (22 November 1958, USA) was named the 'scream queen' due to her role in Halloween and several other horror films. She has since appeared in many successful films and television series like *Trading Places*, *A Fish Called Wanda*, *True Lies* and *Freaky Friday*. Nowadays, she writes children's books, blogs for *The Huffington Post* and due to her marriage has become Lady Haden-Guest.

Father & daughter: In 1962, after 11 years of marriage, Tony Curtis and Janet Leigh divorced. "By the time I came along ... my parents' bond had deteriorated and, like any other save-the-marriage baby, I failed," Jamie Lee said. • Jamie en Tony were both addicted to cocaine in the 80s.
• Jamie appeared in the television series *Operation Petticoat*, which was based on the film of the same name her father had previously starred in.

Bernard Schwartz (3 juin 1925 - 29 septembre 2010, États-Unis), mieux connu sous le nom de Tony Curtis, a incarné au cinéma une centaine de rôles des plus éclectiques. Il a cartonné dans la série "Amicalement vôtre" et, au grand écran, dans des films comme *Certains l'aiment chaud*, *Tarass Boulba*, *La Chaîne* et *Spartacus*. Il mena aussi une carrière de peintre dans les années 80.

Jamie Lee Curtis (22 novembre 1958, États-Unis) est surnommée la "*reine du hurlement*" pour son interprétation dans *Halloween* et plusieurs autres films d'horreur. Elle a joué dans de nombreux films, téléfilms et séries à succès, notamment *Un Fauteuil pour deux*, *Un Poisson nommé Wanda*, *True Lies* et *Freaky Friday – Dans la peau de ma mère*. Elle écrit aujourd'hui des livres pour enfants, rédige des billets pour *The Huffington Post* et est devenue, par son mariage, Lady Haden-Guest.

Père & fille : Tony Curtis et Janet Leigh, la mère de Jamie Lee, ont divorcé en 1962 après 11 ans de mariage. • Jamie et Tony ont tous deux connu une addiction à la cocaïne dans les années 80. • Jamie a joué dans la série télévisée "*Operation Petticoat*", basée sur le film du même nom dans lequel avait brillé son père.

Bernard Schwartz (3 juni 1925 - 29 september 2010, VSA), beter gekend als Tony Curtis, bouwde een acteercarrière uit die meer dan 100 zeer uiteenlopende rollen omvat. Op tv scoorde hij vooral met *The Persuaders* en op het grote scherm schitterde hij onder andere in *Some Like it Hot*, *Taras Bulba*, *The Defiant Ones* en *Spartacus*. Daarnaast bouwde hij een tweede carrière uit als kunstschilder.

Jamie Lee Curtis (22 november 1958, VSA) kreeg dankzij haar rol in *Halloween* en een aantal andere horrorfilms de bijnaam 'scream queen'. Sindsdien speelde ze mee in tal van succesvolle prenten, tv-films en series, zoals *Trading Places*, *A Fish Called Wanda*, *True Lies* en *Freaky Friday*. Tegenwoordig schrijft ze kinderboeken, blogt ze voor The Huffington Post en is ze door haar huwelijk Lady Haden-Guest geworden.

Vader & dochter: Tony Curtis en Janet Leigh scheidden in 1962 na 11 jaar huwelijk. *"Toen ik er dan eindelijk aankwam... was de band tussen mijn ouders al verslechterd en net als elke andere red-het-huwelijk-baby, faalde ik."*, zegt Jamie Lee. • Jamie en Tony waren in de jaren 80 allebei verslaafd aan cocaïne. • Jamie speelde mee in de tv-serie *Operation Petticoat*, die gebaseerd was op de gelijknamige film waarin haar vader schitterde.

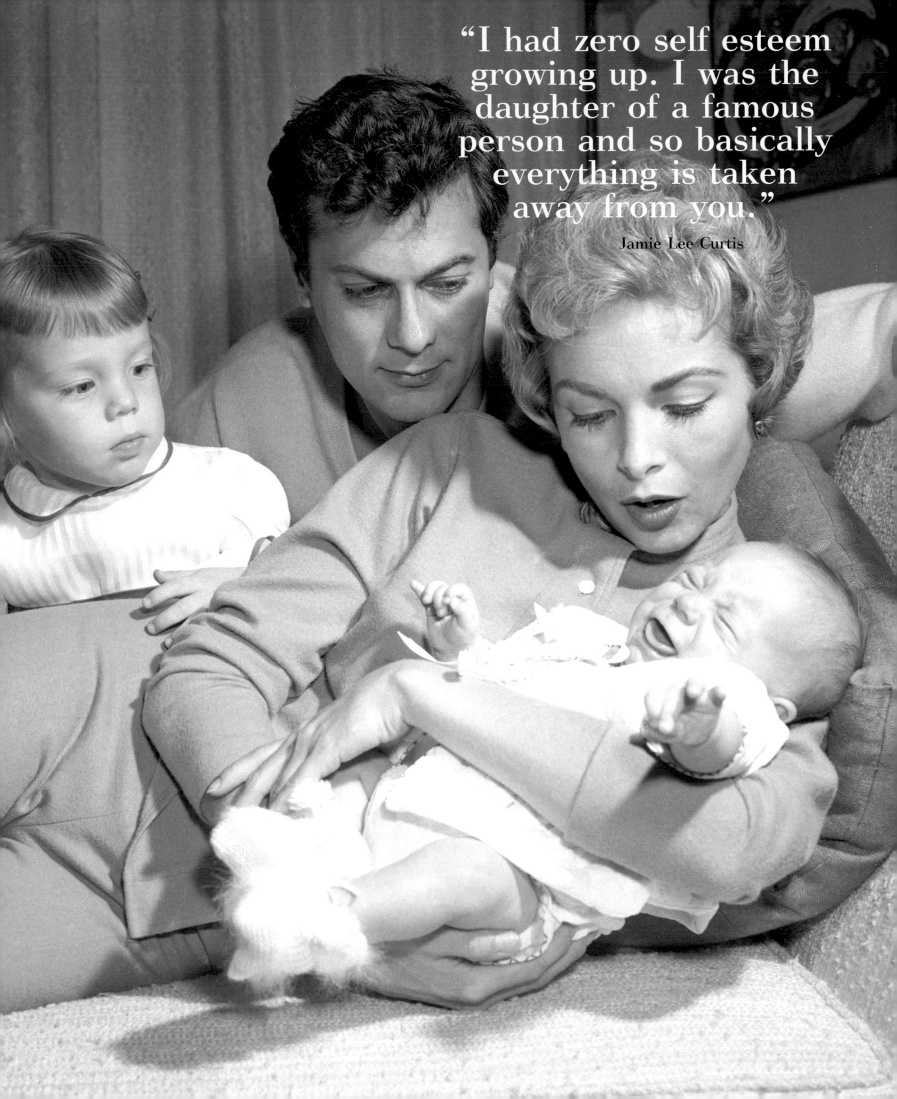

"I had zero self esteem growing up. I was the daughter of a famous person and so basically everything is taken away from you."

Jamie Lee Curtis

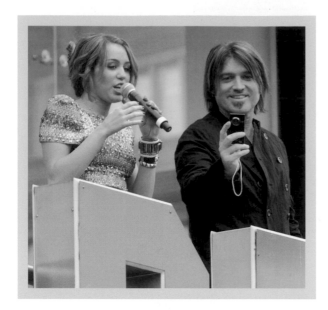

Billy Ray & Miley
Cyrus

William 'Billy' Ray Cyrus (25 Augustus 1961, USA) caused the worldwide revival of country music and line dancing. Since his debut in 1992, he has released 11 albums and 38 singles. He holds the record of longest lasting number 1 in the Billboard 200 (seventeen weeks) with his song *Achy Breaky Heart*. In 2005, he began to star as Miley's father in the popular television series *Hannah Montana*.
Destiny Hope 'Miley Ray' Cyrus (23 November 1992, USA) made her acting debut at the age of nine in her father's television series *Doc* and at the age of twelve secured the title role in *Hannah Montana*. Thanks to this successful series, she has established herself as a teen idol and has been able to pursue a music career. In the meantime, she has also appeared in several films and has begun to cultivate a more adult image and music career.
Father & daughter: As a child, Miley used to travel along with her family to her father's concerts. When she was two years old, she stormed onto the stage during *a live* Elvis homage and joined in. • Billy Ray nicknamed his daughter 'Smiley' because she was always smiling. The name changed into Miley and was made official by his daughter in 2008.

William "Billy" Ray Cyrus (25 août 1961, États-Unis) a contribué au retour de la musique country et de la danse en ligne sur la scène internationale. Depuis ses débuts en 1992, il a réalisé 11 albums et 38 singles et détient, avec "*Achy Breaky Heart*", le record du nombre de semaines en tête du Billboard 200 (17 semaines). Depuis 2005, il incarne le père de Miley dans la série populaire "Hannah Montana".
Destiny Hope "Miley Ray" Cyrus (23 novembre 1992, États-Unis) a fait ses débuts à l'âge de 9 ans dans la série "Doc", dans laquelle joue son père. Elle a décroché à l'âge de 12 ans le rôle principal de "Hannah Montana" et est devenue rapidement l'idole des ados. En parallèle, elle a entamé une carrière musicale. Elle compte désormais de nombreux films à son actif et jouit d'un statut de chanteuse à part entière.
Père & fille : Enfant, Miley suivait son père en concert. Lorsqu'elle avait deux ans, elle fit irruption sur le podium durant un hommage *live* à Elvis, pour chanter elle aussi. • Billy Ray surnomma sa fille "*Smiley*" parce qu'elle riait toujours. Ce surnom est devenu ensuite Miley et fut adopté définitivement par la jeune fille en 2008.

William 'Billy' Ray Cyrus (25 augustus 1961, VSA) zorgde hoogstpersoonlijk voor de wereldwijde heropleving van countrymuziek en linedancing. Sinds zijn debuut in 1992 heeft hij 11 albums en 38 singles uitgebracht en houdt hij met *Achy Breaky Heart* het record van de langstgenoteerde nummer één-plaat in de Billboard 200 (zeventien weken). Sinds 2005 speelt hij Miley's vader in de populaire tv-serie *Hannah Montana*.
Destiny Hope 'Miley Ray' Cyrus (23 november 1992, VSA) maakte op haar negende haar acteerdebuut in haar vaders tv-serie *Doc* en versierde op haar twaalfde de titelrol in *Hannah Montana*. Dankzij deze successerie groeide ze uit tot een tieneridool en kreeg ze er een muziekcarrière bovenop. Intussen heeft ze ook al een paar films gemaakt en heeft ze ook onder eigen naam een meer volwassen imago en muziekcarrière uitgebouwd.
Vader & dochter: Als kind reisde Miley met haar familie mee naar de concerten van haar vader. Als tweejarige rende ze tijdens een live eerbetoon aan Elvis het podium op en begon mee te doen. • Billy Ray gaf zijn dochter de bijnaam 'Smiley' omdat ze altijd lachte. De naam werd later verbasterd tot Miley en door dochterlief in 2008 officieel aangenomen.

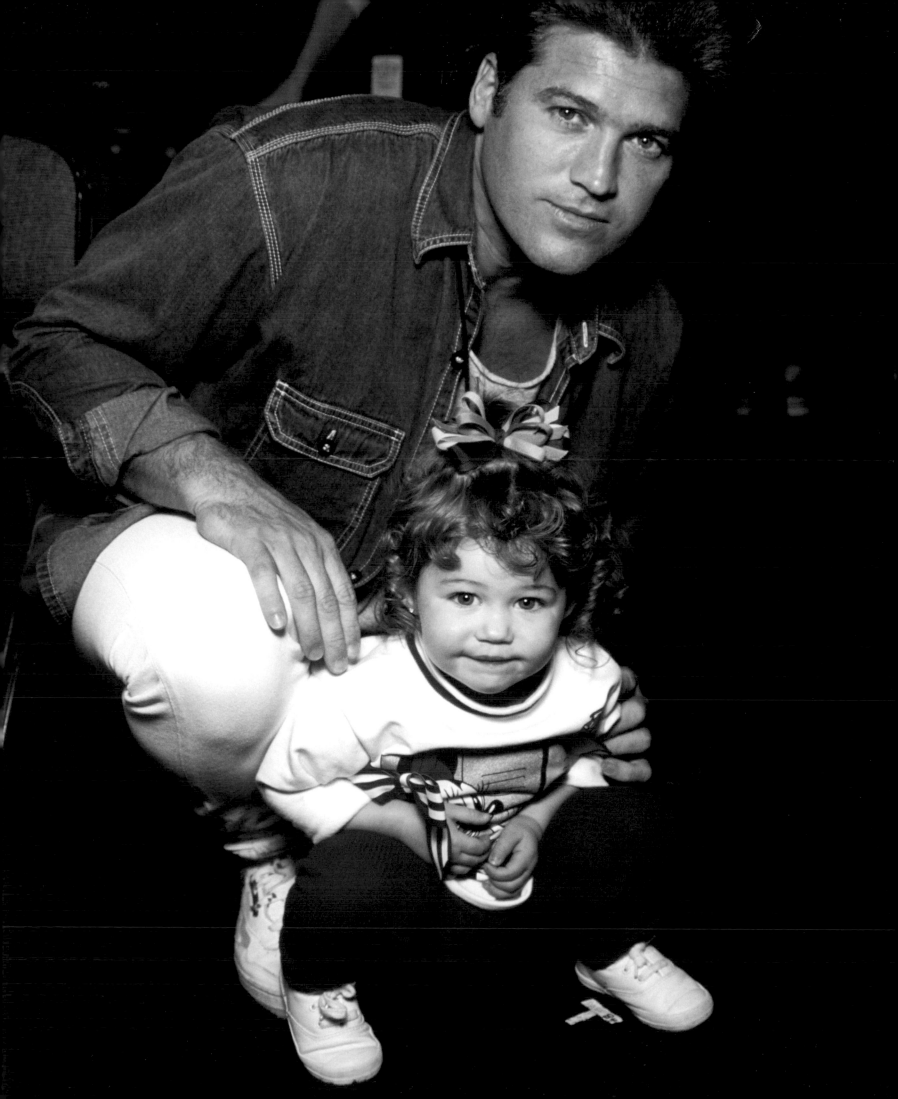

Decleir

Jan Amande Gustaaf Decleir (14 February 1946, Belgium) is one of the most famous and honoured actors in Belgium. He played his first big role in 1971 in *Mira* and has since appeared in numerous Flemish and Dutch films and television productions. He gained international interest when he appeared in the films *Daens* and *De Zaak Alzheimer* and starred in Oscar winning films like *Karakter* and *Antonia*. He was even offered roles in Stanley Kubrick's *Eyes Wide Shut* and the James Bond film *The World is Not Enough*.

Jenne Decleir (5 December 1977, Belgium) is both an actor and a musician. He became famous thanks to his role in the youth series *W817*, played in numerous television series and theatre productions and acted in films like *Dief!*, *Amasones* and *The Girl in Hyacinth Blue*. He is also the front man of his band Hotel Amigo.

Father & son: Jenne played his first role in *Antonia*, in which his father played the lead role. • Hotel Amigo, Jenne's band, played a series of concerts with Jan as guest.

The Decleir family: Jenne's sister Sophie and his mother Caroline Van Gastel are both theatre actresses. • Jan, son Jenne and daughter Sofie played father, son and daughter in the television series *De Kavijaks*.

Jan Amanda Gustaaf Decleir (14 février 1946, Belgique) est l'un des acteurs belges les plus célèbres qui soit. Il a interprété son premier grand rôle en 1971 dans *Mira* et joué ensuite dans de nombreux films flamands et néerlandais. Il connaît un succès international avec *Daens* et *La Mémoire du tueur*, et apparaît dans les films oscarisés *Karakter* et *Antonia*. Plus récemment, on lui proposa de jouer dans *Eyes Wide Shut*, de Stanley Kubrick, et dans le James Bond *Le Monde ne suffit pas*.

Jenne Decleir (5 décembre 1977, Belgique) est acteur et musicien. Révélé par la série pour adolescents "W817", il a joué dans de nombreux feuilletons et productions théâtrales, ainsi que dans les films *Dief!*, *Amazones* et *The Girl in Hyacinth Blue*. Il est aussi le leader du groupe *Hotel Amigo*.

Père & fils : Jenne a interprété son premier rôle dans *Antonia*, où son père tenait le rôle-titre. • *Hotel Amigo*, le groupe de Jenne, a donné une série de concerts en présence de Jan.

La famille Decleir : La sœur de Jenne, Sophie, et sa mère, Caroline Van Gastel, sont comédiennes. • Jan, Jenne et Sofie ont incarné les rôles de père, fils et fille dans la série "*De Kavijaks*".

Jan Amande Gustaaf Decleir (14 februari 1946, België) is een de meest beroemde en gelauwerde acteurs in België. Hij vertolkte zijn eerste grote rol in 1971 in *Mira* en speelde sindsdien mee in talloze Vlaamse en Nederlandse films en tv-producties. Hij liet zich internationaal opmerken in de films *Daens* en *De Zaak Alzheimer* en schitterde in Oscarwinnende prenten als *Karakter* en *Antonia*. Hij werd zelfs gevraagd voor Stanley Kubricks *Eyes Wide Shut* en de James Bond-film *The World is Not Enough*.

Jenne Decleir (5 december 1977, België) is zowel bezig met muziek maken als met acteren. Hij werd bekend dankzij de jongerenserie *W817*, speelde mee in tal van tv-series en theaterproducties en vertolkte rollen in films als *Dief!*, *Amasones* en *The Girl in Hyacinth Blue*. Hij is ook de frontman van de groep Hotel Amigo.

Vader & zoon: Jenne speelde zijn eerste filmrol in *Antonia*, waarin zijn vader een hoofdrol vertolkte. • Hotel Amigo, de band van Jenne, heeft een concertreeks verzorgd met Jan als gast.

De familie Decleir: Jennes zus Sophie en zijn moeder Caroline Van Gastel zijn allebei theateractrices. • Jan, zoon Jenne en dochter Sofie speelden vader, zoon en dochter in de de tv-serie *De Kavijaks*.

"Als Jenne er rotsvast van overtuigd is dat hij een uniek verhaal te vertellen heeft, komt er een dag dat hij niet langer

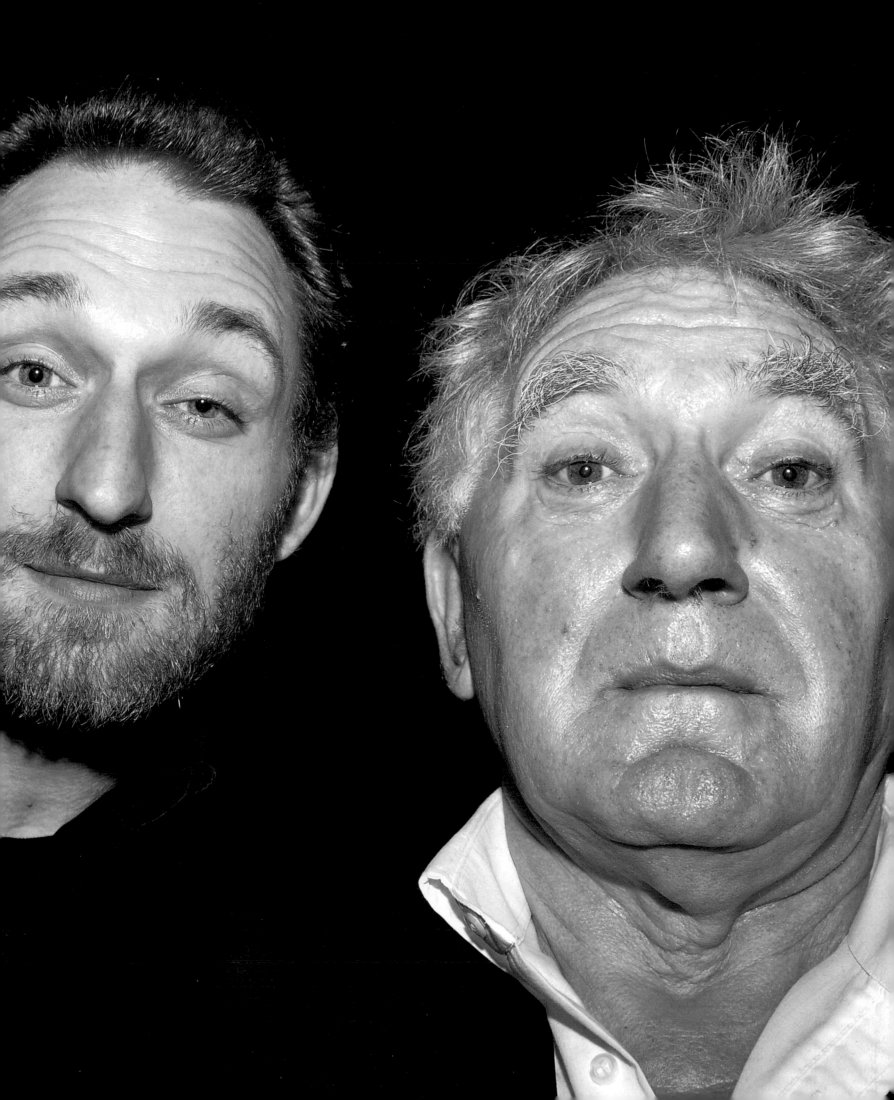

Alain & Anthony
Delon

Alain Fabien Maurice Marcel Delon (8 November 1935, France) is an internationally honoured legend in French cinema. Films like *Plein Soleil*, *Il Gattopardo*, *Le Samourai*, *Borsalino* and *Monsieur Klein* made him world famous and his looks earned him the nickname 'the male Brigitte Bardot'. He is still at work as an actor, but has not been able to match his first successes.
Anthony Delon (30 September 1964, USA) got on the right track when he began portraying roles in films like *Chronique d'un mort annoncée* and *La vérité si je mens*. At present, he still acts in films, television series and theatre productions while dividing his time between France and the United States.
Father & son: After his parents divorced when he was four years old, Alain struggled through a rebellious youth until he became an actor at the age of 21. Anthony's parents also divorced when he was four and his youth was equally troublesome until he succeeded in developing an acting career of his own. • Anthony fled to the United States because French critics relentlessly kept comparing him to his father. • Even though the relationship between the two men was lousy for a long time, Anthony spoke highly of his father in his biography *Le premier maillon*.

Alain Fabien Maurice Marcel Delon (8 novembre 1935, France) est une légende du cinéma français. Des films comme *Plein Soleil*, *Le Guépard*, *Le Samouraï*, *Borsalino* et *Monsieur Klein* ont fait sa renommée internationale, et lui ont valu le surnom de "Brigitte Bardot au masculin". Il tourne encore aujourd'hui, même si le succès est plus mitigé qu'à ses débuts.
Anthony Delon (30 septembre 1964, États-Unis) a suivi la voie de son père en jouant notamment dans *Chronique d'une mort annoncée* et *La Vérité si je mens*. Il est aujourd'hui présent au cinéma, à la télévision et au théâtre, et partage son temps entre la France et les États-Unis.
Père & fils : Les parents d'Alain ont divorcé lorsque celui-ci avait quatre ans. Il connut une jeunesse rebelle avant de devenir acteur à l'âge de 21 ans. Les parents d'Anthony divorcèrent également lorsque celui-ci avait quatre ans ; il connut une jeunesse mouvementée avant de percer en tant qu'acteur. • Anthony est parti aux États-Unis, las des critiques français qui ne cessaient de le comparer à son père. • Même si leurs relations furent longtemps tourmentées, Anthony parle avec beaucoup de respect de son père dans sa biographie *Le Premier Maillon* (2008).

Alain Fabien Maurice Marcel Delon (8 november 1935, Frankrijk) is een internationaal gelauwerde legende van de Franse cinema. Films als *Plein Soleil*, *Il Gattopardo*, *Le Samourai*, *Borsalino* en *Monsieur Klein* maakten hem wereldberoemd en bezorgden hem de bijnaam 'de mannelijke Brigitte Bardot'. Hij werkt nog altijd als acteur, hoewel hij zijn eerste successen nooit heeft kunnen evenaren.
Anthony Delon (30 september 1964, VSA) geraakte op het goeie spoor toen hij rollen begon te vertolken in films als *Chronique d'un mort annoncée* en *La vérité si je mens*. Momenteel speelt hij mee in films, tv-series en theaterstukken, terwijl hij zijn tijd verdeelt tussen Frankrijk en de States.
Vader & zoon: Alains ouders scheidden toen hij vier was, waarna hij een rebelse jeugd doorspartelde tot hij op zijn 21e acteur werd. Ook Anthony's ouders scheidden toen hij vier jaar was, en hij kende een al even woelige jeugd tot ook hij erin slaagde een acteercarrière uit te bouwen. • Anthony vluchtte naar de States omdat de Franse critici het niet konden laten hem te vergelijken met zijn vader. • Hoewel de relatie tussen beiden lang problematisch was, spreekt Anthony in zijn biografie *Le premier maillon* met respect over zijn vader.

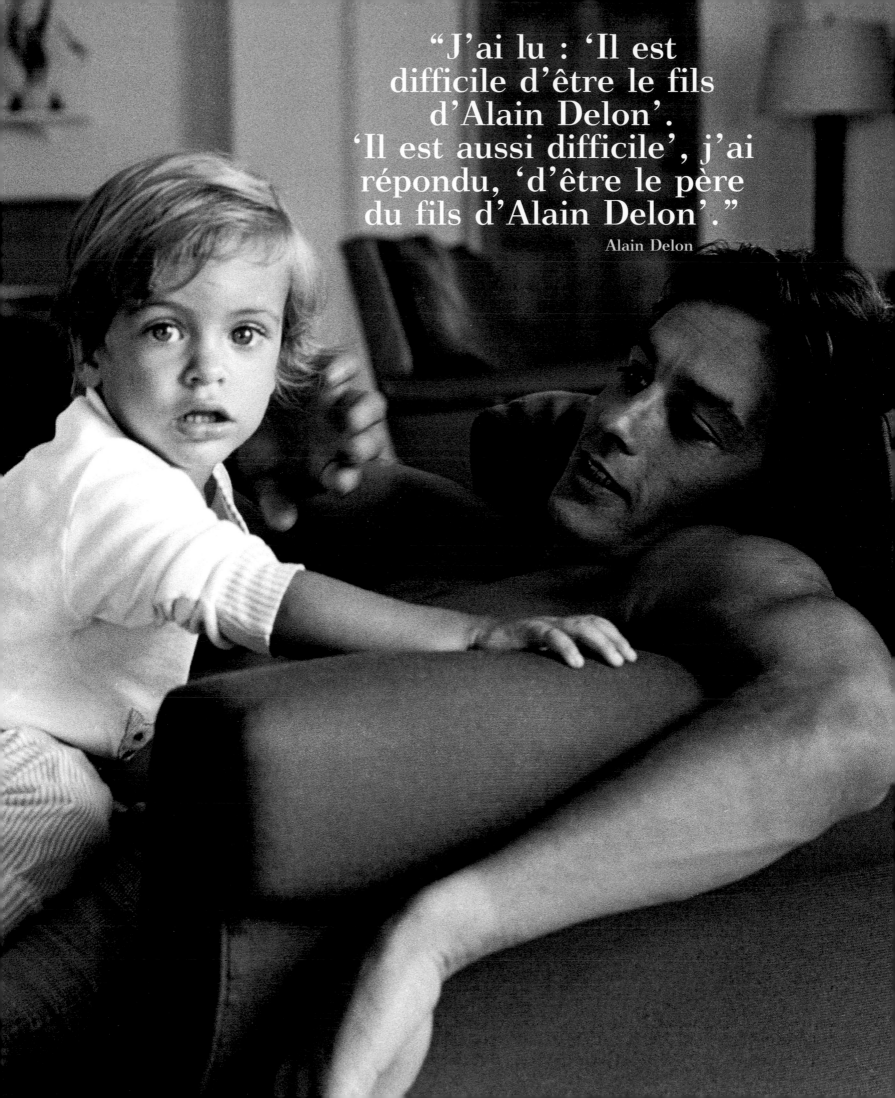

"J'ai lu : 'Il est difficile d'être le fils d'Alain Delon'. 'Il est aussi difficile', j'ai répondu, 'd'être le père du fils d'Alain Delon'."

Alain Delon

John Sr., John Jr. & Linda
De Mol

Johannes Hendrikus 'John' de Mol Sr. (28 December 1931, Netherlands) is a crooner who, in the 50s, rose to fame as the Dutch Frank Sinatra. He was involved in the Academie voor Lichte Muziek and became director of the pirate radio station Radio Noordzee in the early 70s. He was knighted for his work in Dutch light music.

Johannes Hendrikus Hubert 'John' de Mol Jr. (24 April 1955, Netherlands) became the largest Dutch media tycoon due to being the man behind the production companies Endemol and Talpa. His first hit ratings show was *Medisch Centrum West* and with *Big Brother* he reached the whole world. In the meantime he has become a billionaire.

Linda Margaretha de Mol (8 July 1964, Netherlands) conquered the Netherlands and Germany as presenter of television programmes like *Love Letters*, *De Leukste Thuis* and *Miljoenenjacht*. She demonstrated her acting talent in *Spangen*, *Gooische Vrouwen* and the film *Ellis in Glamourland*. She heads her own magazine Linda.

Father, son & daughter: John Jr. started his career as a deejay at his father's radio station Radio Noordzee.

The de Mol family: John Sr. was the son of accordionist and conductor John de Mol Sr. • Johnny, the son of John Jr. and Willeke Alberti is a singer, presenter and actor.

Johannes Hendrikus "John" de Mol Sr. (28 décembre 1931, Pays-Bas) est un célèbre crooner des années 50, surnommé le "Frank Sinatra néerlandais". Il a fondé l'Academie voor Lichte Muziek et est devenu directeur de la radio pirate Radio Noordzee au début des années 70. Il fut reçu chevalier pour sa contribution à la musique populaire.

Johannes Hendrikus Hubert "John" de Mol Jr. (24 avril 1955, Pays-Bas), le plus grand magnat des médias néerlandais, est le fondateur des sociétés de production Endemol et Talpa. Il a réalisé ses premiers records d'audience avec la série "*Medisch Centrum West*" ; *Big Brother* lui a ensuite apporté une notoriété internationale.

Linda Margaretha de Mol (8 juillet 1964, Pays-Bas) a conquis le cœur des téléspectateurs néerlandais et allemands en présentant les émissions "*Love Letters*", "*De Leukste Thuis*" et "*Miljoenenjacht*". Elle a également démontré ses talents d'actrice dans "*Spangen*", le feuilleton dramatique "*Jardins secrets*" et le film *Ellis in Glamourland*. Elle possède son propre magazine, *Linda*.

La famille de Mol : John Sr. était le fils de l'accordéoniste et chef d'orchestre John de Mol Sr. • Johnny, le fils de John Jr. et Willeke Alberti, est chanteur, présentateur et acteur.

Johannes Hendrikus 'John' de Mol Sr. (28 december 1931, Nederland) is een charmezanger die in de jaren 50 bekend stond als de Nederlandse Frank Sinatra. Hij zat achter de Academie voor Lichte Muziek en werd begin jaren 70 directeur van de piratenzender Radio Noordzee. Vanwege zijn verdiensten voor de lichte muziek werd hij geridderd.

Johannes Hendrikus Hubert 'John' de Mol Jr. (24 april 1955, Nederland) groeide als de man achter de productiebedrijven Endemol en Talpa uit tot Nederlands grootste mediamagnaat. Zijn eerste kijkcijferhit scoorde hij met *Medisch Centrum West*, en met *Big Brother* brak hij wereldwijd door. Intussen is hij miljardair.

Linda Margaretha de Mol (8 juli 1964, Nederland) veroverde als presentatrice Nederland en Duitsland dankzij tv-programma's als *Love Letters*, *De Leukste Thuis* en *Miljoenenjacht*. Haar acteertalent toonde ze onder meer in *Spangen*, de dramedy *Gooische Vrouwen* en de film *Ellis in Glamourland*. Ze leidt haar eigen tijdschrift, *Linda*.

Vader, zoon & dochter: John jr. begon zijn carrière als deejay bij zijn vaders zender Radio Noordzee.

De familie de Mol: John Sr. was de zoon van accordeonist en orkestleider John de Mol Sr. • Johnny, de zoon van John Jr. en Willeke Alberti, is zanger, presentator en acteur.

> "Andere ouders zouden denken:
> 'M'n kind is op tv, het wordt beroemd.'
> Hij had liever gezegd: 'Mijn dochter
> is meester in de rechten'."
>
> Linda de Mol

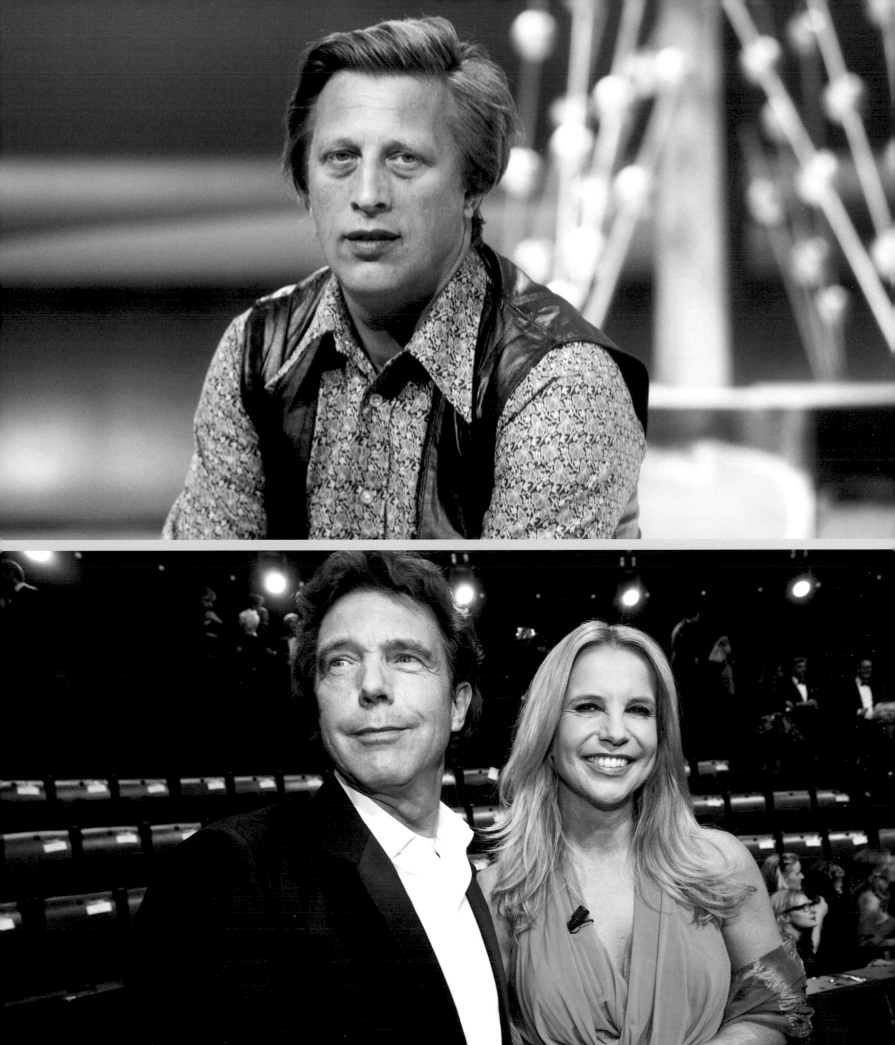

Gérard & Guillaume
Depardieu

Gérard Xavier Marcel Depardieu (27 December 1948, France) left his turbulent youth behind to pursue a career in acting, which in 1974 developed rapidly thanks to his role in the cult film *Les Valseuses*. Starring in films like *La Chèvre*, *Jean de Florette*, *Cyrano de Bergerac* and *1492: Conquest of Paradise*, he became one of the greatest French actors of the 80s and 90s.
Guillaume Jean Maxime Antoine Depardieu (17 April 1971 - 13 October 2008, France) appeared in approximately 40 films like *Les Apprentis* and *Aime ton père,* despite his rebellious life filled with alcohol and drugs. He also wrote an opera and an autobiography. In 1995 he was involved in a motorcycle accident and as a result of this he lost a leg due to an incurable infection eight years later. He died after contracting pneumonia.
Father & son: Guillaume frequently came along to sets and was an extra in films like *Pas si méchant que ça* and *Jean de Florette*. He played the younger version of his father's character Marin Marais in *Tous les matins du monde*. • The relationship between father and son was quite bad.
The Depardieu family: Mother Élisabeth and daughter Julie Depardieu are also actresses.

Gérard Xavier Marcel Depardieu (27 décembre 1948, France) se plonge corps et âme dans une carrière d'acteur après une jeunesse mouvementée. Il connaît la consécration en 1974 grâce au film culte *Les Valseuses*. Puis *La Chèvre*, *Jean de Florette*, *Cyrano de Bergerac* et *1492 : Christophe Colomb* font de lui l'un des acteurs français incontournables des années 80 et 90.
Guillaume Jean Maxime Antoine Depardieu (17 avril 1971 - 13 octobre 2008, France) a tourné une quarantaine de longs-métrages, dont *Les Apprentis* et *Aime ton père*, malgré une existence rebelle marquée par les excès d'alcool et de drogue. Il est à l'origine d'un opéra et d'une autobiographie. Un accident de moto survenu en 1995 le contraint à se faire amputer d'une jambe huit ans plus tard. Il décède en 2008 des suites d'une infection pulmonaire.
Père & fils : Guillaume se rendait souvent sur les plateaux de tournage et joua même comme figurant dans *Pas si méchant que ça* et *Jean de Florette*. Il incarna le personnage de Martin Marais jeune dans *Tous les matins du monde*. • Les relations entre Gérard et Guillaume furent extrêmement tourmentées.
La famille Depardieu : La mère et la sœur de Guillaume sont également actrices.

Gérard Xavier Marcel Depardieu (27 december 1948, Frankrijk) liet zijn turbulente jeugd achter zich door zich op een acteercarrière te gooien die in 1974 in een stroomversnelling terechtkwam dankzij de cultprent *Les Valseuses*. Met films als *La Chèvre*, *Jean de Florette*, *Cyrano de Bergerac* en *1492: Conquest of Paradise* groeide hij uit tot een van de grootste Franse acteurs van de jaren 80 en 90.
Guillaume Jean Maxime Antoine Depardieu (17 april 1971 - 13 oktober 2008, Frankrijk) slaagde er ondanks zijn rebelse leven vol drank en drugs toch in om mee te spelen in zo'n 40 films, waaronder *Les Apprentis* en *Aime ton père*. Daarnaast schreef hij ook een opera en een autobiografie. Een motorongeluk in 1995 kostte hem acht jaar later een been wegens een ongeneeslijke infectie. Hij stierf aan de gevolgen van een longontsteking.
Vader & zoon: Guillaume mocht geregeld mee naar de set en figureerde in films als *Pas si méchant que ça* en *Jean de Florette*. Hij speelde de jongere versie van zijn vaders personage Marin Marais in *Tous les matins du monde*. • De relatie tussen vader en zoon was sterk getroubleerd.
De familie Depardieu: Moeder Élisabeth en dochter Julie Depardieu zijn ook actrices.

> "Mon enfance a été pauvre mais gaie, et puis nous sommes devenus riches et tous les ennuis inhérents à la célébrité de mon père ont commencé."
>
> Guillaume Depardieu

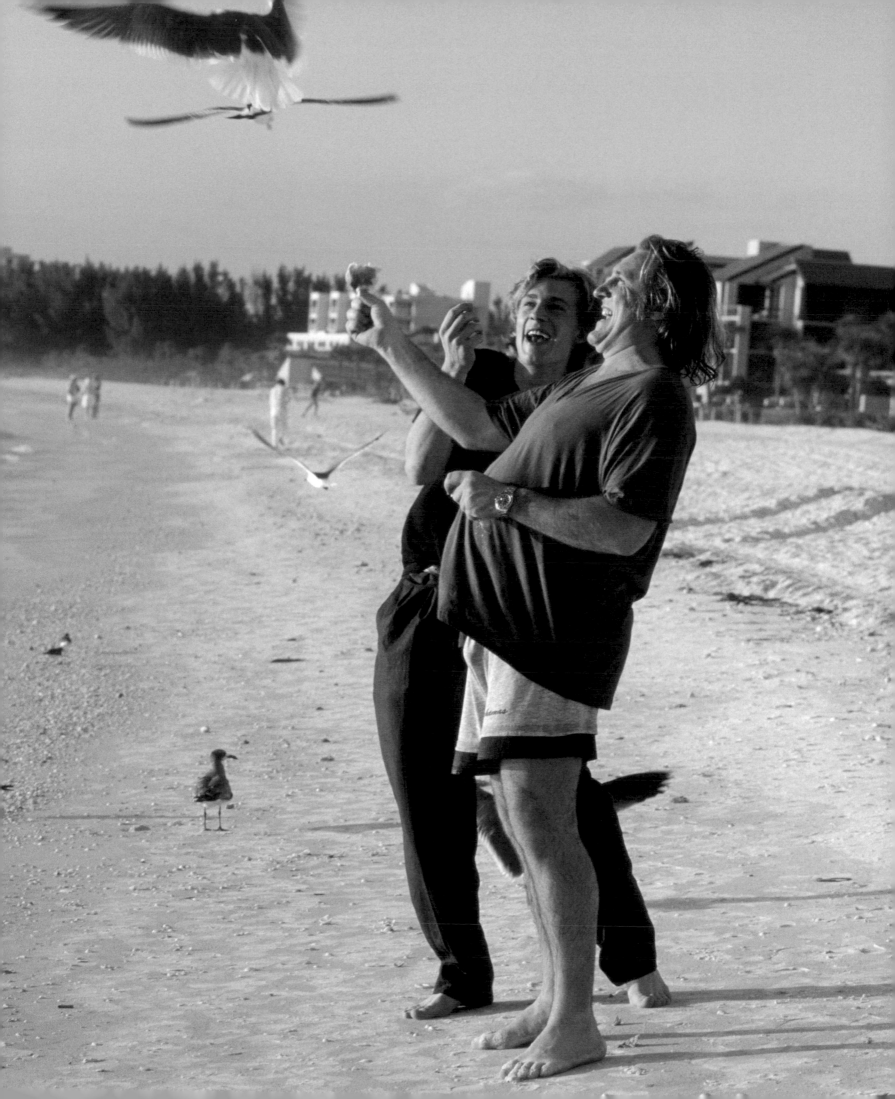

Vittorio & Christian
De Sica

Vittorio Domenico Stanislao Gaetano Sorano De Sica (7 July 1901 - 13 November 1974, Italy) was an Italian director, actor and a leading figure in the Italian neorealist movement. He had a typical, minimalistic style, which he applied to bring attention to the social problems that ran rampant in Italy after WWII. He received much attention with his film *Ladri di biciclette*, helped Sophia Loren win an Oscar for best actress in *La Ciociara* (the first film that was not in English to win the award) and he received two Oscars himself for *Ieri, oggi, domani* and *Il Giardino dei Finzi-Contini*.

Christian De Sica (5 January 1951, Italy) participated in the Sanremo Festival in 1973 but was more successful as a comedian and entertainer in variety programmes. Moving on to the film industry, he worked his way up to become one of the most famous actors in 'cinepanettoni'-films (typical Italian humorous Christmas films). He later worked as a character actor, screenwriter and director, which resulted in winning three David di Donatello and two Nastri d'Argento film prizes.

Father & son: Christian paid homage to his father in 1991 when he directed a remake of the film *Il Conte Max*, in which his father had played an important role in 1957.

Vittorio Domenico Stanislao Gaetano Sorano De Sica (7 juillet 1901 - 13 novembre 1974, Italie) est un metteur en scène et acteur emblématique du néoréalisme italien. Il exploitait un style typique et minimaliste pour aborder les problèmes sociaux de l'Italie d'après-guerre. Il s'est fait remarquer avec *Le Voleur de bicyclette* et fit la gloire de Sophia Loren, la première comédienne non anglaise à avoir reçu un Oscar de la meilleure actrice, pour son rôle dans *La Paysanne aux pieds nus*. Il a remporté deux Oscars du meilleur film en langue étrangère, pour *Hier, aujourd'hui et demain* et *Le Jardin des Finzi-Contini*.

Christian De Sica (5 janvier 1951, Italie) a participé au Festival de San Remo en 1973, mais connaît ses premiers succès comme comique et humoriste dans des programmes de variété. Au cinéma, il reste l'un des acteurs les plus connus du "*Cinema Panettone*" (films comiques typiquement italiens sortant à la période de Noël), bien qu'il soit devenu un acteur de composition, scénariste et metteur en scène. Il a d'ailleurs reçu trois David di Donatello et deux Nastri d'Argento.

Père & fils : Christian rendit hommage à son père en 1991 en réalisant un remake du film *Il Conte Max*, dans lequel son père avait tenu un grand rôle en 1957.

Vittorio Domenico Stanislao Gaetano Sorano De Sica (7 juli 1901 - 13 november 1974, Italië) was als regisseur en acteur een boegbeeld van het Italiaanse neorealisme. Hij had een typische, minimalistische stijl die hij aanwendde om de sociale problemen aan te kaarten die welig tierden in het naoorlogse Italië. Hij deed zich opmerken met *Ladri di biciclette*, bezorgde Sophia Loren als eerste niet-Engelstalige een Oscar voor beste vrouwelijke hoofdrol met *La Ciociara*, en rijfde zelf twee Oscars binnen voor *Ieri, oggi, domani* en *Il Giardino dei Finzi-Contini*.

Christian De Sica (5 januari 1951, Italië) nam in 1973 deel aan het Sanremo Festival maar oogstte zijn eerste successen als komiek en entertainer in variétéprogramma's. In de filmwereld groeide hij uit tot een van de bekendste vertolkers van 'cinepanettoni'-films (typisch Italiaanse komische kerstfilms), hoewel hij later ook aan de slag ging als karakteracteur, scenarioschrijver en regisseur. Dit leverde hem in totaal drie David di Donatello- en twee Nastri d'Argento-filmprijzen op.

Vader & zoon: Christian bracht in 1991 hulde aan zijn vader door een remake te regisseren van de film *Il Conte Max*, waarin zijn vader in '57 een belangrijke rol vertolkte.

> "My father is a master artist,
> I am a Sunday painter."
> Christian De Sica

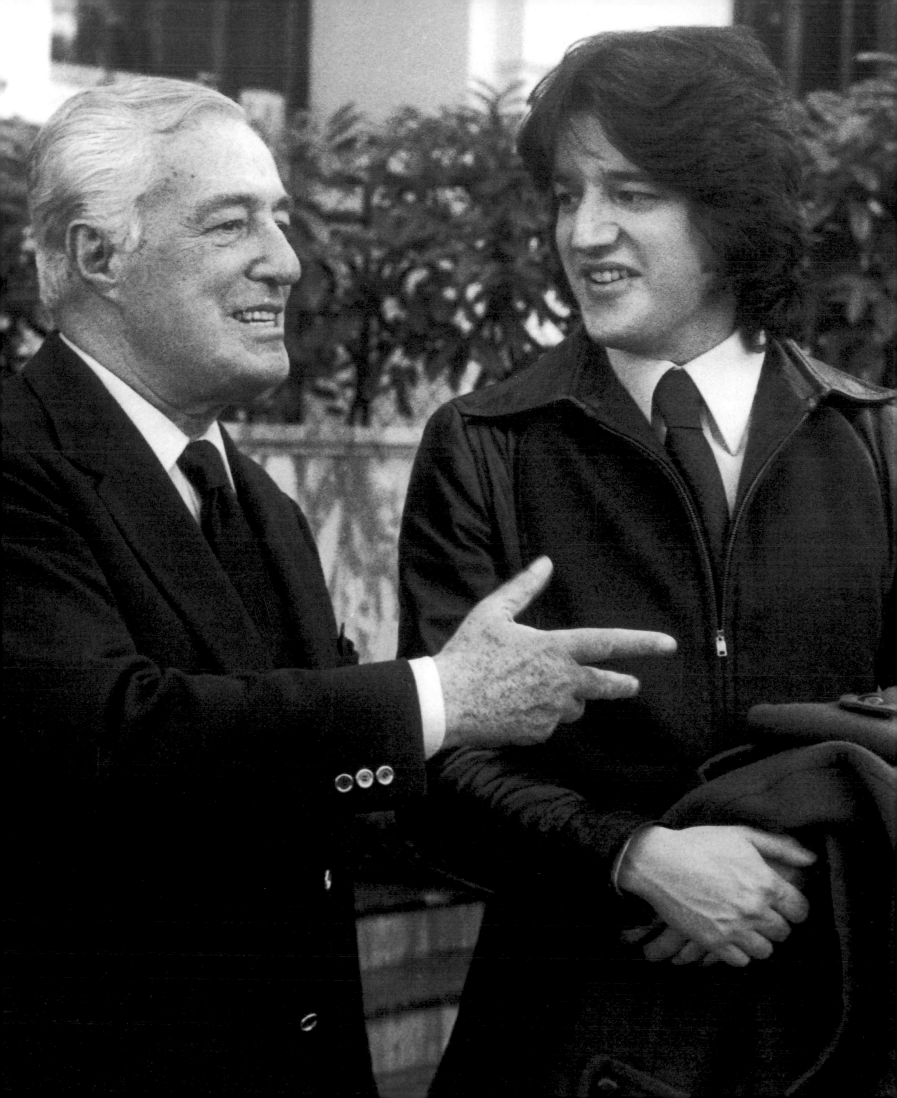

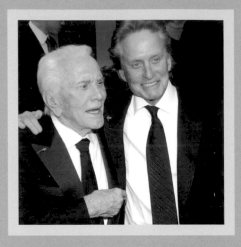

Kirk & Michael
Douglas

Issur Danielovitch Demsky (9 December 1916, USA) grew up in the 50s and 60s as Kirk Douglas and became an international star due to his leading roles in over 85 productions with such box office successes as *Gunfight at the O.K. Corral*, *20.000 Leagues under the Sea* and *Spartacus*.

Michael Kirk Douglas (25 September 1944, USA) appeared in *The Streets of San Francisco* for four consecutive years and then went on to produce the Acadamy Award-winning film *One Flew Over the Cuckoo's Nest*. As a result of his roles in *The Jewel of the Nile*, *Fatal Attraction*, *Basic Instinct* and *Wall Street*, he became a world famous actor.

Father & son: Michael inherited the dimple in his chin and his bright blue eyes from his father. • He became familiar with the world of film when visiting his father on the set of *Lonely Are the Brave* and worked for him as assistant director in the 60s for several of his films. • Initially, Michael portrayed mainly soft characters to avoid being compared with Kirk.

The Douglas family: Michael's brother Joel is a film producer and his mother Diane Dill was an actress. He married actress Catherine Zeta-Jones. • In *It Runs in the Family* Kirk, Diana Dill, Michael and his son Cameron portray respectively grandfather, grandmother, father and son.

Issur Danielovitch Demsky (9 décembre 1916, États-Unis), alias Kirk Douglas, est devenu une star mondiale du 7ᵉ art dans les années 50 et 60, grâce à des premiers rôles dans plus de 85 productions, dont les célèbres *Règlement de compte à O.K. Corral*, *Vingt Mille Lieues sous les mers* et *Spartacus*.

Michael Kirk Douglas (25 septembre 1944, États-Unis) a joué quatre ans dans la série "Les Rues de San Francisco" avant de produire le film oscarisé *Vol au-dessus d'un nid de coucou*. Il a ensuite connu un succès planétaire en tant qu'acteur avec *Le Diamant du Nil*, *Liaison fatale*, *Basic Instinct* ou *Wall Street*.

Père & fils : Michael a hérité de la fossette au menton et des yeux bleu acier de son père. • Il découvre le cinéma aux côtés de Kirk sur le tournage de *Seuls sont les indomptés* et travaillera même comme assistant réalisateur. • Michael a d'abord interprété des personnages plutôt loufoques, évitant ainsi toute comparaison avec son père.

La famille Douglas : Le frère de Michael est producteur et sa mère, Diana Dill, était actrice. Il a épousé Catherine Zeta-Jones, elle-même comédienne. • Dans *Une si belle famille*, Kirk, Diana Dill, Michael et son fils Cameron interprètent les rôles de grand-père, grand-mère, père et fils.

Issur Danielovitch Demsky (9 december 1916, VSA) groeide in de jaren 50 en 60 als Kirk Douglas uit tot een internationale ster dankzij hoofdrollen in meer dan 85 producties, waaronder kaskrakers zoals *Gunfight at the O.K. Corral*, *20.000 Leagues under the Sea* en *Spartacus*.

Michael Kirk Douglas (25 september 1944, VSA) speelde vier jaar mee in *The Streets of San Francisco* om daarna de oscarwinnende film *One Flew Over the Cuckoo's Nest* te produceren. Dankzij rollen in prenten als *The Jewel of the Nile*, *Fatal Attraction*, *Basic Instinct* en *Wall Street* werd hij een wereldster.

Vader & zoon: Michael erfde het kuiltje in zijn kin en de staalblauwe kijkers van zijn vader. • Hij leerde de filmwereld kennen op de set van zijn vaders film *Lonely Are the Brave* en werkte in de jaren 60 als assistent-regisseur voor enkele van diens films. • Michael vertolkte aanvankelijk vooral halfzachte personages om de vergelijking met Kirk uit de weg te gaan.

De familie Douglas: Michaels broer Joel is filmproducent en zijn moeder Diane Dill was actrice. Hij trouwde met actrice Catherine Zeta-Jones. • In *It Runs in the Family* spelen Kirk, Diana Dill, Michael en zijn zoon Cameron respectievelijk grootvader en -moeder, vader en zoon.

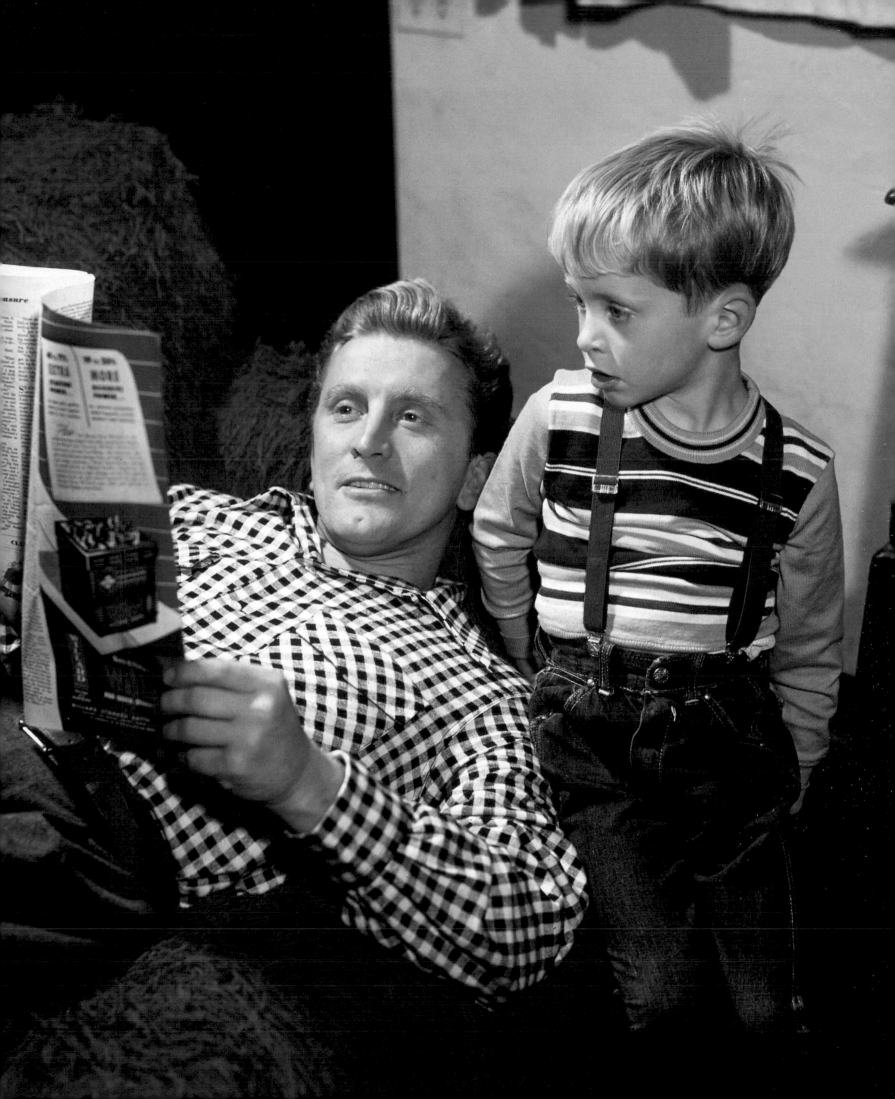

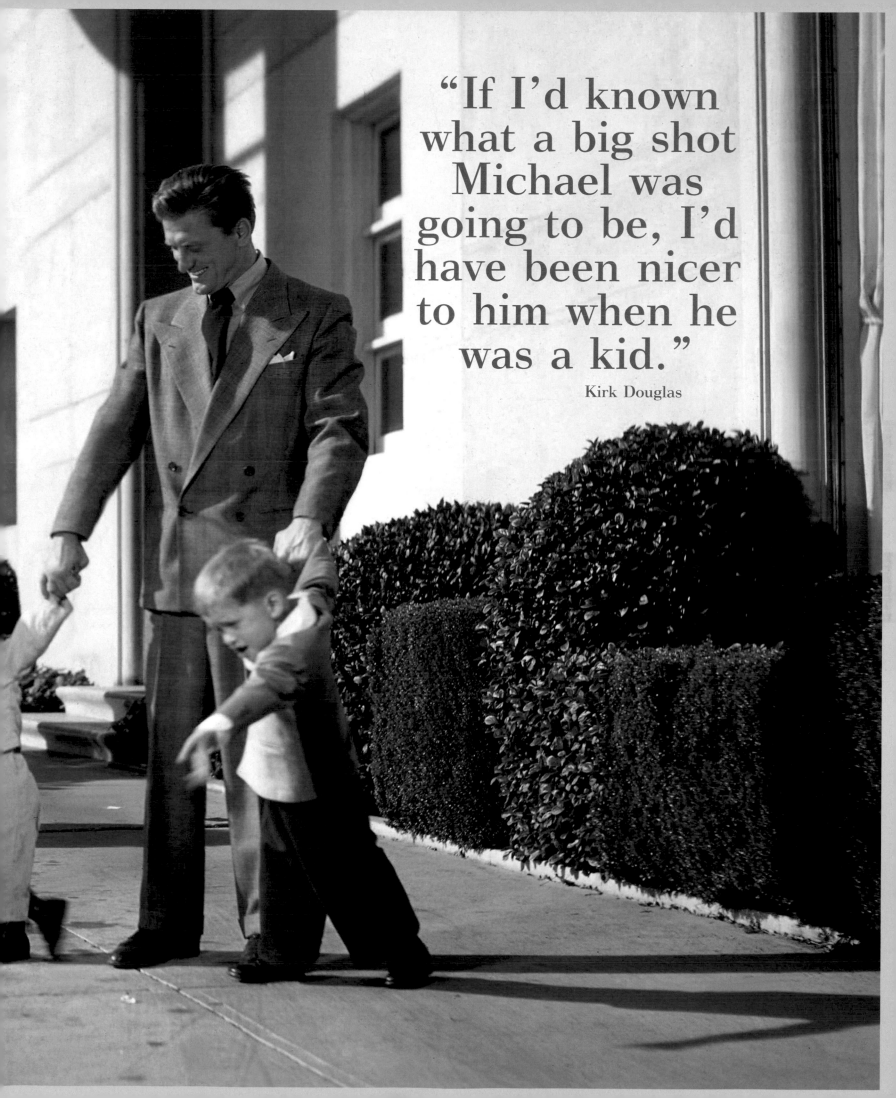

"If I'd known what a big shot Michael was going to be, I'd have been nicer to him when he was a kid."

Kirk Douglas

Willem & Willem Jr.
Drees

Willem Drees (5 July 1886 - 14 May 1988, Netherlands) is generally looked upon as one of the most important post-war Dutch politicians. As Prime Minister from 1948 to 1958, he initialised several social laws and witnessed developments such as the decolonisation of Dutch India and the post-war reconstruction of the Netherlands. He member was popular across the political party borders and was nicknamed Little Father Drees.
Willem Drees Jr. (24 December 1922 - 5 September 1998, Netherlands) left the PvdA in the beginning of the 70s because of the influence of New Left and founded the Democratic Socialists '70 (DS'70) together with some supporters. As head of the DS'70, he played a brief important role in Dutch politics and later as minister of Transport.
Father & son: Father Drees left the PvdA after the establishment of the DS'70 as well. He did not join his son's new party but did give it his vote.
• In the middle of the 70s Drees started to leave out the Jr. suffix of his name. From then onwards his father called himself W. Drees Sr.
The Drees family: Willem Jr.'s brother Jan also joined the DS'70 and daughter Marijke Drees is currently politically active in the PvdA.

Willem Drees (5 juillet 1886 - 14 mai 1988, Pays-Bas) est considéré comme l'un des principaux hommes d'État néerlandais de l'après-guerre. Premier ministre de 1948 à 1958, il initia plusieurs lois sociales, se chargea de la décolonisation des Indes néerlandaises et de la reconstruction des Pays-Bas. Le "petit père Drees", social-démocrate (PvdA), était d'ailleurs populaire bien au-delà de sa famille politique.
Willem Drees Jr. (24 décembre 1922 - 5 septembre 1998, Pays-Bas) quitta le PvdA au début des années 70 pour protester contre l'influence de la nouvelle gauche ; il fondit une dissidence de droite, les Démocrates-socialistes 70 (DS'70), et joua un rôle important dans la politique néerlandaise en tant que leader du DS'70 et Ministre des transports, des travaux publics et de la gestion de l'eau.
Père & fils : Après la création du DS'70, Willem Drees quitta également le PvdA. S'il n'adhéra pas au parti de son fils, il lui apporta néanmoins sa caution. • Dès le milieu des années 70, Drees abandonna le suffixe "junior" ; son père s'appelait désormais W. Drees Sr.
La famille Drees : Le frère de Willem Jr., Jan, a également rejoint le DS'70 ; sa fille Marijke Drees milite actuellement pour le PvdA.

Willem Drees (5 juli 1886 - 14 mei 1988, Nederland) wordt door velen aanzien als een van de belangrijkste naoorlogse Nederlandse politici. Als minister-president van 1948 tot 1958 initieerde hij verscheidene sociale wetten en kreeg hij te maken met de dekolonisatie van Nederlands-Indië en de naoorlogse wederopbouw van Nederland. De PvdA'er was populair over partijpolitieke grenzen heen en kreeg de bijnaam Vadertje Drees.
Willem Drees Jr. (24 december 1922 - 5 september 1998, Nederland) verliet de PvdA begin jaren 70 uit onvrede over de invloed van Nieuw Links en stichtte samen met een aantal medestanders de Democratisch Socialisten '70 (DS'70). Hij speelde gedurende een korte tijd een rol van betekenis in de Nederlandse politiek als leider van DS'70 en minister van Verkeer en Waterstaat.
Vader & zoon: Na de oprichting van DS'70 brak ook vader Drees met de PvdA. Hij werd geen lid van zijn zoons nieuwe partij, maar stemde er wel voor. • Vanaf het midden van de jaren 70 liet zoon Drees bewust het achtervoegsel 'junior' weg. Zijn vader noemde zich vanaf toen W. Drees Sr.
De familie Drees: Willem Juniors broer Jan maakte mee de overstap naar DS'70, en dochter Marijke Drees is momenteel politiek actief voor de PvdA.

Hans & Candy
Dulfer

Hans Dulfer (28 May 1940, Netherlands) is one of the most striking musicians in the Dutch jazz scene. The tenor saxophone player has played in dozens of bands since 1957, besides working as a car salesman, director of the concert hall Paradiso, columnist and radio presenter. His international breakthrough album *Big Boy* was a mixture of jazz, house beats, live sax, contrabass and rap.

Candy Dulfer (19 September 1969, Netherlands) started out at the age of fourteen with her band Funky Stuff that performed as the opening act for Madonna in 1987. After collaborating with Prince, she broke through internationally two years later thanks to the song *Lily was here* with Eurythmics musician Dave Stewart. Her debut album was released in 1990 and sold over a million copies. She went on to release albums regularly and perform with artists like Van Morrison and Aretha Franklin.

Father & daughter: Her father named her after Candy Finch, the drummer of Dizzy Gillespie. • Candy was six years old when she first picked up the saxophone and started her career by joining her father on stage. At the age of eleven she made her first recordings with her father. • In 2002 they brought out the double album *Dulfer/Dulfer*.

Hans Dulfer (28 mai 1940, Pays-Bas) est l'une des figures les plus marquantes de la scène jazz néerlandaise. Dès 1957, il joue comme saxophoniste ténor dans des dizaines de groupes, tout en travaillant comme vendeur de voitures, directeur de la salle de concert Paradiso, éditorialiste et animateur radio. L'album *Big Boy*, à l'origine de sa consécration internationale, est un mélange de jazz, house beats, live sax, contrebasse et rap.

Candy Dulfer (19 septembre 1969, Pays-Bas) débute sa carrière musicale à l'âge de quatorze ans avec son groupe *Funky Stuff* et fait la première partie de Madonna en 1987. Après avoir collaboré avec Prince, le morceau "*Lily Was Here*" (avec le musicien d'Eurythmics, Dave Stewart) la propulse sur le devant de la scène internationale. En 1990, elle sort son premier album, qui s'écoule à plus d'un million d'exemplaires. D'autres albums suivront et Candy se produira notamment aux côtés de Van Morrison et d'Aretha Franklin.

Père & fille : Hans a appelé sa fille Candy en hommage à Candy Finch, le batteur du band de Dizzy Gillespie. • Candy commence le saxophone à 6 ans et se produit très tôt sur scène aux côtés de son père. À l'âge de 11 ans, elle fait son premier enregistrement avec lui. • En 2002, ils publièrent un album de duos intitulé *Dulfer/Dulfer*.

Hans Dulfer (28 mei 1940, Nederland) is een van de meest opvallende figuren uit de Nederlandse jazzscene. Vanaf 1957 speelde hij als tenorsaxofonist mee in tientallen bands, in combinatie met jobs als autoverkoper, directeur van concertzaal Paradiso, columnist en radiopresentator. Op zijn internationale doorbraakalbum *Big Boy* pakte hij uit met een mix van jazz, housebeats, live sax, contrabas en rap.

Candy Dulfer (19 september 1969, Nederland) begon op haar veertiende met haar band Funky Stuff en stond er in '87 mee in het voorprogramma van Madonna. Na een samenwerking met Prince brak ze twee jaar later internationaal door dankzij het nummer *Lily was here* met Eurythmics muzikant Dave Stewart. In '90 volgde haar debuutalbum, dat wereldwijd ruim een miljoen keer over de toonbank ging. Daarna bracht ze geregeld albums uit en trad ze op met onder meer Van Morrison en Aretha Franklin.

Vader & dochter: Haar vader vernoemde haar naar Candy Finch, de drummer van Dizzy Gillespie. • Candy was zes toen ze voor het eerst een saxofoon vastpakte en begon haar carrière met haar vader op het podium. Op haar elfde maakte ze haar eerste opname met hem. • In 2002 brachten ze het duo-album *Dulfer/Dulfer* uit.

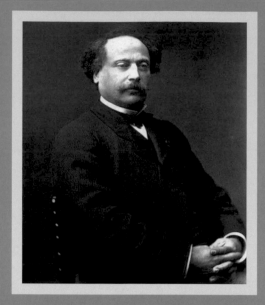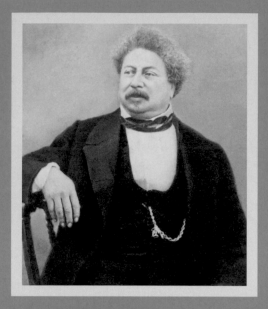

Alexandre & Alexandre
Dumas

Alexandre Davy de La Pailleterie Dumas (24 July 1802 - 5 December 1870, France) wrote historical adventure novels, which have made him one of the most widely read French authors in the world. Many of his books, including *Les Trois Mousquetaires*, *Le Comte de Monte-Cristo*, *La Reine Margot* and *La Tulipe Noire*, were initially published in newspapers as series and were then repeatedly turned into films. He also wrote theater scripts, magazine articles and letters.
Alexandre Dumas fils (27 July 1824 - 27 November 1895, France), like his father, was a famous French author. His most famous pieces of work were *Le Fils naturel*, *Un Père prodigue* and *La Dame aux Camélias*, which was later turned into film several times and inspired Verdi to compose the opera *La Traviata*.
Father & son: Dumas 'fils' grew up as an illegitimate child in a home, but was recognised legally by his parents at the age of seven and subsequently separated from his mother again by his father, something that he would never forgive him for.

Alexandre Davy de La Pailleterie Dumas (24 juillet 1802 - 5 décembre 1870, France) est l'auteur de célèbres romans d'aventures qui ont fait de lui l'un des écrivains français les plus lus à travers le monde. Nombre de ses livres, tels que *Les Trois Mousquetaires*, *Le Comte de Monte-Cristo*, *La Reine Margot* et *La Tulipe Noire*, ont d'abord été publiés dans un journal sous forme d'épisodes avant d'être maintes fois adaptés au cinéma. Il a également écrit des pièces de théâtre, des articles et une riche correspondance.
Alexandre Dumas fils (27 juillet 1824 - 27 novembre 1895, France) est, à l'instar de son père, un écrivain français à grand succès dont les principales œuvres (*Le Fils naturel*, *Un Père prodigue* et *La Dame aux Camélias*) ont été adaptées pour le grand écran. *La Dame aux Camélias* a d'ailleurs inspiré à Verdi son célèbre opéra "*La Traviata*".
Père & fils : Dumas "fils", déclaré enfant naturel, grandit dans un orphelinat avant d'être reconnu par ses parents à l'âge de 7 ans. Il fut ensuite brutalement séparé de sa mère par son père, ce qu'il ne lui pardonna jamais.

Alexandre Davy de La Pailleterie Dumas (24 juli 1802 - 5 december 1870, Frankrijk) schreef historische avonturenromans die van hem een van de meest gelezen Franse auteurs ter wereld maakten. Veel van zijn boeken, zoals *Les Trois Mousquetaires*, *Le Comte de Monte-Cristo*, *La Reine Margot* en *La Tulipe Noire*, werden aanvankelijk in de krant gepubliceerd als reeksen en zijn uiteindelijk meermaals verfilmd geworden. Hij schreef ook toneelstukken, tijdschriftartikels en brieven.
Alexandre Dumas fils (27 juli 1824 - 27 november 1895, Frankrijk) was net zoals zijn vader een beroemd Frans auteur, met als bekendste werken *Le Fils naturel*, *Un Père prodigue* en *La Dame aux Camélias*, dat later meermaals verfilmd werd en Verdi inspireerde tot het creëren van de opera *La Traviata*.
Vader & zoon: Dumas 'fils' groeide op als een onwettig kind in een tehuis, maar werd op zijn zevende door zijn ouders erkend en vervolgens op traumatische wijze weer door zijn vader van zijn moeder gescheiden, iets wat hij hem nooit zou vergeven.

"Et les fautes des pères retomberont
sur les enfants jusqu'à
la troisième et la
quatrième générations."

Alexandre Dumas père
(*Le Capitaine Paul*, 1838)

Jacques & Thomas
Dutronc

Jacques Dutronc (28 April 1943, France) is a singer, composer, guitarist and actor who has become a living legend in the French-speaking world. He wrote many hits for his wife Françoise Hardy and simultaneously worked on developing a successful solo career with such hits as *Il est cinq heures, Paris s'éveille* and *J'aime les filles*. In 1973 he got into the acting business and appeared in 39 films. He received a César award for Best Actor for this role in *Van Gogh*.

Thomas Dutronc (16 June 1973, France) was destined to follow in his parents' footsteps as the only son of two French cultural icons. He appeared in several films, composed soundtracks and has recently started singing. After having played in jazz bands like Gipsy Project and A.J.T. Guitar Trio, he released his first solo album *Comme un Manouche sans Guitare* in 2007.

Father & son: Thomas looks a lot like his father and judging from his performances, he has also inherited his nonchalance and sense of humour. • He regularly writes music together with his father, as they did for the song *A Part ça*. • It was Thomas who encouraged his father, after 15 years of absence, to start performing again in 2010.

Jacques Dutronc (28 avril 1943, France) est, en tant que chanteur, parolier, guitariste, compositeur et acteur, une légende vivante de la scène française. Il a écrit de nombreux tubes pour son épouse Françoise Hardy et a mené une belle carrière solo parsemée de succès, tels que *"Il est cinq heures, Paris s'éveille"* et *"J'aime les filles"*. Dès 1973, il entame une carrière d'acteur. Il jouera dans une quarantaine de films et remportera en 1992 le César du meilleur acteur pour son interprétation de *Van Gogh*.

Thomas Dutronc (16 juin 1973, France), fils unique de deux icônes de la chanson française, ne pouvait qu'embrasser une carrière artistique. Il a fait quelques apparitions au cinéma, composé des musiques de films et entrepris une carrière de chanteur en 2006. Après avoir joué dans les groupes de jazz *Gipsy Project* et *A.J.T. Guitar Trio*, il a sorti son premier album solo en 2007, intitulé *Comme un manouche sans guitare*.

Père & fils : La ressemblance entre Thomas et son père est frappante. Sur scène, il affiche la même nonchalance et semble avoir hérité du sens de l'humour de Jacques. • Il coécrit régulièrement des chansons pour son père, comme *"À Part ça"*. • Thomas a encouragé son père à remonter sur scène en 2010 après 15 ans d'absence.

Jacques Dutronc (28 april 1943, Frankrijk) is als zanger, liedjesschrijver, gitarist, componist en acteur een levende legende in gebieden waar Frans de voertaal is. Hij schreef tal van hits voor zijn latere vrouw Françoise Hardy en bouwde tegelijkertijd een succesvolle solocarrière uit met als grootste hits *Il est cinq heures, Paris s'éveille* en *J'aime les filles*. Vanaf 1973 begon hij ook te acteren, met 39 films en een César voor Beste Acteur voor *Van Gogh* tot gevolg.

Thomas Dutronc (16 juni 1973, Frankrijk) rolde vrijwel vanzelfsprekend in het vak als enige zoon van twee iconen van het Franse chanson. Hij speelde in enkele films, componeerde soundtracks en is sinds kort ook zanger. Na een poos in jazzgroepen als Gipsy Project en A.J.T. Guitar Trio te hebben doorgebracht, maakte hij in 2007 een eerste solo-cd, *Comme un Manouche sans Guitare*.

Vader & zoon: Thomas lijkt sterk op zijn vader en uit zijn optredens blijkt dat hij ook diens nonchalance en gevoel voor humor geërfd heeft. • Hij schrijft geregeld mee aan liedjes van zijn vader, zoals *A Part ça*. • Het was Thomas die zijn vader er in 2010 toe aanzette om na 15 jaar afwezigheid opnieuw te beginnen optreden.

> ## "Thomas, c'est le meilleur duo que j'ai fait avec Françoise."
> Jacques Dutronc

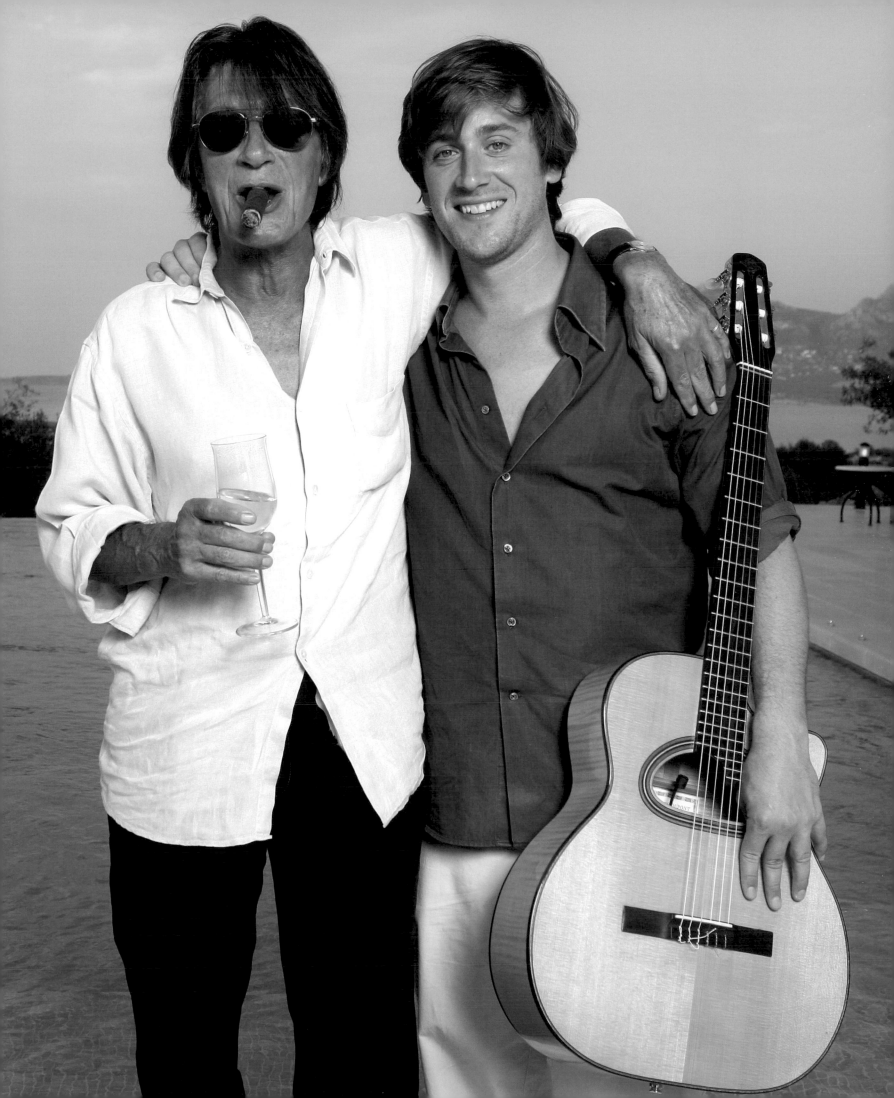

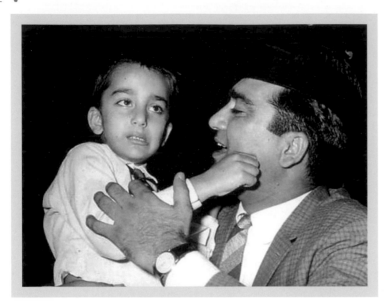

Sunil & Sanjay
Dutt

Sunil Balraj Dutt (6 June 1929 - 25 May 2005, India) became one of the most widely celebrated Bollywood stars ever due his roles in over 100 films. After his film career, he went into politics, served as a member of congress for five terms and eventually held a ministerial post.
Sanjay Dutt (29 July 1959, India) rose to fame in 1993 due his role in *Khal Nayak*. In 1999, he received just about every award available in the Bombay film industry for his role in the film *Vaastav: The Reality*. To date, he has appeared in over 130 films and is in charge of a small production company. Despite his troublesome private life (including a drug addiction, the death of his first wife, a bitter custody fight for his child and being arrested on suspicion of terrorism), his popularity has never diminished.
Father & son: Sanjay was twelve years old when he played his first role in *Reshma Aur Shera*, which his father directed. He made his actual film debut in 1981 in *Rocky*. • In 2008 Sanjay wanted to follow in his father's political footsteps. After his conviction, he chose to work behind the scenes instead.
The Dutt family: Sanjay's mother Nargis was widely regarded as *the first lady* of Hindi cinema.

Sunil Balraj Dutt (6 juin 1929 - 25 mai 2005, Inde) fut l'une des plus grandes stars du cinéma bollywoodien. Il s'est illustré dans plus de 100 films et a également travaillé comme producteur et réalisateur. Au terme d'une carrière bien remplie, il s'est lancé dans la politique, enchaînant cinq mandats parlementaires et un poste ministériel.
Sanjay Dutt (29 juillet 1959, Inde) a été révélé en 1993 avec le film *Khal Nayak*. Avec *Vaastav: The Reality* (1999), il rafle pratiquement toutes les récompenses de l'industrie bollywoodienne. Son palmarès compte désormais 130 films et il est à la tête d'une société de production. Ses difficultés privées – son addiction à la drogue, le décès de sa première épouse, un combat difficile pour la garde de son enfant et une arrestation pour suspicion de terrorisme – n'ont jamais entaché sa popularité.
Père & fils : Sanjay apparaît pour la première fois au cinéma dans *Reshma Aur Shera*, film réalisé par son père. Il débute officiellement en 1981 dans *Rocky*. • En 2008, Sanjay souhaitait suivre son père en politique ; mais après sa condamnation, il préféra s'en abstenir.
La famille Dutt : La mère de Sanjay, Nargis, était considérée comme la *First Lady* du cinéma indien.

Sunil Balraj Dutt (6 juni 1929 - 25 mei 2005, India) was dankzij rollen in ruim 100 films en het nodige produceer- en regisseerwerk een van de meest gevierde Bollywoodsterren aller tijden. Op het einde van zijn filmcarrière ging hij in de politiek, met vijf termijnen als congreslid en een ministerpost tot gevolg.
Sanjay Dutt (29 juli 1959, India) brak in 1993 door dankzij zijn rol in *Khal Nayak*. Voor *Vaastav: The Reality* uit 1999 sleepte hij vrijwel alle mogelijke prijzen in de wacht die in de Bombayse filmindustrie te behalen zijn. Intussen heeft hij 130 films op zijn palmares en leidt hij een productiebedrijfje. Zijn privémoeilijkheden - waaronder een drugverslaving, de dood van zijn eerste vrouw, een bittere voogdijstrijd om zijn kind en een arrestatie op verdenking van terrorisme - hebben zijn popularen nooit geschaad.
Vader-zoon: Sanjay trad op zijn twaalfde voor het eerst aan in *Reshma Aur Shera*, waarvan zijn vader regisseur was. Hij maakte zijn eigenlijke debuut in 1981 in diens film *Rocky*. • In 2008 wilde Sanjay zijn vader opvolgen in de politiek, maar na zijn veroordeling opteerde hij voor een functie achter de schermen.
De familie Dutt: Sanjays moeder was Nargis, de first lady van de Indiase film.

"Come mothers and fathers
throughout the land
And don't criticize what
you can't understand
Your sons and your daughters
are beyond your command
Your old road is rapidly agin'.
Please get out of the new one
if you can't lend your hand
For the times they
are a-changin'."

From *"The Times they are a-changin"* by Bob Dylan

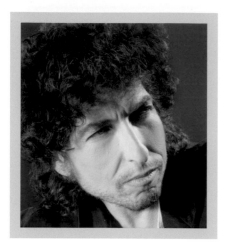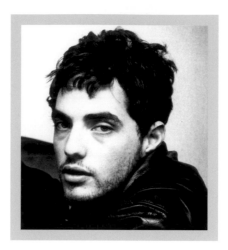

Bob & Jakob
Dylan

Robert Allen Zimmerman (24 May 1941, USA), better known as Bob Dylan, is considered one of the greatest and most influential American singer-songwriters ever. Spanning over 6 decades, his career skyrocketed in the 60s due to socially and politically driven songs like *Blowin' in the Wind* and *The Times they are a-Changin'*. He is the first rock star to have received the Pulitzer Prize.

Jakob Luke Dylan (9 December 1969, USA) started out his career as the singer of The Wallflowers, which came to fame in 1996 with their album *Bringing Down the Horse*. Since 2007 he has continued to follow in his father's footsteps by focusing on pursuing a solo career as a singer and songwriter, which has resulted in such albums as *Seeing Things* and *Women + Country*.

Father & son: Jakob was reportedly the inspiration for Bob's hit *Forever Young*. • The resemblance between their work is especially noticeable in Jacob's solo work with their vocal timbre, style of music (acoustic blues/folk/country) and choice of subject-matter (e.g. *War is Kind*) being strikingly similar.

The Dylan family: Jakob's brother Jesse is the founder of Freeform, a socially engaged production company that has produced work like the award-winning music video *Yes We Can* for Barack Obama's election campaign.

Robert Allen Zimmerman (24 mai 1941, États-Unis), alias Bob Dylan, est l'un des auteurs-compositeurs-interprètes majeurs de la musique populaire américaine. Sa carrière, qui couvre plus de six décennies, a été lancée dans les années 60 grâce à des chansons engagées comme "*Blowin' in the Wind*" et "*The Times They Are a-Changin'*". Il est le premier artiste de rock à avoir obtenu le prix Pulitzer.

Jakob Luke Dylan (9 décembre 1969, États-Unis) débute sa carrière musicale avec le groupe *The Wallflowers*, qui connaît un beau succès en 1996 avec l'album *Bringing Down the Horse*. Depuis 2007, il suit davantage la voie paternelle en s'orientant vers une carrière solo de chanteur et de parolier, avec notamment les albums *Seeing Things* et *Women + Country*.

Père & fils : Jakob aurait inspiré à Bob le tube "*Forever Young*". • La ressemblance entre Jakob et son père est frappante, tant au niveau du timbre de voix que du style musical (blues/ folk/ country acoustique) et du choix des thèmes.

La famille Dylan : Le frère de Jakob, Jesse, est le fondateur de Freeform, une société de production socialement engagée qui a notamment réalisé le célèbre clip "*Yes We Can*" pour la campagne électorale de Barack Obama.

Robert Allen Zimmerman (24 mei 1941, VSA) ofte Bob Dylan wordt beschouwd als een van de grootste en meest invloedrijke Amerikaanse singer-songwriters ooit. Zijn carrière, die meer dan 6 decennia overspant, nam in de jaren 60 een hoge vlucht dankzij sociaal-politiek gedreven nummers als *Blowin' in the Wind* en *The Times they are a-Changin'*. Hij is de eerste rockartiest die een Pulitzerprijs ontving.

Jakob Luke Dylan (9 december 1969, VSA) begon zijn muzikale carrière als zanger van The Wallflowers, die in '96 het nodige succes kenden dankzij het album *Bringing Down the Horse*. Sinds 2007 treedt hij nog meer in zijn vaders voetsporen door zich te richten op een solocarrière als zanger en liedjesschrijver, met albums als *Seeing Things* en *Women + Country* tot gevolg.

Vader & zoon: Jakob vormde naar verluidt de inspiratie voor Bobs hit *Forever Young*. • Vooral in Jakobs solowerk is de gelijkenis met zijn vader treffend, niet alleen qua stemtimbre, maar ook qua muziekstijl (akoestische blues/folk/country) en keuze van onderwerpen (bv. *War is Kind*).

De familie Dylan: Jakobs broer Jesse is de stichter van Freeform, een sociaal geëngageerde productiemaatschappij die onder meer de gelauwerde *Yes We Can*-muziekclip afleverde voor Barack Obama's verkiezingscampagne.

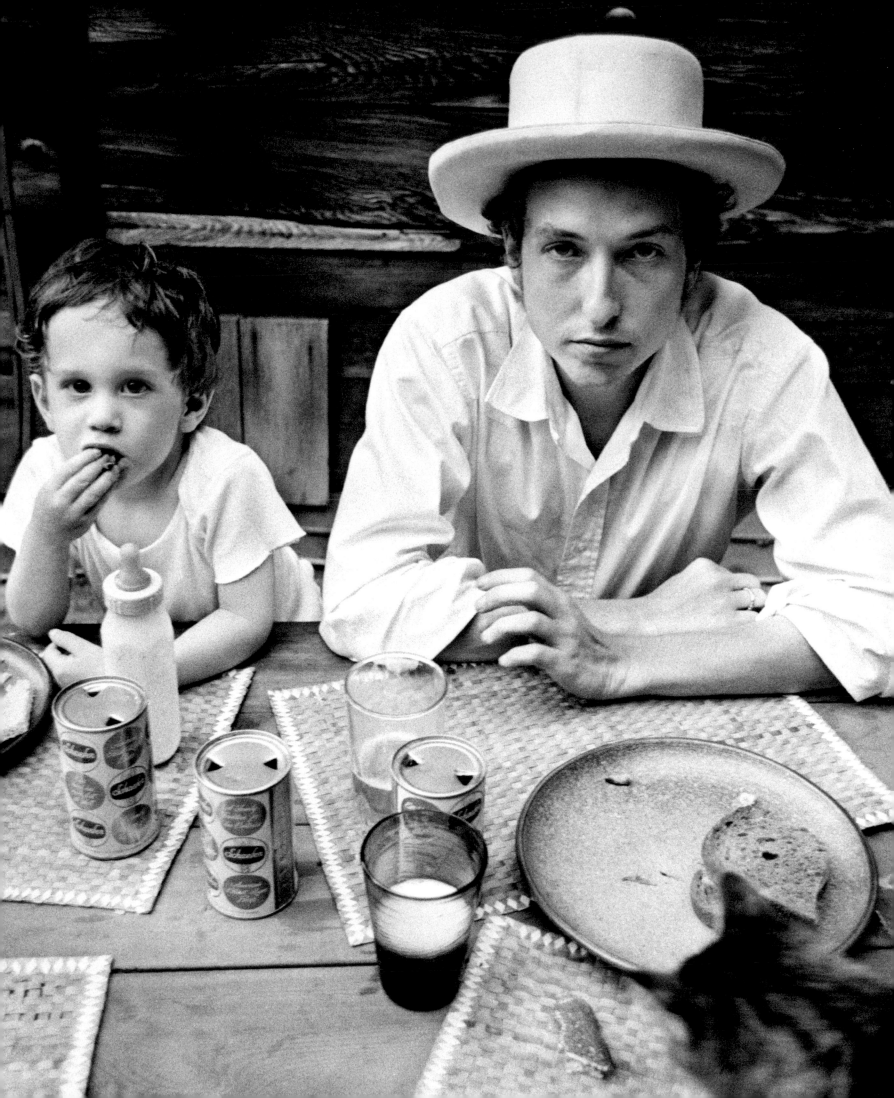

Ralph, Dale Sr. & Dale Jr.
Earnhardt

Ralph Lee Earnhardt (23 February 1928 - 26 September 1973, USA) was a NASCAR racing legend and an innovator in car construction and tuning. In a career that lasted 23 years, he won over 350 races and held the lap record on more than 7 tracks.
Ralph Dale Sr. Earnhardt (29 April 1951 - 18 February 2001, USA) was one of the most popular NASCAR drivers ever. He won 76 races in the Winston Cup and won the title seven times.
Ralph Dale Jr. Earnhardt (10 October 1974, USA) won the championship of the second highest NASCAR series twice and then transferred to the highest class. He won the most important race, the Daytona 500, in 2004 and won de Talledaga Superspeedway five times.
Father, son & grandson: Ralph's nickname was Mr. Consistency, his son's was The Intimidator and his grandson's was Little E. • Ralph Sr. died in a last-lap crash during the Daytona 500 while Dale Jr. came in second place.
The Earnhardt family: • Dale Junior's half-brother Kerry was a NASCAR driver. He is currently employed by Dale Earnhardt Inc. as a consultant. His son Jeffrey entered the racing world in 2007.

Ralph Lee Earnhardt (23 février 1928 - 26 septembre 1973, États-Unis) est une légende des courses de NASCAR et un pionnier en matière de mécanique et de préparation de voitures de courses. Sur 23 années de carrière, il a remporté plus de 350 courses et décroché le record du tour sur plus de 7 circuits.
Ralph Dale Sr. Earnhardt (29 avril 1951 - 18 février 2001, États-Unis) est l'un des pilotes de NASCAR les plus populaires de l'histoire. Vainqueur de 76 courses de la Winston Cup, il a également remporté le titre de champion à 7 reprises.
Ralph Dale Jr. Earnhardt (10 octobre 1974, États-Unis) gagne deux fois le championnat de série Busch avant de passer à la catégorie supérieure. Il remporta en 2004 la course la plus prestigieuse, le Daytona 500, et s'est imposé à 5 reprises au Talledaga Superspeedway.
Père, fils & petit-fils : Ralph est surnommé "*Mr. Consistency*", son fils "*The Intimidator*" et son petit-fils "*Little E*". • Ralph Sr. est décédé en 2001 dans un terrible accident au dernier tour du Daytona 500, où Dale Jr. se classa deuxième.
La famille Earnhardt : Le demi-frère de Dale Jr., Kerry, a lui aussi été pilote de NASCAR. Son fils Jeffrey évolue dans la course automobile depuis 2007.

Ralph Lee Earnhardt (23 februari 1928 - 26 september 1973, VSA) was een NASCAR-racelegende en een vernieuwer wat autoconstructie en -afstelling betrof. In een carrière die 23 jaar duurde, won hij meer dan 350 races en hield hij het ronderecord op meer dan 7 circuits.
Ralph Dale Sr. Earnhardt (29 april 1951 - 18 februari 2001, VSA) was een van de meest populaire NASCAR-chauffeurs ooit. Hij won 76 races in de Winston Cup en won de titel zeven keer.
Ralph Dale Jr. Earnhardt (10 oktober 1974, VSA) won het kampioenschap van de op een na hoogste NASCAR-serie twee keer, om daarna over te stappen naar de hoogste klasse. Hij won de belangrijkste race, de Daytona 500, in 2004 en won de Talledaga Superspeedway vijf keer.
Vader, zoon & kleinzoon: Ralphs bijnaam was Mr. Consistency, die van zijn zoon The Intimidator en die van zijn kleinzoon Little E. • Ralph Sr. stierf na een fatale crash tijdens de laatste ronde van de Daytona 500 terwijl Dale Jr. tweede werd.
De familie Earnhardt: • Ook Dale Juniors halfbroer Kerry was een NASCAR-racer. Hij werkt nu bij Dale Earnhardt Inc. als consultant. Zijn zoon Jeffrey zit sinds 2007 in de racesport.

"**When somebody says, 'Man, that's something your daddy would do,' that's a big-ass compliment.**"

Dale Jr. Earnhardt

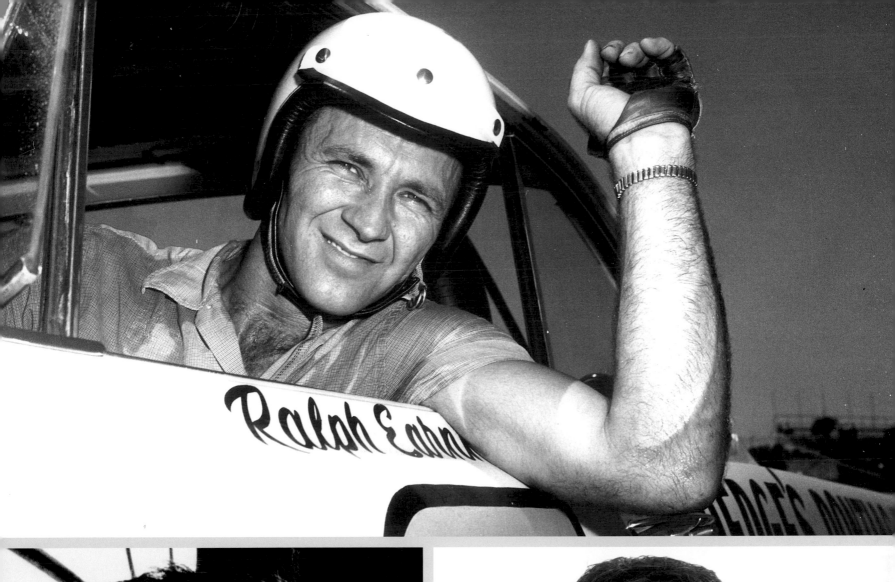

Clint & Alison
Eastwood

Clint Elias Eastwood Jr. (31 May 1930, USA) became an icon of masculinity because of his roles in action and western films like *Dirty Harry* and the *Dollars* trilogy. As a director he made over 25 films and won several Oscars for productions like *Million Dollar Baby* and *Unforgiven*. He is also an admirable pianist, composer and singer.
Alison Eastwood (22 May 1972, USA) rose to fame on the catwalks of Paris before pursuing a career in acting. She played her first big role in her father's film *Midnight in the Garden* of *Good and Evil* and went on to excel in *Breakfast of Champions*, *Just a Little Harmless Sex*, *If You Only Knew*, *Poolhall Junkies*, *Power Play* and *I'll Be Seeing You*. In 2007, she made her directorial debut with *Rails & Ties*, which starred Kevin Bacon.
Father & daughter: Alison made her film debut at the age of seven in her father's film *Bronco Billy*. • They played father and daughter in the serial killer-film *Tightrope*.
The Eastwood family: Clint likes to keep it in the family: he cast his son Scott in films like *Flags of Our Fathers*, *Gran Torino* and *Invictus*, while his brother Kyle co-wrote several soundtracks.

Clint Elias Eastwood Jr. (31 mai 1930, États-Unis), véritable icône du cinéma américain, a joué dans de nombreux films d'action et de westerns, dont *L'Inspecteur Harry* et *La Trilogie du dollar*. Il a réalisé plus de 25 films et remporté plusieurs Oscars, notamment pour *Million Dollar Baby* et *Impitoyable*. Il est aussi pianiste, compositeur et chanteur de talent.
Alison Eastwood (22 mai 1972, États-Unis) a fait fureur comme mannequin avant d'entamer une carrière cinématographique. Elle a joué son premier grand rôle dans un film de Clint, *Minuit dans le jardin du bien et du mal*, et a brillé ensuite dans *Breakfast of Champions*, *Sexe, strip-tease et tequila*, *Si j'avais su*, *Poolhall Junkies*, *Power Play* et *I'll Be Seeing You*. En 2007, elle a réalisé son premier film, *Rails & Ties*, avec Kevin Bacon.
Père & fille : Alison fit ses débuts d'actrice dans le film de Clint *Bronco Billy*. • Père et fille se sont donnés la réplique dans *La Corde raide*.
La famille Eastwood : Clint a le sens de la famille. Son fils Scott a joué dans *Mémoires de nos pères*, *Gran Torino* et *Invictus*, et son fils Kyle a co-écrit plusieurs musiques de ses films.

Clint Elias Eastwood Jr. (31 mei 1930, VSA) groeide uit tot een icoon van mannelijkheid dankzij zijn rollen in actie- en westernfilms als *Dirty Harry* en de *Dollars*-trilogie. Als regisseur maakte hij meer dan 25 films en won hij meerdere Oscars, onder meer voor *Million Dollar Baby* en *Unforgiven*. Hij is bovendien een verdienstelijk pianist, componist en zanger.
Alison Eastwood (22 mei 1972, VSA) maakte furore op de Parijse catwalks alvorens zich op een acteercarrière te werpen. Ze speelde haar eerste grote rol in haar vaders *Midnight in the Garden* of *Good and Evil*, en liet zich later opmerken in *Breakfast of Champions*, *Just a Little Harmless Sex*, *If You Only Knew*, *Poolhall Junkies*, *Power Play* en *I'll Be Seeing You*. In 2007 regisseerde ze haar eerste film, *Rails & Ties*, met Kevin Bacon in de hoofdrol.
Vader & dochter: Alison maakte op haar zevende haar filmdebuut in haar vaders film *Bronco Billy*. • In de seriemoordenaar-film *Tightrope* speelden ze vader en dochter.
De familie Eastwood: Clint houdt het graag in de familie: zo castte hij zoon Scott in een aantal films, waaronder *Flags of Our Fathers*, *Gran Torino* en *Invictus*, terwijl diens broer Kyle meeschreef aan verscheidene soundtracks.

Harry & Stefan Everts

Harry Everts (1952, Belgium) won 23 Grand Prix and four world championships and is therefore widely regarded as one of the best motocross racers the world has ever seen. He was a member of the Belgian team that won the Motocross des Nations in both 1976 and 1979. After his active career he founded the Everts MX School in Spain.

Stefan Everts (25 November 1972, Belgium) smashed all standing motocross records: he secured 10 World Titles, collected 101 GP victories, was the first to win three different GP victories in one day, is one of only two drivers who succeeded in becoming world champion in all three motocross categories (125, 250, 500 cc) and is the only one to have become world champion with the four large Japanese brands (Suzuki, Kawasaki, Honda and Yamaha).

Father & son: Harry was the champion of training and won because of his willpower. Stefan was a natural and was not pleased with his father's tough approach. This regularly caused conflicts but it never led to them splitting up. • Stefan often teaches at his father's school.

The Everts family: In 2006, Stefan's two-year-old son Liam got a 'contract' for three seasons with Yamaha, mini bike included.

Harry Everts (1952, Belgique) est, avec 23 Grands Prix et 4 titres de champion de monde, l'un des meilleurs pilotes de motocross de tous les temps. En 1976 et 1979, il a remporté avec l'équipe belge le Motocross des Nations. Après une carrière exemplaire, il créa la Everts MX School en Espagne.

Stefan Everts (25 novembre 1972, Belgique) pulvérisa tous les records de motocross : 10 fois champion du monde, vainqueur de 101 Grands Prix, il est le premier à en avoir remporté 3 différents dans la même journée. Il est l'un des deux seuls pilotes sacrés champion du monde dans les trois catégories de motocross (125, 250, 500 cc) ; et le seul champion du monde à s'être imposé avec les moteurs des 4 géants japonais (Suzuki, Kawasaki, Honda et Yamaha).

Père & fils : Harry, champion de l'entraînement, s'imposait grâce à sa détermination. Stefan, doué de nature, n'appréciait guère la rudesse de son père. Ce différend leur valut quelques heurts, heureusement sans conséquences. • Stefan enseigne dans l'école de son père.

La famille Everts : Le fils de Stefan, Liam, a obtenu en 2006 – alors qu'il n'avait que 2 ans – un "contrat" de trois saisons chez Yamaha (mini-motos).

Harry Everts (1952, België) wordt met 23 gewonnen Grand Prix en vier wereldtitels beschouwd als een van de beste motorcrossers aller tijden. In 1976 en '79 maakte hij deel uit van het winnende Belgische landenteam van de Motocross der Naties. Na zijn actieve carrière begon hij de Everts MX School in Spanje.

Stefan Everts (25 november 1972, België) reed alle motorcross-records aan flarden: hij werd tienmaal wereldkampioen, behaalde 101 GP-overwinningen, won als eerste drie verschillende GP's op één dag, is een van slechts twee piloten die erin slaagde wereldkampioen te worden in alledrie de klassen van het motorcross (125, 250, 500 cc) én de enige die wereldkampioen werd met motors van de vier grote Japanse merken (Suzuki, Kawasaki, Honda en Yamaha).

Vader & zoon: Harry was de kampioen van het trainen en won op wilskracht. Stefan was een natuurtalent en niet blij met de harde aanpak van zijn vader. Dit gaf meermaals aanleiding tot botsingen, die echter nooit tot een breuk leidden. • Stefan geeft geregeld les aan de school van zijn vader.

De familie Everts: Stefans zoon Liam kreeg in 2006, toen hij twee jaar was, een 'contract' voor drie seizoenen bij Yamaha met bijbehorende minimotor.

Gaston & Marc
Eyskens

Burggraaf Gaston François Marie Eyskens (1 April 1905 - 3 January 1988, Belgium) was one of the most important post-war Belgian politicians. He was the Christian Democrat Prime Minister of six Belgian governments between 1949 and 1972 when he dealt with great ideological conflicts like the King's Issue, the School War, the Unity Law, the first constitutional reform and Congo's declaration of independence.

Burggraaf Marc 'Mark' Maria Frans Eyskens (29 April 1933, Belgium) combined an academic and political career, just like his father. He was part of thirteen successive Belgian governments, was Prime Minister from April to December in 1981 and always left his mark on government policy. He is an amateur painter and has published an impressive number of books.

Father & son: Gaston Eyskens is still called 'father Eyskens', while Mark Eyskens seemingly remains to be referred to as 'the son'. • Gaston Eyskens was ennobled as viscount with hereditary transferral of the title to his firstborn, Mark Eyskens. The Eyskens motto is 'For the people'.
• Mark wrote the prologue *Vaders dood en leven* in his father's book *De Memoires* in 2003.

Vicomte Gaston François Marie Eyskens (1er avril 1905 - 3 janvier 1988, Belgique) fut l'un des plus grands Premiers ministres belges de l'après-guerre. Chrétien-démocrate, il fut à la tête de six gouvernements entre 1949 et 1972 et se vit confronté à d'importants conflits idéologiques tels que la Question royale, le Pacte scolaire, la "Loi unique", la première réforme de l'État et l'indépendance du Congo.

Vicomte Marc "Mark" Maria Frans Eyskens (29 avril 1933, Belgique) mena, à l'instar de son père, une carrière professorale à l'université et une carrière politique. Il fit partie de 13 gouvernements successifs et endossa le rôle de Premier ministre d'avril à décembre 1981. Il marqua véritablement la politique gouvernementale belge de son empreinte. Peintre amateur, il a en outre publié une quantité impressionnante d'ouvrages.

Père & fils : Gaston restera éternellement "le père Eyskens" et Mark "le fils". • Gaston Eyskens a hérité en 1973 du titre de vicomte, avec transmission à son premier enfant, Mark Eyskens. La devise choisie par Eyskens est "Voor 't volk" ("Pour le peuple"). • Mark rédigea le prologue "*Vaders dood en leven*" du livre de son père, *De Mémoires*, paru en 2003 en Hollandais.

Burggraaf Gaston François Marie Eyskens (1 april 1905 - 3 januari 1988, België) was een van de belangrijkste naoorlogse premiers van België. Hij was Christen-Democratisch eerste minister van zes Belgische regeringen in de periode tussen 1949 en 1972, en kreeg tijdens zijn regeerperiode te maken met grote ideologische conflicten zoals de Koningskwestie, het schoolpact, de Eenheidswet, de eerste staatshervorming en de onafhankelijkheidsverklaring van Congo.

Burggraaf Marc 'Mark' Maria Frans Eyskens (29 april 1933, België) combineerde net zoals zijn vader een academische loopbaan met een politieke carrière. Hij maakte deel uit van dertien opeenvolgende Belgische regeringen, was van april tot december 1981 premier van België en drukte iedere keer zeer nadrukkelijk zijn stempel op het regeringsbeleid. Hij is amateurschilder en publiceerde een indrukwekkend aantal boeken.

Vader & zoon: Gaston Eyskens wordt nog altijd 'vader Eyskens' genoemd, terwijl Mark Eyskens blijkbaar voor eeuwig 'de zoon' blijft. • Gaston Eyskens kreeg in 1973 de titel van burggraaf, met erfelijke overdracht op zijn eerstgeborene, Mark Eyskens. De Eyskens-wapenspreuk is 'Voor 't volk'. • Mark schreef de proloog *Vaders dood en leven* in het boek *De Memoires* van zijn vader Gaston uit 2003.

Errol & Sean
Flynn

Errol Flynn (20 June 1909 - 14 October 1959, Australia) became world famous in the 1930s thanks to his roles in adventure films like *Captain Blood*, *The Sea Hawk* and *The Sun Also Rises*. He was equally known for his dissipated lifestyle as a bisexual playboy and for being an alcohol and morphine addict. Errol died at the age of 50 due to a heart attack.
Sean Flynn (31 May 1941 - 1971, USA) made his acting debut at the age of fifteen in the television series *The Errol Flynn Theatre*, appeared in a dozen films and tried his hand as a singer. He went to Vietnam in 1966 as a photojournalist for Paris-Match, where he quickly gained the reputation of an intrepid photographer. In 1970, he disappeared without a trace in Cambodia after being captured by guerrillas.
Father & son: It has been said that womanizer Errol once stole away his fourteen-year-old son's girlfriend. • Sean fought his whole life against being compared to his father. While Errol merely acted being brave in films, Sean decided to find out what being a hero was truly like in real life. Ironically, it is because of the intensity with which he worked that he continued to be compared to his illustrious father.
The Flynn family: Errol's daughter Rory has a son named Sean who also works as an actor.

Errol Flynn (20 juin 1909 - 14 octobre 1959, Australie) est devenu dès les années 30 une vedette incontestée pour ses rôles dans les films d'aventure *Captain Blood*, *L'Aigle des mers* et *Le Soleil se lève aussi*. Il défraya la chronique avec ses frasques de playboy bisexuel et son penchant pour l'alcool et la morphine. Il décède à 50 ans à la suite d'un arrêt cardiaque.
Sean Flynn (31 mai 1941 - 1971, États-unis) débute sa carrière à l'âge de 15 ans dans la série "*The Errol Flynn Theatre*", avant de tourner une dizaine de films et de s'essayer à la chanson. Devenu photojournaliste pour *Paris Match*, il est parti en 1966 au Vietnam, où il s'est forgé une réputation de photographe intrépide. En 1970, il a mystérieusement disparu au Cambodge, kidnappé par la junte militaire.
Père & fils : Coureur de jupons invétéré, Errol aurait séduit, dit-on, la petite amie de son fils. • Sean a refusé toute sa vie la moindre comparaison avec son père. Tandis qu'Errol se montrait héroïque à l'écran, Sean faisait de même, mais dans la réalité. L'ironie du sort voulut que sa fougue suscitât justement la comparaison avec son père.
La famille Flynn : Sean, le fils de Rory (la fille d'Errol), est également acteur.

Errol Flynn (20 juni 1909 - 14 oktober 1959, Australië) werd vanaf de jaren 30 wereldberoemd dankzij zijn rollen in avonturenfilms als *Captain Blood*, *The Sea Hawk* en *The Sun Also Rises*. Hij stond evenwel beter bekend voor zijn liederlijke levensstijl als biseksuele playboy, drank- en morfineverslaafde, en overleed op 50-jarige leeftijd aan een hartaanval.
Sean Flynn (31 mei 1941 - 1971, VSA) maakte op zijn vijftiende zijn acteerdebuut in de tv-serie *The Errol Flynn Theatre*, speelde mee in een tiental films en probeerde zijn geluk als zanger. In 1966 trok hij voor Paris-Match als fotojournalist naar Vietnam, waar hij snel een reputatie opbouwde als onversaagde fotograaf. In 1970 verdween hij spoorloos nadat hij gevangen genomen werd door guerilla's in Cambodja.
Vader & zoon: Rokkenjager Errol ging naar verluidt ooit lopen met het liefje van zijn veertienjarige zoon. • Sean verzette zich zijn hele leven tegen de vergelijking met zijn vader. Terwijl die deed alsof hij heldhaftig was in films, besloot Sean uit te vissen wat echte heldhaftigheid was. Ironisch genoeg werd hij net door de intensiteit waarmee hij zich smeet toch weer vergeleken met zijn roemruchte vader.
De familie Flynn: Sean, de zoon van Errols dochter Rory, werkt ook als acteur.

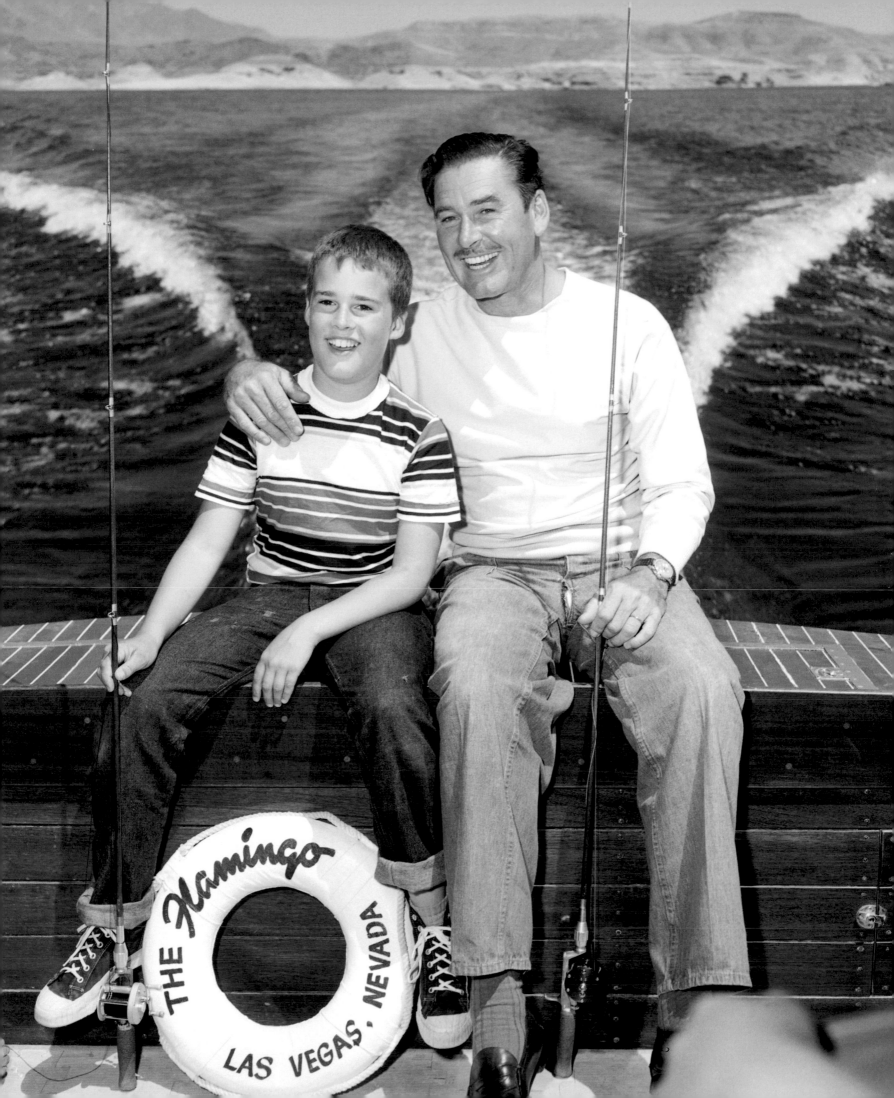

Henry & Jane
Fonda

Henry Jaynes Fonda (16 May 1905 - 12 August 1982, USA) started his career on Broadway, played great roles in such classics as *The Ox-Bow Incident*, *Mister Roberts*, *Twelve Angry Men* and *Once Upon a Time in the West* and won an Oscar for his role in *On Golden Pond*.
Lady Jane Seymour Fonda (21 December 1939, USA) was first noticed as a fashion model, rose to fame thanks to her roles in *Barbarella* and *Cat Ballou* and won Oscars for *Klute* and *Coming Home*. She became controversial through her actions against the war in Vietnam and later became a fitness guru.
Father & daughter: In 1954, father and daughter performed together in the play *The Country Girl*. • In 1980, Jane bought the screen rights to the play *On Golden Pond* and cast her father and herself for the leading roles. The father-daughter relationship in the film reflected the strained relationship they had themselves. She accepted her father's Oscar on his behalf because he was too ill to collect it himself.
The Fonda family: Jane's brother Peter, her niece Bridget (see Peter & Bridget Fonda) and her son Troy Garity are also in the acting business, while her daughter Vanessa Vadim is a producer and cinematographer.

Henry Jane Fonda (16 mai 1905 - 12 août 1982, États-Unis) a débuté sa carrière à Broadway, puis a interprété de grands rôles dans des classiques comme *L'Étrange Incident*, *Permission jusqu'à l'aube*, *Douze Hommes en colère* et *Il était une fois dans l'Ouest*. Sa prestation dans *La Maison du lac* lui valut un Oscar en 1981.
Lady Jane Seymour Fonda (21 décembre 1939, États-Unis) est devenue célèbre comme mannequin avant de briller au cinéma dans *Barbarella* et *Cat Ballou*. Elle a remporté à deux reprises l'Oscar de la meilleure actrice, pour *Klute* et *Le Retour*. Ses actions contre la guerre du Vietnam ont alimenté la controverse ; puis elle est ensuite devenue la reine du fitness.
Père & fille : En 1954, père et fille se donnent la réplique au théâtre dans "*The Country Girl*". • En 1980, Jane achètent les droits de *La Maison du lac* afin d'y partager la vedette avec son père. La relation père-fille dans le film reflète les difficultés qu'eux-mêmes traversaient à cette époque. Elle viendra à la cérémonie pour recevoir l'Oscar au nom de son père, celui-ci étant alors trop souffrant pour faire le déplacement.
La famille Fonda : Peter, Bridget et Troy Garity, respectivement les frère, nièce et fils de Jane, sont tous les trois acteurs ; sa fille, Vanessa Vadim, est productrice et cinéaste.

Henry Jaynes Fonda (16 mei 1905 - 12 augustus 1982, VSA) begon zijn carrière op Broadway, speelde grote rollen in klassiekers als *The Ox-Bow Incident*, *Mister Roberts*, *Twelve Angry Men* en *Once Upon a Time in the West* en kreeg een Oscar voor *On Golden Pond*.
Lady Jane Seymour Fonda (21 december 1937, VSA) kwam onder de aandacht als fotomodel, werd een ster dankzij films als *Barbarella* en *Cat Ballou* en won Oscars voor *Klute* en *Coming Home*. Ze werd controversieel door haar acties tegen de Vietnamoorlog en groeide later uit tot fitnessgoeroe.
Vader & dochter: In 1954 speelden vader en dochter samen in het stuk *The Country Girl*. • In 1980 kocht Jane de filmrechten van *On Golden Pond* om er zelf met haar vader de hoofdrol in te kunnen spelen. De vader-dochter relatie in de film reflecteerde de moeizame verstandhouding die ze zelf hadden. Later nam ze haar vaders Oscar in ontvangst omdat hij toen al te ziek was om hem zelf te accepteren.
De familie Fonda: Janes broer Peter, haar nichtje Bridget (zie ook Peter & Bridget Fonda) en haar zoon Troy Garity zitten ook in het acteervak, terwijl haar dochter Vanessa Vadim producer en cinematografe is.

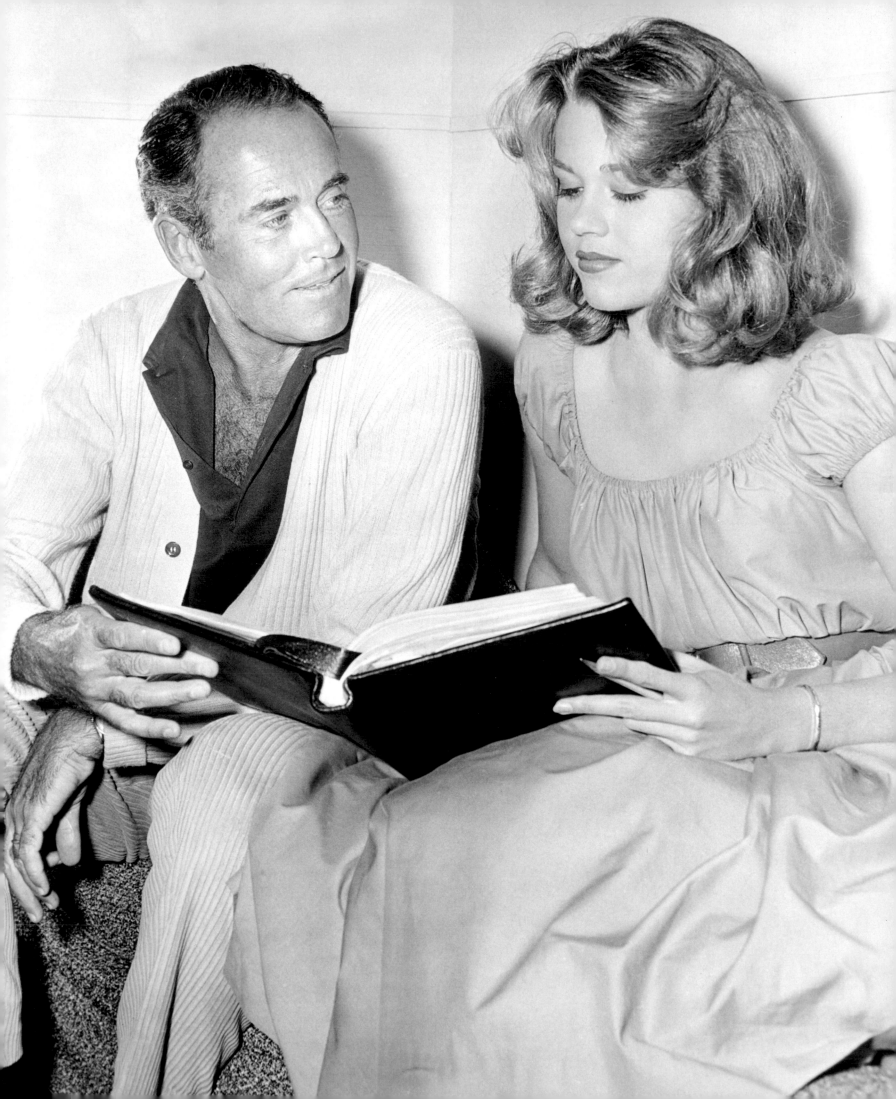

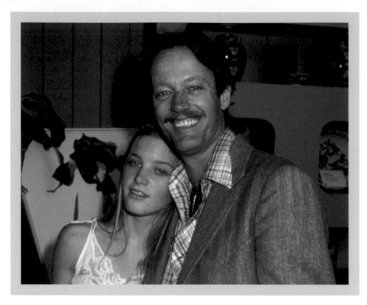

Peter & Bridget
Fonda

Peter Henry Fonda (23 February 1940 - 12 August 1982, USA) became an icon of the anti-culture thanks to his roles in sixties cult films like *The Wild Angels*, *The Trip* and *Easy Rider*. It seemed hard to match this success until his made his comeback in the 90s with such films as *Nadia*, *Escape From L.A.*, *Ulee's Gold*, *The Limey* and *3:10 to Yuma*.
Bridget Jane Fonda (27 January 1964, USA) secured her first substantial film role with her appearance in *You Can't Hurry Love* in 1988. She first caught the public's eye in *Scandal*, broke through with *Singles* and *Single White Female*, and played big roles in *Jackie Brown* and *A Simple Plan*. She has not appeared in a film since her marriage.
Father & daughter: Bridget made her film debut at the age of five as an extra in *Easy Rider*. • Peter's cameo role in Bridget's film *Bodies, Rest & Motion* in 1993 announced the beginning of his comeback.
The Fonda family: The Fondas (see also Henry & Jane Fonda) constitute a famous film dynasty and Peter is the family member who became most famous as 'Henry's son', 'Jane's brother' and 'Bridget's father'. His son Justin works as a cameraman.

Peter Henry Fonda (23 février 1940 - 12 août 1982, États-Unis) est devenu une icône de la contre culture en jouant dans des films cultes des sixties comme *Les Anges sauvages*, *The Trip* et *Easy Rider*. Après l'immense succès d'*Easy Rider*, Peter a du mal à trouver des propositions de scripts qui l'enthousiasment. Il reviendra néanmoins sur le devant de la scène dans les années 90 avec *Nadja*, *Los Angeles 2013*, *L'Or de la vie*, *L'Anglais* et *3h10 pour Yuma*.
Bridget Jane Fonda (27 janvier 1964, États-Unis) interprète son premier grand rôle dans *You Can't Hurry Love* en 1988. Remarquée dans *Scandal*, elle connaît la célébrité grâce aux succès des films *Singles* et *J.F. partagerait appartement*. Elle a incarné de grands rôles dans *Jackie Brown* et *Un Plan simple*. Depuis son mariage, elle a mis sa carrière entre parenthèses.
Père & fille : Bridget apparaît à 5 ans comme figurante dans *Easy Rider*. • Peter a joué dans le film de Bridget, *Bodies, Rest & Motion* (1993), amorçant ainsi son retour au cinéma.
La famille Fonda : Les Fonda sont une célèbre famille d'acteurs. Le fils de Peter, Justin, est caméraman.

Peter Henry Fonda (23 februari 1940 - 12 augustus 1982, VSA) werd een icoon van de tegencultuur dankzij zijn rollen in sixties-cultfilms als *The Wild Angels*, *The Trip* en *Easy Rider*. Dit succes bleek moeilijk te evenaren, tot hij in de jaren 90 een comeback maakte met films als *Nadia*, *Escape From L.A.*, *Ulee's Gold*, *The Limey* en *3:10 to Yuma*.
Bridget Jane Fonda (27 januari 1964, VSA) speelde haar eerste grote filmrol in *You Can't Hurry Love* in 1988. Ze viel voor het eerst op in *Scandal*, brak door met *Singles* en *Single White Female*, en speelde grote rollen in *Jackie Brown* en *A Simple Plan*. Sinds haar huwelijk ligt haar carrière stil.
Vader & dochter: Bridget maakte op haar vijfde haar filmdebuut als figurante in *Easy Rider*. • Peters cameo in *Bridgets film Bodies, Rest & Motion* uit 1993 kondigde het begin aan van zijn comeback.
De familie Fonda: De Fonda's (zie ook Henry & Jane Fonda) vormen een beroemde filmdynastie en Peter is het familielid dat nog het meest bekend werd als 'de zoon van Henry', 'de broer van Jane' en 'de vader van Bridget'. • Peters zoon Justin werkt als cameraman.

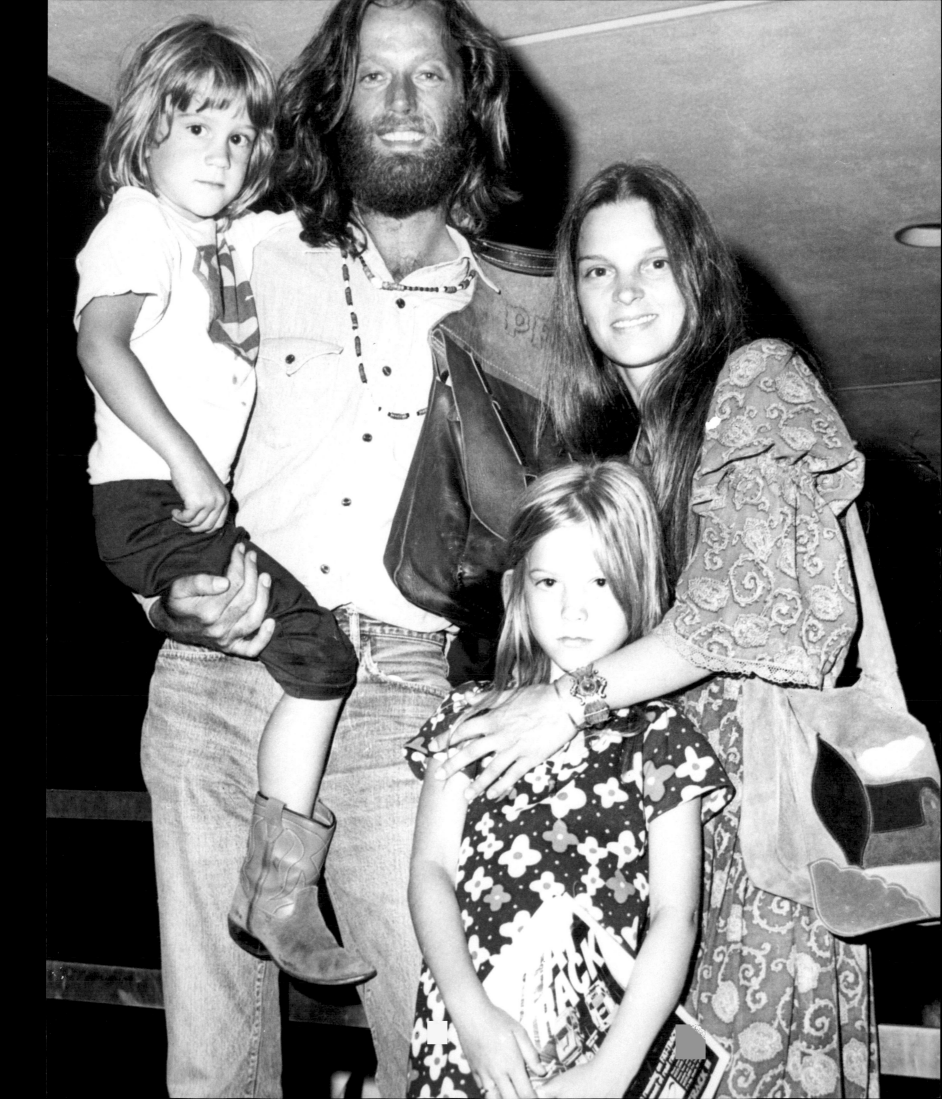

"For rarely are sons similar to their fathers; most are worse, and a few are better than their fathers."

Homer (ca. 8th century BC)
Greek author

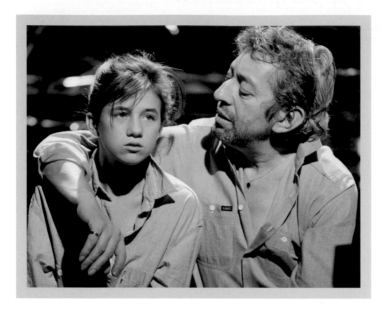

Serge & Charlotte
Gainsbourg

Lucien Ginsburg (2 April 1928 - 2 March 1991, France) became one of the greatest French icons of the 20th century under the name of Serge Gainsbourg. He was equally known for his extensive oeuvre, as he was for his decadent lifestyle and cynical outlook on life. The revered actor, singer and songwriter became infamous in 1969 with his worldwide hit *Je T'Aime, Moi Non Plus* with Jane Birkin. His *Histoire de Melody Nelson* is a masterpiece, which continues to influence musicians. He died of a heart attack.
Charlotte Gainsbourg (21 July 1971, Great Britain) went into the film world at the age of thirteen due to the insistence of her mother Jane Birkin. Her most famous roles were in the films *The Cement Garden*, *The Science of Sleep*, *I'm Not There*, *21 Grams* and *Antichrist*. In 2006 she started focusing more on her career as a singer, which resulted in the critically acclaimed albums *5:55* and *IRM*.
Father & daughter: Serge and his thirteen-year-old daughter shocked the world in 1984 with their song *Lemon Incest*. • Charlotte admits that she prefers writing songs in English to avoid any comparison to her father.

Lucien Gainsbourg (2 avril 1928 - 2 mars 1991, France), alias Serge Gainsbourg, est l'une des plus grandes icônes françaises du 20ᵉ siècle. Son mode de vie décadent, son attitude provocatrice et son cynisme incomparable ont défrayé la chronique et marqué l'histoire, tout comme son œuvre artistique fortement métissée. Acteur, mais avant tout chanteur et compositeur, il connaît la notoriété en 1969 avec le tube planétaire "Je t'aime, moi non plus", interprété en duo avec Jane Birkin. Son album *Histoire de Melody Nelson* fut ressenti comme un pur chef-d'œuvre, et influence aujourd'hui encore bon nombre de musiciens. Il est décédé d'une crise cardiaque en 1991.
Charlotte Gainsbourg (21 juillet 1971, Angleterre), encouragée par sa mère Jane Birkin, démarre sa carrière cinématographique à l'âge de 13 ans. Elle a tenu ses plus grands rôles dans les films *Cement Garden*, *La Science des rêves*, *I'm Not There*, *21 grammes* et *Antichrist*. Depuis 2006, sa carrière de chanteuse a également pris son envol, avec un accueil chaleureux réservé aux albums *5:55* et *IRM*.
Père & fille : Serge et Charlotte – 13 ans à l'époque – provoquèrent un scandale en 1984 avec la chanson "*Lemon Incest*". • Charlotte préfère écrire ses chansons en anglais afin d'éviter toute comparaison avec son père.

Lucien Ginsburg (2 april 1928 - 2 maart 1991, Frankrijk) groeide als Serge Gainsbourg uit tot een van de grootste Franse iconen van de 20ste eeuw. Hij stond al even bekend voor zijn decadente levenstijl en cynische levensvisie als voor zijn uitgebreide œuvre. Hoewel ook geroemd als acteur maar vooral als zanger en liedjesschrijver, werd hij in '69 berucht dankzij de wereldhit *Je T'Aime, Moi Non Plus* met Jane Birkin. Zijn *Histoire de Melody Nelson* is een meesterwerk dat nog altijd muzikanten beïnvloedt. Hij stierf aan een hartaanval.
Charlotte Gainsbourg (21 juli 1971, Groot-Brittannië) rolde op aandringen van moeder Jane Birkin op dertienjarige leeftijd de filmwereld in. Haar bekendste rollen speelde ze in de films *The Cement Garden*, *The Science of Sleep*, *I'm Not There*, *21 Grams* en *Antichrist*. Sinds 2006 stapt ze meer en meer op de voorgrond als zangeres, met als resultaat de prima ontvangen albums 5:55 en IRM.
Vader & dochter: Serge en zijn toen dertienjarige dochter choqueerden de wereld in '84 met het nummer *Lemon Incest*. • Charlotte geeft zelf toe dat ze liever in het Engels liedjes schrijft om elke vergelijking met haar vader te vermijden.

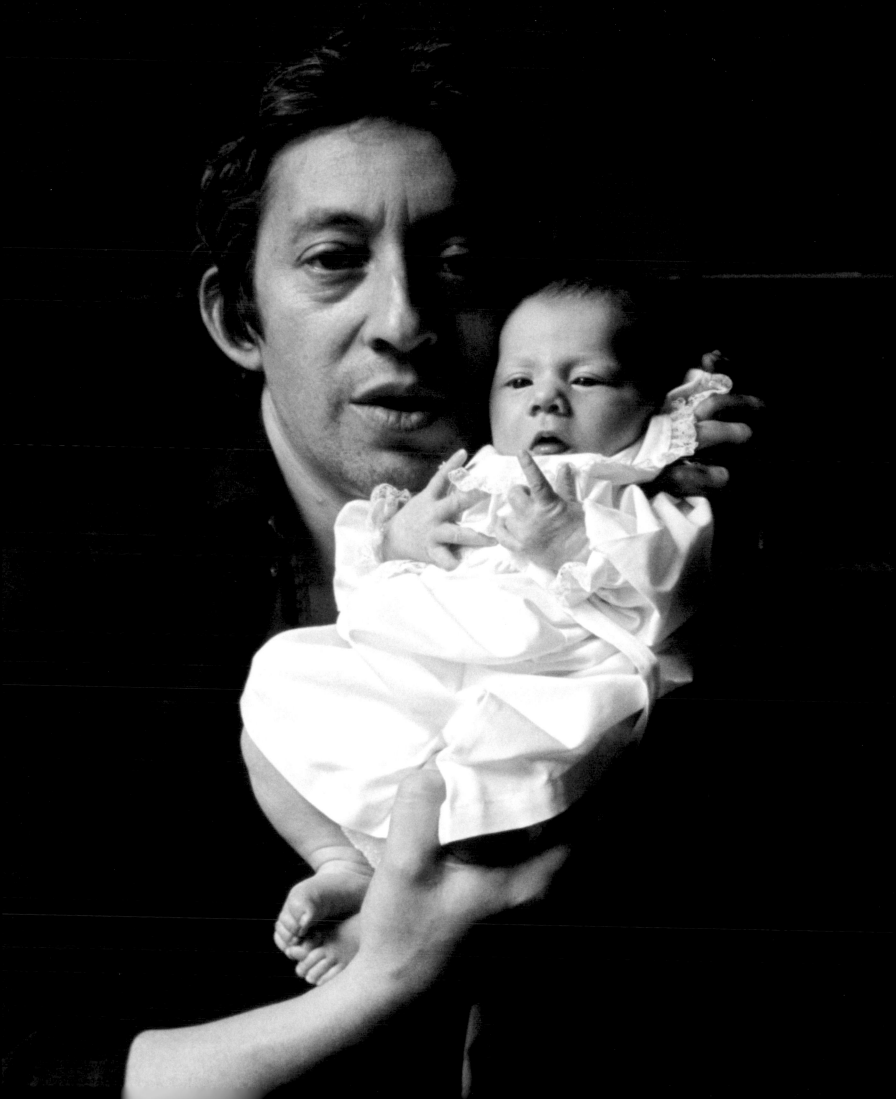

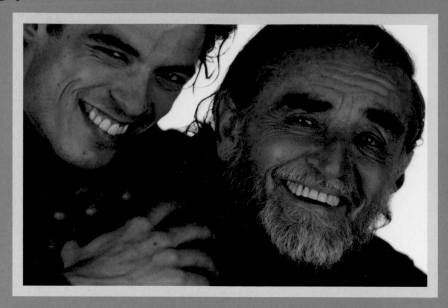

Vittorio & Alessandro
Gassman

Vittorio Gassman (1 September 1922 - 29 June 2000, Italy) is regarded as one of the greatest Italian theatre, television and film actors. He was an extremely professional, flexible and magnetic interpreter, who worked in both Hollywood and Italy. He is mainly remembered for his roles in films like *Il Sorpasso*, *La Grande guearra*, *Produmo di Donna* and the television series *Il Mattatore*.

Alessandro Gassman (24 February 1965, Italy) appeared in several popular films like *I miei più cari amici* and *Transporter 2*, and television series like *Piccolo mondo antico*. He was chosen by Yves Saint Laurent to represent the perfume Opium and posed for a nude calendar. He received several prestigious prizes for his role in *Caos Calma*.

Father & son: Alessandro debuted at the age of seventeen in the autobiographical film *Di Padre in figlio*, which was written and directed by his father. • He was later tutored by his father in *The Theatre Workshop* of Firenze.

Vittorio Gassman (1er septembre 1922 - 29 juin 2000, Italie) est considéré comme l'un des plus grands acteurs italiens de tous les temps. Il mena de front sa carrière dans les milieux du cinéma, de la télévision et du théâtre. Extrêmement professionnel, flexible et charismatique, Vittorio a tourné en Italie aussi bien qu'à Hollywood, et est entré dans la légende grâce à des grands rôles au cinéma (*Le Fanfaron*, *La Grande Guerre*, *Parfum de femme*) et à la télévision (la série télévisée "*Il Mattatore*").

Alessandro Gassman (24 février 1965, Italie) a joué dans quelques films populaires comme *I miei più cari amici* et *Le Transporteur 2*, ainsi que dans des séries télévisées telles que "*Piccolo mondo antico*". Son rôle dans *Caos Calmo* lui a valu plusieurs prix prestigieux. Choisi par Yves Saint Laurent pour incarner le visage du parfum Opium, Alessandro a également posé pour un calendrier sexy.

Père & fils : Alessandro a débuté sa carrière à l'âge de 17 ans dans le film autobiographique écrit et réalisé par son père, *Di Padre in figlio*. • Par la suite, il a fait ses classes dans l'école de théâtre créée par Vittorio à Florence.

Vittorio Gassman (1 september 1922 - 29 juni 2000, Italië) wordt beschouwd als een van de grootste Italiaanse theater-, tv- en filmacteurs aller tijden. Hij was een extreem professionele, flexibele, magnetische speler die zowel in Hollywood als in Italië aan de bak kwam en vooral herinnerd wordt dankzij rollen in films als *Il Sorpasso*, *La Grande guearra*, *Produmo di Donna* en de tv-serie *Il Mattatore*.

Alessandro Gassman (24 februari 1965, Italië) speelde in enkele populaire films als *I miei più cari amici* en *Transporter 2*, en tv-series als *Piccolo mondo antico*. Hij werd door Yves Saint Laurent gekozen als het gezicht van het parfum Opium en poseerde voor een naaktkalender. Voor zijn rol in *Caos Calma* kreeg hij verscheidene prestigieuze prijzen.

Vader & zoon: Alessandro debuteerde op zijn zeventiende in de door zijn vader geschreven en geregisseerde autobiografische film *Di Padre in figlio*. • Later zat hij in de klas bij zijn vader in *The Theatre Workshop* van Firenze.

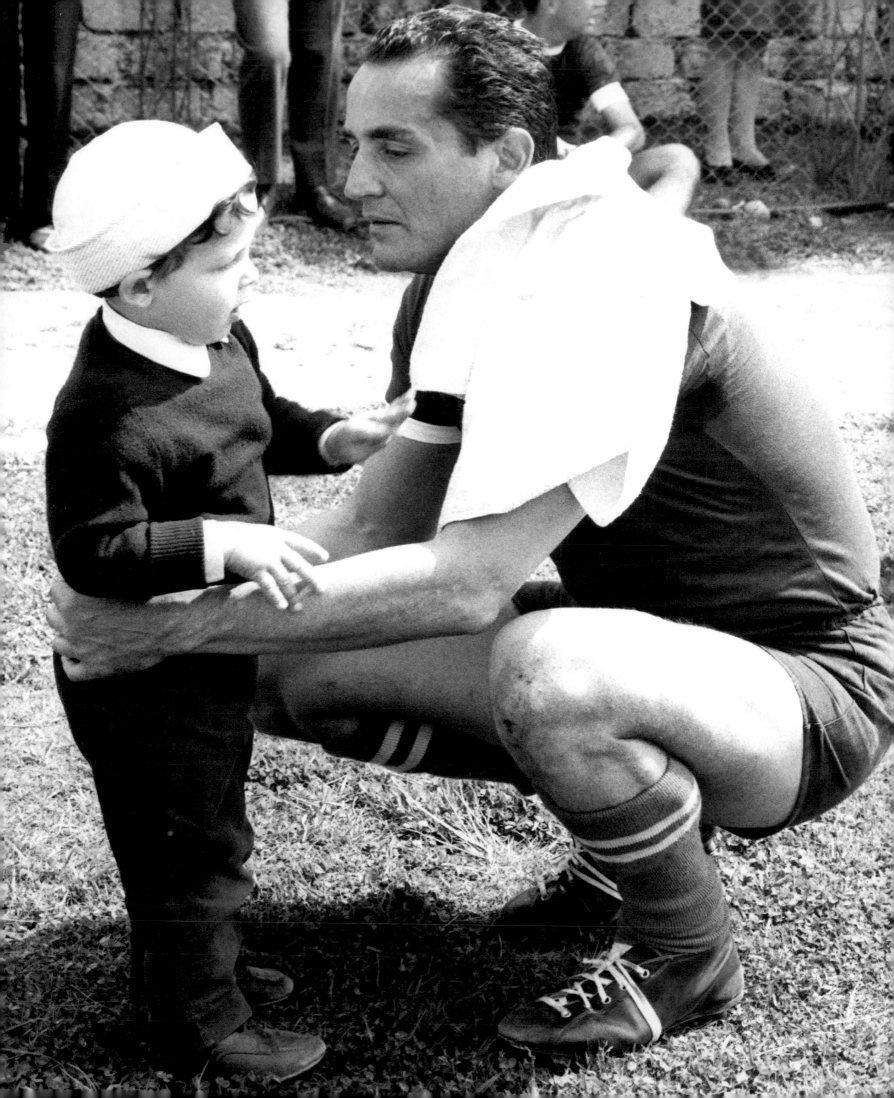

Rein & Richard
Groenendaal

Reinier Groenendaal (24 April 1951, Netherlands) was one of the more successful Dutch cyclo-cross cyclists in the 80s. He won the Dutch championship in 1985 and came in second and third respectively in the final classification of the Superprestige in 1984 and 1985. He racked up 117 victories during his whole career.

Richard Marinus Anthonius Groenendaal (13 July 1971, Netherlands) is a living monument in Dutch cyclo-cross history. He won the Junior World Cyclo-Cross Championship in 1989, the national championship thirteen times and after turning professional, became World Champion in 2000. When he retired in 2009 he was knighted.

Father & son: Richard initially concentrated on swimming but when he defeated his father on holiday in Switzerland, he stepped over to cycling. • Rein continued to race until he was 40 and competed together with his son for two of those years. He remained at his son's side right up to end of Richard's retirement. • The Grand Prix Groenendaal, dedicated to both athletes since 2009, is an annual international cyclocross race in their hometown of Sint-Michielsgestel.

The Groenendaal family: Richard married Evelien Basten, a former successful cyclist.

Reinier Groenendaal (24 avril 1951, Pays-Bas) s'est imposé dans les années 80 comme l'un des meilleurs coureurs néerlandais de cyclocross. Il remporta le championnat des Pays-Bas en 1985 et termina respectivement deuxième et troisième au classement final du Superprestige en 1984 et 1985. Il a raflé pas moins de 117 titres au cours de sa carrière.

Richard Marinus Anthonius Groenendaal (13 juillet 1971, Pays-Bas) est un véritable monument du cyclocross néerlandais. Champion du monde junior en 1989, il fut champion du monde professionnel en 2000 et 13 fois champion des Pays-Bas. Il mit un terme à sa carrière en 2009 et fut reçu chevalier.

Père & fils : Richard s'est d'abord essayé à la natation avant d'embrasser une carrière de cycliste, suite à des vacances en Suisse au cours desquelles il serait parvenu à distancer son père. • Reiner enchaîna les courses de cyclocross jusqu'à l'âge de 40 ans. Père et fils ont couru ensemble pendant deux ans. Reinier suivit ensuite Richard jusqu'à la fin de sa carrière. • Le Grand Prix Groenendaal, créé en leur honneur en 2009, est une course annuelle et internationale de cyclocross, qui se déroule dans leur commune de Sint-Michielsgestel.

La famille Groenendaal : Richard a épousé Evelien Basten, une ancienne cycliste émérite.

Reinier Groenendaal (24 april 1951, Nederland) gold in de jaren 80 als een van de betere Nederlandse veldrijders. Hij won het Nederlands kampioenschap in 1985 en werd respectievelijk tweede en derde in het eindklassement van de superprestige in 1984 en 1985. Hij schreef in zijn hele carrière 117 veldritten op zijn naam.

Richard Marinus Anthonius Groenendaal (13 juli 1971, Nederland) is een levend monument voor de Nederlandse cyclocross. Hij werd wereldkampioen bij de junioren in 1989, dertien keer nationaal kampioen veldrijden en wereldkampioen bij de professionals in 2000. Bij zijn afscheid in 2009 werd hij geridderd.

Vader & zoon: Richard legde zich aanvankelijk toe op zwemmen maar toen hij er tijdens een vakantie in Zwitserland in slaagde zijn vader uit zijn wiel te rijden, stapte hij over. • Rein bleef tot zijn 40e cyclocrosswedstrijden rijden en reed gedurende twee jaar samen met zijn zoon. Op de cross bleef hij aan de zijde van zijn zoon tot het eind van diens carrière. • De Grand Prix Groenendaal, sinds 2009 aan beiden opgedragen, is een jaarlijkse internationale cyclocrosswedstrijd in hun woonplaats Sint-Michielsgestel.

De familie Groenendaal: Richard trouwde met Evelien Basten, een voormalig verdienstelijk wielrenster.

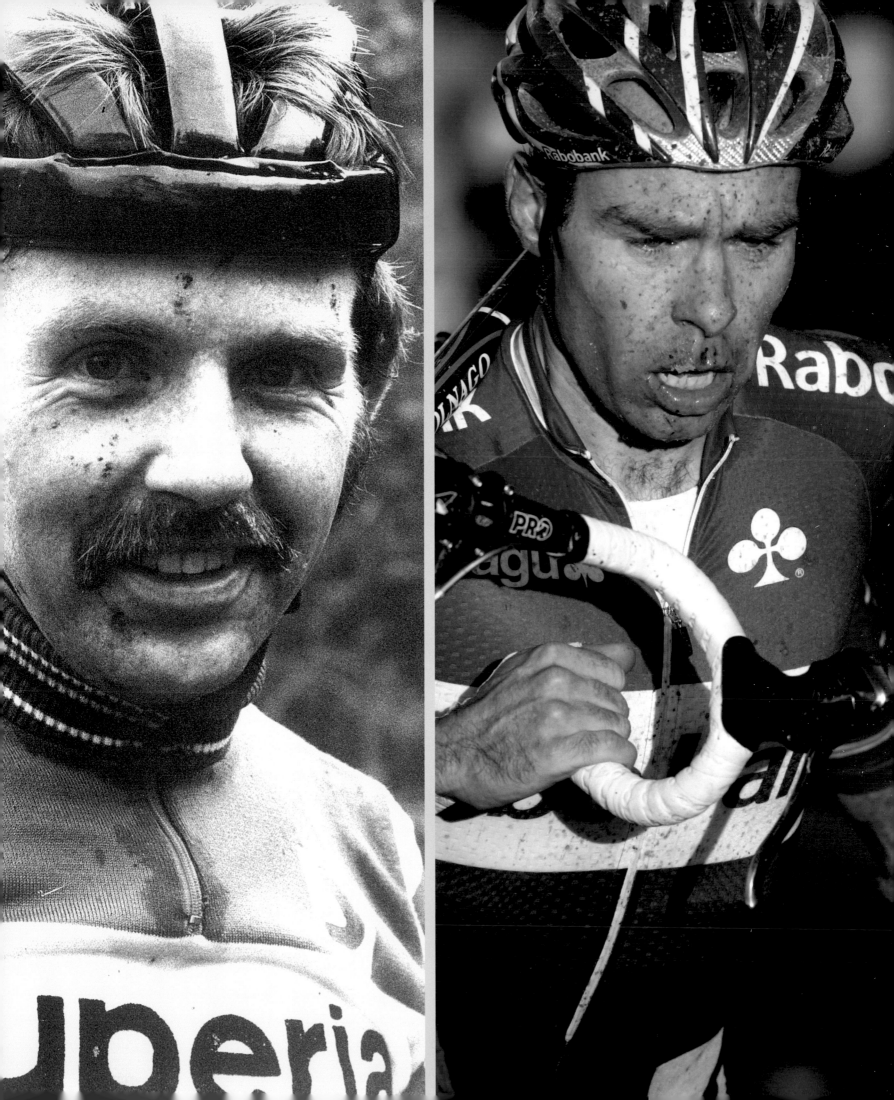

Johnny & David
Hallyday

Johnny Hallyday (Jean-Philippe Smet, 15 June 1943, France) completed 200 tours, sold around 100 million albums, received 39 gold records and appeared in numerous films over the course of his 40-year career. In English-speaking countries, the French rock'n'roll icon is referred to as the biggest rock star you've never heard of.

David Hallyday (David Michael Benjamin Smet, 14 August 1966, France) grew up in the United States as the son of Johnny en yéyé singer Sylvie Vartan. He was quite successful as an amateur sports car racer, but was first noticed as an actor in *He's My Girl* and revealed himself to be a talented singer, multi-instrumentalist and composer.

Father & son: David played drums at the concert for the 20th anniversary of Johnny's career to accompany him on *Les Bon temps du rock'n'roll*. Later they played together more often. • David composed all the music for Johnny's 1999 album *Sang pour Sang*. A year later, he was successful in his own country for the first time when he released his first French album *Un Paradis/Un Enfer*.

The Hallyday family: David recorded the duet *On Se Fait Peur* with his sister Laura Smet in 2010.

Johnny Hallyday (15 juin 1943, France), alias Jean-Philippe Smet, a assuré plus de 180 tournées en 50 ans de carrière, vendu quelque 100 millions d'albums, reçu 39 disques d'or et joué dans un nombre important de films. L'icône française du rock'n'roll est surnommée dans les pays anglophones "la plus grande rock star dont vous n'avez jamais entendu parler".

David Hallyday (14 août 1966, France), alias David Michael Benjamin Smet, est le fils de Johnny et de la chanteuse yéyé Sylvie Vartan. Il a grandi aux États-Unis, puis s'est illustré en tant que pilote de course, avant de s'essayer au cinéma dans les comédies *He's My Girl* et *Grosse Fatigue*. Sur le plan musical, il s'est ensuite révélé un auteur-compositeur-interprète de talent.

Père & fils : Lors du concert célébrant les 20 ans de carrière de Johnny en 1979, David a accompagné son père à la batterie sur le titre "*Le bon temps du rock'n'roll*". Ils joueront régulièrement ensemble par la suite. • David a composé les musiques de l'album *Sang pour Sang* (1999) pour son père et a connu, dès l'année suivante, un grand succès en France avec son premier album en français, *Un Paradis / Un Enfer*.

La famille Hallyday : David a choisi sa sœur, Laura Smet, pour interpréter le duo "*On se fait peur*" en 2010.

Johnny Hallyday (Jean-Philippe Smet, 15 juni 1943, Frankrijk) ondernam tijdens zijn 40 jaar durende carrière 200 tournees, verkocht ongeveer 100 miljoen albums, kreeg 39 gouden platen en speelde in talloze films. Het Franse rock-'n-roll-icoon wordt in Engelstalige landen *the biggest rock star you've never heard* of genoemd.

David Hallyday (David Michael Benjamin Smet, 14 augustus 1966, Frankrijk) groeide op in de States als de zoon van Johnny en yéyé-zangeres Sylvie Vartan. Als autocoureur koerste hij zich een niet onaardig palmares bijeen, als acteur viel hij vooral op in de komedie *He's My Girl* en als muzikant ontpopte hij zich tot een getalenteerd zanger, multi-instrumentalist en componist.

Vader & zoon: Tijdens het concert voor de 20e verjaardag van Johnny's carrière in 1979 sprong David achter het drumstel om hem te begeleiden op *Les Bon temps du rock'n'roll*. Later speelden ze vaker samen. • David schreef alle muziek voor Johnny's album *Sang pour Sang* uit 1999 en scoorde een jaar later zijn eerste succes in zijn geboorteland met zijn eerste Franstalige album *Un Paradis/Un Enfer*.

De familie Hallyday: Met zijn zus Laura Smet nam David in 2010 het duet *On Se Fait Peur* op.

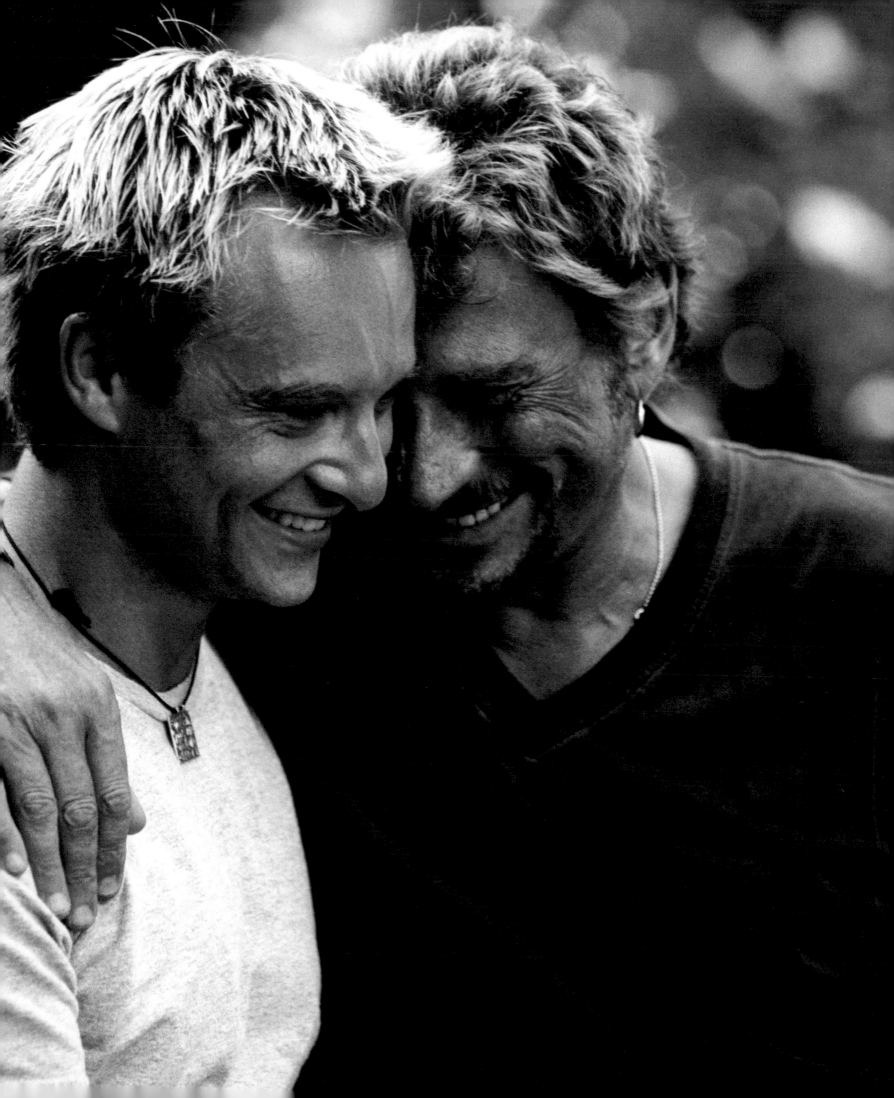

Tom & Colin
Hanks

Thomas Jeffrey Hanks (9 July 1956, USA) is one of the most popular film stars in modern American cinema. He is the first actor, after Spencer Tracy, to win two consecutive Best Actor Academy Awards, in 1994 for *Philadelphia* and in 1995 for *Forrest Gump*. He also won more than 50 other awards for such films as *Big*, *Cast Away*, *A League of their Own* and *Saving Private Ryan*.
Colin Hanks (24 November 1977, USA) became famous due to his appearance in the sci-fi series *Roswell* and the award-winning war series *Band of Brothers*. Since then, he has portrayed a fair amount of decent film roles in films such as *King Kong*, *Orange County* and *Alone With Her*.
Father & son: The physical resemblance between both actors is undeniable. • Colin made his debut in the film *That Thing You Do!* and starred in the miniseries *Band of Brothers*, which were both produced by his father. • Tom decided to play Colin's father in the film *The Great Buck Howard*. "I didn't even ask Colin, I just said, ' Hey listen, I'd like to play the dad.' He kind of rolled his eyes and said, 'Well yeah, I can see why.' And that was that."

Thomas Jeffrey Hanks (9 juillet 1956, États-Unis) est l'une des stars les plus populaires du cinéma américain. Il est le seul, après Spencer Tracy, à avoir remporté consécutivement deux Oscars du meilleur acteur – pour *Philadelphia* (1994) puis *Forrest Gump* (1995). Il a en outre reçu plus de 50 récompenses, notamment pour les films *Big, Seul au monde, Une Équipe hors du commun* et *Il faut sauver le soldat Ryan*.
Colin Hanks (24 novembre 1977, États-Unis) est devenu célèbre grâce à la série de science-fiction "Roswell" et au feuilleton historique "Frères d'armes". Il a également interprété de nombreux rôles au cinéma, notamment dans *King Kong*, *Orange County* et *Alone With Her*.
Père & fils : La ressemblance physique entre les deux acteurs est indéniable. • Colin a fait ses débuts dans le film *That Thing You Do!* et a joué dans la série "Frères d'armes", deux productions signées Tom Hanks. • Tom a lui-même décidé d'incarner le père de Colin à l'écran dans *The Great Buck Howard*. "Je ne l'ai même pas demandé à Colin, j'ai simplement dit, 'Écoute, je veux jouer le père'. Il m'a regardé et a répondu, 'Bien, je peux comprendre pourquoi'. Cela s'est passé comme ça…".

Thomas Jeffrey Hanks (9 juli 1956, VSA) is een van de populairste filmsterren in de moderne Amerikaanse cinema. Hij is de eerste acteur na Spencer Tracy die twee keer na elkaar de Oscar voor beste acteur won, in '94 voor *Philadelphia* en in '95 voor *Forrest Gump*. Daarnaast kreeg hij meer dan 50 andere acteerprijzen, onder meer voor de films *Big, Cast Away, A League of their Own* en *Saving Private Ryan*.
Colin Hanks (24 november 1977, VSA) maakte naam met de scifiserie *Roswell* en de gelauwerde oorlogsserie *Band of Brothers*. Sindsdien heeft hij een respectabel aantal degelijke filmrollen op zijn naam geschreven, onder meer in *King Kong*, *Orange County* en *Alone With Her*.
Vader & zoon: De fysieke gelijkenis tussen beide acteurs is onmiskenbaar. • Colin debuteerde in de film *That Thing You Do!* en speelde mee in de miniserie B*and of Brothers*, beide geproduceerd door zijn vader. • Tom besloot zelf om Colins vader te spelen in de film *The Great Buck Howard*. "Ik heb het Colin niet eens gevraagd, maar gewoon gezegd, 'Hey luister, ik wil de vader spelen.' Hij rolde met zijn ogen en zei, 'Wel ja, ik kan zien waarom.' En dat was dat."

"If I'm still answering the same questions about working with him 10 years from now, I'm going to be disappointed."

Colin Hanks

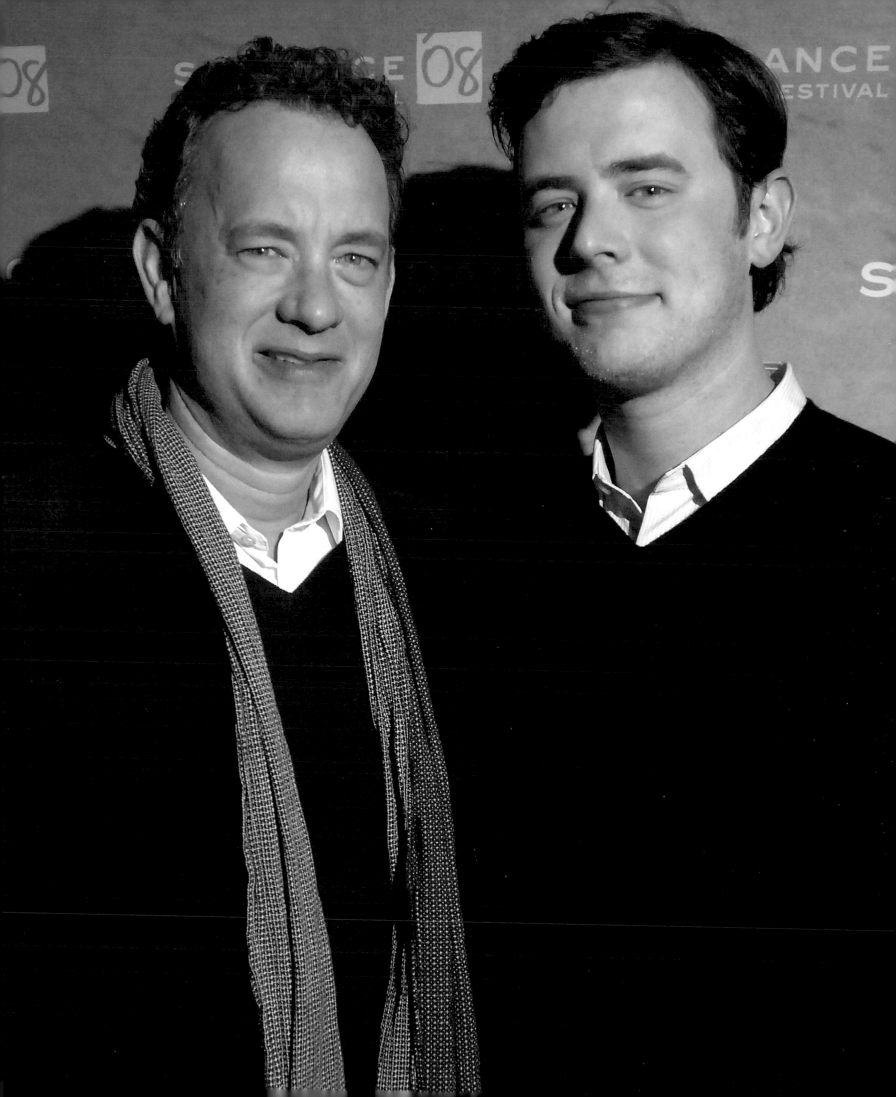

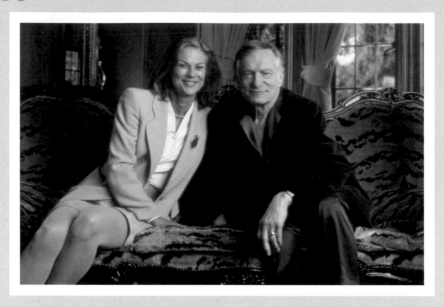

Hugh & Christie
Hefner

Hugh Hefner (9 April 1926, USA) is one of the world's most famous magazine publishers thanks to being the founder, publisher and creative director of Playboy Enterprises. He started his career working at the men's magazine *Esquire* and in 1953 published the first issue of his homemade magazine *Playboy* with Marilyn Monroe as centrefold. His life at the Playboy Mansion, which he has shared with several girlfriends, was extensively captured in the reality series *The Girls of the Playboy Mansion* (also known as *The Girls Next Door*).
Christie Ann Hefner (8 November 1952, USA) started working at Playboy Enterprises in 1974, was then promoted to vice president and was finally made chairman of the board and CEO in 1988. Under her leadership *Playboy* got a worldwide distribution, became the first American national magazine on the internet in 1994 and developed into a lifestyle and multimedia company. In 2009, Barack Obama's victory inspired her to dedicate her life to charity.
Father & daughter: They were in charge of Playboy Enterprises together for 35 years. • Christie created the Hugh M. Hefner First Amendment Award in honour of her father.

Hugh Hefner (9 avril 1926, États-Unis), fondateur, éditeur et directeur créatif de Playboy Enterprises, Inc., est l'un des éditeurs de magazines les plus célèbres de l'histoire. Débutant sa carrière en travaillant pour le magazine masculin *Esquire*, il a créé en 1953 le magazine *Playboy*, avec Marilyn Monroe en page centrale. Sa vie dans la Playboy Mansion, où il cohabite depuis des années avec plusieurs de ses conquêtes, a été mise en lumière dans le programme de télé-réalité "Les Girls de Playboy" (également connue sous le nom de *"The Girls Next Door"*).
Christie Ann Hefner (8 novembre 1952, États-Unis) commence à travailler pour Playboy Enterprises en 1974. Elle en devient la vice-présidente, puis la présidente du conseil d'administration et le PDG en 1988. Sous l'impulsion de Christie, *Playboy* a connu une distribution mondiale et est devenu, en 1994, le premier magazine national américain sur Internet. Playboy Enterprises a également évolué et s'impose désormais comme une société "lifestyle et multimédia". En 2009, Christie déclare avoir été inspirée par Barack Obama et quitte son poste pour aider son pays.
Père & fille : Tous deux ont dirigé Playboy Enterprises pendant 35 ans. • Christie créa le Hugh M. Hefner First Amendment Award en l'honneur de son père.

Hugh Hefner (9 april 1926, VSA) is als stichter, uitgever en creatief directeur van Playboy Enterprises een van 's werelds bekendste tijdschriften-uitgevers. Hij begon zijn carrière bij het mannenblad Esquire en publiceerde in '53 het eerste nummer van zijn zelfgemaakte blad *Playboy* met als centerfold Marilyn Monroe. Zijn leven in de Playboy Mansion, dat hij al jaren deelt met meerdere vriendinnetjes, werd uitgebreid vastgelegd in de realityserie *The Girls of the Playboy Mansion* (ook gekend als *The Girls Next Door*).
Christie Ann Hefner (8 november 1952, VSA) ging in '74 aan de slag bij Playboy Enterprises, werd vervolgens vicepresidente en in 1988 voorzitster van de raad van bestuur en CEO. Onder haar leiding kreeg *Playboy* een wereldwijde distributie, werd het in '94 het eerste Amerikaanse natio-nale magazine op het internet en groeide de tijdschriftuitgeverij uit tot een lifestyle- en multimediabedrijf. In 2009 voelde ze zich door Barack Obama's overwinning geïnspireerd om zich voltijds te gaan wijden aan liefdadigheid.
Vader & dochter: Ze stonden 35 jaar samen aan het roer van Playboy Enterprises. • Christie riep de Hugh M. Hefner First Amendment Award in het leven ter ere van haar vader.

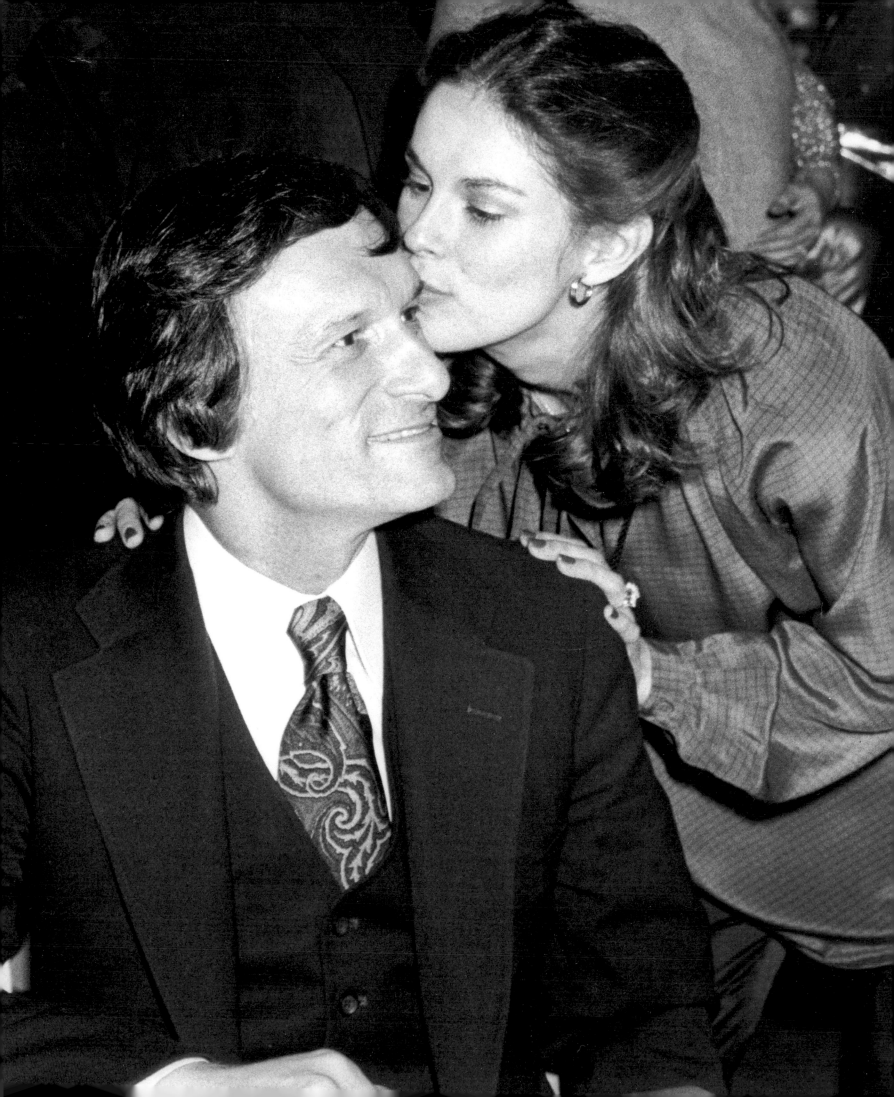

Graham & Damon
Hill

Norman Graham Hill (17 February 1929 - 29 November 1975, Great Britain) was a two-time Formula One World Champion and the only driver to win the Triple Crown of Motorsport: the Indianapolis 500, the 24 hours of Le Mans and the Monaco Grand Prix (five times).
Damon Graham Devereux Hill (17 September 1960, Great Britain) went into Formula 1 racing in 1992 and promptly became Michael Schumacher's greatest rival. He won the 1996 World Championship but was then dropped by the Williams team for unclear reasons. Three disappointing seasons later, he retired to become a businessman and guest guitarist in celebrity bands.
Father & son: Damon is the only son of a Formula 1 World Champion to have won the title.
The Hill family: Graham was killed, along with five others, when the small aeroplane that he was piloting crashed. Because he was not insured, his inheritance went almost completely to settlements. After that, his family struggled to make ends meet. • Damon's son Josh drives in the Formula Ford championship. Just like Graham and Damon, he wears a dark blue helmet with eight white stripes and the number '0'.

Norman Graham Hill (17 février 1929 - 29 novembre 1975, Angleterre) a été deux fois champion du monde de Formule 1. Il demeure le seul pilote au monde à avoir remporté la "Triple couronne", à savoir : les 500 miles d'Indianapolis, les 24 Heures du Mans et le Grand Prix de Monaco (à cinq reprises).
Damon Graham Devereux Hill (17 septembre 1960, Angleterre) est devenu pilote de Formule 1 en 1992, se présentant rapidement comme l'un des principaux rivaux de Michael Schumacher. Il a remporté le championnat du monde en 1996, mais a ensuite quitté l'écurie Williams. Après trois saisons décevantes, il s'est retiré de la compétition pour se lancer dans les affaires et la musique. Il est désormais guitariste au sein de différents groupes.
Père & fils : Damon est le seul pilote champion du monde de F1 dont le père fut également champion du monde.
La famille Hill : Graham fut victime d'un accident, aux côtés de 5 autres personnes, aux commandes de son avion privé. • Le fils de Damon, Josh, s'est lancé dans le sport automobile. Il porte, comme Graham et Damon, un casque bleu avec huit bandes blanches et le numéro 0, comme son père.

Norman Graham Hill (17 februari 1929 - 29 november 1975, Groot-Brittannië) was tweevoudig wereldkampioen Formule 1 en de enige ter wereld die de Triple Crown of Motorsport wist te winnen: de Indianapolis 500, de 24 uur van Le Mans en de Grand Prix van Monaco (vijfmaal).
Damon Graham Devereux Hill (17 september 1960, Groot-Brittannië) kwam in '92 in de Formule 1 terecht en groeide prompt uit tot Michael Schumachers grootste rivaal. Hij won in '96 het wereldkampioenschap maar werd daarna om onduidelijke redenen uit het Williams-team gezet. Drie teleurstellende seizoenen later trok hij zich terug om zakenman en gastgitarist bij celebrity bands te worden.
Vader & zoon: Damon is de enige zoon van een Formule 1-wereldkampioen die zelf ook wereldkampioen werd.
De familie Hill: Graham kwam met vijf anderen om het leven toen het vliegtuigje dat hij bestuurde neerstortte. Omdat hij niet verzekerd was, ging zijn nalatenschap vrijwel geheel op aan regelingen. Van dan af moesten de Hills schrapen om rond te komen. • Damons zoon Josh rijdt mee in de Formula Ford serie. Hij draagt net zoals Graham en Damon een donkerblauwe helm met acht witte strepen en het nummer '0' waar zijn vader mee racete.

"My father didn't tell me how to live; he lived and let me watch him do it."

Clarence Budington Kelland
(1881-1964), American author

Bobby & Brett
Hull

Robert Marvin 'Bobby' Hull (3 January 1939, Canada) is regarded as one of the greatest ice hockey players of all time and perhaps the greatest left-winger ever. He played for the Chicago Black Hawks, Winnipeg Jets and Hartford Whalers. Hull was famous for his blond hair, unmatched skating speed and fast shooting.

Brett Andrew Hull (9 August 1964, Canada) was an impressive all-round hockey player who scored 741 goals, placing him third all-time for most goals in the National Hockey League. In 1999, he won the Stanley Cup with the Dallas Stars and once again in 2002, with the Detroit Red Wings. Currently, he is the executive Vice President of the Dallas Stars.

Father & son: Bobby was nicknamed The Golden Jet, Brett was called The Golden Brett and together they were known as The Golden Duo. • Brett and Bobby are the only father-son combination to have played in the NHL and to be inducted into the Hockey Hall of Fame. • Brett wore number 9 at the end of his career. This number had been withdrawn after his father had left the Winnipeg Jets but Brett had been given permission to use it.

The Hull family: Brother Dennis Hull is also a famous ice hockey player.

Robert Marvin "Bobby" Hull (3 janvier 1939, Canada) est considéré comme l'un des plus grands hockeyeurs de tous les temps, voire comme le meilleur ailier gauche. Il a joué pour les Blackhawks de Chicago, les Jets de Winnipeg et les Whalers de Hartford, et est resté dans les mémoires pour sa chevelure blonde, sa vitesse imparable et ses lancers foudroyants.

Brett Andrew Hull (9 août 1964, Canada) est un hockeyeur prodige et complet, devenu avec 741 buts le 3e meilleur buteur de tous les temps de la Ligue nationale de hockey. En 1999 et 2002, il a remporté la Stanley Cup avec les Stars de Dallas puis les Red Wings de Détroit. Il est aujourd'hui le manager des Stars de Dallas.

Père & fils : Bobby fut surnommé *"The Golden Jet"*, Brett *"The Golden Brett"* ; ils sont également connus comme étant *"The Golden Duo"*.
• Brett et Bobby sont le seul duo père-fils à avoir évolué en LNH et à être admis au *Hall of Fame* du hockey.

La famille Hull : Le frère de Bobby, Dennis Hull, est aussi un hockeyeur célèbre.

Robert Marvin 'Bobby' Hull (3 januari 1939, Canada) wordt aanzien als een van de grootste ijshockeyers aller tijden en wellicht de beste left wing-speler ooit. Hij speelde voor de Chicago Black Hawks, Winnipeg Jets en Hartford Whalers, en stond bekend voor zijn blonde haardos, ongeëvenaarde schaatssnelheid en snelle schot.

Brett Andrew Hull (9 augustus 1964, Canada) was een indrukwekkende allround hockeyspeler die met 741 goals de derde beste schutter aller tijden is in de National Hockey League. In 1999 veroverde hij de Stanley Cup met de Dallas Stars, in 2002 met de Detroit Red Wings. Momenteel is hij de Executive Vice President van de Dallas Stars.

Vader & zoon: Bobby droeg de bijnaam The Golden Jet, Brett werd The Golden Brett genoemd, en samen staan ze gekend als The Golden Duo. • Brett en Bobby vormen de enige vader-zoon combinatie die in de NHL meespeelde en opgenomen werd in de Hockey Hall of Fame. • Brett speelde op het eind van zijn carrière met het nummer 9, een nummer dat na zijn vaders vertrek bij de Winnipeg Jets was teruggetrokken, maar dat hij met diens toestemming toch mocht gebruiken.

De familie Hull: Bobby's broer Dennis is ook een bekend ijshockeyspeler.

John & Anjelica
Huston

John Huston (5 August 1906 - 28 August 1987, USA) is referred to as the 'renaissance man' of the film industry: he acted in films like in *Chinatown* and also wrote most of the 37 films he directed, including such classics as *The Maltese Falcon*, *Key Largo*, *The Asphalt Jungle* and *The Misfits*.
Anjelica Huston (8 July 1951, USA) started out as a model but became world famous as an actress in films like *Prizzi's Honor*, *Enemies, a Love Story*, *The Grifters*, *The Addams Family* and more recently *The Royal Tenenbaums*. She has regularly directed films since the end of the 90s.
Father & daughter: Anjelica made her film debut in 1969 in her father's *A Walk With Love and Death*, won an Oscar with his *Prizzi's Honour* and also appeared in his last film *The Dead*.
The Huston family: John's father Walter was an actor who came to fame in the time of the first 'talkies'. • Anjelica's half-brother Danny and her nephew Jack Huston are actors. • Together with the Coppolas, the Hustons are the only Hollywood family with Oscar winners in three generations: John Huston won two Oscars and directed both his father and his daughter in Oscar winning performances.

John Huston (5 août 1906 - 28 août 1987, États-Unis) fut l'un des maîtres d'Hollywood : il a écrit la plupart des 37 films qu'il a réalisés, dont *Le Faucon maltais*, *Key Largo*, *Quand la ville dort* et *Les Désaxés*. Il a également joué dans des classiques tels que *Chinatown*.
Anjelica Huston (8 juillet 1951, États-Unis) a débuté sa carrière comme mannequin, avant de connaître la consécration au cinéma en tournant dans *L'Honneur des Prizzi*, *Ennemies*, *Une Histoire d'amour*, *Les Arnaqueurs*, *La Famille Addams* et, plus récemment, *La Famille Tenenbaum*. Depuis la fin des années 90, on la retrouve également au poste de réalisatrice.
Père & fille : Anjelica fit ses débuts en 1969 dans le film de son père *A Walk With Love and Death* ; elle remporta un Oscar pour *L'Honneur des Prizzi* et joua dans le dernier film de John, *Gens de Dublin*.
La famille Huston : Le père de John, Walter Huston, fut l'une des premières grandes vedettes du cinéma parlant. • Danny et Jack Huston, demi-frère et neveu d'Anjelica, sont également acteurs. • Avec les Coppola, les Huston sont la seule famille hollywoodienne oscarisée sur trois générations : John Huston remporta deux Oscars et dirigea son père et sa fille dans des productions elles-mêmes oscarisées.

John Huston (5 augustus 1906 - 28 augustus 1987, VSA) wordt de 'renaissance man' van de filmwereld genoemd: hij acteerde in films als *Chinatown* en schreef de meeste van de 37 films die hij regisseerde zelf, waaronder klassiekers als *The Maltese Falcon*, *Key Largo*, *The Asphalt Jungle* en *The Misfits*.
Anjelica Huston (8 juli 1951, VSA) begon haar carrière als model maar werd wereldberoemd als actrice in films als *Prizzi's Honor*, *Enemies - a Love Story*, *The Grifters* en *The Addams Family* en meer recentelijk *The Royal Tenenbaums*. Sinds het eind van de jaren 90 kruipt ze ook regelmatig in de regisseursstoel.
Vader & dochter: Anjelica maakte in '69 haar filmdebuut in haar vaders *A Walk With Love and Death*, won een oscar met zijn *Prizzi's Honour* en speelde ook mee in zijn laatste prent *The Dead*.
De familie Huston: Johns vader Walter was een acteur die naam maakte in de tijd van de eerste gesproken films. • Anjelica's halfbroer Danny en haar neefje Jack Huston zijn acteurs. • Samen met de Coppola's zijn de Hustons de enige Hollywoodfamilie met oscarwinnaars in drie generaties: John Huston won twee oscars en regisseerde zijn vader én zijn dochter in oscarwinnende vertolkingen.

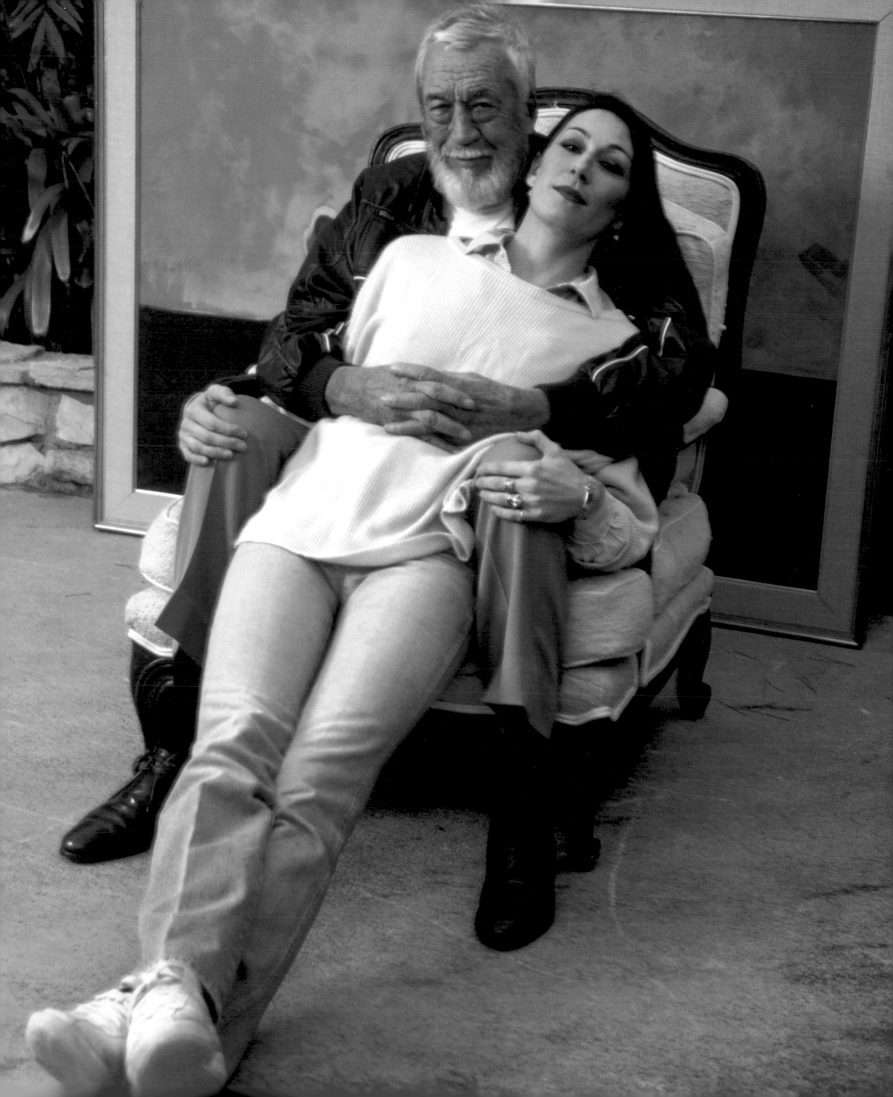

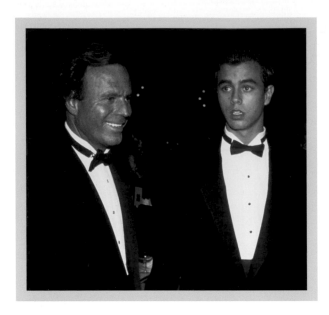

Julio & Enrique
Iglesias

Julio José Iglesias de la Cueva (23 September 1943, Spain) has long been the best-selling artist in Spain and one of the most famous Spanish singers in the world. He has sold over 260 million albums worldwide in 14 languages, released 77 albums and scored numerous worldwide hits with such songs as *Un Canto a Galicia* and *To All the Girls I've Loved Before*.

Enrique Miguel Iglesias Preysler (8 May 1975, Spain) moved to the United States with his mother after his parents' divorce. There he became one of the most successful crossover artists and later went on to become the world's most popular Latino singer. He has sold over 60 million albums in English and Spanish, and has recently widened his repertoire with French songs.

Father & son: There have been rumours going around of a feud between them ever since Enrique admitted that he felt obliged to flee to Toronto to build his own career. • Enrique took his first musical steps as Enrique Martinez to avoid any comparison to his father.

The Iglesias family: Julio has eight children. Julio Jr. and Chabeli are also in the music business.

Julio José Iglesias de la Cueva (23 septembre 1943, Espagne) est, depuis des années, l'artiste qui vend le plus de disques en Espagne et l'un des chanteurs espagnols les plus célèbres au monde. Il a vendu au total plus de 260 millions de disques dans 14 langues, a sorti 77 albums et interprété de nombreux hits planétaires comme "*Un Canto a Galicia*" et "*To All the Girls I've Loved Before*".

Enrique Miguel Iglesias Preysler (8 mai 1975, Espagne) s'installe aux États-Unis avec sa mère après le divorce de ses parents. Il devient un artiste célèbre et s'impose progressivement comme le chanteur latino le plus populaire outre-Atlantique. Il a vendu plus de 60 millions d'albums en anglais et en espagnol, et a aussi interprété récemment quelques titres en français.

Père & fils : Des rumeurs d'inimitié entre Julio et Enrique circulent depuis que celui-ci a déclaré avoir dû s'expatrier à Toronto pour lancer sa propre carrière. • Pour éviter toute comparaison avec son père, Enrique a fait ses premiers pas dans la chanson sous le nom d'Enrique Martinez.

La famille Iglesias : Julio est à la tête d'une fratrie de 8 enfants. Julio Jr. et Chabeli sont également chanteurs.

Julio José Iglesias de la Cueva (23 september 1943, Spanje) is sinds jaar en dag de best verkopende artiest in Spanje en een van de beroemdste Spaanse zangers ter wereld. Hij verkocht wereldwijd ruim 260 miljoen platen in 14 talen, bracht 77 albums uit en scoorde talloze wereldhits met nummers als *Un Canto a Galicia* en *To All the Girls I've Loved Before*.

Enrique Miguel Iglesias Preysler (8 mei 1975, Spanje) trok na de scheiding van zijn ouders met zijn moeder naar de States. Daar werd hij een van de meest succesvolle cross-overartiesten en later groeide hij zelfs uit tot 's werelds meest populaire Latino zanger. Hij verkocht al meer dan 60 miljoen albums in het Engels en het Spaans, en breidde onlangs zijn repertoire uit met nummers in het Frans.

Vader & zoon: Geruchten over een vete tussen beiden doen al de ronde sinds Enrique toegaf dat hij zich ertoe verplicht zag naar Toronto te vluchten om een eigen carrière uit te bouwen. • Om elke vergelijking met zijn vader te vermijden, zette Enrique zijn eerste muzikale stappen onder de naam Enrique Martinez.

De familie Iglesias: Julio heeft acht kinderen. Ook Julio Jr. en Chabeli zitten in de muziekwereld.

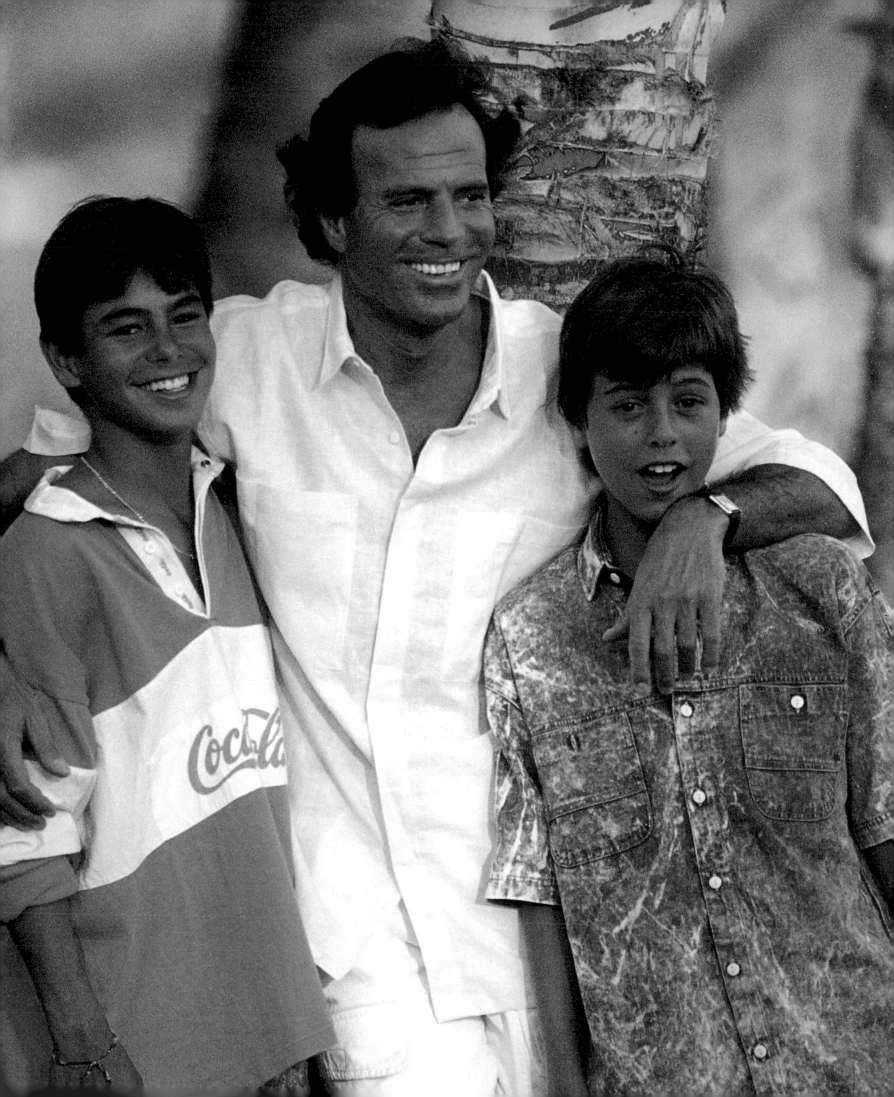

"Being someone else's son makes you unoriginal."

Enrique Iglesias

Maurice & Jean-Michel
Jarre

Maurice-Alexis Jarre (13 September 1924 - 28 March 2009, France) was one the greatest film composers ever. He wrote music for over 150 films and won Academy Awards for *Lawrence of Arabia*, *Doctor Zhivago* and *A Passage to India*. In the 80s, he started experimenting with electronic music, which is clearly echoed in the soundtracks of films such as *Ghost*, *Witness* and *Fatal Attraction*.

Jean-Michel André Jarre (24 August 1948, France) is an iconic 70s, 80s and 90s synthesizer music composer. He broke through with his first album and rose to international prominence due to his huge outdoor concerts with laser displays and fireworks. Albums like *Equinoxe* and his later work for television and films validated his success and aided him in selling 60 million albums over the course of his career that now spans over 30 years.

Father & son: Reportedly, Maurice en Jean-Michel had a strained relationship for some time and never worked together. • Jean-Michel became a big name in the genre that his father had evolved into in his later life: electronic music.

The Jarre family: Youngest son Kevin Jarre is the screenplay writer of, amongst others, *Tombstone* and *Glory*.

Maurice-Alexis Jarre (13 septembre 1924 - 28 mars 2009, France) est l'un des plus grands compositeurs de musiques de films de l'histoire. Il a composé la musique de plus de 150 films et remporté des Oscars, notamment pour *Lawrence d'Arabie*, *Docteur Jivago* et *La Route des Indes*. Dans les années 80, il expérimenta la musique électronique, comme en témoignent les bandes originales de *Ghost*, *Witness* et *Liaison fatale*.

Jean-Michel André Jarre (24 août 1948, France) est l'icône par excellence de la musique électronique des années 70 et 80. Son premier album, *Oxygène*, est un succès et Jean-Michel devient bientôt mondialement célèbre pour ses concerts géants effectués en plein air à grands renforts de lasers et d'effets pyrotechniques. Divers albums et des compositions pour la télévision et le cinéma ont ensuite confirmé son succès. Jean-Michel a vendu quelque 60 millions de disques en 30 ans de carrière.

Père & fils : Maurice et Jean-Michel ont connu des relations difficiles et n'ont jamais travaillé ensemble. • Jean-Michel exploita bien davantage le genre vers lequel son père avait progressivement évolué : la musique électronique.

La famille Jarre : Le fils cadet de Maurice, Kevin Jarre, est l'auteur des scénarios des films *Tombstone* et *Glory*.

Maurice-Alexis Jarre (13 september 1924 - 28 maart 2009, Frankrijk) was een van de grootste filmcomponisten aller tijden. Hij schreef muziek voor ruim 150 films en won oscars voor *Lawrence of Arabia*, *Doctor Zhivago* en *A Passage to India*. In de jaren 80 begon hij te experimenteren met elektronische muziek, wat duidelijk doorklonk in de soundtracks van onder meer *Ghost*, *Witness* en *Fatal Attraction*.

Jean-Michel André Jarre (24 augustus 1948, Frankrijk) is hét icoon van de synthesizermuziek uit de jaren 70 en 80. Hij brak door met zijn eerste album *Oxygène* en werd wereldberoemd dankzij zijn grootschalige openluchtconcerten met lasers en vuurwerk. Albums als *Equinoxe* en zijn latere werk voor tv en film bevestigden zijn succes en hielpen hem een totaal van 60 miljoen platen verkopen tijdens een carrière die nu reeds 30 jaar overspant.

Vader & zoon: Maurice en Jean-Michel hadden naar verluidt een tijdlang een stroeve relatie en hebben nooit samengewerkt. • Feit is wel dat Jean-Michel verder ging in het genre waar zijn vader in zijn latere leven naartoe evolueerde: de elektronische muziek.

De familie Jarre: Jongste zoon Kevin Jarre is scenarioschrijver van onder meer *Tombstone* en *Glory*.

Laurent-Désiré & Joseph
Kabila

Laurent-Désiré Kabila (27 November 1938 - 16 January 2001, Congo) fought for over 33 years against the military regime of President Mobutu Sese Seko in Congo. After succeeding in 1997, he proclaimed himself President of the Democratic Republic of the Congo. However, his reign did not bring democracy and prosperity, and another civil war broke out barely a year later.

Joseph Kabila Kabange (4 December 1971, Congo) became President at the age of 29 when his father was assassinated. In 2003, after several attempts to end the civil war, he finally succeeded in setting up an interim government with the leaders of the two rebel groups as vice-presidents. In the middle of 2006, he was re-elected in the first democratic elections in 60 years.

Father & son: Many people are convinced that Laurent-Désiré is not Joseph's biological father, but more likely his foster father. There are three different versions concerning Joseph's parents' identity, his birthplace and age. The opposition has repeatedly demanded a DNA test, so far without success. • Joseph served under Laurent-Désiré as Deputy Chief of Staff of the army.

The Kabila family: Laurent-Désiré fathered over 25 children with more than 13 wives.

Laurent-Désiré Kabila (27 novembre 1938 - 16 janvier 2001, Congo) a combattu plus de 33 ans le régime militaire du président Mobutu au Congo. Après avoir renversé le pouvoir en 1997, il s'autoproclama président de la République démocratique du Congo. Son régime n'apporta néanmoins ni la démocratie, ni la prospérité. À peine un an plus tard, le pays était de nouveau en proie à la guerre civile.

Joseph Kabila Kabange (4 décembre 1971, Congo) devient président à l'âge de 29 ans suite à l'assassinat de son père. Après plusieurs tentatives visant à mettre un terme à la guerre civile, il parvient à mettre en place en 2003 un gouvernement de transition, avec comme vice-présidents les leaders de deux groupes rebelles. Il est réélu en 2006, lors des premières élections démocratiques organisées dans le pays en 60 ans.

Père & fils : Beaucoup affirment que Laurent-Désiré n'est pas le père biologique de Joseph, mais son père adoptif. Il existe effectivement trois versions différentes concernant l'identité des parents de Joseph, son âge et son lieu de naissance. L'opposition a déjà maintes fois exigé un test ADN, en vain. • Joseph a tenu le poste de Vice-Chef d'État-Major de l'armée sous Laurent-Désiré.

La famille Kabila : Laurent-Désiré a eu plus de 25 enfants avec 13 femmes différentes.

Laurent-Désiré Kabila (27 november 1938 - 16 januari 2001, Congo) bevocht ruim 33 jaar lang het militaire regime van president Mobutu Sese Seko in Congo. Nadat hij er in 1997 in slaagde deze te verjagen, riep hij zichzelf uit tot president van de Democratische Republiek Congo. Zijn bewind bracht echter geen democratie en welvaart, en amper een jaar later ontstond er opnieuw een burgeroorlog.

Joseph Kabila Kabange (4 december 1971, Congo) werd op zijn 29e president na de moord op zijn vader. Na meerdere pogingen om een eind te maken aan de burgeroorlog, slaagde hij er in 2003 eindelijk in een interimregering op te zetten met de leiders van twee rebellengroeperingen als vicepresidenten. Midden 2006 werd hij tijdens de eerste democratische verkiezingen in 60 jaar herverkozen.

Vader & zoon: Velen zijn ervan overtuigd dat Laurent-Désiré niet de biologische vader is van Joseph, maar veeleer zijn pleegvader. Feit is dat er drie verschillende versies bestaan omtrent de identiteit van Josephs ouders, zijn geboorteplaats en leeftijd. De oppositie heeft al meermaals een DNA-test geëist, tot nog toe zonder gevolg. • Joseph diende onder Laurent-Désiré als vicestafchef van het leger.

De familie Kabila: Laurent-Désiré had meer dan 25 kinderen bij ruim 13 vrouwen.

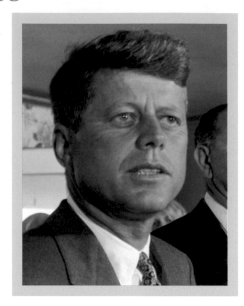

John F. & John F. Jr.
Kennedy

John Fitzgerald Kennedy (29 May 1917 - 22 November 1963, USA) became the youngest President of the United States elected to office in 1961. He is particularly remembered as the man who initiated the Space Race with the Soviet Union and averted the Cuban Missile Crisis. He was assassinated when driving through Dallas in a limousine.
John Fitzgerald Kennedy Jr. (25 November 1960 - 16 July 1999, USA) studied law, was assistant district attorney of New York and in 1995, founded *George*, a monthly politics-as-lifestyle magazine that sometimes critically targeted his own family. He died, along with his wife Carolyn Bessette and her sister Lauren, when the aeroplane that he was piloting crashed.
Father & son: At the age of three, John Jr. was the subject of two iconic photographs: one in which he was playing under his father's desk and the other when he saluted his coffin. • JFK was 46 years old when he died, his son was 38.
The Kennedy family: The Kennedy family constitutes a prominent Irish-American political dynasty that is still influential. • The family has had a long and tragic history of murder and fatal accidents, which is sometimes referred to as the *'Kennedy curse'*.

John Fitzgerald Kennedy (29 mai 1917 - 22 novembre 1963, États-Unis) est devenu en 1961 le plus jeune président de l'histoire des États-Unis. Il a engagé l'Amérique dans la course spatiale avec l'Union soviétique et désamorcé la crise de Cuba. Il fut assassiné dans sa limousine lors d'une visite à Dallas.
John Fitzgerald Kennedy Jr. (25 novembre 1960 - 16 juillet 1999, États-Unis) étudie le droit, devient assistant du procureur de New York, puis fonde en 1995 le magazine *George*, mensuel people et politique dans lequel il épingle parfois les membres de sa famille. Il disparaît tragiquement dans un accident d'avion avec sa femme, Carolyn Bessette, et la sœur de cette dernière.
Père & fils : À l'âge de 3 ans, John Jr. est immortalisé sur deux photos qui font le tour du monde : l'une où il joue sous le bureau présidentiel, l'autre où il fait le salut militaire devant le passage du cercueil de son père. • JFK est mort à l'âge de 46 ans, son fils à l'âge de 38 ans.
La famille Kennedy : Les Kennedy forment une puissante famille politique américaine d'origine irlandaise, dont l'influence est encore très présente aujourd'hui. • Le clan Kennedy a connu de nombreuses tragédies (meurtres et accidents) ; on parle de la "malédiction des Kennedy".

John Fitzgerald Kennedy (29 mei 1917 - 22 november 1963, VSA) werd in 1961 de jongst verkozen president van de Verenigde Staten. Hij wordt vooral herinnerd als de man die de ruimtewedloop met de Sovjet-Unie ontketende en de Cubacrisis afwendde. Hij werd vermoord toen hij in een limousine door Dallas reed.
John Fitzgerald Kennedy Jr. (25 november 1960 - 16 juli 1999, VSA) studeerde rechten, was assistent van de officier van justitie in New York en startte in 1995 het tijdschrift *George*, een maandblad over politiek als levensstijl waarin hij soms zelfs zijn eigen familieleden op de korrel nam. Hij kwam samen met zijn vrouw Carolyn Bessette en haar zus Lauren om in een vliegtuigje dat hij zelf bestuurde.
Vader & zoon: Als driejarige werd John Jr. het onderwerp van twee iconische foto's: een waarin hij onder zijn vaders buro zit te spelen en een waarop hij diens doodskist groet. • JFK was 46 toen hij stierf, zijn zoon 38.
De familie Kennedy: De Kennedy's vormen een prominente Iers-Amerikaanse politieke dynastie die nog steeds invloedrijk is. • De familie kent een lange en tragische geschiedenis van moorden en dodelijke ongevallen, soms de *'Kennedy curse'* genoemd.

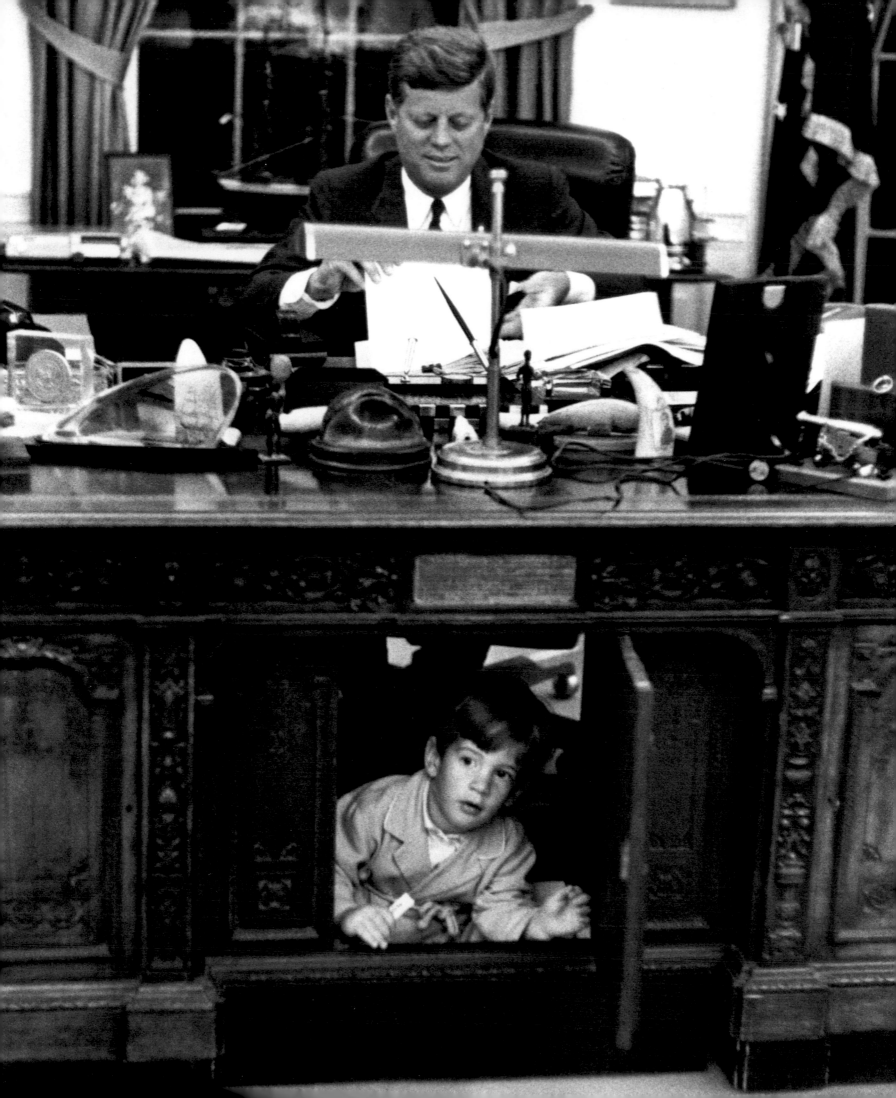

Stephen Joe
King & Hill

Stephen Edwin King (21 September 1947, USA) is the world famous author of numerous collections of short stories and around fifty horror, science fiction and fantasy fiction novels. He has sold over 500 million copies and several of his most famous books have been made into motion pictures, such as *Carrie*, *The Shining*, *The Stand*, *It*, *Misery* and *The Green Mile*.

Joseph 'Joe' Hillstrom King (4 June 1972, USA) started out in 1997 and tried so succeed as a writer of realistic novels using the name Joe Hill. His fantasy story collection *20th Century Ghosts* won him many prizes and his horror novels *Heart-Shaped Box* and *Horns* became international bestsellers.

Father & son: Stephen dedicated *The Shining* to 'Joe Hill, who shines on.' • At the age of 10, he appeared in the film *Creepshow*, which co-starred his father. • Together, they wrote the short story *But Only Darkness Loves Me*. • Joe chose to use a pseudonym because he wanted to succeed on his own merits. However, after his first novel was published, the resemblance to his father blew his cover.

The King family: Joe's mother Tabitha, his brother Owen and his wife Kelly Braffet are also authors. • Joe's wife Leanora proofreads both her husband's and her father-in-law's manuscripts.

Stephen Edwin King (21 septembre 1947, États-Unis), auteur mondialement célèbre, a publié une cinquantaine de romans d'horreur ou fantastiques ainsi que des recueils de nouvelles, dont *Carrie*, *Shining*, *Le Fléau*, *Ça*, *Misery* et *La Ligne verte*. Il a vendu plus de 500 millions d'exemplaires de ses livres à travers le monde. Plusieurs de ses récits ont même été adaptés sur grand écran.

Joseph "Joe" Hillstrom King (4 juin 1972, États-Unis), écrivain de romans réalistes, essaie de se faire connaître sous le nom de plume de Joe Hill depuis 1997. Ses romans d'horreur *Le Costume du mort* et *Horns* sont des best-sellers internationaux. Il reçoit en 2005 de nombreux prix pour son recueil de nouvelles fantastiques *Fantômes - Histoires troubles*.

Père & fils : Stephen a écrit *Shining* en hommage à son fils. • À l'âge de 10 ans, Joe a joué dans *Creepshow* avec Stephen. • Ils ont écrit ensemble la nouvelle "*But Only Darkness Loves Me*".

La famille King : La mère de Joe, Tabitha, son frère Owen et son épouse Kelly Braffet sont également écrivains. • La femme de Joe, Leanora, relit les manuscrits de son mari et ceux de son beau-père.

Stephen Edwin King (21 september 1947, VSA) is de wereldberoemde auteur van een vijftigtal horror-, scifi- en fantasyfictionromans en verscheidene verhalenbundels, waarvan ruim 500 miljoen exemplaren over de toonbank vlogen en een aantal ook verfilmd werden. Enkele van zijn bekendste werken zijn *Carrie*, *The Shining*, *The Stand*, *It*, *Misery* en *The Green Mile*.

Joseph 'Joe' Hillstrom King (4 juni 1972, VSA) probeerde het vanaf 1997 als Joe Hill te maken als schrijver van realistische romans. De fantasyverhalenbundel *20th Century Ghosts* leverde hem in 2005 een karrevracht prijzen op en de horrorromans *Heart-Shaped Box* en *Horns* werden internationale bestsellers.

Vader & zoon: Stephen droeg *The Shining* op aan 'Joe Hill, who shines on.' • Joe speelde op zijn tiende naast zijn vader in de film *Creepshow*. • Samen schreven ze het kortverhaal *But Only Darkness Loves Me*. • Joe koos voor een pseudoniem omdat hij wilde slagen op eigen verdienste. Maar na de publicatie van zijn eerste roman deed de gelijkenis met zijn vader hem de das om.

De familie King: Ook Joe's moeder Tabitha, zijn broer Owen en diens vrouw Kelly Braffet zijn auteurs. • Joe's vrouw Leanora leest zowel de manuscripten van haar man als van haar schoonvader na.

> **"I felt like if I wrote as Joseph King I might not want to write genre fiction, but if I wrote as Joe Hill, I could write whatever I wanted."**
>
> Joe Hill

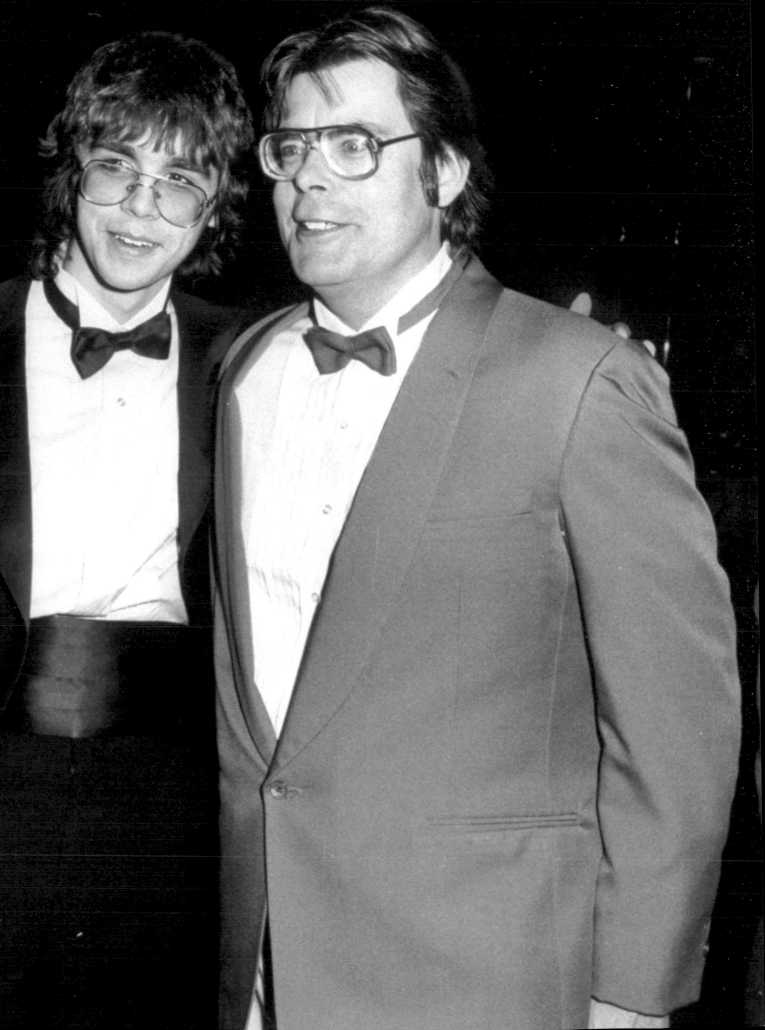

Klaus & Nastassja
Kinski

Nikolaus Karl Günther Nakszyński (18 October 1926 - 23 November 1991, Germany) was a German actor who was especially known for his intense portrayals and temper. He rose to international fame in the 70s thanks to his collaboration with director Werner Herzog, which resulted in masterpieces like *Aguirre: der Zorn Gottes*, *Nosferatu: Phantom der Nacht* and *Cobra Verde*. He starred in over 130 films.

Nastassja Aglaia Nakszyński (24 January 1960 or 1961, Germany) became famous as a teenager due to her controversial relationship with director Roman Polanski and the role in *Tess* that it got her. She became a sex symbol due her appearance in the erotic films *Stay As You Are* and *Cat People* and Richard Avedon's iconic photo of her, nude with a large python. She played in more than 60 productions like *One From the Heart*, *Paris, Texas*, *The Hotel New Hampshire*, *Terminal Velocity* and *One Night Stand*, but has never been able to match the success she experienced in the past.

Father & daughter: After her parents divorced, Nastassja grew up with her mother (actress Ruth Brigitte Tocki) and hardly ever saw her father after the age of 10.

The Kinski family: Klaus's son Nikolai and daughter Pola Kinski were also actors.

Nikolaus Karl Günther Nakszyński (18 octobre 1926 - 23 novembre 1991, Allemagne) a joué dans quelque 130 films. Il s'est rendu célèbre pour l'intensité de ses interprétations à l'écran et son tempérament impulsif. Il connaît un succès international dans les années 70 grâce à sa collaboration avec le réalisateur Werner Herzog, à qui on doit les chefs-d'œuvre *Aguirre, la colère de Dieu*, *Nosferatu, fantôme de la nuit* et *Cobra Verde*.

Nastassja Aglaia Nakszyński (24 janvier 1960 ou 1961, Allemagne) défraye très tôt la chronique en raison de sa liaison avec le réalisateur Roman Polanski et de son rôle dans *Tess*. Les films sulfureux *La Fille* et *La Féline*, ainsi que la photo que fit d'elle Richard Avedon, nue avec un serpent, l'ont érigée au rang de sex-symbol. Elle a joué dans plus de 60 productions, dont *Coup de cœur*, *Paris, Texas*, *Hotel New Hampshire*, *Terminal Velocity* et *Pour une nuit* ; mais elle n'a jamais renoué avec le succès de ses débuts.

Père & fille : Nastassja a grandi auprès de sa mère, l'actrice Ruth Brigitte Tocki, après le divorce de ses parents. Elle n'a que très peu connu son père.

La famille Kinski : Nikolai et Pola Kinski, deux autres enfants de Klaus, sont eux aussi acteurs.

Nikolaus Karl Günther Nakszyński (18 oktober 1926 - 23 november 1991, Duitsland) stond als acteur vooral bekend om zijn intense vertolkingen en temperament. Hij brak in de jaren 70 internationaal door dankzij zijn samenwerking met regisseur Werner Herzog, die pareltjes opleverde als *Aguirre: der Zorn Gottes*, *Nosferatu: Phantom der Nacht* en *Cobra Verde*. In totaal speelde hij in minstens 130 films.

Nastassja Aglaia Nakszyński (24 januari 1960 of 1961, Duitsland) werd als tiener bekend dankzij haar spraakmakende relatie met regisseur Roman Polanski en de daaruitvoortvloeiende rol in *Tess*. Ze groeide uit tot een sekssymbool dankzij de erotische films *Stay As You Are* en *Cat People* en de iconische naaktfoto die Richard Avedon van haar maakte met een wurgslang. Ze speelde in totaal mee in ruim 60 producties, waaronder *One From the Heart*, *Paris, Texas*, *The Hotel New Hampshire*, *Terminal Velocity* en *One Night Stand*, maar wist het succes uit haar begindagen niet meer te evenaren.

Vader & dochter: Nastassja groeide na de scheiding van haar ouders op bij haar moeder, actrice Ruth Brigitte Tocki, en zag haar vader nauwelijks na haar tiende.

De familie Kinski: Klaus' zoon en dochter, Nikolai en Pola Kinski, waren ook acteurs.

> **"I grew up very fast, and yet part of me was always a child longing for that father figure."**
>
> Nastassja Kinski

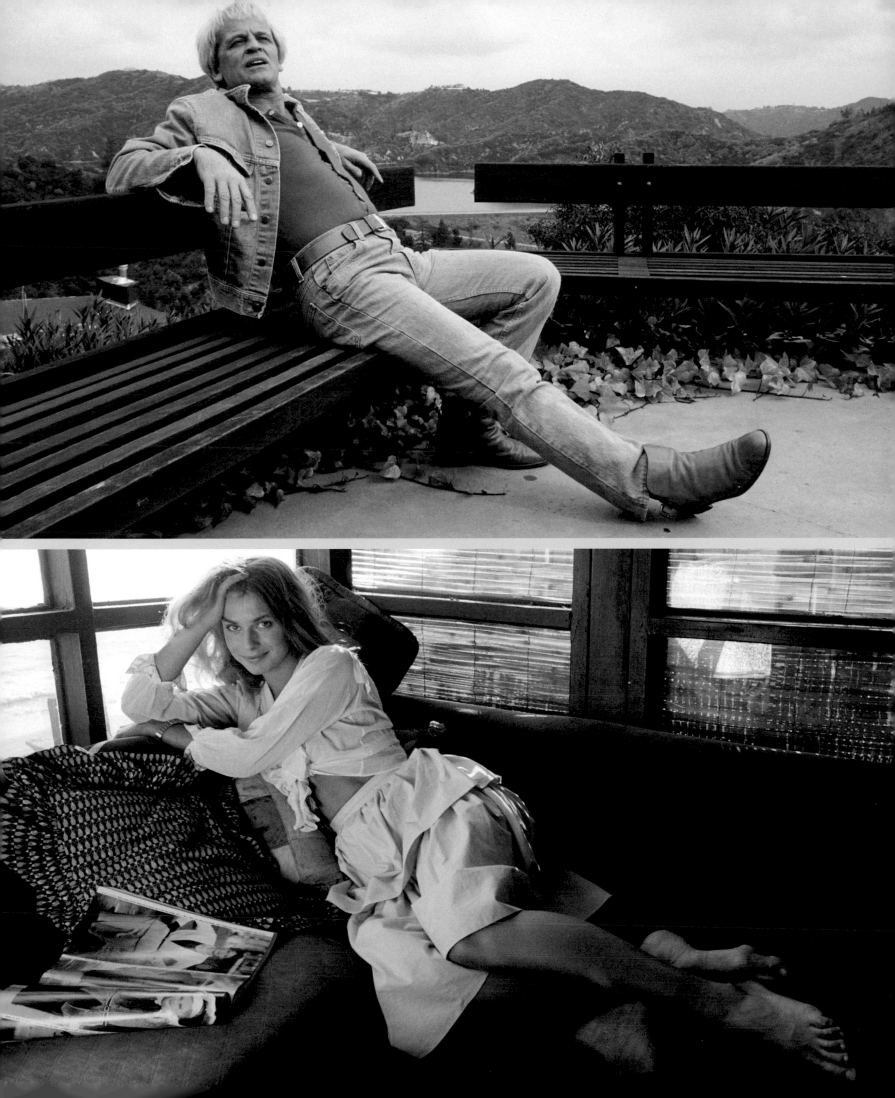

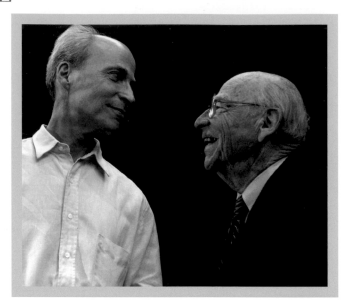

Arthur & Roger D.
Kornberg

Arthur Kornberg (3 March 1918 - 26 Octobers 2007, USA) was a biochemist who conducted pioneering scientific work. Together with Severo Ochoa, he won the Nobel Prize in Physiology or Medicine in 1959 for his 'synthesis of the nucleic acids DNA and RNA'.
Roger D. Kornberg (24 April 1947, USA) was the first chemist and biochemist to be able to visualise DNA transcription. He was awarded the Nobel Prize in Chemistry in 2006 for his 'Studies of the molecular basis of eukaryotic transcription'.
Father & son: Their research followed each other perfectly: Arthur described what genetic information transfers from mother to daughter cell and his son did research into how DNA is copied to messenger RNA. This process, referred to as transcription, is necessary in all living organisms.
• Roger was twelve years old when he attended his father's Nobel Prize ceremony. Arthur lived just long enough to witness his son's triumph.
The Kornberg family: Arthur's first wife Sylvy Ruth Levy was also a biochemist and worked closely with her husband. His son Thomas is also a leading biochemist and his third son Kenneth Andrew is an architect who specialises in designing biochemical laboratories.

Arthur Kornberg (3 mars 1918 - 26 octobre 2007, États-Unis) est le biochimiste qui a mis au point la synthèse des acides nucléiques ADN et ARN. Grâce à ces travaux, il a obtenu en 1959 le prix Nobel "de physiologie ou médecine" avec Severo Ochoa.
Roger D. Kornberg (24 avril 1947, États-Unis) est le premier biochimiste à avoir esquissé une transcription de l'ADN. Il fut le lauréat du prix Nobel de chimie en 2006 "pour ses travaux sur les bases moléculaires de la transcription chez les eucaryotes".
Père & fils : Les recherches du père et du fils se complètent parfaitement : Arthur a décrit comment l'information génétique se transmet de la cellule mère à la cellule fille ; Roger étudia comment l'ADN se transmet à l'ARN messager. Ce processus appelé "transcription" est nécessaire à toute vie sur la Terre. • Alors que Roger assista à la remise du prix Nobel de son père, Arthur était également présent lors du triomphe de son fils.
La famille Kornberg : Sylvy Ruth Levy, biochimiste et première épouse d'Arthur, a étroitement collaboré avec son mari. Les frères de Roger, Thomas et Kenneth Andrew, sont respectivement biochimiste et architecte. Kenneth Andrew s'occupe de la conception de laboratoires biochimiques.

Arthur Kornberg (3 maart 1918 - 26 oktober 2007, VSA) verrichtte als biochemicus baanbrekend wetenschappelijk werk. Voor zijn 'synthese van de nucleïnezuren DNA en RNA' ontving hij in 1959 samen met Severo Ochoa de Nobelprijs voor de Fysiologie of Geneeskunde.
Roger D. Kornberg (24 april 1947, VSA) was de eerste scheikundige en biochemicus die een beeld wist te schetsen van DNA-transcriptie. Voor zijn 'studies omtrent de moleculaire basis van eukaryotische transcriptie' kreeg hij in 2006 de Nobelprijs voor Scheikunde.
Vader & zoon: Het onderzoek van vader en zoon sluit perfect bij elkaar aan: waar Arthur beschreef hoe genetische info van de moeder- naar de dochtercel wordt overgebracht, onderzocht Roger hoe DNA wordt gekopieerd naar boodschapper-RNA. Dit proces, dat transcriptie wordt genoemd, is noodzakelijk voor al het leven op aarde. • Roger was als twaalfjarige getuige van de uitreiking waarop zijn vader de Nobelprijs in ontvangst mocht nemen. Arthur maakte de triomf van zijn zoon nog net mee.
De familie Kornberg: Arthurs eerste vrouw, Sylvy Ruth Levy, werkte als biochemicus nauw samen met haar man. Zoon Thomas is ook een vooraanstaand biochemicus, en derde zoon Kenneth Andrew een architect die zich toelegt op het ontwerpen van biochemische laboratoria.

"There must always be a struggle between a father and son, while one aims at power and the other at independence."

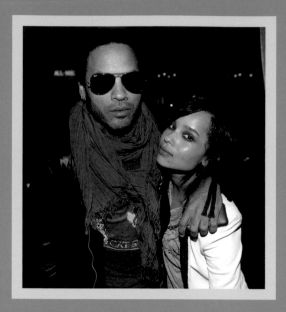

Lenny & Zoë
Kravitz

Leonard Albert 'Lenny' Kravitz (26 May 1964, USA) broke through with his debut album *Let Love Rule* in 1989 and became a world star thanks to its successor *Mama Said*. He has worked with great stars like Madonna, Mick Jagger and Bruce Springsteen, and scored major hits, including *Mr. Cabdriver*, *Are You Gonna Go My Way*, *It Ain't Over Till It's Over* and *Where are We Running*.
Zoë Isabella Kravitz (1 December 1988, USA), daughter of actress Lisa Bonet, works regularly as a model, is the face of Vera Wang's perfume Princess and singer in the band Elevator Fight. She has appeared in several popular television series and eight films, including *No Reservations* and *The Brave One*. Some of Vera's next projects are a *Mad Max* sequel and an *X-Men* spinoff.
Father & daughter: Lenny wrote the songs *Flowers for Zoë* and *Little Girl's Eyes* for her. • Bonet and Kravitz divorced when Zoë was five. She went to live with her father when she was eleven. • Father and daughter are very close and are often spotted together. They showed up together at the 2010 Academy Awards ceremony. • Zoë, like her father, loves tattoos: he has four and she has eighteen.

Leonard Albert "Lenny" Kravitz (26 mai 1964, États-Unis) sort son premier album, *Let Love Rule*, en 1989 et connaît la consécration avec son deuxième opus, intitulé *Mama Said*. Il collabore avec les plus grands, dont Madonna, Mick Jagger ou encore Bruce Springsteen, et produit les tubes planétaires "*Mr. Cab Driver*", "*Are You Gonna Go My Way*", "*It Ain't Over Till It's Over*" et "*Where Are We Running*".
Zoë Isabella Kravitz (1ᵉʳ décembre 1988, États-Unis) est la fille de l'actrice Lisa Bonet. Mannequin, elle a notamment prêté son visage au parfum *Princess*, de Vera Wang. Chanteuse du groupe *Elevator Fight*, elle a également joué dans plusieurs séries et fait ses premiers pas au cinéma dans *Le Goût de la vie* puis *À vif*. D'autres longs métrages suivront, notamment *Mad Max: Fury Road* et *X-Men: First Class*.
Père & fille : Lenny a écrit les titres "*Flowers for Zoë*" et "*Little Girl's Eyes*" pour sa fille. • Kravitz et sa femme ont divorcé lorsque Zoë avait 5 ans. • Père et fille sont très proches : ils s'étaient d'ailleurs rendus ensemble à la cérémonie des Oscars en 2010. • Comme Lenny, Zoë aime les tatouages : il en a 4, elle 18.

Leonard Albert 'Lenny' Kravitz (26 mei 1964, VSA) brak in 1989 door met zijn debuutalbum *Let Love Rule* en werd een wereldster dankzij de opvolger *Mama Said*. Hij werkte samen met groten als Madonna, Mick Jagger en Bruce Springsteen, en scoorde wereldhits als *Mr. Cabdriver*, *Are You Gonna Go My Way*, *It Ain't Over Till It's Over* en *Where are we Running*.
Zoë Isabella Kravitz (1 december 1988, VSA), dochter van actrice Lisa Bonet, werkt geregeld als model, is het gezicht van Vera Wangs parfum Princess en zangeres van de band Elevator Fight. Ze speelde al mee in een aantal populaire tv-series en een achttal films, waaronder *No Reservations* en *The Brave One*, en mag binnenkort aantreden in onder meer een *Mad Max*-sequel en een *X-Men*-spinoff.
Vader & dochter: Lenny schreef de nummers *Flowers for Zoë* en *Little Girl's Eyes* voor haar. • Bonet en Kravitz scheidden toen Zoë er vijf was. Op haar elfde trok ze in bij haar vader. • Vader en dochter zijn erg close en worden geregeld samen gespot. Zo gingen ze in 2010 samen naar de Oscaruitreiking. • Zoë houdt net als haar vader van tatoeages: hij heeft er een viertal, zij intussen al achttien.

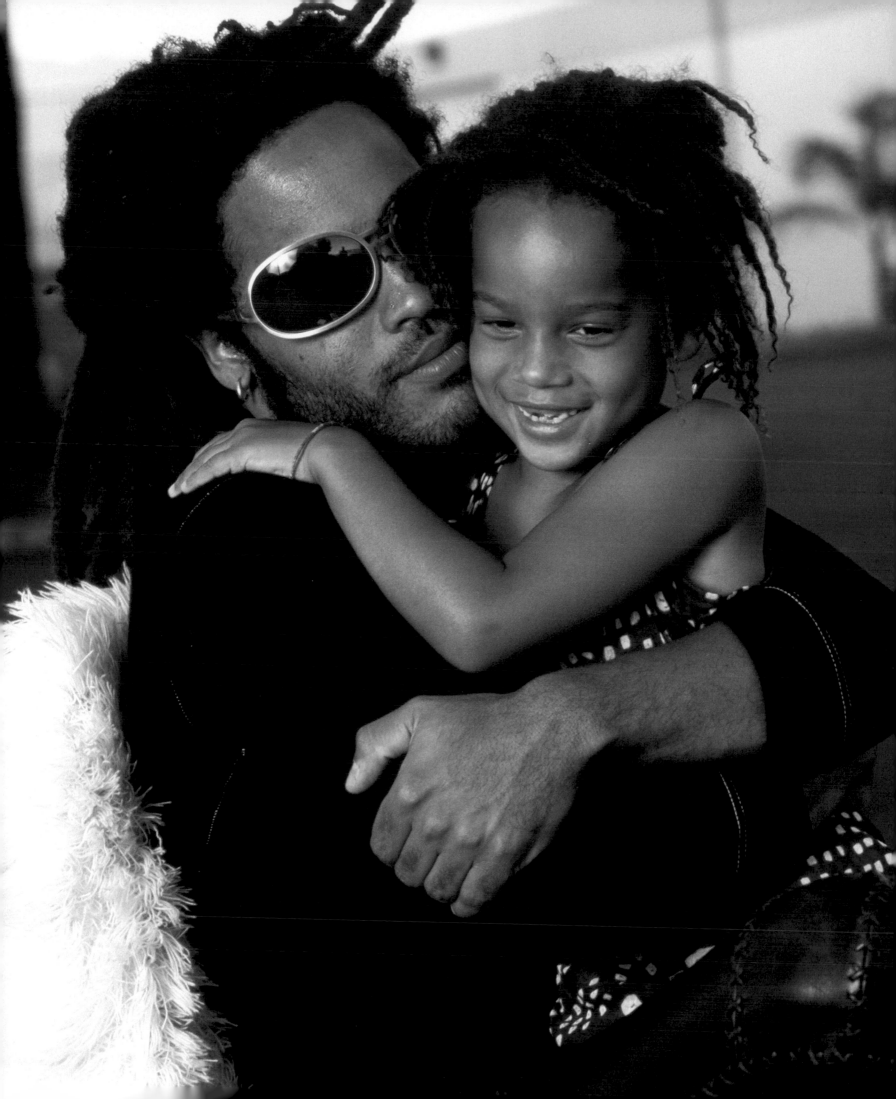

Bruce & Brandon
Lee

Bruce Lee (Lee Jun Fan, 27 November 1940 - 20 July 1973, USA) broke through in 1971 in Hong Kong with the film *The Big Boss*. His success grew exponentially with *Fist of Fury* and *Way of the Dragon*, and conquered the world with the Chinese-American coproduction *Enter the Dragon*.
Brandon Bruce Lee (1 February 1965 - 31 March 1993, USA) started out his acting career in 1986 in the television film *Kung Fu: The Movie*, appeared in *Showdown in Little Tokyo* and secured his first starring role in 1992 in *Rapid Fire*.
Father & son: Brandon declined the offer to portray his father in *Dragon: The Bruce Lee Story*. This film, which was released two months after his death, was dedicated to him. • They both died at a young age and in bizarre circumstances. Bruce had a cerebral oedema caused by an allergic reaction to painkillers 6 days before the release of *Enter the Dragon*. While filming *The Crow*, Brandon was shot with a gun that should only have been loaded with blank cartridges.
The Lee family: Brandon believed that the male members of his family were cursed because his grandfather had angered some Chinese businessmen.

Bruce Lee (Lee Jun Fan, 27 novembre 1940 - 20 juillet 1973, États-Unis) lance sa carrière à Hong Kong avec le film *The Big Boss* en 1971. Il connaît un immense succès avec *La Fureur de vaincre* et *La Fureur du dragon*, puis avec la production sino-américaine *Opération Dragon*.
Brandon Bruce Lee (1er février 1965 - 31 mars 1993, États-Unis) débute en 1986 dans le téléfilm *Kung Fu: The Movie* et est révélé au grand écran avec *Dans les griffes du Dragon rouge*. Il interprète son premier grand rôle en 1992 dans *Rapid Fire*.
Père & fils : Brandon refusa d'incarner son père dans *Dragon : l'histoire de Bruce Lee*. Ce film hommage à Bruce Lee sortit deux mois seulement après la disparition de Brandon. • Tous deux sont décédés jeunes et dans des circonstances incertaines : Bruce est mort d'une réaction allergique à un analgésique 6 jours avant la sortie d'*Opération Dragon*, Brandon des suites d'un accident sur le tournage du film *The Crow*.
La famille Lee : Brandon pensait que les hommes de sa famille étaient maudits, car son grand-père s'était mis à dos la mafia chinoise.

Bruce Lee (Lee Jun Fan, 27 november 1940 - 20 juli 1973, VSA) brak in 1971 in Hong Kong door met de film *The Big Boss*. Hij zag zijn succes exponentieel aangroeien met *Fist of Fury* en *Way of the Dragon*, en veroverde de wereld met de Chinees-Amerikaanse coproductie *Enter the Dragon*.
Brandon Bruce Lee (1 februari 1965 - 31 maart 1993, VSA) begon zijn acteercarrière in '86 in de tv-film *Kung Fu: The Movie*, schitterde onder meer in *Showdown in Little Tokyo* en vertolkte in '92 zijn eerste hoofdrol in *Rapid Fire*.
Vader & zoon: Brandon sloeg het aanbod af om de rol van zijn vader te vertolken in *Dragon: The Bruce Lee Story*. Deze film, die twee maanden na zijn dood uitkwam, werd aan hem opgedragen. • Ze stierven allebei jong en op behoorlijk bizarre manier. Bruce kreeg 6 dagen voor de release van *Enter the Dragon* hersenoedeem door een allergische reactie op pijnstillers. Brandon werd tijdens de opnames van *The Crow* doodgeschoten met een pistool dat enkel losse flodders had mogen bevatten.
De familie Lee: Brandon dacht dat de mannelijke leden van zijn familie vervloekt waren omdat zijn grootvader enkele Chinese handelaars tegen zich in het harnas had gejaagd.

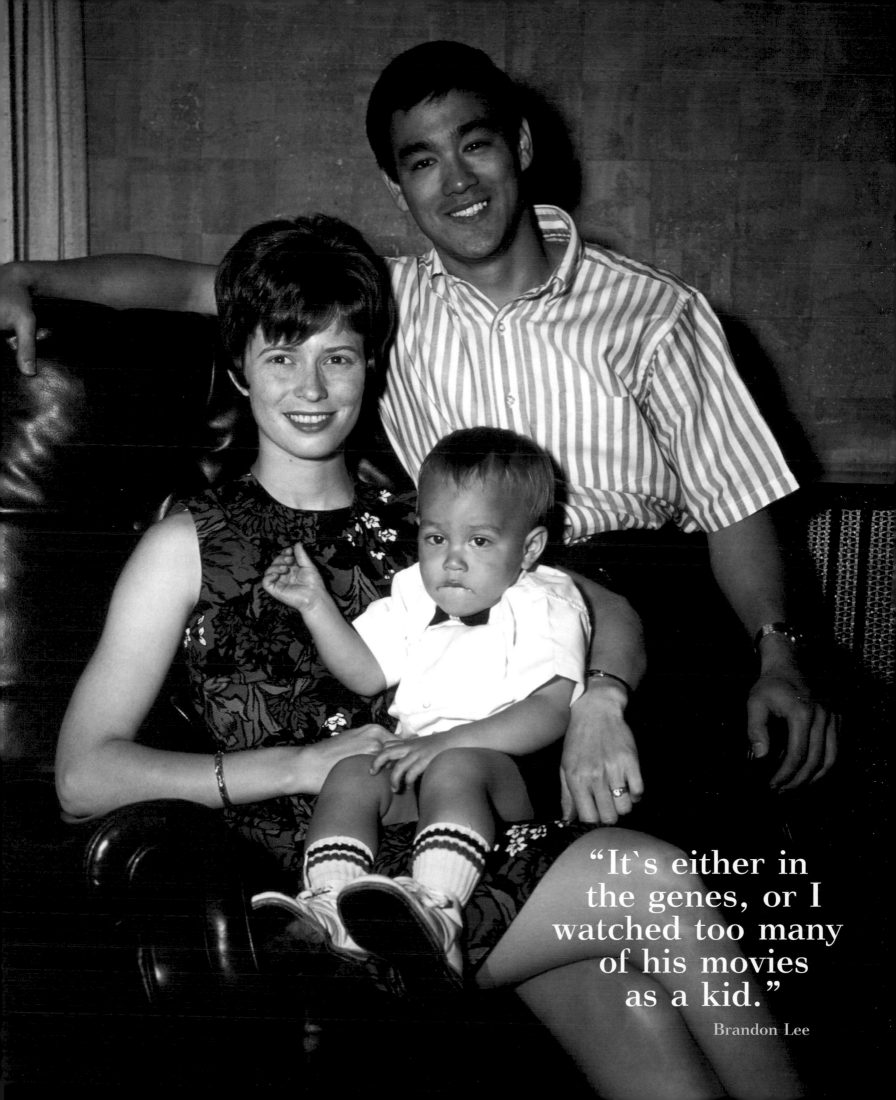

"It's either in the genes, or I watched too many of his movies as a kid."

Brandon Lee

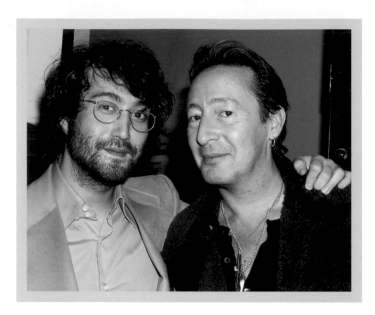

John, Julian & Sean
Lennon

John Winston Lennon (9 October 1940 - 8 December 1980, Great Britain) was a singer and songwriter who, with the Beatles and solo, changed the face of pop music thanks to songs like *Imagine* and *All You Need is Love*.
John Charles Julian Lennon (8 April 1963, Great Britain) is the son of Cynthia Powell. As a musician and songwriter, he had several hits in the 80s and 90s with such songs as *Too late for Goodbyes* and *Saltwater*. He is currently involved in both music and photography.
Seán Taro Ono Lennon (9 October 1975, USA) is the son of Yoko Ono. He joined Cibo Matto and soon after released his solo albums *Into the Sun* and *Friendly Fire*. These days he works behind the scenes as a producer and musician.
Father & sons: John wrote *Lucy in the Sky with Diamonds*, inspired by the name of a drawing Julian had made of a friend. • At the age of 11, Julian made his musical debut playing drums in his father's song *Ya-Ya*. • John adopted the role of househusband when Sean was born. • John's voice and style can be clearly heard in his sons' music, and they resemble him physically as well. They both had a hard time being constantly compared to their father.

John Winston Lennon (9 octobre 1940 - 8 décembre 1980, Angleterre) est un chanteur-auteur-compositeur qui, avec *Les Beatles* mais aussi en solo, réinventa la musique pop avec d'immenses tubes tels qu'"*Imagine*" et "*All You Need is Love*".
John Charles Julian Lennon (8 avril 1963, Angleterre) est le fils de Cynthia Powell. Musicien et compositeur, il a sorti quelques hits dans les années 80 et 90 ("*Too late for Goodbyes*" et "*Saltwater*"). Il s'occupe aujourd'hui de musique et de photographie.
Sean Taro Ono Lennon (9 octobre 1975, États-Unis) est le fruit de l'union entre John et Yoko Ono. Musicien, il joua pour *Cibo Matto*, avant de sortir les albums solo *Into the Sun* et *Friendly Fire*. Il est aujourd'hui également producteur.
Père & fils : John composa le tube "*Lucy in the Sky with Diamonds*" d'après le nom d'un dessin de Julian • À 11 ans, Julian faisait ses débuts à la batterie sur le morceau de John "*Ya-Ya*". • John est devenu homme au foyer après la naissance de Sean. • La voix et le style de John se retrouvent dans la musique de ses fils. Leur ressemblance physique est également frappante. Tous deux ont souffert de la comparaison permanente avec leur père.

John Winston Lennon (9 oktober 1940 - 8 december 1980, Groot-Brittannië) is een zanger en liedjesschrijver die, met The Beatles en solo, het aanzien van de popmuziek veranderde dankzij nummers als *Imagine* en *All You Need is Love*.
John Charles Julian Lennon (8 april 1963, Groot-Brittannië) is de zoon van Cynthia Powell. Als muzikant en liedjesschrijver scoorde hij in de jaren 80 en 90 enkele hits met nummers als *Too late for Goodbyes* en *Saltwater*. Momenteel is hij zowel bezig met muziek als met fotografie.
Sean Taro Ono Lennon (9 oktober 1975, VSA) werd geboren uit Johns relatie met Yoko Ono. Hij ging spelen bij Cibo Matto en bracht even later solo de albums *Into the Sun* en *Friendly Fire* uit. Momenteel werkt hij achter de schermen als producer en muzikant.
Vader & zonen: John maakte een hit van *Lucy in the Sky with Diamonds*, de naam van een tekening die Julian had gemaakt van een vriendinnetje • Julian maakte op zijn elfde zijn muzikale debuut op de drums in Johns nummer *Ya-Ya*. • John werd huisman na de geboorte van Sean. • Johns stem en stijl klinkt door in de muziek van zijn zonen, en ook fysiek lijken ze sterk op hem. Allebei hadden ze het zwaar met de voortdurende vergelijking met hun vader.

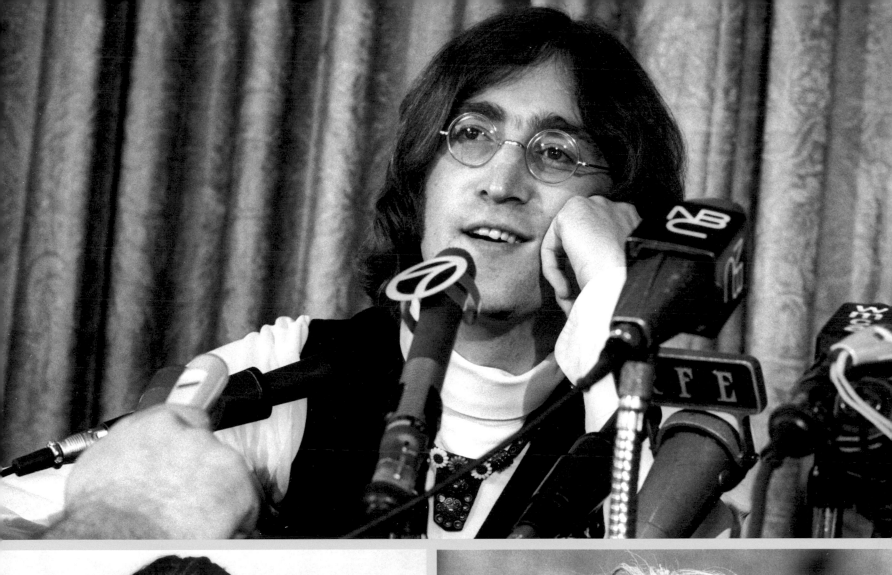

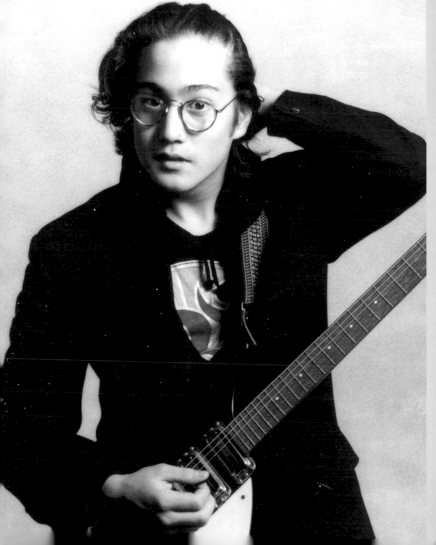

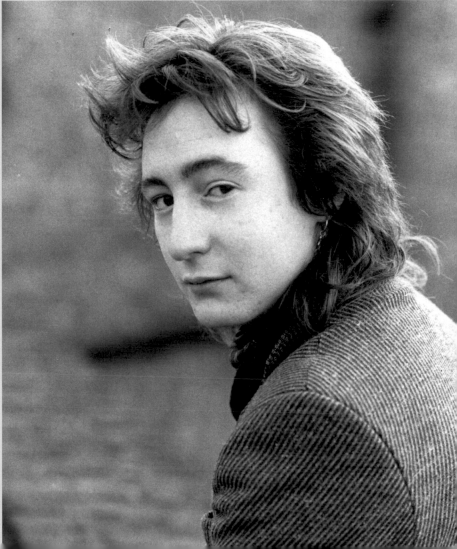

"A man knows when he is growing old because he begins to look like his father."

Gabriel Garcia Marquez (born 1927), Colombian author

Roger & Romelu
Lukaku

Roger Menama Lukaku (6 June 1967, Congo) played professional football for 10 years in Belgian clubs , including KV Oostende, KV Mechelen and Germinal Ekeren. In 1995, he ended in fourth place in the Belgian top scorer list with his 15 goals.
Romelu Lukaku (13 May 1993, Belgium) signed a professional contract with RCA Anderlecht at the age of 16. At the end of that year he was named most promising player and after his first complete season, he became Belgium's top scorer. In February 2010, he became the second youngest player to play for the Belgian national team. He has attracted the interest of many top foreign clubs but has stated that he wants to finish his schooling first.
Father & son: The name Romelu is a combination of the first two letters of all his father's names. • Just like his father, Romelu's jersey has 'R. Lukaku' printed on the back. • Roger does not hold back from putting his son in his place: When Romelu kicked Amorebieta of Athletic Bilbao, he not only received a yellow card from the referee, but his father also told him off very strongly.
The Lukaku family: Romelu's one-year-younger brother Jordan has attracted the interest of European top clubs as well.

Roger Menama Lukaku (6 juin 1967, Congo) a mené une carrière de footballeur durant une dizaine d'années. Il joua notamment au KV Oostende, au FC Malines et au Germinal Ekeren. En 1995, il s'est hissé à la 4e place du classement belge des meilleurs buteurs.
Romelu Lukaku (13 mai 1993, Belgique) signa, le jour de ses 16 ans, un contrat professionnel avec le RSC Anderlecht. À la fin de la même année, il fut élu "espoir sportif belge de l'année". Après sa première saison, il devint le meilleur buteur belge et, en février 2010, le 3e plus jeune "Diable Rouge". Il est alors approché par de grands clubs étrangers, mais entend avant tout terminer ses études.
Père & fils : Le prénom Romelu comporte les deux premières lettres des noms de son père. • À l'instar de Roger, Romelu porte le maillot R. Lukaku. • Roger n'hésite pas à se montrer ferme avec son fils : le jour où Romelu commit une faute sur Amorebieta, joueur de l'Athletic Bilbao, il reçut un carton jaune mais également les foudres de son père.
La famille Lukaku : Le frère cadet de Romelu, Jordan, suscite l'intérêt des grands clubs européens.

Roger Menama Lukaku (6 juni 1967, Congo) speelde in zijn tienjarige voetbalcarrière onder meer bij de Belgische clubs KV Oostende, KV Mechelen en Germinal Ekeren. In 1995 eindigde hij met 15 doelpunten op de vierde plaats in de Belgische topschutterslijst.
Romelu Lukaku (13 mei 1993, België) tekende op zijn zestiende verjaardag een profcontract bij RSC Anderlecht. Eind dat jaar werd hij Sportbelofte van het jaar en reeds na zijn eerste volledige seizoen werd hij Belgisch topscorer. In februari 2010 werd hij de op twee na jongste Rode Duivel ooit. Hij wordt gegeerd door buitenlandse topclubs maar heeft aangegeven eerst zijn studie te willen afmaken.
Vader & zoon: De naam Romelu is een samenstelling van de eerste twee letters van alle namen van zijn vader. • Net zoals bij zijn vader vroeger, staat er R. Lukaku op de rug van Romelu's voetbalshirt. • Roger ziet er niet tegenop om zijn zoon op zijn plaats te zetten: toen Romelu Amorebieta van Athletic Bilbao een trap verkocht had, kreeg hij niet alleen een gele kaart van de scheidsrechter maar ook een uitbrander van zijn vader.
De familie Lukaku: Ook Romelu's één jaar jongere broertje Jordan heeft intussen de interesse gewekt van Europese topclubs.

> "Vroeger, als voetballer,
> had ik geen zenuwen. Nu, als
> vader, heb ik het des te meer."
> Roger Lukaku

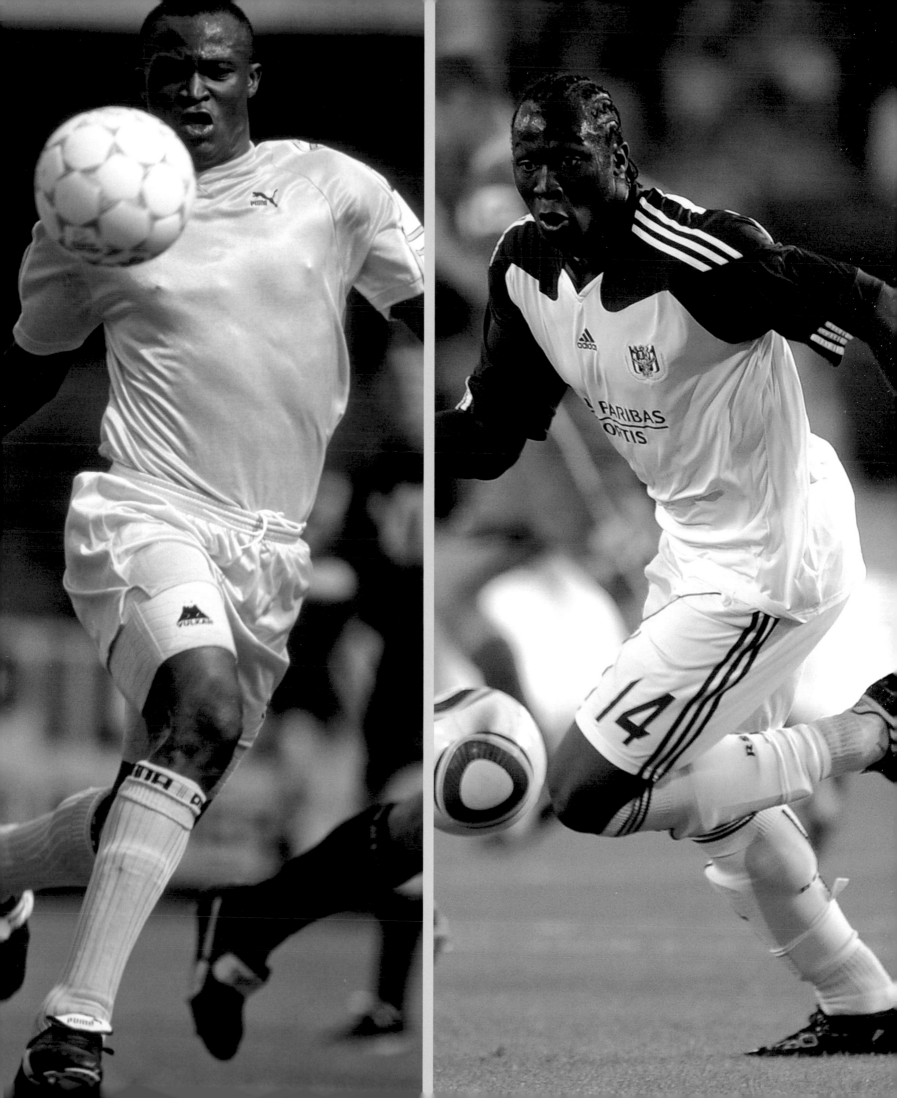

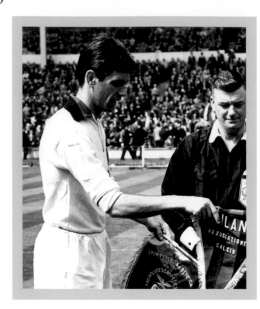
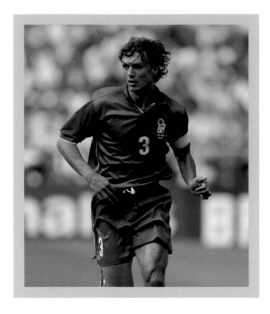

Cesare & Paolo
Maldini

Cesare Maldini (5 February 1932, Italy) won the European Cup as captain of AC Milan in 1963 and played for the Italian national team for two World Cups. He was assistant-coach when Italy won the World Cup in 1982 and led the Italian Under-21 side to victory three times. He later became coach of Paraguay's national team, is a scout for AC Milan and is now a television sports analyst.

Paolo Maldini (26 June 1968, Italy) started playing for AC Milan's first team at the age of sixteen and stayed there for as many as 25 seasons. Over the course of his career, in which he played a record amount of 900 official games for the team, they won numerous national and international titles. He played 126 games for the national team in a period of fourteen years. His lengthy appointment as captain of AC Milan and the national team earned him the nickname 'Il Capitano'.

Father & son: Paolo won the European Cup final with AC Milan exactly forty years after his father had done the same. • They were both captain of AC Milan. • In 1998, the Italian squad reached the quarter finals with Cesare as coach and Paolo as captain.

The Maldini family: Grandson Christian plays as a defender in AC Milan's youth squad.

Cesare Maldini (5 février 1932, Italie), capitaine du Milan AC, a remporté La Ligue des champions de l'UEFA en 1963 et participé à 2 coupes du monde avec l'équipe italienne. Il est assistant-entraîneur lorsque l'Italie remporte le trophée mondial en 1982 et mène 3 fois à la victoire l'équipe d'Italie espoirs. Il devient par la suite entraîneur de l'équipe du Paraguay et découvreur de jeunes talents pour le Milan AC. Il est actuellement journaliste sportif.

Paolo Maldini (26 juin 1968, Italie) participe à son premier match en division 1 pour le Milan AC à l'âge de 16 ans. Il enchaîne ensuite 25 saisons au sein de l'équipe italienne. Sa carrière homérique – il a disputé 900 matchs officiels et compte 126 sélections en équipe nationale ! –, est jalonnée de titres nationaux et internationaux. Longtemps capitaine du Milan AC et de l'équipe d'Italie, on lui attribua le surnom de "*Il Capitano*".

Père & fils : 40 ans après son père, Paolo a remporté La Ligue des champions. • Ils furent tous les deux capitaines du Milan AC. • Lors de la coupe du monde 1998, l'Italie arrive en quart de finale avec Cesare comme entraîneur et Paolo comme capitaine.

La famille Maldini : Le petit-fils de Cesare, Christian, est défenseur dans l'équipe espoir du Milan AC.

Cesare Maldini (5 februari 1932, Italië) won als kapitein voor AC Milan in 1963 de Europacup I en speelde gedurende twee Wk's voor het Italiaanse elftal. Hij was assistent-coach toen Italië in 1982 het WK won en voerde het Italiaanse voetbalelftal onder 21 driemaal naar de overwinning. Hij werd later nog coach voor Paraguay, scout voor AC Milan en is nu sportverslaggever.

Paolo Maldini (26 juni 1968, Italië) ging als zestienjarige aan de slag in het eerste elftal van AC Milan, en hield het daar maar liefst 25 seizoenen vol. Tijdens zijn carrière, waarin hij een recordaantal van 900 officiële wedstrijden voor de ploeg speelde, wonnen ze tal van nationale en internationale titels. In een periode van veertien jaar speelde hij 126 keer voor het nationale elftal. Zijn lange aanstelling als kapitein van AC Milan en het nationale team leverden hem de bijnaam 'Il Capitano' op.

Vader & zoon: Paolo won in 2003, precies veertig jaar na zijn vader met AC Milan de Europacup I-finale. • Beide waren ooit kapitein van AC Milan.• In 1998 haalde het Italiaanse elftal de WK-kwartfinale met Cesare als coach en Paolo als kapitein.

De familie Maldini: Kleinzoon Christian is verdediger in AC Milan's A-jeugdploeg.

"The son becomes the father and the father becomes the son."

Superman in *Superman Returns* (2006)

Bob & Ziggy
Marley

Robert Nesta 'Bob' Marley (6 February 1945 - 11 May 1981, Jamaica) escaped the slums by covering soul songs on homemade instruments. In 1964, he conquered Jamaica with his band The Wailers and the song *Simmer Down*. He took on the rest of the world in the 70s with reggae hits like *No Woman, No Cry* and *I Shot the Sheriff* and such albums as *Exodus* and *Uprising*.
David Nesta 'Ziggy' Marley (17 October 1968, Jamaica) laid the foundation for Ziggy & The Melody Makers at the age of eleven, along with several brothers and sisters. 1985 saw the release of their first LP *Play the Game Right*. They went on to record five more albums, with *Conscious Party* being the most successful. In 2000, they went their own ways to pursue solo careers. Ziggy released two more albums and had a hit with *Love is My Religion*.
The Marley family: Bob had thirteen children: three with his wife, two adopted and eight more with as many women. • These also got into the music business: Cedella, Sharon, Stephen, Damian, Julian and Ky-Mani Marley. • Just like his father, Ziggy is involved in politics: he works with the UNO and founded (with several of his brothers) a record label to help underprivileged reggae musicians.

Robert Nesta "Bob" Marley (6 février 1945 - 11 mai 1981, Jamaïque) parvient à sortir du ghetto grâce à des succès soul qu'il interprète avec des instruments "faits maison". En 1964, il se fait connaître en Jamaïque avec son groupe *The Wailers* et conquiert le monde dans les années 70 avec les hits reggae "*No Woman, No Cry*", "*I Shot the Sheriff*" et les albums *Exodus* et *Uprising*.
David Nesta "Ziggy" Marley (17 octobre 1968, Jamaïque) a créé, à l'âge de 11 ans, le groupe *Ziggy & The Melody Makers* avec plusieurs de ses frères et sœurs. Ils sortent *Play the Game Right* en 1985. Cinq autres albums viendront ensuite, dont le célèbre *Conscious Party*. En 2000, les membres du groupe s'orientent vers une carrière solo. Ziggy sort deux albums et fait un tabac avec le titre "*Love is My Religion*".
La famille Marley : Bob a eu 13 enfants : 3 avec sa femme, 2 qu'il a adoptés et 8 avec autant de femmes différentes. • Cedella, Sharon, Stephen, Damian, Julian et Ky-Mani Marley ont tous entrepris une carrière musicale. • À l'instar de son père, Ziggy milite politiquement : il travaille avec l'ONU et a créé un label destiné à soutenir les musiciens du mouvement reggae.

Robert Nesta 'Bob' Marley (6 februari 1945 - 11 mei 1981, Jamaica) ontvluchtte de sloppenwijken door op zelfgemaakte instrumenten soulnummers na te spelen. Met The Wailers palmde hij in '64 met *Simmer Down* Jamaica in, en tijdens de jaren 70 veroverde hij de wereld met reggaehits als *No Woman, No Cry* en *I Shot the Sheriff* en albums als *Exodus* en *Uprising*.
David Nesta 'Ziggy' Marley (17 oktober 1968, Jamaica) legde op zijn elfde met een aantal zussen en broers de basis voor Ziggy & The Melody Makers. In 1985 kwam hun eerste LP uit, *Play the Game Right*. Hierna maakten ze nog vijf andere albums, met *Conscious Party* als meest succesvolle. In 2000 gingen ze uit elkaar om solocarrières op te starten. Ziggy bracht nog twee albums uit en scoorde een hit met *Love is My Religion*.
De familie Marley: Bob had dertien kinderen: drie met zijn vrouw, twee geadopteerd en acht bij evenzoveel andere vrouwen. • Stapten ook in de muziek: Cedella, Sharon, Stephen, Damian, Julian en Ky-Mani Marley. • Net als zijn vader houdt Ziggy zich bezig met politiek: hij werkt met de UNO en stichtte samen met enkele broers een platenlabel om kansarme reggaemuzikanten te helpen.

> "The more I grow as an artist, the more I think I become like my father as an artist."
>
> Ziggy Marley

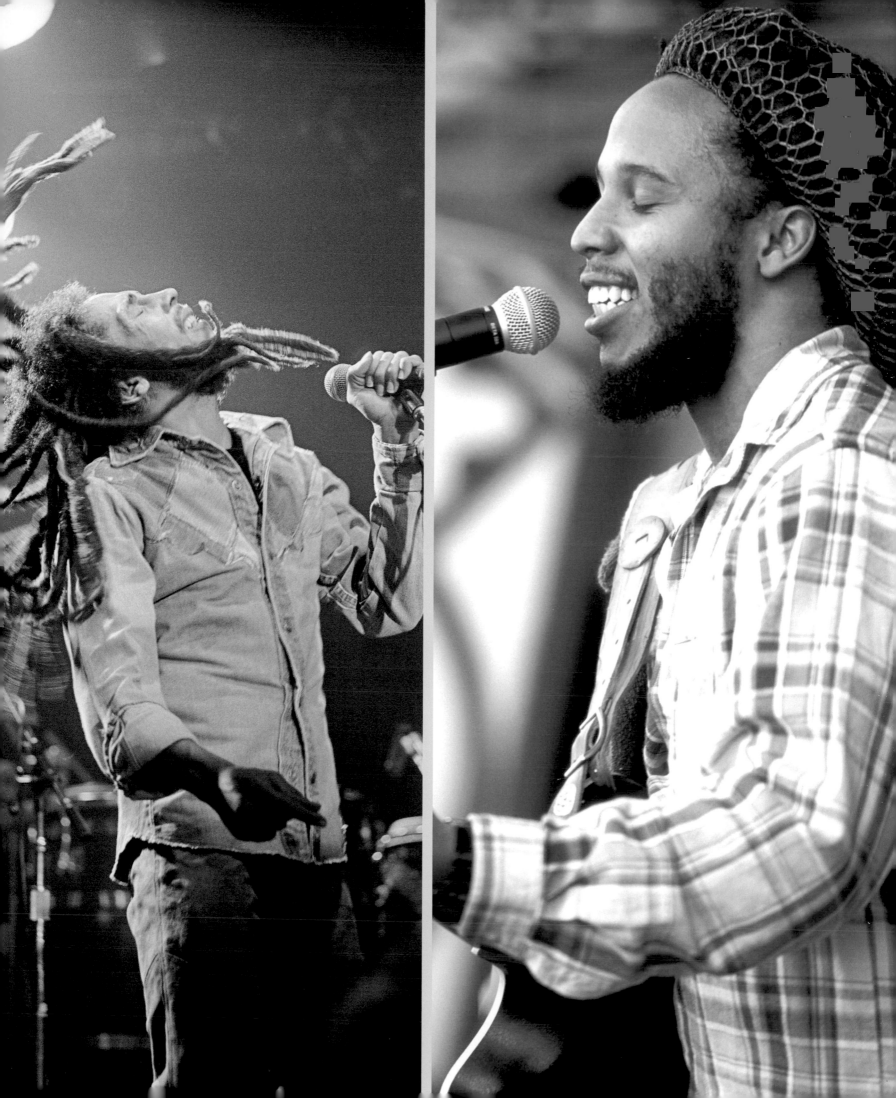

Tomáš Garrigue & Jan
Masaryk

Tomáš Garrigue Masaryk (7 March 1850 - 14 September 1937, Austrian Empire) was a politician, sociologist and philosopher. He was the founder and first President of Czechoslovakia, is still held in high esteem by most Czechs and is regarded internationally as a symbol of democracy, humanism and morality.
Jan Masaryk (14 September 1886 - 10 March 1948, Czechoslovakia) was the Czech ambassador in Great Britain until WWII broke out and he became Minister of Foreign Affairs of the Government-in-Exile. He remained Foreign Minister after the return of the government and after the communist coup in February 1948. He was found dead a few days later, presumably murdered.
Father & son: Both of their tombs, near the baroque castle of Lány (which is still the official summer residence of the Czech Presidents), have become symbols of Czechoslovak democracy.

Tomáš Garrigue Masaryk (7 mars 1850 - 14 septembre 1937, Autriche-Hongrie), homme politique, sociologue et philosophe, fut le fondateur et le premier président de la Tchécoslovaquie. Toujours extrêmement populaire auprès de la majorité des Tchèques, il est considéré dans le monde entier comme un symbole de démocratie, d'humanisme et de moralité.
Jan Masaryk (14 septembre 1886 - 10 mars 1948, Tchécoslovaquie) a été l'ambassadeur de la Tchécoslovaquie en Angleterre jusqu'à l'éclatement de la Seconde Guerre mondiale, puis le Ministre des Affaires étrangères du gouvernement en exil. Il conserva ce poste après le retour du gouvernement, ainsi qu'après le putsch communiste de février 1948. Quelques jours plus tard, il fut néanmoins retrouvé mort – probablement assassiné.
Père & fils : Leurs tombes respectives, situées à proximité du château baroque de Lány (qui est aujourd'hui encore la résidence d'été officielle des présidents tchèques), sont devenues un symbole de la démocratie tchécoslovaque.

Tomáš Garrigue Masaryk (7 maart 1850 - 14 september 1937, Keizerrijk Oostenrijk) was een politicus, socioloog en filosoof. Hij was de stichter en eerste president van Tsjechoslowakije, wordt nog altijd in hoog aanzien gehouden door de meeste Tsjechen en wordt internationaal beschouwd als een symbool van democratie, humanisme en moraliteit.
Jan Masaryk (14 september 1886 - 10 maart 1948, Tsjechoslowakije) was de Tsjechoslowaakse ambassadeur in Groot-Brittannië tot WO II uitbrak en hij minister van Buitenlandse Zaken werd van de regering-in-ballingschap. Hij behield deze post na de terugkeer van de regering en na de communistische coup in februari 1948. Een paar dagen later werd hij dood - vermoedelijk vermoord - aangetroffen.
Vader & zoon: Hun beider graf, vlakbij het barokke kasteel van Lány (dat nog steeds dienst doet als de officiële zomerresidentie van de Tsjechische presidenten) is uitgegroeid tot een symbool van de Tsjechoslowaakse democratie.

Paul & Stella
McCartney

Sir James Paul McCartney (18 June 1942, Great Britain) is the world's most successful songwriter in the history of popular music. He changed the face of pop music with The Beatles and later had countless hits with his band Wings. His most famous songs are *Yesterday* and *Mull of Kintyre*.

Stella Nina McCartney (13 September 1971, Great Britain) was appointed Creative Director of fashion house Chloé in 1997. Four years later, she started a fashion label under her own name with the Gucci Group, which has expanded with perfumes, accessories and a skincare line. She makes sports clothing for Adidas and designed an amazingly popular collection for H&M in 2005.

Father & daughter: At his daughter's birth, by emergency caesarean section, Paul prayed that she be born quickly "on the wings of an angel". Afterwards, he decided to name his new band Wings. • Paul and Stella are, just as Linda McCartney was, advocates of vegetarianism. • Friends like Naomi Campbell and Kate Moss modelled for Stella's graduation collection to the song *Stella May Day*, which was written by her father.

The McCartney family: Paul's son James is also a musician and released his EP *Available Light* in 2010.

Sir James Paul McCartney (18 juin 1942, Angleterre) détient, selon le Guinness Book, le record absolu des ventes de disques. Il réinventa la musique pop avec les *Beatles*, puis composa d'innombrables tubes avec le groupe *Wings*. Ses titres phares demeurent "*Yesterday*" et "*Mull of Kintyre*".

Stella Nina McCartney (13 septembre 1971, Angleterre) est devenue directrice artistique de la maison de mode Chloé en 1997 avant de lancer sa propre maison sous l'égide du groupe Gucci. Sa marque propose également des parfums, des accessoires et des produits de soins. En 2005, elle signe une ligne de vêtements pour Adidas et crée une collection au succès foudroyant pour H&M.

Père & fille : Paul pria pour que la naissance de Stella se déroule "sur les ailes d'un ange". Il baptisa ensuite son nouveau groupe *Wings* ("ailes"). • Paul et Stella sont tous les deux végétariens. • La collection réalisée par Stella à la fin de ses études fut entre autres présentée par Naomi Campbell et Kate Moss sur une musique de Paul, "*Stella May Day*".

La famille McCartney : Le fils de Paul, James, est musicien ; il a sorti en 2010 un EP intitulé *Available Light*.

Sir James Paul McCartney (18 juni 1942, Groot-Brittannië) is volgens het Guinness Book of Records de meest succesvolle liedjesschrijver in de geschiedenis van de populaire muziek. Hij veranderde het aanzien van popmuziek met The Beatles en scoorde later nog talloze hits met zijn band Wings. Zijn bekendste liedjes zijn *Yesterday* en *Mull of Kintyre*.

Stella Nina McCartney (13 september 1971, Groot-Brittannië) werd in 1997 creatief directeur van het modehuis Chloé en startte vier jaar later onder eigen naam een modelabel bij de Gucci Group, inmiddels uitgebreid met parfums, accessoires en een huidverzorginglijn. Voor Adidas maakt ze sportkleding en in 2005 ontwierp ze een waanzinnig populaire collectie voor H&M.

Vader & dochter: Tijdens haar geboorte, die uitliep op een noodkeizersnede, bad Paul dat ze snel geboren mocht worden "op de vleugels van een engel". Hierna besloot hij zijn nieuwe band Wings te noemen. • Paul en Stella zijn, net als Linda McCartney indertijd, voorstanders van het vegetarisme. • Stella's eindexamencollectie werd geshowd door vriendinnen als Naomi Campbell en Kate Moss op het liedje *Stella May Day* dat haar vader voor haar schreef.

De familie McCartney: Pauls zoon James is ook muzikant en bracht in 2010 de EP *Available Light* uit.

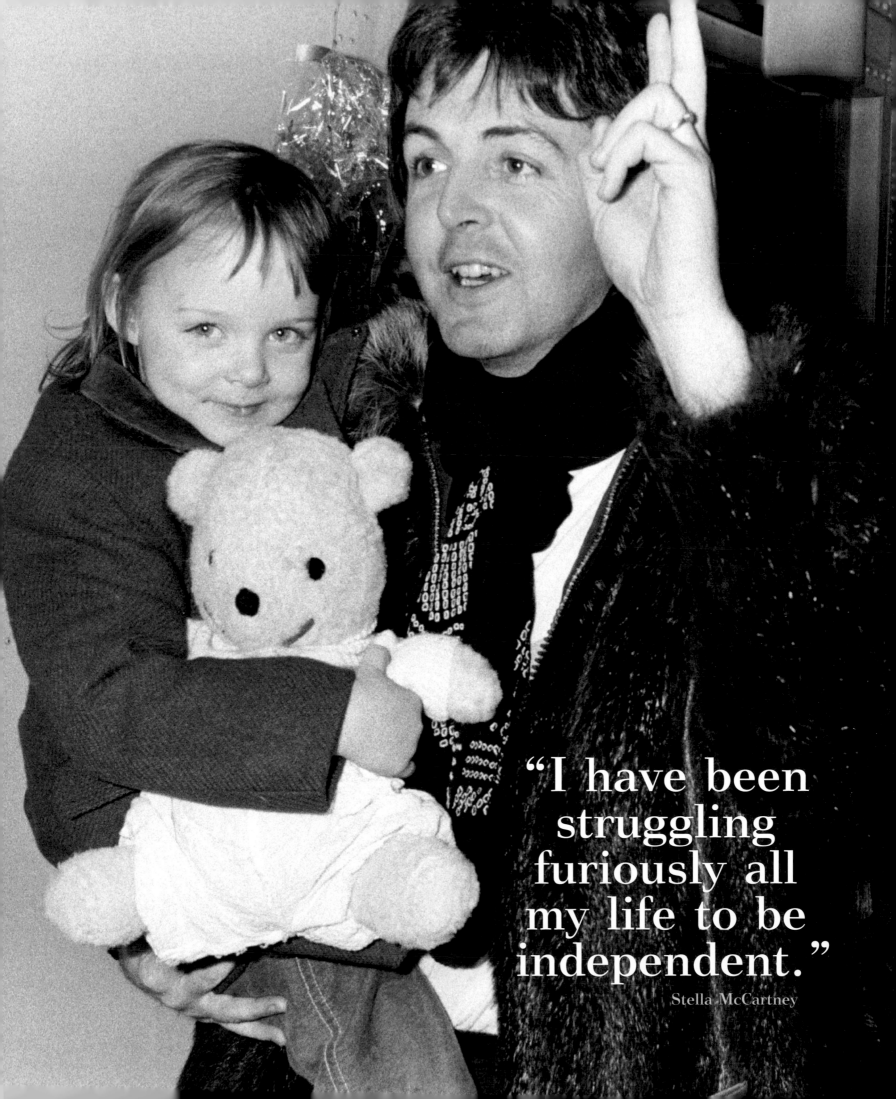

"I have been
struggling
furiously all
my life to be
independent."

Stella McCartney

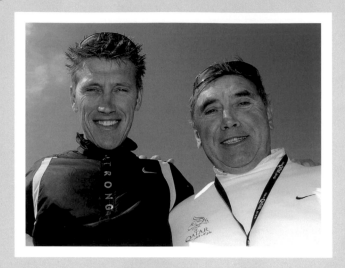

Eddy & Axel
Merckx

Baron Édouard Louis Joseph 'Eddy' Merckx (17 June 1945, Belgium) won 525 races, making him the most successful professional cyclist ever. He won both the Tour de France and the Giro d'Italia five times, won the Vuelta a Espagna and just about all the classics, broke the world hour record and won the World Championship as an amateur and a professional.

Axel Merckx (8 August 1972, Belgium) built up a fine career with several memorable highlights, including winning the Belgian national championship, a legendary stage win in the Giro and a bronze Olympic medal. He currently serves as Sports Manager for Lance Armstrong's Trek-Livestrong team.

Father & son: Axel has stated that he inherited his determination and willingness to work hard from his father. • Eddy tried to get his son to play football because he knew that his name would cause difficulties in cycling. Axel was a promising player in the youth squad of Anderlecht, until his explosive growth became a problem. • Axel declined his father's offer to take over his bicycle factory because he wanted to tread his own path. This made Eddy decide to sell the majority stake in the business after 30 years of entrepreneurship in 2010.

Baron Édouard Louis Joseph "Eddy" Merckx (17 juin 1945, Belgique) est, avec 525 victoires, le plus grand cycliste de tous les temps. Il a remporté à 5 reprises le Tour de France et le Tour d'Italie, gagné le Tour d'Espagne ainsi que la quasi totalité des classiques. Il a également pulvérisé le record de l'heure et raflé les titres de champion du monde amateur et professionnel.

Axel Merckx (8 août 1972, Belgique) a réalisé une belle carrière de cycliste avec quelques triomphes mémorables, comme un titre national sur route, une victoire légendaire au Giro et une médaille de bronze aux Jeux olympiques. Il est ensuite devenu directeur sportif de l'équipe Trek-Livestrong, dans laquelle évolue notamment Lance Armstrong.

Père & fils : Axel a hérité de la détermination et de la persévérance de son père. • Eddy souhaitait que son fils embrasse une carrière de footballeur, car il savait que son nom serait difficile à porter dans le milieu du cyclisme. Axel était un élément prometteur de l'équipe de jeunes d'Anderlecht, jusqu'à ce que sa croissance rapide lui joue des tours. • Axel refusa de reprendre l'usine de cycles de son père, préférant suivre sa propre voie. Eddy a depuis vendu la majorité des parts de son entreprise.

Baron Édouard Louis Joseph 'Eddy' Merckx (17 juni 1945, België) is met 525 gewonnen wedstrijden de meest succesvolle wielrenner aller tijden. Hij won zowel de Tour de France als de Giro d'Italia vijf keer, won de Vuelta a Espagna en vrijwel alle klassiekers, brak het werelduurrecord, en rijfde als professional én als amateur het wereldkampioenschap binnen.

Axel Merckx (8 augustus 1972, België) bouwde een mooie carrière uit met enkele memorabele uitschieters, zoals een nationale titel op de weg, een legendarische ritzege in de Giro en een bronzen medaille tijdens de Olympische Spelen. Momenteel is hij sportmanager van het Trek-Livestrong team van Lance Armstrong.

Vader & zoon: Axel erfde naar eigen zeggen zijn vastberadenheid en bereidheid tot hard werk van zijn vader. • Eddy probeerde zijn zoon aan het voetballen te krijgen omdat hij wist dat zijn naam hem moeilijkheden zou opleveren in de wielrennerij. Axel was een beloftevolle speler in de jeugdploeg van Anderlecht, tot zijn explosieve groei hem parten begon te spelen. • Axel sloeg zijn vaders aanbod om diens fietsenfabriek over te nemen af omdat hij zijn eigen weg wil bewandelen. Dat deed Eddy in 2010 besluiten om na 30 jaar ondernemerschap het meerderheidsbelang in de zaak te verkopen.

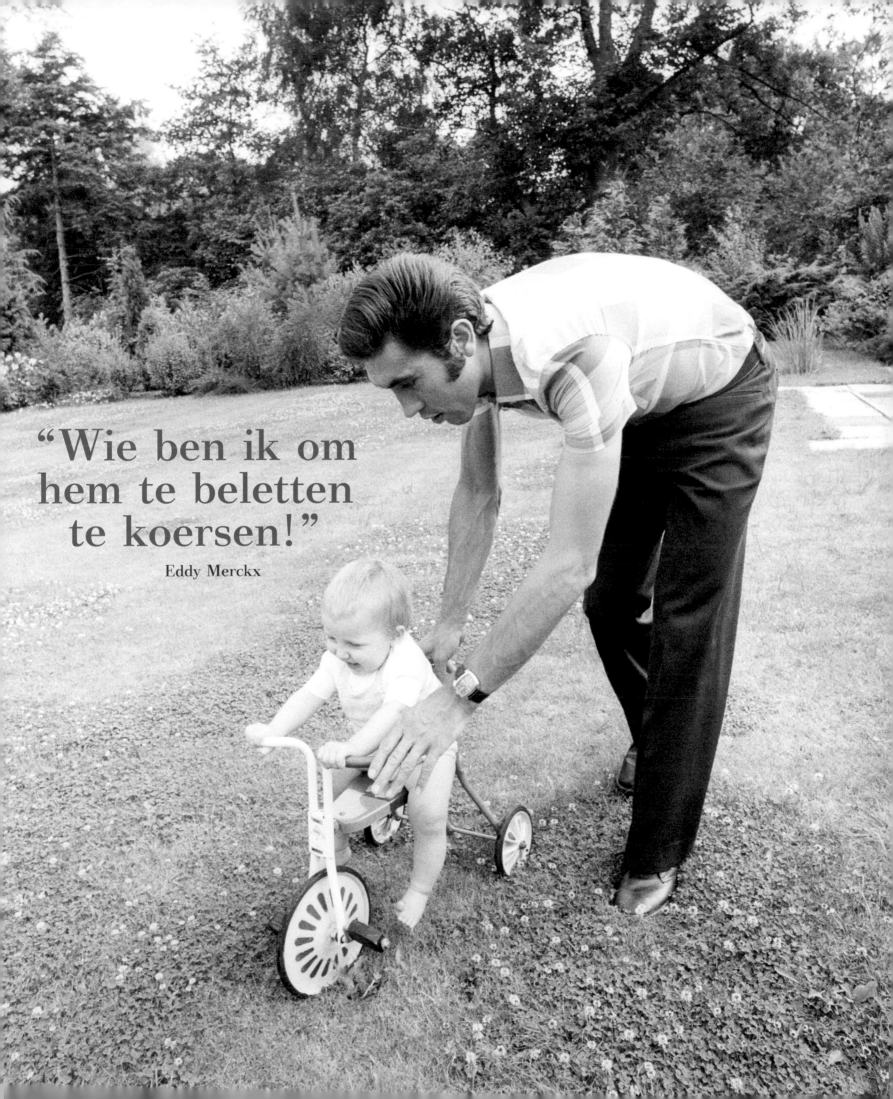

"Wie ben ik om hem te beletten te koersen!"

Eddy Merckx

Rupert & James
Murdoch

Keith Rupert Murdoch (11 March 1931, Australia) is considered the world's most influential media magnate. He is the founder, chairman and CEO of News Corporation, one the world's greatest media conglomerates with branches in Australia, the United Kingdom and Asia.
James Murdoch (13 December 1972, Great Britain) is the chairman and CEO of News Corporation Europe and Asia. He is credited for inspiring his father's interest in the Internet. The television stations under his control reach 200 million people in 60 countries.
Father & son: According to co-workers, James is just as 'instinctive, competitive, hard and intense' as his father. Since the departure of his older brother, James is considered to be Rupert's most likely successor.
The Murdoch family: Rupert's father Sir Keith Murdoch was one of the most influential people in the Australian media scene due to his function as director of the Australian magazine and newspaper company Herald and Weekly Times. • James's older brother Lachlan had held a high position within News Corporation from the age of 22. He seemed destined to be Rupert's successor until he unexpectedly announced his resignation in 2005. Sister Elisabeth left the company in 2000 to start her own successful television company in London.

Keith Rupert Murdoch (11 mars 1931, Australie) est considéré comme le plus puissant magnat des médias. Il est le fondateur de News Corporation, l'un des plus grands conglomérats au monde, qui possède des filiales en Australie, aux États-Unis et en Asie.
James Murdoch (13 décembre 1972, Angleterre) est le président de News Corporation en Europe et en Asie. Il a suscité l'intérêt de son père pour Internet. Ses chaînes de télévision sont regardées par 200 millions de téléspectateurs dans plus de 60 pays.
Père & fils : Selon ses collaborateurs, James est aussi "instinctif, compétitif, dur et intense" que son père. • Depuis le départ de son frère aîné, James est pressenti comme le successeur le plus probable de Rupert.
La famille Murdoch : Le père de Rupert, sir Keith Murdoch, directeur du groupe de presse Herald and Weekly Times, fut l'une des personnes les plus influentes du monde médiatique australien. • Le frère aîné de James, Lachlan, semblait pressenti depuis toujours pour succéder à son père ; contre toutes attentes, il remit cependant sa démission en 2005. Sa sœur Élisabeth quitta News Corporation en 2000 pour lancer sa propre société de télévision à Londres.

Keith Rupert Murdoch (11 maart 1931, Australië) wordt beschouwd als 's werelds meest invloedrijke mediatycoon. Hij is de stichter, voorzitter en CEO van News Corporation, een van 's werelds grootste mediaconglomeraten met takken in Australië, de Verenigde Staten en Azië.
James Murdoch (13 december 1972, Groot-Brittannië) is de voorzitter en de CEO van News Corporation Europe en Asia. Hij was degene die zijn vaders interesse in het internet wist te wekken. De tv-zenders onder zijn hoede bereiken 200 miljoen mensen in een 60-tal landen.
Vader & zoon: Volgens medewerkers is James even 'instinctief, competitief, hard en intens' als zijn vader. • Sinds het vertrek van zijn oudere broer wordt James beschouwd als Ruperts meest waarschijnlijke troonopvolger.
De familie Murdoch: Ruperts vader sir Keith Murdoch was een van de meest invloedrijke personen uit de Australische mediawereld dankzij zijn functie als directeur van de Australische bladen- en krantengroep Herald and Weekly Times. • James' oudere broer Lachlan, die al sinds zijn 22e een hoge positie binnen News Corporation bekleedde, leek voorbestemd om Ruperts troonopvolger te worden tot hij in 2005 onverwacht zijn ontslag aankondigde. Zus Elisabeth verliet het bedrijf in 2000 om haar eigen succesvolle tv-bedrijfje op te starten in Londen.

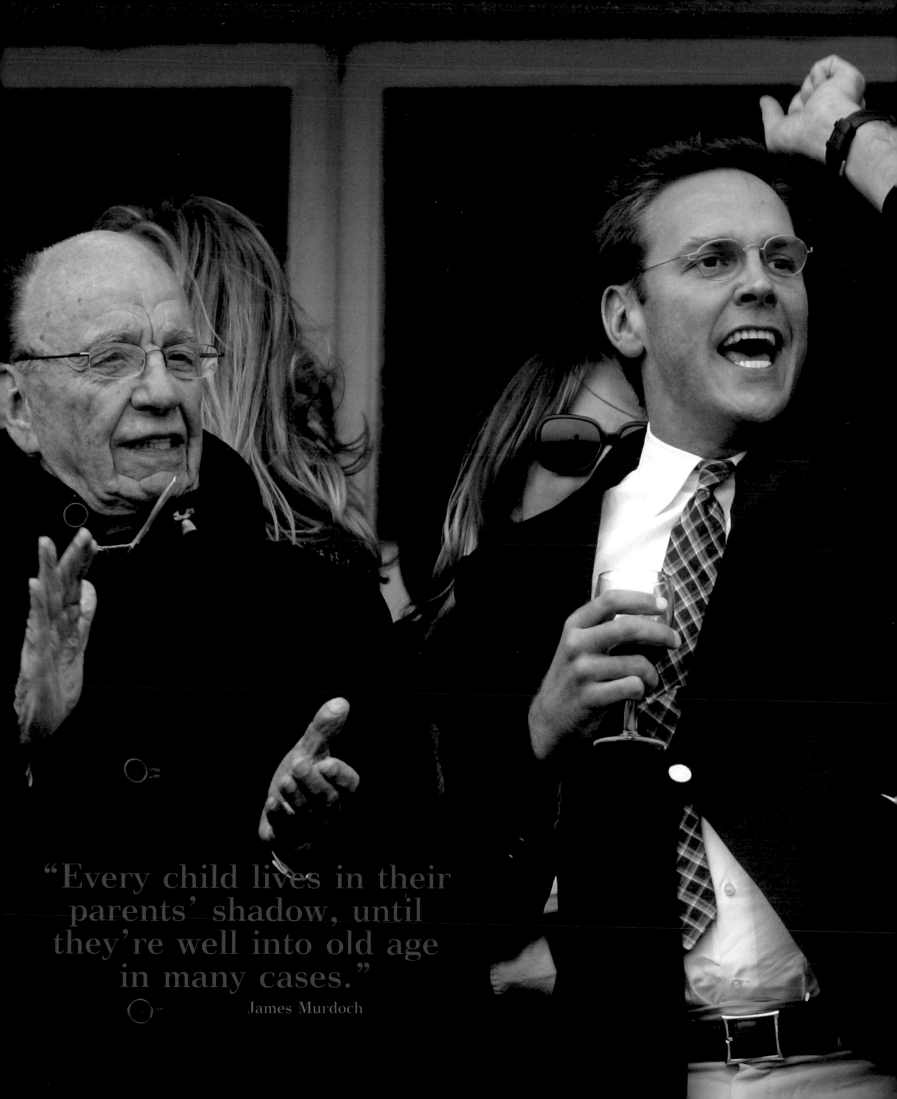

"Every child lives in their parents' shadow, until they're well into old age in many cases."

James Murdoch

Louis & Günther
Neefs

Ludwig Adèle Maria Jozef 'Louis' Neefs (8 August 1937 - 25 December 1980, Belgium) had numerous hits in the 60s with songs like *Benjamin, Aan het strand van Oostende, Margrietje, Laat ons een bloem* and *Annelies uit Sas van Gent*. He was chosen as the Belgian participant for the Eurovision Song Contest twice, in 1967 with *Oh Oh ik heb zorgen* and in 1969 with *Jennifer Jennings*. Besides being a singer, he was also a presenter of television programmes like *Tienerklanken*.
Günther Neefs (21 September 1965, Belgium) started out his career in Belgium as a percussionist, but soon rose to fame as a singer. Up to now he has released 10 CDs and has had hits with both original Dutch songs and English covers, from ballads to motown and big band songs.
Father & son: Günther has the same warm vocal timbre as his father. • In 2000, Günther paid homage to his father with the CD and concert *Louis Neefs 20 jaar later*. For this occasion, a new version was released of *Laat ons een Bloem*, on which Günther's voice was combined with his father's. • In 2008, Günther was the voice of the street cat Thomas O'Malley in the remake of the Dutch version of *De Aristokatten* - something his father had done before him in 1970.

Ludwig Adèle Maria Jozef "Louis" Neefs (8 août 1937 - 25 décembre 1980, Belgique) a produit de nombreux tubes dans les années 60 ("*Benjamin*", "*Aan het strand van Oostende*", "*Margrietje*", "*Laat ons een bloem*" et "*Annelies uit Sas van Gent*"). En 1967 puis en 1969, il défend les couleurs de la Belgique à l'Eurovision, avec les titres "*Oh Oh ik heb zorgen*" et "*Jennifer Jennings*". Il sera par la suite présentateur à la télévision.
Günther Neefs (21 septembre 1965, Belgique) débute comme percussionniste avant de devenir un célèbre chanteur en Flandre. Il a sorti 10 albums, comportant des morceaux originaux et néerlandais ainsi que des versions anglaises de ballades, de titres de la Motown et de chansons de big bands.
Père & fils : Günther possède le même timbre de voix que son père. • En 2000, Günther rend hommage à son père avec l'album et le concert *Louis Neefs 20 jaar later*. À cette occasion sort une nouvelle version de "*Laat ons een Bloem*", où la voix de Günther se mêle à celle de Louis.
• Günther a prêté sa voix au chat de gouttière Thomas O'Malley dans la nouvelle version néerlandaise des *Aristochats* (2008) – son père avait fait de même en 1970.

Ludwig Adèle Maria Jozef 'Louis' Neefs (8 augustus 1937 - 25 december 1980, België) scoorde in de jaren 60 tal van hits met nummers als *Benjamin, Aan het strand van Oostende, Margrietje, Laat ons een bloem* en *Annelies uit Sas van Gent*. Hij verdedigde zijn vaderland tweemaal tijdens het Eurovisiesongfestival, in 1967 met *Oh Oh ik heb zorgen* en in '69 met *Jennifer Jennings*. Naast zanger was hij ook presentator van tv-programma's als *Tienerklanken*.
Günther Neefs (21 september 1965, België) begon zijn carrière als percussionist maar werd in Vlaanderen al snel bekend als zanger. Hij bracht totnogtoe 10 cd's uit en scoorde zowel met originele Nederlandstalige nummers als met Engelstalige covers van ballads, Motown-nummers en big band-songs.
Vader & zoon: Günther beschikt over hetzelfde warme stemtimbre als zijn vader. • In 2000 bracht Günther een eerbetoon aan zijn vader met de cd en het concert Louis Neefs 20 jaar later. Ter gelegenheid hiervan werd een nieuwe versie uitgebracht van *Laat ons een Bloem*, waarop Günthers stem gecombineerd werd met die van Louis. • Günther sprak in 2008 de stem in van straatkat Thomas O'Malley in de herwerkte Nederlandstalige uitgave van *De Aristokatten* - iets wat zijn vader hem in 1970 voordeed.

"The worst
misfortune that
can happen to an
ordinary man
is to have an
extraordinary
father."

Austin O'Malley (1858-1932),
American author

Jawaharlal Indira & Rajiv
Nehru & Gandhi

Jawaharlal Nehru (14 November 1889 - 27 May 1964, India) was a key figure in the Indian independence movement and the country's first (and to date the longest serving) Prime Minister.
As one of the founders and leaders of the Non-aligned movement, he was also an important figure in international politics in the post-war era.
Indira Priyadarshini Gandhi (19 November 1917 - 31 October 1984, India) was the third and fifth Prime Minister of India for a total of 15 years. She was India's only female Prime Minister and the world's longest serving female Prime Minister. She was murdered by two of her bodyguards.
Rajiv Gandhi (20 August 1944 - 21 May 1991, India) was nominated to be India's youngest Prime Minister after his mother's death. Two months later, he won the elections with the largest majority in the history of the Indian Parliament. He was killed in an attack by Tamil Tiger rebels.
The Nehru-Gandhi family: Jawaharlal's father Motilal Nehru was an early Indian independence fighter and political leader of the Indian National Congress. He was the actual founding father of the Nehru-Gandhi family, India's most powerful political family. • Rajiv's son Rahul Gandhi is a Member of Parliament. • Indira and Rajiv are not related to the famous Indian freedom fighter Mahatma Gandhi.

Jawaharlal Nehru (14 novembre 1889 - 27 mai 1964, Inde) est l'une des figures de proue de la lutte pour l'indépendance de l'Inde. Il fut le premier homme à accéder au poste de Premier ministre du pays. Après la guerre, il joua un rôle important au niveau international, en tant que cofondateur et membre du Mouvement des non-alignés.
Indira Priyadarshini Gandhi (19 novembre 1917 - 31 octobre 1984, Inde) est la seule femme à avoir tenu la fonction de Premier ministre en Inde. Elle occupa ce poste pendant 15 ans (de 1966 à 1977 puis de 1980 à 1984) avant d'être assassinée par deux de ses gardes du corps.
Rajiv Gandhi (20 août 1944 - 21 mai 1991, Inde) fut proclamé Premier ministre après la mort de sa mère. Deux mois plus tard, il remporta les élections avec la plus large majorité de l'histoire du parlement indien. Il périt dans un attentat fomenté par les rebelles tamouls.
La famille Nehru-Gandhi : Le père de Jawaharlal, Motilal Nerhu, fut l'un des premiers activistes indiens pour l'indépendance et le leader du Parti du Congrès. Il est le patriarche de la lignée des Nehru-Gandhi, l'une des plus puissantes familles politiques indiennes. • Le fils de Rajiv, Rahul Gandhi, est un parlementaire. • Indira et Rajiv ne sont pas parents avec le Mahatma Gandhi.

Jawaharlal Nehru (14 november 1889 - 27 mei 1964, India) was een sleutelfiguur in de Indiase onafhankelijkheidsbeweging en 's lands eerste en totnogtoe langst dienende premier. Als een van de stichters en leiders van de Organisatie van Niet-Gebonden Landen speelde hij in de naoorlogse periode ook een belangrijke rol op internationaal gebied.
Indira Priyadarshini Gandhi (19 november 1917 - 31 oktober 1984, India) was de derde en vijfde premier van India, gedurende een totaal van vijftien jaar. Ze is India's enige vrouwelijke premier en 's werelds langst dienende vrouwelijke premier. Ze werd vermoord door twee van haar lijfwachten.
Rajiv Gandhi (20 augustus 1944 - 21 mei 1991, India) werd na zijn moeders dood gebombardeerd tot India's jongste premier. Twee maanden later won hij de verkiezingen met de grootste meerderheid in de geschiedenis van het Indiase parlement. Hij kwam om het leven bij een aanslag gepleegd door Tamilstrijders.
De familie Nehru-Gandhi: Jawaharlals vader, Motilal Nerhu, was een vroege Indiase onafhankelijkheidsstrijder en politiek leider van het Indiase Nationale Congres. Hij was de eigenlijke stichter van de Nehru-Gandhi-lijn, India's machtigste politieke familie. • Rajivs zoon Rahul Gandhi is parlementslid. • Indira en Rajiv zijn geen familie van de beroemde Indiase vrijheiddstrijder Mahatma Gandhi.

> **"My father was a statesman,
> I'm a political woman. My father
> was a saint. I'm not."**
>
> Indira Gandhi

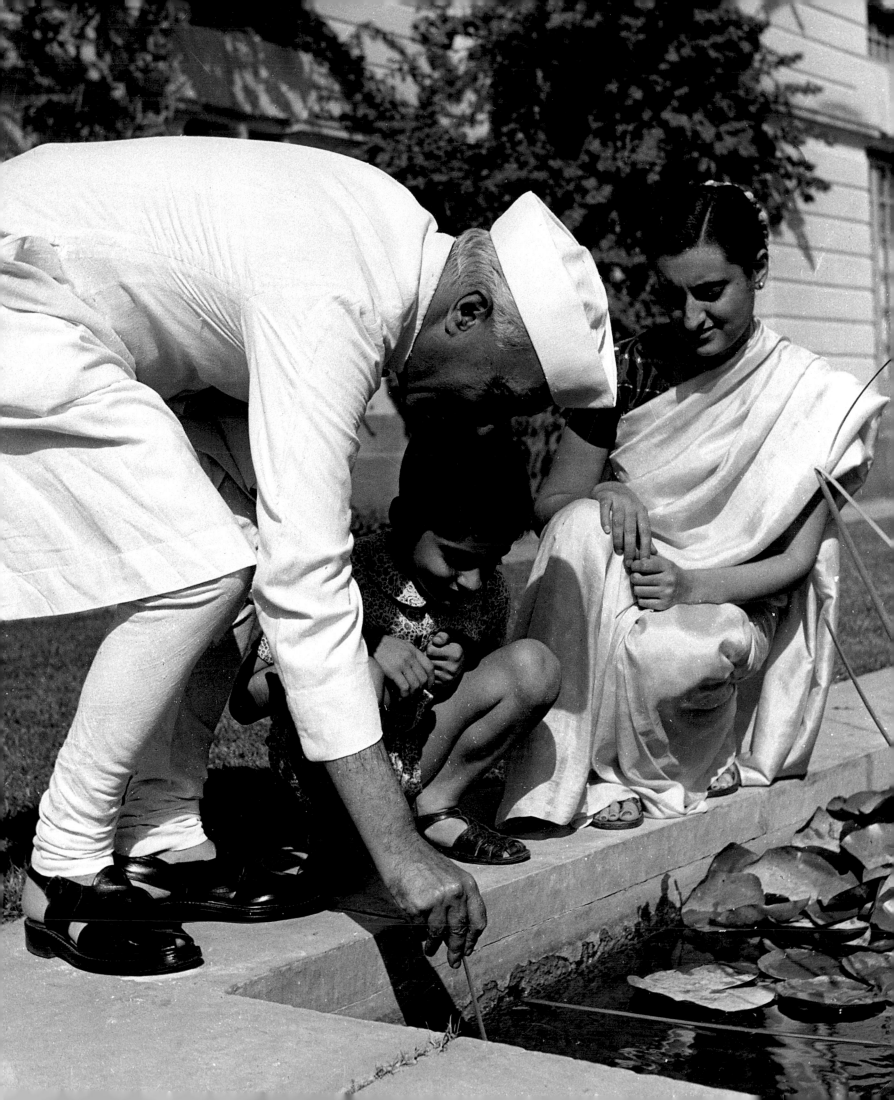

Ryan & Tatum
O'Neal

Charles Patrick Ryan O'Neal (20 April 1941, USA) broke through with the soap opera *Peyton Place* and became world famous due to films like *Love Story*, *Barry Lyndon* and *A Bridge too Far*. His career went downhill in the 80s. Since 2007, he regularly appears in the television series *Bones*.

Tatum Beatrice O'Neal (5 November 1963, USA) was nine when she made her film debut in *Paper Moon* and ten when she became the youngest to win an Academy Award. In the 70s, she became the best-paid child star in film history due her roles in films like *The Bad News Bears* and *International Velvet*. After her marriage to John McEnroe in 1986, she put her career on the backburner.

Father & daughter: Ryan portrayed the role of Tatum's father in her first film. They appeared together once more in *Nickelodeon*. • In her autobiography, *A Paper Life*, Tatum accuses her father of physical and emotional abuse as a result of his drug use. • In an interview with Vanity Fair, Ryan explains how he accidently tried to seduce his daughter at the funeral of his great love Farrah Fawcett.

The family O'Neal: Ryan's father Charles was a screenplay writer, his mother Patricia Callaghan was an actress. • Tatum's mother Joanna Cook Moore was also an actress.

Charles Patrick Ryan O'Neal (20 avril 1941, États-Unis) est révélé grâce au feuilleton "*Peyton Place*". Il devint une star internationale grâce aux films *Love Story*, *Barry Lyndon* et *Un Pont trop loin*. Si sa carrière est en dents de scie dans les années 80, il apparaît régulièrement dans la série "*Bones*" depuis 2007.

Tatum Beatrice O'Neal (5 novembre 1963, États-Unis) débute à 9 ans dans *La Barbe à papa* ; l'année suivante, elle remporte un Oscar et devient la plus jeune lauréate jamais récompensée. Dans les années 70, elle tourne *The Bad News Bears* et *International Velvet*, et devient l'enfant star la mieux payée de l'histoire du cinéma. Après son mariage avec John McEnroe en 1986, elle met sa carrière entre parenthèses.

Père & fille : Tatum et Ryan ont partagé l'affiche de *La Barbe à papa* et de *Nickelodeon*. • Dans son autobiographie, Tatum accuse son père de violences physiques et psychologiques dues à sa toxicomanie. • Ryan a avoué à *Vanity Fair* avoir malencontreusement dragué sa propre fille le jour de l'enterrement de son grand amour, Farrah Fawcett !

La famille O'Neal : Le père de Ryan, Charles, était scénariste ; sa mère, Patricia Callaghan, était quant à elle actrice. • La mère de Tatum, Joanna Cook Moore, fut également actrice.

Charles Patrick Ryan O'Neal (20 april 1941, VSA) brak door met de soap *Peyton Place* en werd wereldberoemd dankzij films als *Love Story*, *Barry Lyndon* en *A Bridge too Far*. In de jaren 80 raakte zijn carrière in het slop. Sinds 2007 duikt hij regelmatig op in de tv-serie *Bones*.

Tatum Beatrice O'Neal (5 november 1963, VSA) was negen toen ze haar filmdebuut maakte in *Paper Moon* en tien toen ze de jongste Oscarwinnaar ooit werd. In de jaren 70 groeide ze dankzij films als *The Bad News Bears* en *International Velvet* uit tot de bestbetaalde kindster in de filmgeschiedenis. Na haar huwelijk met John McEnroe in '86 zette ze haar carrière op een laag pitje.

Vader & dochter: In Tatums eerste film vertolkte Ryan de rol van haar vader. In Nickelodeon speelden ze opnieuw samen. • In de autobiografie *A Paper Life* beschuldigt Tatum hem van fysiek en emotioneel misbruik ten gevolge van zijn drugmisbruik. • In een interview met Vanity Fair vertelde Ryan hoe hij tijdens de begrafenis van zijn grote liefde Farrah Fawcett - per ongeluk - zijn eigen dochter probeerde te versieren.

De familie: Ryans vader Charles was scenarioschrijver, zijn moeder Patricia Callaghan actrice. • Ook Tatums moeder Joanna Cook Moore was actrice.

> **"He was really loving to me until I got more attention than he did. Then he hated me."**
> Tatum O'Neal

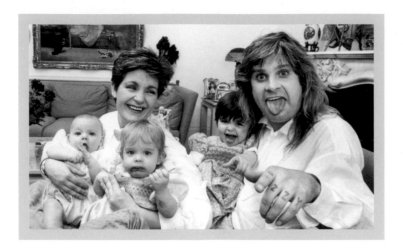

Ozzy & Kelly
Osbourne

Ozzy Osbourne (3 December 1948, Great Britain) is regarded as the 'Godfather of heavy metal' due to his contributions as lead vocalist and songwriter of Black Sabbath. He also sold 32 million albums as a solo artist, starred in the reality show *The Osbournes* and created the successful annual heavy metal event Ozzfest.

Kelly Osbourne (27 October 1984, Great Britain) came to fame in 2002 due to *The Osbournes* and soon thereafter released two fairly successful albums. She launched her own fashion line, began to do television and radio work, appeared in the West End musical *Chicago* and took home third place in *Dancing with the Stars*. After her last rehab attempt in 2009 and the publication of her autobiography/self-help book *Fierce* it seems like the world has finally started to take her seriously.

Father & daughter: Ozzy first checked into rehab the day after Kelly was born. • When she was eight years old, Kelly, her sister and her brother were told by their father that "one, if not all, of you will have the gene that cause alcohol abuse". • In 2003, Kelly and Ozzy had a number 1 hit with their cover of the song *Changes*.

The Osbourne family: Mother Sharon and son Jack have also become media personalities.

Ozzy Osbourne (3 décembre 1948, Angleterre) fut surnommé le "Dieu du heavy metal" du fait de sa carrière de chanteur-compositeur au sein du groupe *Black Sabbath*. En solo, il a vendu 32 millions d'albums et connu un grand succès avec l'émission de télé-réalité "The Osbournes". Il est à l'origine du festival d'heavy metal *Ozzfest*.

Kelly Osbourne (27 octobre 1984, Angleterre) est devenue célèbre en 2002 grâce à l'émission de télé-réalité consacrée à sa famille. Peu après sa diffusion, elle sort deux albums et lance une ligne de vêtements, travaille pour la radio et la télévision, joue dans la comédie musicale *Chicago* et termine à la 3e place du concours "Dancing with the Stars". Après une troisième cure de désintoxication en 2009, elle publie *Fierce*, une autobiographie saluée par la critique.

Père & fille : Le lendemain de la naissance de Kelly, Ozzy se fit admettre dans un centre de désintoxication. • Enfants, Kelly, son frère et sa sœur s'entendent dire de la bouche d'Ozzy que l'un d'eux – si ce n'est tous – possède le gène de l'alcoolisme. • En 2003, Kelly et Ozzy reprennent le tube "Changes" du groupe *Black Sabbath*.

La famille Osbourne : L'épouse d'Ozzy et leur fils Jack sont aujourd'hui des personnalités médiatiques.

Ozzy Osbourne (3 december 1948, Groot-Brittannië) wordt dankzij zijn bijdrage als leadzanger en liedjesschrijver van Black Sabbath beschouwd als de 'Godfather of heavy metal'. Daarnaast wist hij ook solo 32 miljoen albums aan de man te brengen, schitterde hij in de realityshow *The Osbournes* en creëerde hij het succesvolle jaarlijkse heavymetal-evenement Ozzfest.

Kelly Osbourne (27 oktober 1984, Groot-Brittannië) raakte in 2002 bekend door de realityreeks rond haar familie en bracht kort daarna twee redelijk succesvolle albums uit. Ze lanceerde een eigen modelijn, begon tv- en radiowerk te doen, trad aan in de West End-musical *Chicago* en behaalde een derde plaats in *Dancing with the Stars*. Na een derde afkickpoging in 2009 wordt ze eindelijk serieus genomen dankzij haar autobiografie-zelfhulpboek *Fierce*.

Vader & dochter: De dag na Kelly's geboorte liet Ozzy zich voor het eerst opnemen in een ontwenningskliniek. • Op haar achtste kregen Kelly, haar zus en broer van hun vader te horen dat "een van jullie, zoniet allen, het gen zal hebben" dat aanzet tot drankmisbruik. • In 2003 scoorden Kelly en Ozzy een nummer één-hit met hun cover van de Black Sabbath-hit *Changes*.

De familie Osbourne: Ook moeder Sharon en zoon Jack zijn uitgegroeid tot media-persoonlijkheden.

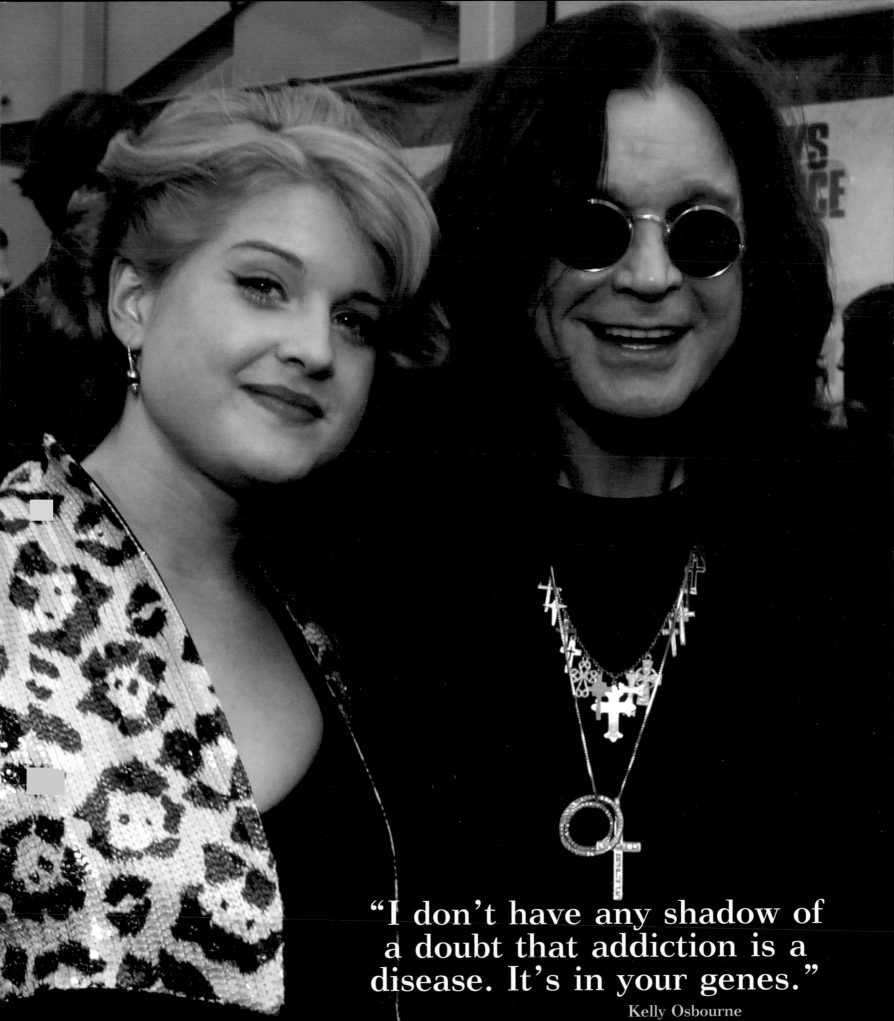

"I don't have any shadow of a doubt that addiction is a disease. It's in your genes."

Kelly Osbourne

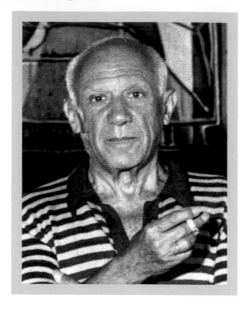

Pablo & Paloma
Picasso

Pablo Diego José Francisco de Paula Juan Nepomuceno María de los Remedios Cipriano de la Santísima Trinidad Ruiz y Picasso (25 October 1881 - 8 April 1973, Spain) was one of the most famous artists of the 20th century. His contributions to the emergence of Cubism and the variety of styles with which he experimented made him world famous and incredibly rich.

Anne Paloma Picasso (19 April 1949, France) is a French/Spanish designer who came to fame due to her colourful jewellery designs for Tiffany & Co. and signature perfumes such as *Paloma* and *Minotaure*. Since 2000, she has also developed an interior design line.

Father & daughter: Pablo named his daughter Paloma (Spanish for pigeon) after his drawing of a pigeon that became symbol of the World Peace Conference in 1949. • Paloma appears in paintings like *Paloma with an Orange* and *Paloma in Blue*. • She quit designing temporarily after her father's death and chose paintings instead of money as her inheritance. • She founded the Paloma Picasso Foundation to promote the work of her parents.

The Picasso family: Paloma's mother Françoise Gilot was an artist and a writer; her brother Claude is a famous photographer.

Pablo Diego José Francisco de Paula Juan Nepomuceno María de los Remedios Cipriano de la Santísima Trinidad Ruiz y Picasso (25 octobre 1881 - 8 avril 1973, Espagne) est l'un des artistes majeurs du 20ᵉ siècle. Son rôle dans l'émergence du cubisme, ainsi que la variété des autres styles qu'il a expérimentés, lui ont valu une reconnaissance internationale et une immense fortune.

Anne Paloma Picasso (19 avril 1949, France), célèbre créatrice de mode franco-espagnole, dessine des bijoux colorés pour Tiffany & Co et signe des parfums phares tels que *Paloma* et *Minotaure*. Elle lança également en 2000 une ligne de linge de maison.

Père & fille : Pablo appela sa fille Paloma ("colombe" en espagnol) en référence au dessin de *La Colombe de la paix* qu'il avait réalisé en 1949. • Paloma apparaît sur les toiles *Paloma avec orange* et *Paloma en bleu*. • À la mort de Pablo, Paloma arrêta provisoirement de créer et choisit comme héritage des tableaux plutôt que de l'argent. • Elle créa la fondation Paloma Picasso pour promouvoir l'œuvre de ses parents.

La famille Picasso : La mère de Paloma, Françoise Gilot, était artiste et écrivain, et son frère, Claude, est aujourd'hui un photographe célèbre.

Pablo Diego José Francisco de Paula Juan Nepomuceno María de los Remedios Cipriano de la Santísima Trinidad Ruiz y Picasso (25 oktober 1881 - 8 april 1973, Spanje) was een van de beroemdste kunstenaars van de 20e eeuw. Zijn bijdrage aan het ontstaan van het kubisme en de variëteit aan andere stijlen waarmee hij experimenteerde, leverden hem wereldroem en een immens fortuin op.

Anne Paloma Picasso (19 april 1949, Frankrijk) is een Frans/Spaanse ontwerpster die beroemd werd dankzij haar kleurrijke juweelontwerpen voor Tiffany & Co. en iconische parfums als Paloma en Minotaure. Sinds 2000 heeft ze ook een interieurlijn.

Vader & dochter: Pablo noemde zijn dochter Paloma (Spaans voor duif) naar zijn tekening van een duif die symbool werd van de World Peace Conference in 1949. • Paloma duikt op in schilderijen als *Paloma with an Orange* en *Paloma in Blue*. • Ze gaf het ontwerpen na de dood van haar vader tijdelijk op en koos als erfenis voor schilderijen in plaats van geld. • Ze richtte de Paloma Picasso Foundation op om het werk van haar ouders te promoten.

De familie Picasso: Paloma's moeder Françoise Gilot was kunstenares en schrijfster, haar broer Claude is een bekend fotograaf.

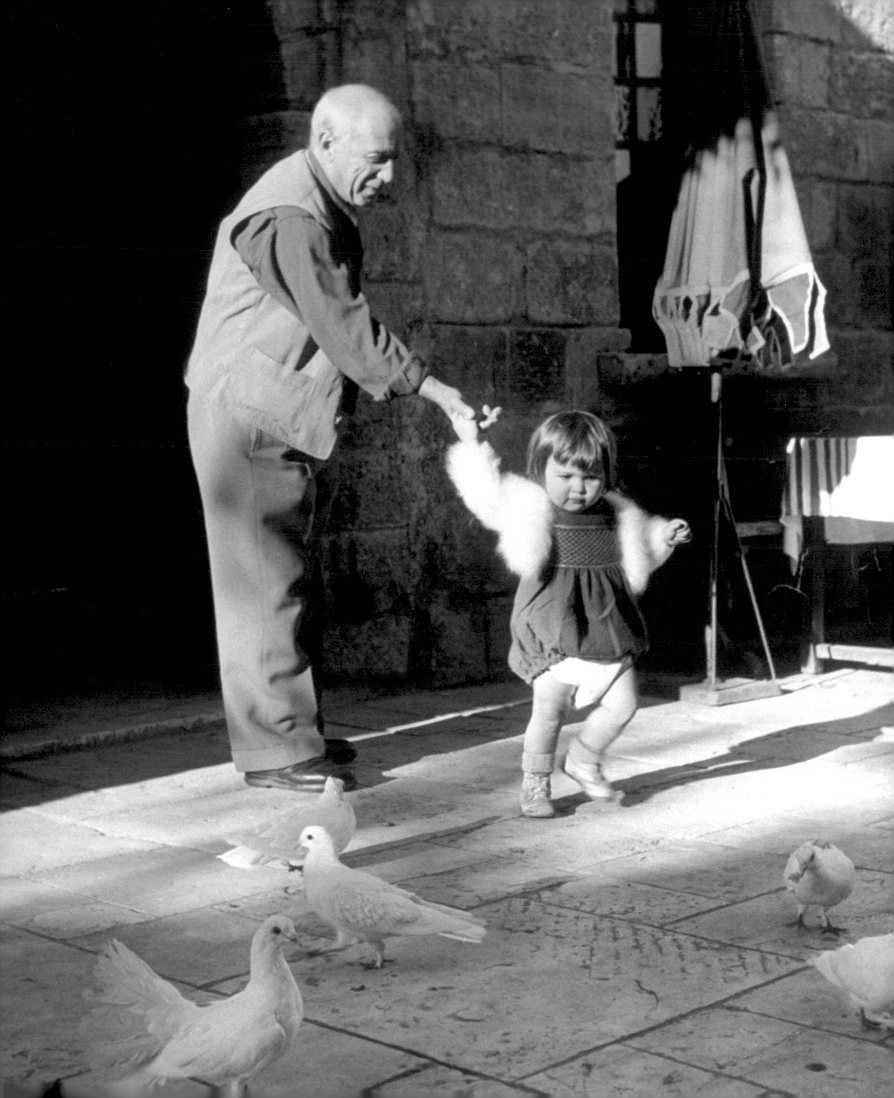

Nelson & Nelson Jr.
Piquet

Nelson Piquet Souto Maior (17 August 1952, Brazil) won three World Championship Formula 1 titles, making him one of the most important F1 racers of the 80s. He also tried to make it in Indycar racing, but gave up after an accident. These days, he is a successful businessman.
Nelson Ângelo Tamsma Piquet Souto Maior (25 July 1985, Germany) won three titles in diverse Brazilian cart categories, won the South American Formula 3 title and became the youngest British Formula 3 Champion at the age of 19. In 2006, he became the best Brazilian Formula 1 debutant ever. He transferred to NASCAR in 2009.
Father & son: Nelson Jr. is called 'Nelsinho' ('little Nelson'). • He moved in with his divorced father when he was eight. • Nelson founded the racing team Piquet Sports in order to give his son a solid start in Formula 3 racing. • He encouraged his son to tell the truth about the Singapore Crashgate scandal in 2008, in which Nelson Jr. had deliberately crashed his car, at the request of his team leaders, so his teammate could win the race.
The Piquet family: Son Geraldo tried to make it in racing but was not successful, while the younger Pedro can't wait to make his debut.

Nelson Piquet Souto Maior (17 août 1952, Brésil), triple champion du monde de Formule 1, est l'un des plus grands pilotes des années 80. Il s'essaya aux courses d'IndyCar, mais abandonna cette catégorie après un accident. Il est aujourd'hui un riche homme d'affaires.
Nelson Angelo Tamsma Piquet Souto Maior (25 juillet 1985, Allemagne) a remporté 3 titres dans différentes catégories de karting au Brésil et le championnat d'Amérique du Sud de Formule 3. Il est devenu, à l'âge de 19 ans, le plus jeune champion d'Angleterre de F3. En 2006, il s'affirme comme le meilleur débutant brésilien en F1 avant de passer en NASCAR en 2009.
Père & fils : Nelson Jr. est surnommé "*Nelsinho*". • Il a vécu chez son père après le divorce de ses parents. • Nelson créa l'écurie Piquet Sports pour lancer son fils en F3. • Il l'encouragea à faire toute la lumière sur le scandale du Grand Prix de Singapour 2008, où Nelson Jr. fut contraint d'avoir un accident pour donner un avantage décisif à son coéquipier.
La famille Piquet : Le fils de Nelson, Geraldo, a tenté en vain une carrière de pilote et Pedro, le cadet, fait quant à lui ses débuts.

Nelson Piquet Souto Maior (17 augustus 1952, Brazilië) is met drie wereldkampioenstitels een van de belangrijkste Formule 1-coureurs uit de jaren 80. Hij probeerde ook nog naam te maken in de Indycars, maar trok zich na een ongeluk terug. Tegenwoordig is hij een succesvol zakenman.
Nelson Ângelo Tamsma Piquet Souto Maior (25 juli 1985, Duitsland) behaalde drie titels in diverse Braziliaanse kart-categorieën, won de Zuid-Amerikaanse Formule 3-titel en werd op zijn negentiende de jongste winnaar ooit van het Britse Formule 3-kampioenschap. In 2006 werd hij de beste Braziliaanse Formule 1-debutant ooit. In 2009 stapte hij over naar NASCAR.
Vader & zoon: Nelson Jr. wordt 'Nelsinho' ('kleine Nelson') genoemd. • Hij trok op zijn achtste in bij zijn gescheiden vader. • Nelson richtte het raceteam Piquet Sports op om zijn zoon een goeie start te geven in de Formule 3. • Hij zette zijn zoon aan om de waarheid op te biechten over het Singapore Crashgate-schandaal uit 2008, waarbij Nelson Jr. op vraag van zijn teamleiding met opzet crashte om zijn teamgenoot aan de zege te helpen.
De familie Piquet: Zoon Geraldo probeerde het vergeefs te maken in de racesport en de jonge Pedro staat te trappelen om zijn debuut te maken.

"My son is much better than I was."
Nelson Piquet

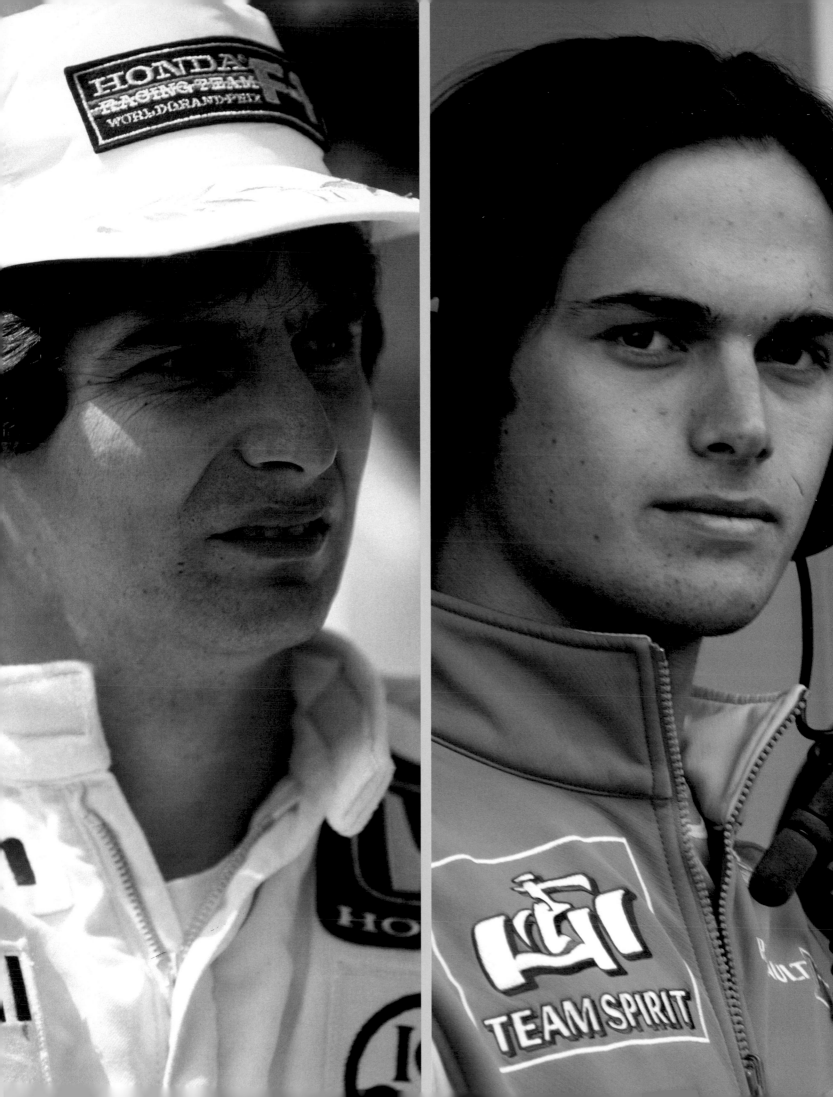

Ferdinand & Ferry
Porsche

Ferdinand Porsche (3 September 1875 - 30 January 1951, Germany) was an Austrian-Hungarian car designer who is commonly referred to as the inventor of the world's first hybrid vehicle and the designer of the Volkswagen Beetle, The Mercedes Benz SS/SSK and the very first Porsche cars.
Ferdinand 'Ferry' Anton Ernst Porsche (19 September 1909 - 27 March 1998, Germany) took over the family company when his father was imprisoned for war crimes. He designed the sports car of his dreams, the 356. He became the general manager and chairman of the board after his father's death.
Father & son: Ferry and his father founded the car design company Porsche in Stuttgart in 1931. When Ferdinand went to prison in France after WWII, Ferry moved the company to Austria. He bought his father's freedom with the money he made with his first designs.
The Porsche family: Ferry's son Ferdinand 'Butzi' Alexander and his cousin designed the world famous Porsche 911 together and sold around 600 000 of them. • Ferdinand Porsche had a daughter whose husband Anton Piëch was also in the company. To this day, the family is divided into the branch 'with the famous name' and the one 'without the famous name', with subsequent rivalry.

Ferdinand Porsche (3 septembre 1875 - 30 janvier 1951, Allemagne), célèbre ingénieur et créateur automobile austro-hongrois, est l'inventeur du moteur hybride et le père de la Coccinelle, de la Mercedes-Benz SS/SSK et des toutes premières Porsche.
Ferdinand "Ferry" Anton Ernst Porsche (19 septembre 1909 - 27 mars 1998, Allemagne) reprend la firme familiale lorsque son père est emprisonné pour crimes de guerre. Il crée la voiture de sport de ses rêves, la 356. À la mort de son père, il devient directeur général et président du conseil d'administration de Porsche.
Père & fils : Ferry créa avec son père le bureau de design automobile Porsche en 1931. Quand Ferdinand fut prisonnier de guerre en France, Ferry déménagea la société en Autriche. Avec l'argent qu'il tira de ses premières réalisations, il acheta la liberté de son père.
La famille Porsche : Le fils de Ferry, Ferdinand "Butzi" Alexander, et son neveu créèrent la célèbre Porsche 911, écoulée à plus de 600 000 exemplaires. • Ferdinand Porsche avait une fille dont le mari, Anton Piëch, travaillait chez Porsche. En proie à de nombreuses rivalités, la famille est aujourd'hui encore divisée entre la branche Porsche et la branche Piëch.

Ferdinand Porsche (3 september 1875 - 30 januari 1951, Duitsland) was een Oostenrijks-Hongaarse auto-ontwerper die vooral bekend staat als de uitvinder van 's werelds eerste hybridevoertuig en de ontwerper van de Volkswagen Kever, de Mercedes-Benz SS/SSK en de allereerste Porsche-wagens.
Ferdinand 'Ferry' Anton Ernst Porsche (19 september 1909 - 27 maart 1998, Duitsland) nam de familiefirma over toen zijn vader in de cel belandde voor oorlogsmisdaden. Hij ontwierp de sportauto van zijn dromen, de 356. Na zijn vaders dood werd hij algemeen manager en bestuursvoorzitter.
Vader & zoon: Ferry opende in 1931 samen met zijn vader het auto-ontwerpburo Porsche in Stuttgart. Toen Ferdinand na WOII in Frankrijk in de gevangenis belandde, verhuisde Ferry de firma naar Oostenrijk. Met het geld dat hij verdiende voor zijn eerste ontwerpen kocht hij zijn vader vrij.
De familie Porsche: Ferry's zoon Ferdinand 'Butzi' Alexander en zijn neef ontwierpen samen de wereldberoemde Porsche 911, waarvan er ongeveer 600.000 verkocht werden. • Ferdinand Porsche had een dochter wiens echtgenoot Anton Piëch ook in het bedrijf zat. De familie is heden ten dage nog altijd verdeeld in de tak 'met de beroemde naam' en die 'zonder de beroemde naam', en de rivaliteit is navenant.

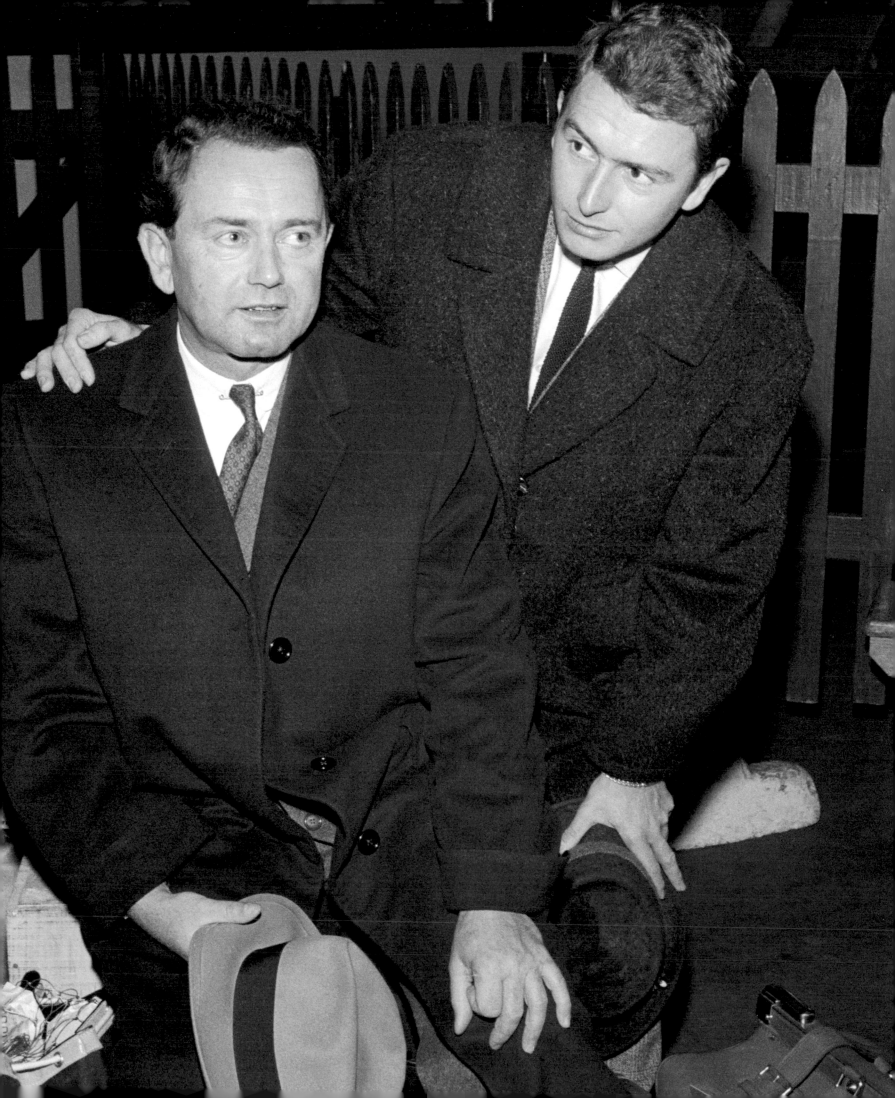

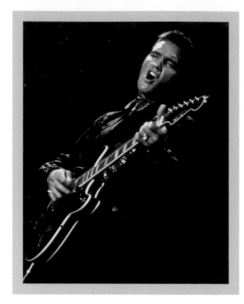

Elvis & Lisa Marie
Presley

Elvis Aaron Presley (8 January 1935 - 16 August 1977, USA) broke through at the age of 20 with *That's All Right, Mama* and then began to make hit songs and films at a high pace. After his military service, he exchanged pure rock 'n roll for quiet music like *Love Me Tender* and *Crying in the Chapel*. In the 70s, he moved his work terrain to Las Vegas.
Lisa Marie Presley (1 February 1968, USA) spent her whole life in the spotlights but waited until 2003 to release her self-written debut album *To Whom It May Concern*. The album *Now What* followed two years later. The albums did not do badly but did not match the success of her father. She is currently working on a third album with singer Richard Hawley.
Father & daughter: To commemorate the 30th anniversary of her father's death in 2007, Lisa Marie released a version of *In the Ghetto* on which her father's voice was mixed with hers.
The Presley family: Lisa Marie's daughter Danielle Riley Keough is an actress and model. Her son Benjamin Presley signed a 5 million dollar record deal in 2009 and is currently working on his first album.

Elvis Aaron Presley (8 janvier 1935 - 16 août 1977, États-Unis), icône du rock, connaît la gloire dès l'âge de 20 ans avec le titre "*That's All Right, Mama*". Il enchaîne ensuite les tubes et les films à succès à un rythme effréné. Après son service militaire, il délaisse le rock'n'roll pur et dur pour des ballades plus tendres comme "*Love Me Tender*" et "*Crying in the Chapel*". Dans les années 70, il décide de poursuivre sa carrière à Las Vegas.
Lisa Marie Presley (1er février 1968, États-Unis), sous les feux de la rampe depuis son enfance, ne sort qu'en 2003 son premier album, *To Whom It May Concern*, dont elle signe les paroles et la musique. Son deuxième opus, *Now What*, sort en 2005 ; le succès est au rendez-vous. Elle prépare un troisième album avec le chanteur Richard Hawley.
Père & fille : Pour commémorer le 30e anniversaire de la mort du *King*, Lisa Marie sort en 2007 une version de "*In the Ghetto*" où ils chantent en duo.
La famille Presley : La fille de Lisa Marie, Danielle Riley Keough, est actrice et mannequin. Son fils Benjamin a signé en 2009 un contrat de 5 millions de dollars avec une maison de disques et prépare son premier album.

Elvis Aaron Presley (8 januari 1935 - 16 augustus 1977, VSA) brak op zijn 20e door met *That's All Right, Mama* en begon daarna tegen een hoog tempo hitnummers en -films te maken. Na zijn militaire dienst verruilde hij de pure rock-'n-roll voor rustigere muziek als *Love Me Tender* en *Crying in the Chapel*. In de jaren '70 verlegde hij zijn werkterrein naar Las Vegas.
Lisa Marie Presley (1 februari 1968, VSA) bracht haar hele leven door in de spotlights maar wachtte tot 2003 om haar zelfgeschreven debuutalbum, *To Whom It May Concern*, uit te brengen. Twee jaar later volgde *Now What*. De albums deden het niet slecht maar het succes van haar vader evenaarde ze niet. Momenteel werkt ze samen met zanger Richard Hawley aan een derde plaat.
Vader & dochter: Om de 30e verjaardag van zijn dood te herdenken, bracht Lisa Marie in 2007 een versie van *In the Ghetto* uit waarop de stem van haar vader gemixt werd met haar eigen stem.
De familie: Lisa Marie's dochter Danielle Riley Keough is actrice en model. Haar zoon Benjamin Presley kreeg in 2009 een platendeal van 5 miljoen dollar en is bezig aan zijn eerste album.

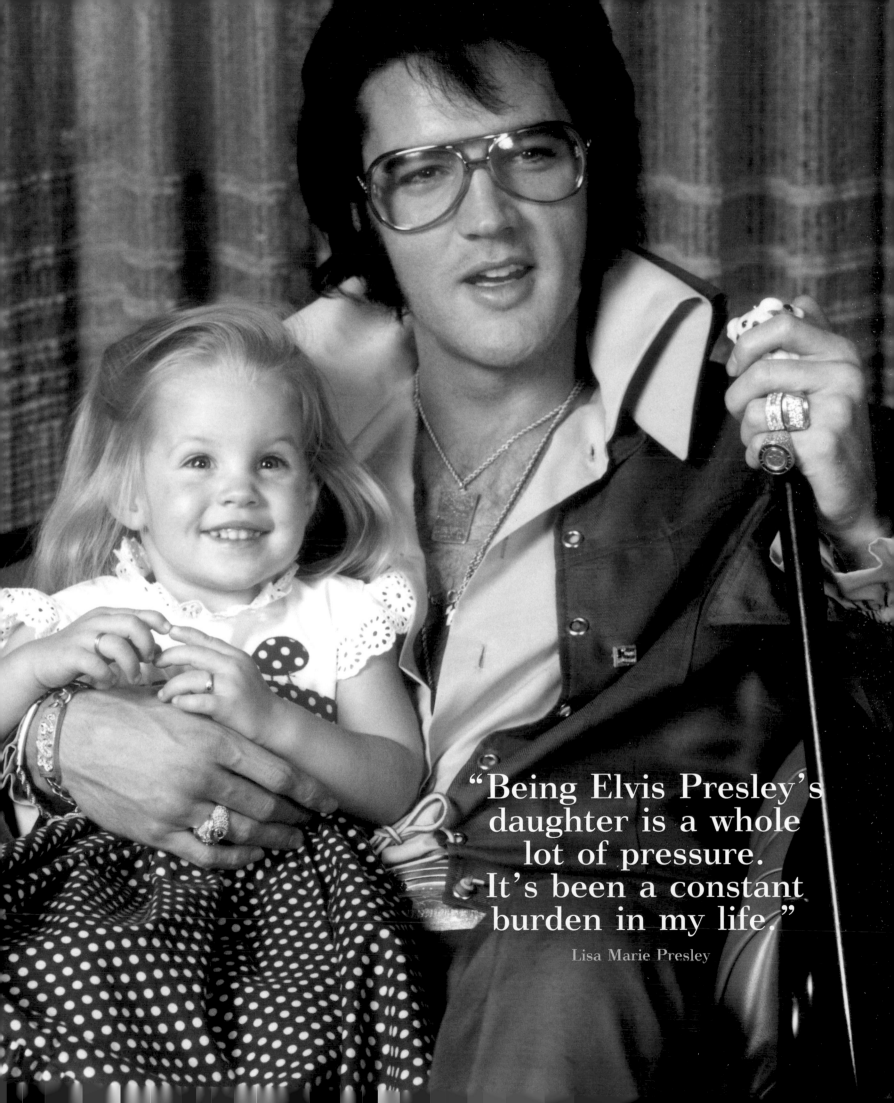

"Being Elvis Presley's daughter is a whole lot of pressure. It's been a constant burden in my life."

Lisa Marie Presley

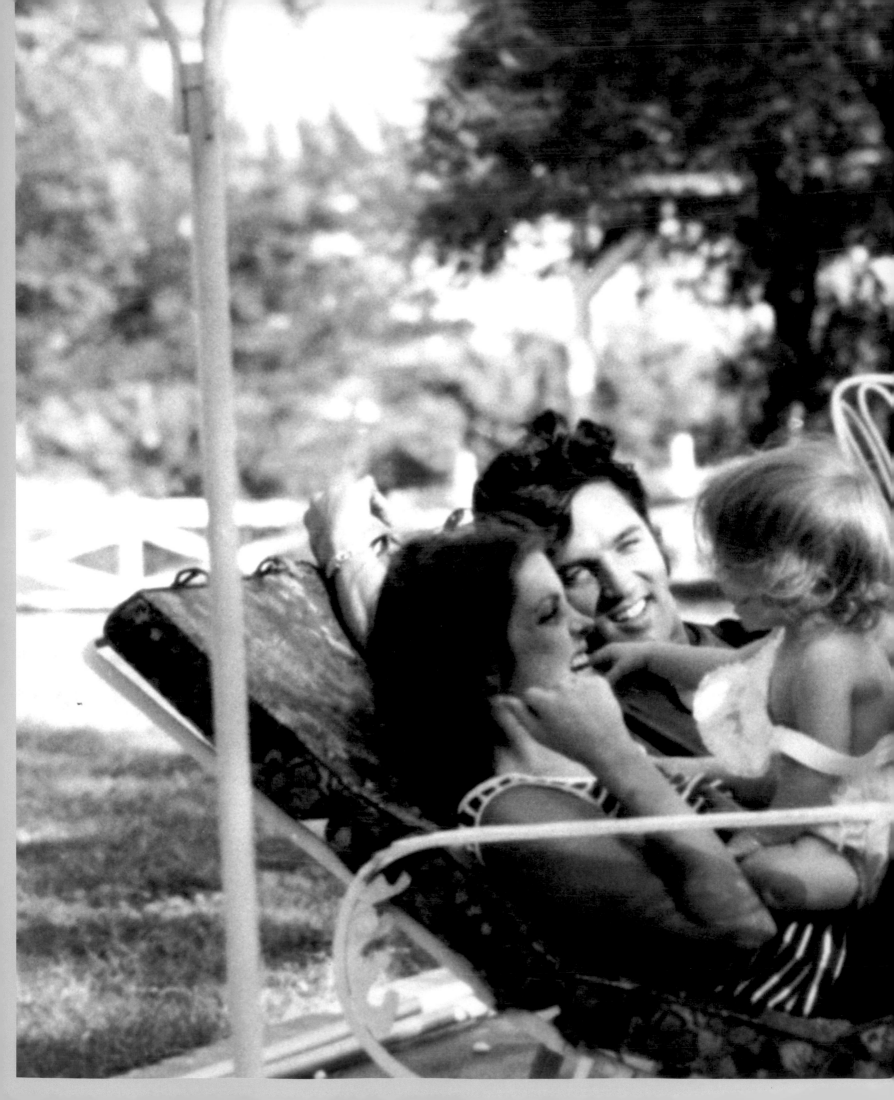

"Luke, I am your father!"

Darth Vader in *Star Wars Episode V: The Empire Strikes Back* (1980)

Sir Michael & Vanessa
Redgrave

Sir Michael Scudamore Redgrave (20 March 1908 - 21 March 1985, Great Britain) is said to have been one of the best British actors of his generation. He started his career in theatres like The Old Vic and starred in films such as *The Lady Vanishes*, *Mourning Becomes Electra*, *The Browning Version* and *The Innocents*. He was also a director, manager and author.

Vanessa Redgrave (30 January 1937, Great Britain) is the only British actress to succeed in winning an Oscar, an Emmy Award, a Tony Award, an Olivier Award, a Golden Palm, a Golden Globe and the Screen Actors Guild Award. She is celebrated on Broadway and the West End and has appeared in over 80 films, including *Julia*, *Isadora*, *Mary*, *Queen of Scots*, *The Bostonians*, *Atonement*, *Wilde*, *Mission Impossible* and *Howard's End*.

Father and daughter: "Ladies and gentlemen, tonight a great actress has been born. Laertes has a daughter." This is how Laurence Olivier announced Vanessa's birth at a performance of *Hamlet*.

The Redgrave family: Michael's father Roy was a star in silent films in Australia. Vanessa's mother is actress Rachel Kempson. Her sister Lynn and brother Corin Redgrave, and daughters Natasha Richardson and Joely Richardson have also proved their worth in acting. Son Carlo Gabriel Nero is a director.

Sir Michael Scudamore Redgrave (20 mars 1908 - 21 mars 1985, Angleterre) est l'un des plus fameux acteurs britanniques de sa génération. Il débute sa carrière au théâtre et joue dans de nombreux films, dont *Une Femme disparaît*, *Le Deuil sied à Électre*, *L'Ombre d'un homme* et *Les Innocents*. Il est également metteur en scène, manager et auteur.

Vanessa Redgrave (30 janvier 1937, Angleterre) est la seule actrice britannique à avoir décroché les récompenses suivantes : Oscar, Emmy Award, Tony Award, Olivier Award, Gouden Palm, Golden Globe et Screen Actors Guild Award. Célèbre à Broadway et au West End, elle a tourné dans plus de 80 films, dont *Julia*, *Isadora*, *Marie Stuart, reine d'Écosse*, *Les Bostoniennes*, *Reviens-moi*, *Oscar Wilde*, *Mission Impossible* et *Retour à Howards End*.

Père & fille : "Mesdames et Messieurs, aujourd'hui une grande actrice est née. Laërte a une fille." Laurence Olivier annonça par ces mots la naissance de Vanessa lors d'une représentation de *Hamlet*.

La famille Redgrave : Le père de Michael fut une star du cinéma muet en Australie. Le frère, la sœur et les filles de Vanessa, Natasha et Joely Richardson, ont tous poursuivi une carrière d'acteur. Le fils de Vanessa, Carlo Gabriel Nero, est réalisateur.

Sir Michael Scudamore Redgrave (20 maart 1908 - 21 maart 1985, Groot-Brittannië) wordt geroemd als een van de beste Britse acteurs van zijn generatie. Hij startte zijn carrière in theaters als The Old Vic en schitterde in films als *The Lady Vanishes*, *Mourning Becomes Electra*, *The Browning Version* en *The Innocents*. Hij was ook regisseur, manager en auteur.

Vanessa Redgrave (30 januari 1937, Groot-Brittannië) is de enige Britse actrice die erin slaagde een Oscar, Emmy Award, Tony Award, Olivier Award, Gouden Palm, Golden Globe én Screen Actors Guild Award te winnen. Ze is gevierd op Broadway en West End en was te zien in ruim 80 films, waaronder *Julia*, *Isadora*, *Mary, Queen of Scots*, *The Bostonians*, *Atonement*, *Wilde*, *Mission Impossible* en *Howard's End*.

Vader & dochter: *"Ladies and gentlemen, tonight a great actress has been born. Laertes has a daughter."* Zo kondigde Laurence Olivier Vanessa's geboorte aan tijdens een opvoering van *Hamlet*.

De familie: Michaels vader Roy was een ster van de stille film in Australië. Vanessa's moeder is actrice Rachel Kempson. Ook haar zus Lynn en broer Corin Redgrave, en dochters Natasha Richardson en Joely Richardson verdienden hun sporen met acteren. Zoon Carlo Gabriel Nero is regisseur.

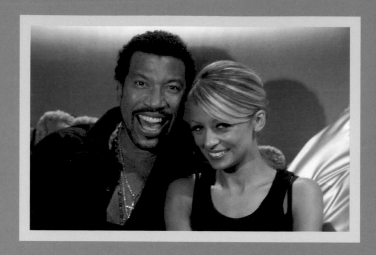

Lionel & Nicole
Richie

Lionel Brockman Richie Jr. (20 June 1949, USA) broke through in the 70s with the Commodores with songs like *Three Times a Lady* and *Still*, and had a successful solo career in the 80s. He sold over 100 million albums thanks to songs like *Hello* and *Dancing on the Ceiling*, and won an Academy Award for *Say You, Say Me* in the film *White Nights*.
Nicole Camille Richie (21 September 1981, USA) became world famous due to her escapades at Paris Hilton's side in the reality show *The Simple Life* in 2003. Since then, she has entered rehabilitation, had two children, written two books, played a few television roles, designed an accessory and jewellery line and become a genuine style icon.
Father & daughter: Nicole was born as Nicole Camille Escovedo, went to live with the Richies at the age of two and was adopted when she was nine. When the couple soon divorced, she started to rebel. • Nicole appeared in three of her father's video clips: *Love, Oh Love, Ballerina Girl* and *I Call it Love*. • For a while, it seemed that Nicole would follow in Lionel's footsteps when she founded the rock band Darling.

Lionel Brockman Richie Jr. (20 juin 1949, États-Unis) est devenu célèbre dans les années 70 avec *The Commodores*, notamment grâce aux titres "*Three Times a Lady*" et "*Still*". Il poursuit une carrière solo à succès dans les années 80, signant des tubes planétaires comme "*Hello*" et "*Dancing on the Ceiling*". Il a vendu plus de 100 millions de disques et reçu l'Oscar de la meilleure chanson originale pour "*Say You, Say Me*", dans le film *White Nights*.
Nicole Camille Richie (21 septembre 1981, États-Unis) est mondialement célèbre pour ses extravagances aux côtés de Paris Hilton, avec laquelle elle a participé à l'émission de télé-réalité "*The Simple Life*" en 2003. Elle a ensuite suivi une cure de désintoxication, donné naissance à deux enfants, écrit deux livres, interprété quelques rôles pour la télévision et lancé une collection de bijoux et d'accessoires. Elle est aujourd'hui considérée comme une icône du stylisme.
Père & fille : Née sous le nom de Nicole Camille Escovedo, Nicole a été adoptée par les Richie. Elle commença à se rebeller lorsque le couple divorça. • Nicole apparaît dans 3 clips de son père : "*Love, Oh Love*", "*Ballerina Girl*" et "*I Call It Love*".

Lionel Brockman Richie Jr. (20 juni 1949, VSA) brak in de jaren 70 door met de Commodores dankzij nummers als *Three Times a Lady* en *Still*, en bouwde in de jaren 80 een succesvolle solocarrière uit. Hij verkocht meer dan 100 miljoen platen met behulp van songs als *Hello* en *Dancing on the Ceiling*, en kreeg een oscar voor *Say You, Say Me* uit de film *White Nights*.
Nicole Camille Richie (21 september 1981, VSA) werd wereldberoemd dankzij haar uitspattingen aan de zijde van Paris Hilton en de reality tv-show *The Simple Life* uit 2003. Sindsdien kickte ze af, kreeg ze twee kinderen, schreef ze twee boeken, speelde ze enkele tv-rollen, bracht ze een accessoire- en juwelenlijn uit en is ze uitgegroeid tot een heus stijlicoon.
Vader & dochter: Nicole werd geboren als Nicole Camille Escovedo, ging op haar tweede bij de Richies wonen en werd op haar negende door hen geadopteerd. Toen het echtpaar even later scheidde, begon ze te rebelleren. • Nicole speelde mee in drie van haar vaders videoclips: *Love, Oh Love, Ballerina Girl* en *I Call it Love*. • Even leek het erop dat Nicole in Lionels voetsporen ging treden toen ze de rockband Darling stichtte.

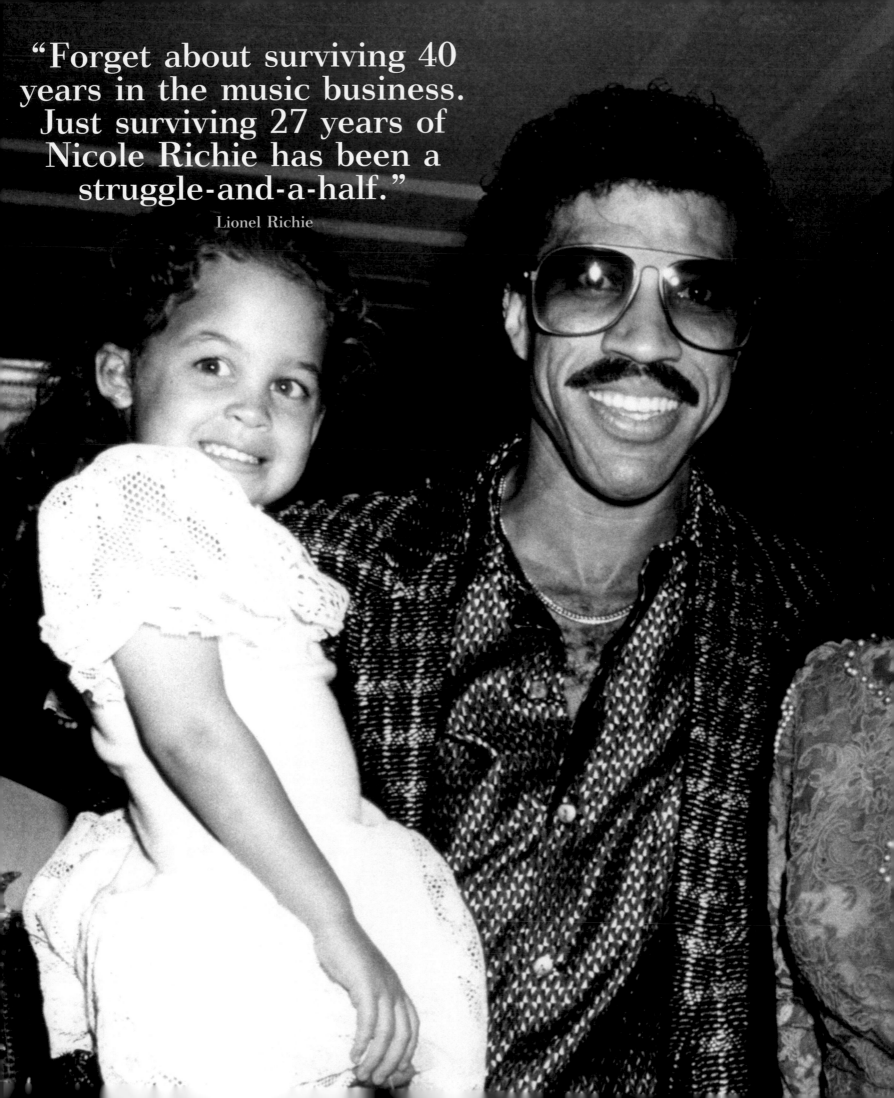

"Forget about surviving 40 years in the music business. Just surviving 27 years of Nicole Richie has been a struggle-and-a-half."

Lionel Richie

Roberto & Isabella
Rossellini

Roberto Rossellini (8 May 1906 - 3 June 1977, Italy) is known as the father of Italian neorealist cinema thanks to his films *Roma - città aperta* and *Paisà*. He made three films with Ingrid Bergman, including *Strombol - terra di Dio*, and together they had an affair that damaged both of their careers. He went on to direct mainly theatre productions and documentaries.

Isabella Fiorella Elettra Giovanna Rossellini (18 June 1952, Italy) initially worked as a television journalist and got into modelling at the age of 28. She played her first role in *Il Prato* in 1979 but only became successful as an actress after her mother's death with films including *White Nights*, *Blue Velvet*, *Cousins*, *Death Becomes Her*, *Immortal Beloved* and *Fearless*. More recently, she had a recurring role in the television series *Alias*, wrote three books and made a series of short films with *Green Porno*.

Father & daughter: Isabella wrote the book *In the name of the Father, the Daughter and the Holy Spirits: Remembering Roberto Rossellini* as a tribute to her father and played almost all the roles in the film *My Dad is 100 Years Old*.

The Rossellini family: Isabella is the daughter of the Swedish actress Ingrid Bergman and has a twin sister named Isotta.

Roberto Rossellini (8 mai 1906 - 3 juin 1977, Italie) est considéré comme le père du néoréalisme italien pour ses films *Rome, ville ouverte* et *Païsa*. Il dirigea à trois reprises Ingrid Bergman, notamment dans *Stromboli*, et vécut avec elle une histoire d'amour qui fit scandale et nuit à leurs carrières respectives. Par la suite, il se consacra principalement à la mise en scène de pièces de théâtre et à la réalisation de documentaires.

Isabella Fiorella Elettra Giovanna Rossellini (18 juin 1952, Italie) fut d'abord journaliste pour la télévision, puis mannequin. Elle décrocha son premier rôle dans *Le Pré*, en 1979. Sa carrière ne décolla qu'après la mort de sa mère, avec les films *Soleil de nuit*, *Blue Velvet*, *Cousins*, *La Mort vous va si bien*, *Ludwig van B.* et *État second*. Elle a également joué dans le feuilleton "Alias", écrit trois livres et réalisé une série de courts-métrages intitulée *Green Porno*.

Père & fille : En hommage à Roberto, Isabella a écrit le livre *Roberto Rossellini, mon père*. Celui-ci s'accompagne d'un court-métrage, *Mon Père a 100 ans*, dans lequel elle joue.

La famille Rossellini : Isabella est la fille de l'actrice suédoise Ingrid Bergman. Elle a une sœur jumelle, Isotta.

Roberto Rossellini (8 mei 1906 - 3 juni 1977, Italië) staat dankzij zijn films *Roma, città aperta* en *Paisà* te boek als de vader van het Italiaanse neorealisme. Met Ingrid Bergman maakte hij drie films, waaronder *Stromboli - terra di Dio*, en begon hij een affaire die hun beider carrières schaadde. Daarna regisseerde hij vooral nog theaterstukken en documentaires.

Isabella Fiorella Elettra Giovanna Rossellini (18 juni 1952, Italië) werkte aanvankelijk als tv-journaliste en rolde op haar 28e in een modellen-carrière. Ze speelde haar eerste rol in *Il Prato* uit '79 maar werd als actrice pas succesvol na de dood van haar moeder, dankzij films als *White Nights*, *Blue Velvet*, *Cousins*, *Death Becomes Her*, *Immortal Beloved* en *Fearless*. Meer recentelijk had ze een vaste rol in de tv-serie *Alias*, schreef ze drie boeken en maakte ze met *Green Porno* een serie kortfilms.

Vader & dochter: Als hulde aan haar vader schreef Isabella het boek *In the name of the Father, the Daughter and the Holy Spirits: Remembering Roberto Rossellini* en speelde ze bijna alle rollen in de film *My Dad is 100 Years Old*.

De familie Rossellini: Isabella is de dochter van de Zweedse actrice Ingrid Bergman en heeft een tweelingzus, Isotta.

Michel & Davy
Sardou

Michel Sardou (26 January 1947, France) is a world famous songwriter who has written over 300 songs and sold over 120 million albums. He scored numerous hits, including *Les Lacs du Connemara* and *La Maladie d'Amour*. After a career spanning 40 years, he is still one of France's most popular - and controversial - artists. He is also a successful actor and the owner of a theatre in Paris.
Davy Sardou (1 June 1978, France) studied drama at the Lee Strasberg Institute and the Actor's Studio in New York, and then appeared in several off-Broadway pieces and films. In 2001, he returned to his homeland, where he became a successful and respected French theatre and film actor.
Father & son: Davy has been co-writing his father's songs since 2004. Father and son Sardou appear on stage together regularly, including as father and son in the comedy *Secret de Famille*.
The Sardou family: The Sardou family constitutes a famous French artist family. Michel's father Fernand Sardou was a singer, cabaret performer and actor; his mother Jackie was a singer and actress. Fernand's father Valentin Sardou was a comedian. Davy Sardou's brother Romain is a writer.

Michel Sardou (26 janvier 1947, France) est un auteur-compositeur-interprète français mondialement célèbre, auteur d'innombrables tubes tels que "Les Lacs du Connemara" et "La Maladie d'Amour". Il a interprété plus de 300 titres et vendu plus de 120 millions de disques. Après 50 ans de carrière, il reste l'un des artistes français les plus populaires, mais aussi une personnalité controversée. Acteur reconnu, il possède en outre un théâtre à Paris.
Davy Sardou (1er juin 1978, France) a suivi des cours de théâtre à New York, à l'Institut Lee Strasberg ainsi qu'à l'Actor's Studio. Il débute sa carrière au théâtre et dans des séries télé de l'autre côté de l'Atlantique, avant de revenir dans l'Hexagone en 2001.
Père & fils : Davy compose pour son père depuis 2004. • Père et fils se sont souvent donnés la réplique au théâtre, notamment dans la comédie *Secret de Famille*.
La famille Sardou : Les Sardou sont une célèbre famille d'artistes. Le père de Michel, Fernand Sardou, était chanteur, cabaretier et acteur ; sa mère, Jackie, était chanteuse et actrice. Le père de Fernand, Valentin Sardou, était un acteur comique. Le frère de Davy Sardou, Romain, est écrivain.

Michel Sardou (26 januari 1947, Frankrijk) is een wereldberoemd chansonnier met ruim 300 nummers en meer dan 120 miljoen verkochte platen op zijn conto. Hij scoorde ontelbare hits, zoals *Les Lacs du Connemara* en *La Maladie d'Amour*. Na een carrière van 40 jaar is hij nog altijd een van Frankrijks meest populaire - én controversiële - artiesten. Hij is ook een succesvol acteur en eigenaar van een theater in Parijs.
Davy Sardou (1 juni 1978, Frankrijk) ging drama studeren aan het Lee Strasberg Institute en de Actor's Studio in New York en speelde vervolgens mee in enkele off-Broadway stukken en films. In 2001 keerde hij terug naar zijn thuisland, waar hij uitgroeide tot een succesvol en gewaardeerd Frans theater- en filmacteur.
Vader & zoon: Zoon Davy schrijft sinds 2004 mee aan zijn vaders nummers. • Vader en zoon Sardou staan geregeld samen op de planken, onder meer als vader en zoon in de komedie *Secret de Famille*.
De familie Sardou: De Sardous vormen een beroemde Franse artiestenfamilie. Michels vader, Fernand Sardou was zanger, cabaretier en acteur, zijn moeder Jackie zangeres en actrice. Fernands vader Valentin Sardou was een komiek. Davy Sardou's broer Romain is schrijver.

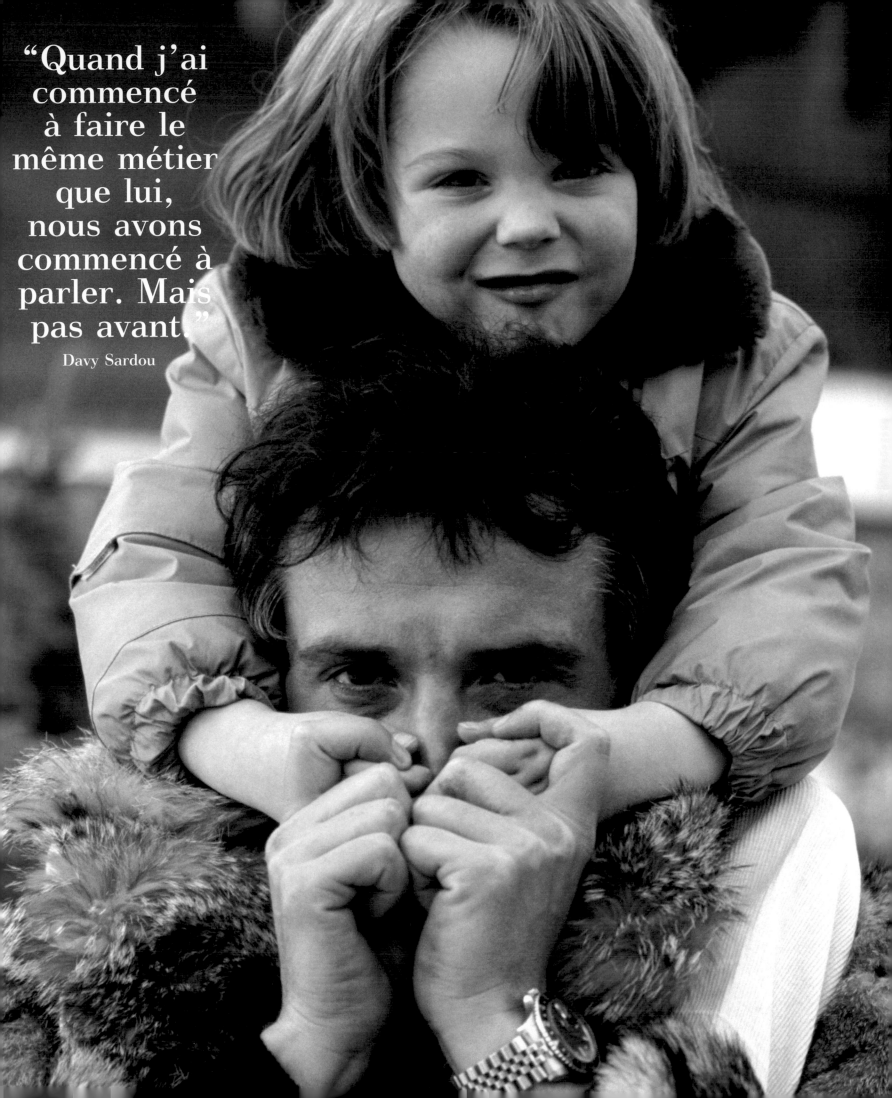

"Quand j'ai
commencé
à faire le
même métier
que lui,
nous avons
commencé à
parler. Mais
pas avant."
Davy Sardou

Ravi

Norah

Shankar & Jones

Ravi Shankar (7 April 1920, India) is a sitar virtuoso who has popularized Indian music worldwide. He has influenced musicians from the Beatles to Yehudi Menuhin and is known in India as the best musician of his era. He performed at Woodstock, composed film music, received numerous international awards and served as a nominated member of the upper chamber of the Parliament of India.

Geethali Norah Jones Shankar (30 March 1979, USA) conquered the world at the age of 22 with her jazzy voice, singles such as *Don't Know Why* and her debut album *Come Away With Me*. This album sold 20 million copies and won her eight Grammy Awards. Her following four albums confirmed her status as a worldwide star. She made her film debut in Wong Kar Wai's *Blueberry Nights*.

Father & daughter: Norah grew up with her American mother Sue Jones and hardly ever saw her father up to the age of eighteen. She often declines to talk about him in interviews. "I've lived my whole life without having to be known as the daughter of somebody. And I didn't want to start now."

The Shankar family: Norah has a half-sister, sitar player Anoushka, who learned the trade from their father and regularly performs with him.

Ravi Shankar (7 avril 1920, Inde) est un cithariste virtuose qui a popularisé la musique indienne dans le monde entier. Considéré en Inde comme le meilleur musicien de son époque, il a influencé de nombreux artistes, des *Beatles* à Yehudi Menuhin. Au cours de sa carrière, il s'est produit à Woodstock, a composé des musiques de films, reçu d'innombrables distinctions internationales et siégé à la Chambre Haute du Parlement indien.

Geetali Norah Jones Shankar (30 mars 1979, États-Unis) a conquis le monde à l'âge de 22 ans avec sa voix suave et jazzy : son single "*Don't Know Why*" et son premier opus intitulé *Come Away With Me* se sont écoulés à plus de 20 millions d'exemplaires. Ses 4 albums suivants ont confirmé son statut de star internationale et lui ont valu 8 Grammy Awards. En 2007, elle faisait ses débuts au cinéma dans *My Blueberry Nights*.

Père & fille : Norah a grandi aux États-Unis avec sa mère, Sue Jones, et n'a pratiquement pas connu son père. Lors de ses interviews, elle refuse le plus souvent de parler de lui : "J'ai toujours vécu sans être connue comme étant la fille de quelqu'un. Et je ne veux pas commencer aujourd'hui."

La famille Shankar : Norah a une demi-sœur, la joueuse de cithare Anoushka, qui accompagne régulièrement son père.

Ravi Shankar (7 april 1920, India) is een sitarvirtuoos die de Indiase muziek wereldwijd gepopulariseerd heeft. Hij beïnvloedde muzikanten van The Beatles tot Yehudi Menuhin en staat in India bekend als de beste muzikant van zijn tijdperk. Hij trad aan op Woodstock, schreef filmmuziek, kreeg talloze internationale onderscheidingen en veroverde een zitje in het Indiase hogerhuis.

Geethali Norah Jones Shankar (30 maart 1979, VSA) veroverde op haar 22e de wereld met haar jazzy stem, singles als *Don't know why* en haar debuutalbum *Come Away With Me*. Daarvan verkocht ze niet alleen 20 miljoen exemplaren, ze sleepte er meteen ook acht Grammy's voor in de wacht. Haar volgende vier albums bevestigden haar status als wereldster. In Wong Kar Wai's *Blueberry Nights* maakte ze haar filmdebuut.

Vader & dochter: Norah groeide op bij haar moeder, de Amerikaanse Sue Jones, en zag haar vader nauwelijks tot haar achttiende. In interviews wil ze het vaak niet over hem hebben. *"Ik heb mijn hele leven geleid zonder dat ik bekend stond als iemands dochter. En ik wil daar liever nu niet mee beginnen."*

De familie Shankar: Norah heeft een halfzus, sitarspeelster Anoushka, die het vak van vader Ravi leerde en geregeld samen met hem speelt.

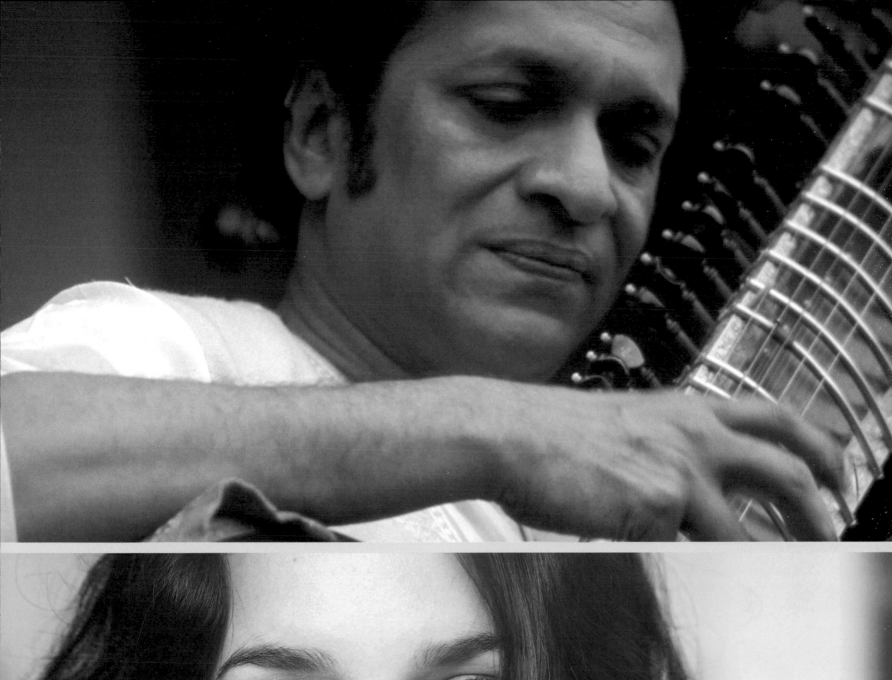
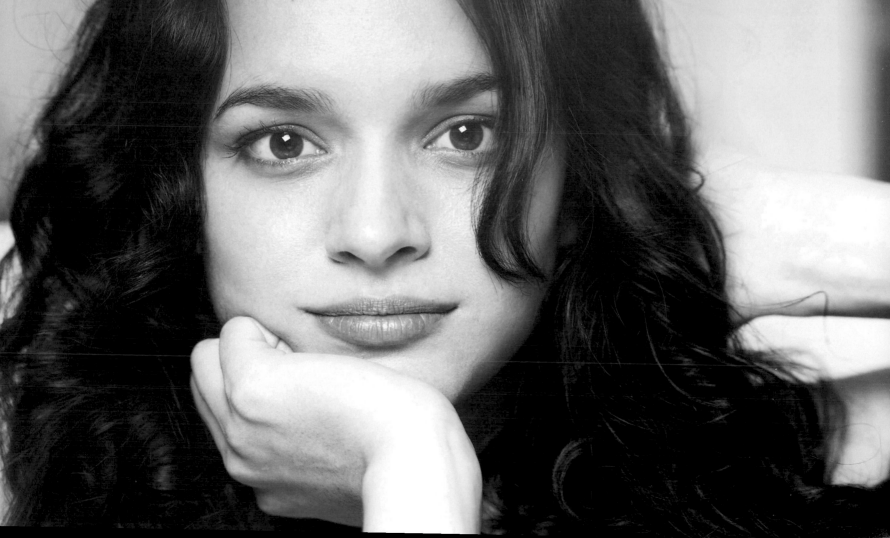

Martin & Charlie, Emilio
Sheen Estevez

Ramón Gerardo Antonio Estévez (3 August 1940, USA), better known as Martin Sheen, broke through in the 70s in films like *Badlands* and *Apocalypse Now*. He appeared in successful films such as *Gandhi* and *The Dead Zone* and revived his popularity at the end of the 90s with the television series *The West Wing*.
Carlos Irwin Estévez (3 September 1965, USA), better known as Charlie Sheen, played his first role in *Platoon* and built up a fine career thanks to films like *Wall Street*, *The Rookie* and *Hot Shots!*. He also appeared in the television sitcoms *Spin City* and *Two and a Half Men*.
Emilio Estevez (12 May 1962, USA) came to fame in the 80s due to his roles in teen movies like *The Outsiders*, *The Breakfast Club* and *St. Elmo's Fire*. He went on to appear in films like *Young Guns* and *Stakeout*. He starred in *Wisdom*, which he also directed and wrote.
Father & sons: Martin and Charlie play father and son in *Wall Street*. Emilio did the same in the self-directed films *The War at Home* and *The Way*. Emilio and Charlie appeared together in *Young Guns* and *Men at Work*.
The Estévez family: Martin's zoon Ramón, daughter Renée and brother Joe are also actors.

Ramón Gerardo Antonio Estévez (3 août 1940, États-Unis), alias Martin Sheen, s'impose à Hollywood dans les années 70 avec *La Balade sauvage* et *Apocalypse Now*. Il enchaîne ensuite avec d'autres grands films, dont *Gandhi* et *Dead Zone*, et apparaît jusqu'à la fin des années 90 dans la série à succès "À la Maison Blanche".
Carlos Irwin Estévez (3 septembre 1965, États-Unis), alias Charlie Sheen, décroche son premier grand rôle dans *Platoon*. Suivront des films à succès tels que *Wall Street*, *La Relève* ou *Hot Shots* et des rôles remarqués dans les séries "Spin City" et "Mon Oncle Charlie".
Emilio Estévez (12 mai 1962, États-Unis) connaît la gloire dans les années 80, à l'affiche de films tels que *Outsiders*, *The Breakfast Club*, *St. Elmo's Fire* ou encore *Young Guns* et *Étroite surveillance*. Il écrit également les scénarios de films qu'il met en scène et dans lesquels il joue, dont *Wisdom* et *Bobby*.
Père & fils : Martin et Charlie ont interprété les rôles du père et du fils dans le cultissime *Wall Street*. Emilio et Martin firent de même dans *The War at Home* et *The Way*. Emilio et Charlie ont joué ensemble dans *Young Guns* et *Men at Work*.
La famille Estévez : Le fils de Martin, Ramón, sa fille Renée et son frère Joe sont tous les trois acteurs.

Ramón Gerardo Antonio Estévez (3 augustus 1940, VSA) brak in de jaren 70 door als Martin Sheen dankzij films als *Badlands* en *Apocalypse Now*. Hij scoorde successen met films als *Gandhi* en *The Dead Zone* en hernieuwde zijn populariteit eind jaren 90 met de tv-serie *The West Wing*.
Carlos Irwin Estévez (3 september 1965, VSA) speelde als Charlie Sheen zijn eerste grote rol in *Platoon* en bouwde een mooie carrière uit dankzij films als *Wall Street*, *The Rookie* en *Hot Shots!*. Op tv dook hij op in de sitcoms *Spin City* en *Two and a Half Men*.
Emilio Estevez (12 mei 1962, VSA) werd beroemd dankzij jaren 80-jongerenfilms als *The Outsiders*, *The Breakfast Club* en *St. Elmo's Fire*. Later speelde hij in films als *Young Guns* en *Stakeout*. *Wisdom* was de eerste film die hij zowel schreef als regisseerde én waarin hij meespeelde.
Vader & zonen: Martin en Charlie speelden vader en zoon in *Wall Street*. Emilio deed hetzelfde in de door hemzelf geregisseerde prenten *The War at Home* en *The Way*. Emilio en Charlie zaten samen in *Young Guns* en *Men at Work*.
De familie Estévez: Ook Martins zoon Ramón, dochter Renée en broer Joe zitten in het acteervak.

"Even if he weren't my son he'd still be my best friend."

Martin Sheen *(about Charlie)*

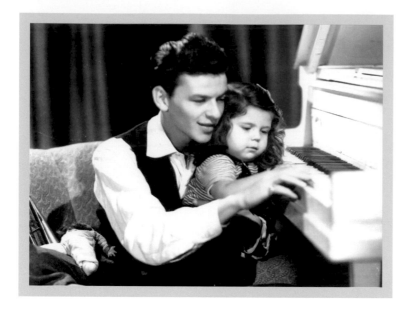

Frank & Nancy
Sinatra

Francis Albert 'Frank' Sinatra (12 December 1915 - 14 May 1998, USA) became one of the world's greatest performers of popular music with songs such as *New York, New York*, *Strangers in the Night*, *Come Fly With Me*, *The Lady is a Tramp* and *My Way*. Moreover, he had a successful second career as an actor in such films as *From Here to Eternity*, *The Man with the Golden Arm*, *Ocean's 11* and *The Manchurian Candidate*.
Nancy Sandra Sinatra (8 June 1940, USA) scored an international hit with *These Boots Are Made for Walkin'* and had more modest success with *Sugar Town* and *You Only Live Twice*. In the 60s, she appeared in the Elvis Presley film *Speedway* and in *The Wild Angels*. In 2003, she was suddenly hip again due to her 60s hit *Bang Bang* being used in the film *Kill Bill*.
Father & daughter: Frank dedicated the song *Nancy With the Laughing Face* to his daughter. • Nancy and Frank recorded the duet *Somethin' Stupid* in 1967. • Nancy published *Frank Sinatra: An American Legend*.
The Sinatra family: His son Frank Jr. tried to pursue a career as a singer, but was less successful. • Nancy's dochter A.J. Lambert is currently working on a career in music.

Francis Albert "Frank" Sinatra (12 décembre 1915 - 14 mai 1998, États-Unis) est, avec "*New York, New York*", "*Strangers in the Night*", "*Come Fly With Me*", "*The Lady is a Tramp*" et "*My Way*", l'un des géants de la musique du 20e siècle. Le crooner mène de front une carrière cinématographique, avec notamment *L'Homme au bras d'or*, *L'Inconnu de Las Vegas* ou *Tant qu'il y aura des hommes*, pour lequel il remporte un Oscar en 1954.
Nancy Sandra Sinatra (8 juin 1940, États-Unis) est propulsée au rang de star avec des titres tels que "*These Boots Are Made for Walkin'*", "*Sugar Town*" et "*You Only Live Twice*". Dans les années 60, elle joue aux côtés d'Elvis Presley dans *Speedway* et de Peter Fonda dans *The Wild Angels*. En 2003, sa carrière redémarre lorsque sa chanson "*Bang Bang*" est reprise dans *Kill Bill*.
Père & fille : Frank a dédié à sa fille la chanson "*Nancy With the Laughing Face*". • Nancy et Frank ont enregistré le duo "*Somethin' Stupid*" en 1967. • Nancy a publié un ouvrage intitulé *Frank Sinatra – Mon père*.
La famille Sinatra : Le fils de Frank, Frank Jr., s'essaya à la chanson sans égaler le succès de son père. • La fille de Nancy, A.J. Lambert, entame elle aussi une carrière musicale.

Francis Albert 'Frank' Sinatra (12 december 1915 - 14 mei 1998, VSA) was met nummers als *New York, New York*, *Strangers in the Night*, *Come Fly With Me*, *The Lady is a Tramp* en *My Way* een van de groootheden van de populaire muziek. Bovendien had hij een succesvolle tweede loopbaan als acteur in films als *From Here to Eternity*, *The Man with the Golden Arm*, *Ocean's 11* en *The Manchurian Candidate*.
Nancy Sandra Sinatra (8 juni 1940, VSA) scoorde een internationale hit met *These Boots Are Made for Walkin'* en oogstte bescheidener succes met *Sugar Town* en *You Only Live Twice*. In de jaren 60 speelde ze in de Elvis Presley-film *Speedway* en in *The Wild Angels*. In 2003 werd ze plots weer hip toen haar jaren 60-hit *Bang Bang* opdook in *Kill Bill*.
Vader & dochter: Frank droeg de song *Nancy With the Laughing Face* op aan zijn dochter. • Nancy en Frank namen in 1967 het duet *Somethin' Stupid* op. • Nancy publiceerde *Frank Sinatra: An American Legend*.
De familie Sinatra: Ook zoon Frank Jr. probeerde het te maken als zanger, zij het minder succesvol. • Nancy's dochter A.J. Lambert timmert momenteel aan een muzikale carrière.

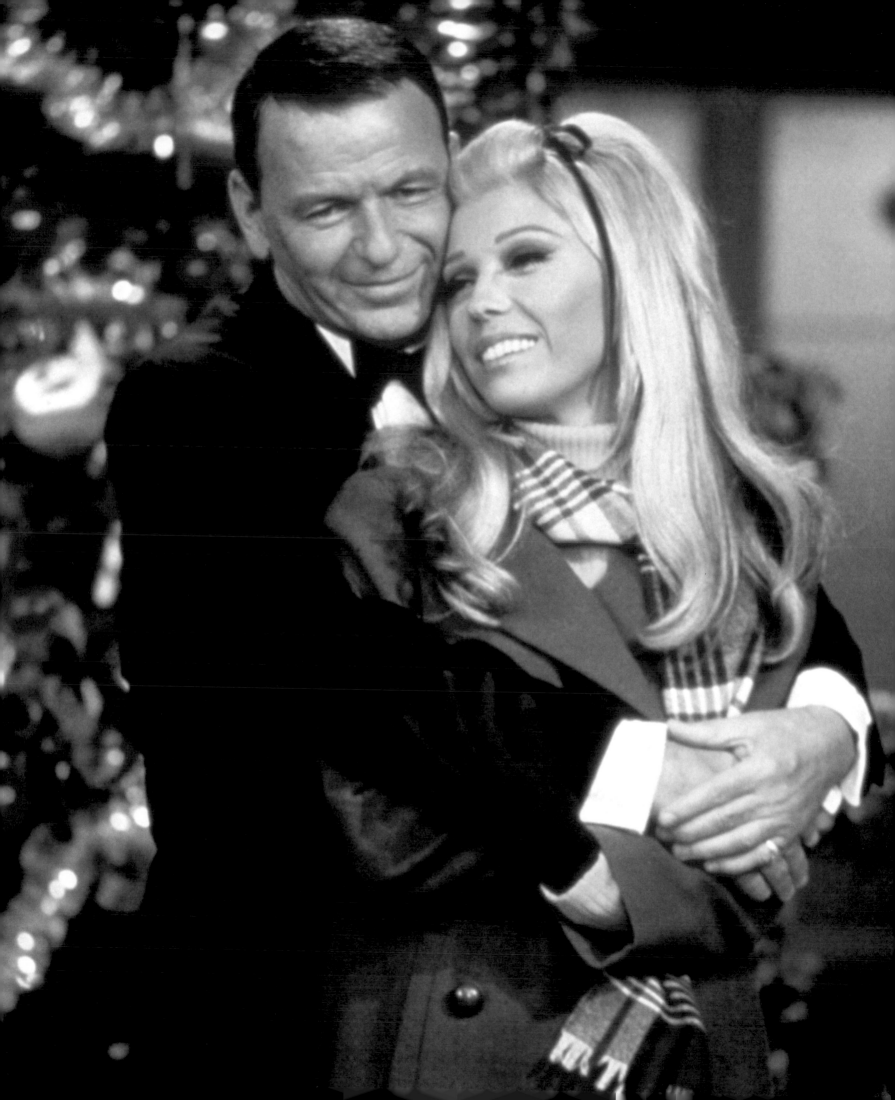

Will & Jaden
Smith

Willard Christopher 'Will' Smith Jr. (25 September 1968, USA) had a few hits as the rapper *The Fresh Prince* and became an actor in the popular television series *The Fresh Prince of Bel Air*. While this show was still running, he starred in the films *Bad Boys* and *Independence Day*. He confirmed his superstar status with films such as *Men in Black*, *Enemy of the State*, *Ali* and *I Am Legend*.
Jaden Christopher Syre Smith (8 July 1998, USA) made his debut at the age of eight when he appeared in *The Pursuit of Happiness*. Two years later, he starred in *The Day the Earth Stood Still* and in 2010, he played the title role in *The Karate Kid* along with Jackie Chan. He sang *Never Say Never* with Justin Bieber.
Father & son: Will and Jaden played father and son in *The Pursuit of Happiness*.
The Smith family: Mother Jada Pinkett Smith is also an actress. Daughter Willow appeared in *An American Girl* and at her father's side in *I Am Legend*. She wrote the song *Whip My Hair* and was immediately handed a hefty record deal. Eldest son Willard Christopher 'Trey' Smith III was the inspiration for Wills hit *Just the Two of Us* and worked as a correspondent for *Access Hollywood*.

Willard Christopher "Will" Smith Jr. (25 septembre 1968, États-Unis), rappeur à succès connu sous le nom de *The Fresh Prince*, doit également sa célébrité à la série populaire "Le Prince de Bel Air". Il a joué dans plusieurs grosses productions tels que *Bad Boys*, *Independence Day*, *Men in Black*, *Ennemi d'état*, *Ali* et *Je suis une légende*.
Jaden Christopher Syre Smith (8 juillet 1998, États-Unis) débute au cinéma à l'âge de 8 ans dans le film *À la recherche du bonheur*. Deux ans plus tard, il enchaîne avec *Le Jour où la Terre s'arrêta* et interprète en 2010 le rôle-titre de *Karaté Kid*, dont il partage l'affiche avec Jackie Chan.
Père & fils : Will et Jaden ont été père et fils à l'écran dans *À la recherche du bonheur*.
La famille Smith : La mère de Jaden, Jada Pinkett Smith, est également actrice. Sa sœur, Willow, a joué dans *An American Girl* et aux côtés de Will dans *Je suis une légende*. Elle a écrit la chanson *Whip My Hair* et signé un contrat avec une importante maison de disques. Le frère aîné, Trey Smith III, est la star du clip video "*Just the Two of Us*" et a travaillé comme correspondant pour *Access Hollywood*.

Willard Christopher 'Will' Smith Jr. (25 september 1968, VSA) scoorde een aantal hits als rapper *The Fresh Prince* en rolde het acteervak in dankzij de populaire tv-serie *The Fresh Prince of Bel Air*. Terwijl deze serie nog liep, scoorde hij met de films *Bad Boys* en *Independence Day*. Hij verzilverde zijn supersterrenstatus met films als *Men in Black*, *Enemy of the State*, *Ali* en *I Am Legend*.
Jaden Christopher Syre Smith (8 juli 1998, VSA) debuteerde op zijn achtste in *The Pursuit of Happiness*. Twee jaar later stond hij in *The Day the Earth Stood Still* en in 2010 speelde hij de titelrol in *The Karate Kid* met Jackie Chan. Met Justin Bieber zong hij *Never Say Never* in.
Vader & zoon: Will en Jaden speelden vader en zoon in *The Pursuit of Happiness*.
De familie Smith: Mama Jada Pinkett Smith is ook een actrice. Dochter Willow speelde in *An American Girl* en aan de zijde van haar vader in *I Am Legend*. Ze schreef de song *Whip My Hair* en kreeg prompt een platencontract. Oudste zoon Willard Christopher 'Trey' Smith III vormde de inspiratie voor de hit *Just the Two of Us* en werkte als correspondent voor *Access Hollywood*.

"This kid is funnier than I was at his age. But then, he did have me as a father."
Will Smith

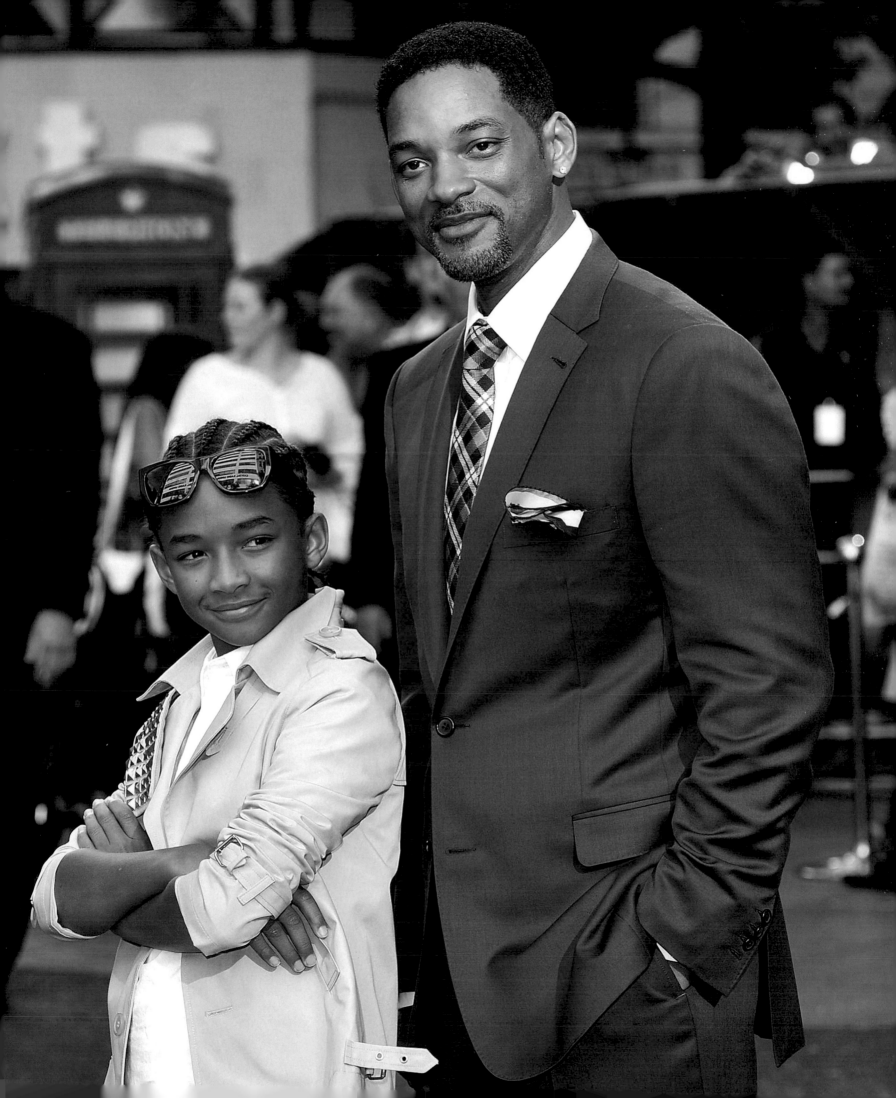

Wlodi & Ebi
Smolarek

Wlodzimierz 'Wlodi' Smolarek (16 July 1957, Poland) was a professional football player for 22 years in Poland, Germany and the Netherlands and is the ambassador of Polish football both at home and abroad. While playing with football club Widzew Łódź, he won the Polish Championship twice and the Polish Cup once. In 1988, he moved to the Netherlands and played for Feyenoord and FC Utrecht. He played for the Polish national team 60 times, eight of which as captain, and helped the team win the third place in the 1982 World Cup in Spain.
Euzebiusz 'Ebi' Smolarek (9 January 1981, Poland) won the UEFA Cup with Feyenoord in 2002. He was named the best Polish player of the year three times and the sportsman of the year once. He has also played for Borussia Dortmund and is currently with Polonia Warschau.
Father & son: Ebi was the first Pole in 20 years to score a goal against Portugal. The previous man to do this was his father. • Wlodi and Ebi are both strikers. The both played for Feyenoord and the Polish national team.
The Smolarek family: Ebi's brother Mariusz is also a professional football player.

Wlodzimierz "Wlodi" Smolarek (16 juillet 1957, Pologne), véritable ambassadeur du football polonais, a été pendant 22 ans joueur professionnel en Pologne, en Allemagne et aux Pays-Bas. Il a remporté deux fois le championnat de Pologne ainsi que la Coupe avec le club Widzew Łódź. En 1988, il part jouer aux Pays-Bas au Feyenoord Rotterdam puis au FC Utrecht. Il totalise 60 sélections en équipe nationale, dont 8 comme capitaine, et a hissé son équipe à la 3e place lors de la Coupe du monde de 1982.
Euzebiusz "Ebi" Smolarek (9 janvier 1981, Pologne) remporte la coupe UEFA en 2002 sous le maillot du Feyenoord Rotterdam. Sacré "sportif de l'année" et même "meilleur joueur polonais de l'année" à 3 reprises, il a également évolué au Borussia Dortmund et au Polonia Warschau.
Père & fils : Ebi est le premier Polonais à avoir marqué contre le Portugal en 20 ans. Le précédent joueur à l'avoir fait était son père. • Wlodi et Ebi ont tous deux évolué au poste d'attaquant, joué pour le Feyenoord et en équipe nationale.
La famille Smolarek : Le frère d'Ebi, Mariusz, est également footballeur professionnel.

Wlodzimierz 'Wlodi' Smolarek (16 juli 1957, Polen) was gedurende 22 jaar profvoetballer in Polen, Duitsland en Nederland en is de ambassadeur van het Poolse voetbal in binnen- en buitenland. Met voetbalclub Widzew Łódź won hij tweemaal het Poolse voetbalkampioenschap en een keer de Poolse beker. In 1988 trok hij naar Nederland, waar hij speelde bij Feyenoord en FC Utrecht. Hij kwam 60 keer uit voor het Poolse nationale elftal, waarvan acht keer als aanvoerder, en wist het team op het WK in Spanje in 1982 naar de derde plaats te voeren.
Euzebiusz 'Ebi' Smolarek (9 januari 1981, Polen) won met Feyenoord in 2002 de UEFA-cup. Daarnaast werd hij tot driemaal toe uitgeroepen tot beste Poolse speler van het jaar en één keer verkozen tot Sportman van het jaar. Hij speelde ook nog bij Borussia Dortmund en zit nu bij Polonia Warschau.
Vader & zoon: Ebi was de eerste Pool sinds twintig jaar die erin slaagde een goal te scoren tegen Portugal. De vorige die dat deed was zijn vader. • Wlodi en Ebi waren allebei aanvallende spelers. Ze kwamen beiden uit voor Feyenoord en het Poolse nationale elftal.
De familie Smolarek: Ook Ebi's broer Mariusz is profvoetballer.

"Il est impossible de satisfaire tout le monde et son père."

Jean de La Fontaine (1621-1695),
French author

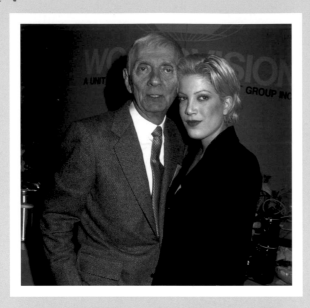

Aaron & Tori
Spelling

Aaron F. Spelling (22 April 1923 - 23 June 2006, USA) was one of the world's most productive and successful producers and screenplay writers, and therefore one of the mightiest men in Hollywood. He worked on over 200 productions, including *The Mod Squad*, *Starsky & Hutch*, *Charlie's Angels*, *Dynasty*, *Melrose Place*, *Twin Peaks*, *7th Heaven* and *Charmed*.
Victoria Davey 'Tori' Spelling (16 May 1973, USA) became known across the world in the 90s for her role in *Beverly Hills 90210*. Since then, she has appeared in several films, written an autobiographical book, starred in her own reality show, created a jewellery line and appeared in a *90210* spinoff.
Father & daughter: Aaron cast his daughter, from a young age, in series like *Love Boat* and *Hotel*, and made her a star with *Beverly Hills 90210*. • Father Spelling's death was surrounded with much controversy: after mother and daughter badmouthed each other in the tabloid press it was revealed that, just three months earlier, the TV magnate had cut his daughter out of his will.
The Spelling family: Tori's mother Cynthia Spelling is an author and her brother Randy has also tried to become an actor but is now a life coach.

Aaron F. Spelling (22 avril 1923 - 23 juin 2006, États-Unis) est l'un des producteurs et scénaristes les plus prolifiques de son temps. Comptant parmi les puissants d'Hollywood, il a plus de 200 productions à son actif, parmi lesquelles "La Nouvelle Équipe", "Starsky & Hutch", "Charlie et ses drôles de dames", "Dynastie", "Melrose Place", "*Twin Peaks*", "Sept à la maison" et "*Charmed*".
Victoria Davey "Tori" Spelling (16 mai 1973, États-Unis) est devenue mondialement célèbre dans les années 90 grâce à la série "Beverly Hills 90210". Elle a également tourné quelques films, rédigé une autobiographie, participé à une émission de télé-réalité, créé une ligne de bijoux et joué dans le spin-off de "Beverly Hills 90210".
Père & fille : Aaron confia à Tori des rôles dans plusieurs de ses séries avant de faire d'elle une star avec "Beverly Hills 90210". • Le décès d'Aaron déclencha une polémique : mère et fille se déchirèrent en effet dans la presse à scandale car le magnat de la télévision aurait rayé sa fille de son testament trois mois avant sa mort.
La famille Spelling : La mère de Tori, Cynthia Spelling, est écrivain ; son frère, Randy, tenta également une carrière d'acteur. Il est aujourd'hui coach personnel.

Aaron F. Spelling (22 april 1923 - 23 juni 2006, VSA) was een van 's werelds meest productieve en succesvolle producers en scenarioschrijvers, en als dusdanig een van de machtigste mannen van Hollywood. Hij zat achter meer dan 200 producties, waaronder *The Mod Squad*, *Starsky & Hutch*, *Charlie's Angels*, *Dynasty*, *Melrose Place*, *Twin Peaks*, *7th Heaven* en *Charmed*.
Victoria Davey 'Tori' Spelling (16 mei 1973, VSA) werd wereldberoemd dankzij de jaren 90-jongerenreeks *Beverly Hills 90210*. Sindsdien speelde ze enkele rollen in films, schreef ze een autobiografisch boek, schitterde ze in haar eigen realityshow, creëerde ze een juwelenlijn en dook ze op in de spinoff *90210*.
Vader & dochter: Aaron gaf zijn dochter al van kleins af rollen in series als *Love Boat* en *Hotel*, en maakte van haar een ster met *Beverly Hills 90210*. • De dood van vader Spelling ging gepaard met de nodige controverse: zo maakten moeder en dochter elkaar zwart in de roddelpers en bleek de TV-mogul zijn dochter drie maanden voor zijn dood uit zijn testament te hebben geschrapt.
De familie Spelling: Tori's moeder Cynthia Spelling is schrijfster, haar broer Randy probeerde het ook te maken als acteur maar is nu a life coach.

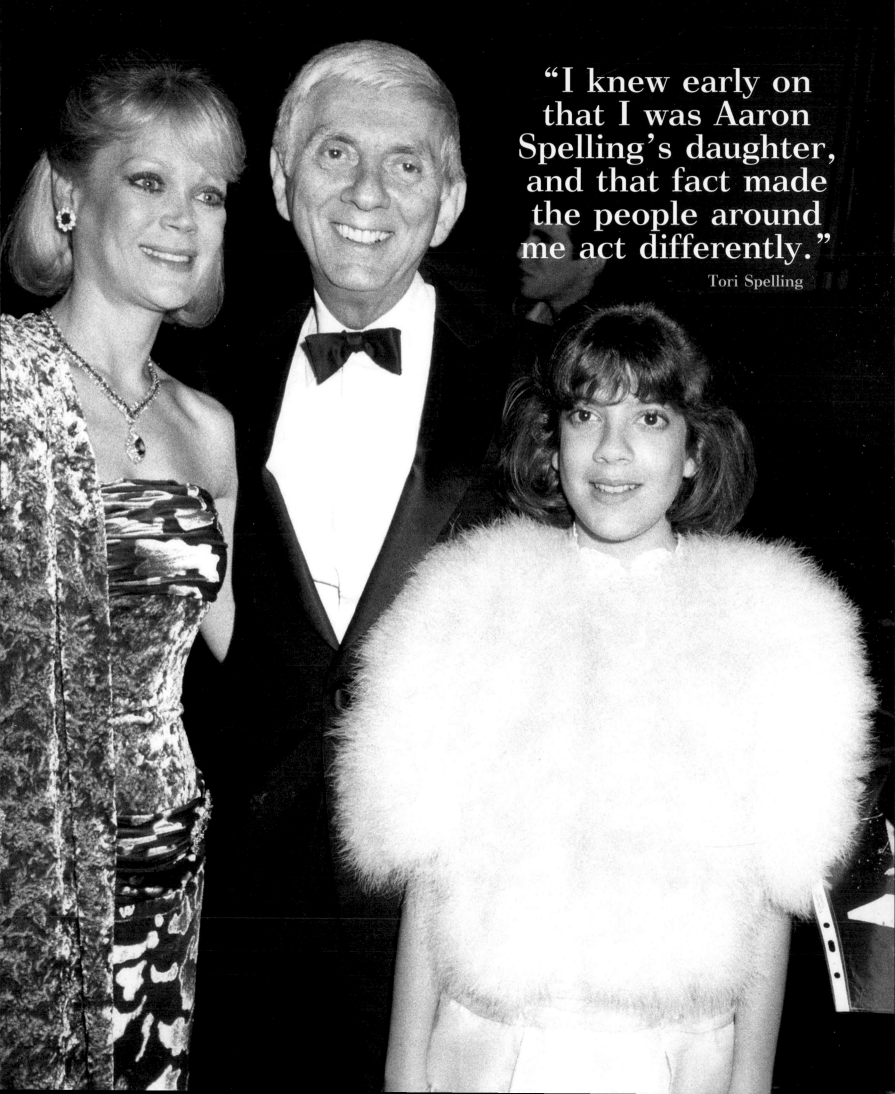

"I knew early on that I was Aaron Spelling's daughter, and that fact made the people around me act differently."

Tori Spelling

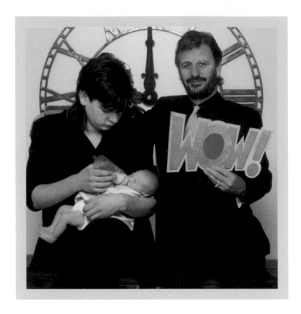

Ringo Zak
Starr & Starkey

Richard 'Ringo' Starkey (7 July 1940, Great Britain) gained worldwide fame as Ringo Starr, the drummer of The Beatles. It is less known that he also wrote successful songs like *With a Little Help From My Friends*, *Photograph* and *You're Sixteen*. After the Beatles split, he had a successful career as a both a solo artist and an actor. He is currently touring with the All-Starr Band.
Zak Starkey (13 September 1965, Great Britain) took drum lessons from his father's close friend Keith Moon. Since 1996, he has replaced Keith Moon as drummer of the rock band The Who. He has also worked with famous bands and musicians such as Oasis, Paul Weller, The Waterboys, ASAP, The Icicle Works and Johnny Marr.
Father & son: Zak blamed his father for his parents' divorce when he was ten. When he was sixteen, he moved into a small house on his estate to play music and drink alcohol all day. As a result, his father kicked him out. • The relationship between father and son was finally restored after the birth of Zak's daughter Tatia in 1985. • Zak regularly performs with Ringo's All-Star Band.
The Starkey family: Zak's daughter Tatia plays bass in the rockband Belakiss under the name of Veronica Avant.

Richard "Ringo" Starkey (7 juillet 1940, Angleterre), alias Ringo Starr, est le célèbre batteur des *Beatles*, groupe pour lequel il composa de nombreux tubes ("*With a Little Help From My Friends*", "*Photograph*" ou "*You're Sixteen*"). Il a ensuite entamé une carrière solo et tourné quelques films. Il se produit aujourd'hui avec le *All-Star Band*.
Zak Starkey (13 septembre 1965, Angleterre) apprend à jouer de la batterie avec l'ami de Ringo, Keith Moon, qu'il remplace à partir de 1996 au sein du groupe *The Who*. Au cours de sa carrière, il collabore avec de nombreuses stars de la chanson, dont les membres d'*Oasis*, Paul Weller, *The Waterboys*, *ASAP*, *The Icicle Works* et Johnny Marr.
Père & fils : Zak reprocha à Ringo le divorce de ses parents. À l'âge de 16 ans, il s'installa dans une petite maison appartenant à son père, afin de passer ses journées à s'enivrer et à jouer de la musique. Ringo le mit à la porte. • À la naissance de Tatia, la fille de Zak, en 1985, père et fils se sont enfin réconciliés. • Zak joue régulièrement avec Ringo et son *All-Star Band*.
La famille Starkey : La fille de Zak, Tatia, joue de la basse dans le groupe de rock *Belakiss* sous le nom de Veronica Avant.

Richard 'Ringo' Starkey (7 juli 1940, Groot-Brittannië) werd wereldwijd beroemd als Ringo Starr, de drummer van The Beatles. Minder bekend is dat hij ook succesnummers schreef als *With a Little Help From My Friends*, *Photograph* en *You're Sixteen*. Na hun breuk oogstte hij succes als solo-artiest en acteur. Momenteel tourt hij met de All-Star Band.
Zak Starkey (13 september 1965, Groot-Brittannië) kreeg drumlessen van zijn vaders goeie vriend Keith Moon en vervangt deze sinds 1996 als drummer van de rockgroep The Who. Bovendien heeft hij gewerkt met beroemde bands en muzikanten als Oasis, Paul Weller, The Waterboys, ASAP, The Icicle Works en Johnny Marr.
Vader & zoon: Zak gaf zijn vader de schuld toen zijn ouders op zijn tiende scheidden. Toen hij zestien was, trok hij in een huisje op diens landgoed, om vervolgens de hele dag door muziek te spelen en zich te bedrinken. Zijn vader gooide hem hierop het huis uit. • Na de geboorte van Zaks dochter Tatia in '85 werd de relatie tussen vader en zoon eindelijk hersteld. • Zak speelt geregeld mee met Ringo's All-Star Band.
De familie Starkey: Zaks dochter Tatia speelt bas in de rockband Belakiss onder de naam Veronica Avant.

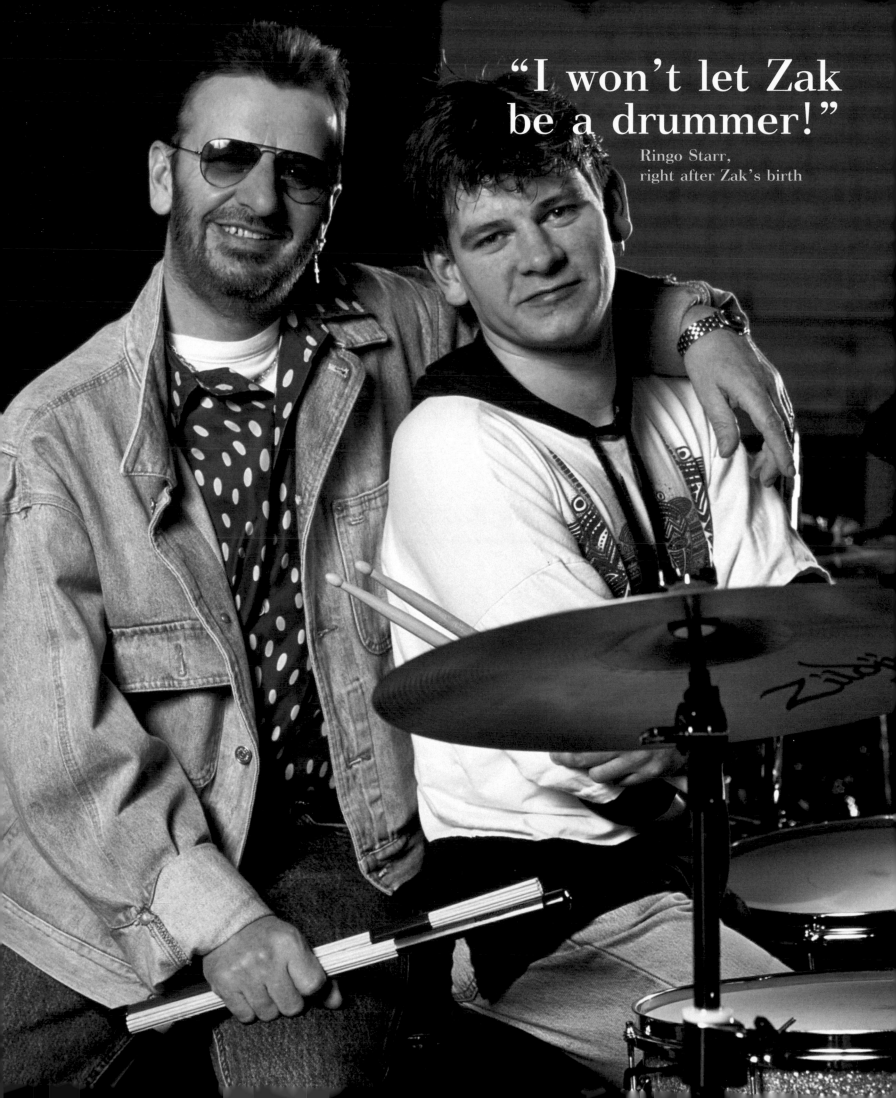

"I won't let Zak
be a drummer!"

Ringo Starr,
right after Zak's birth

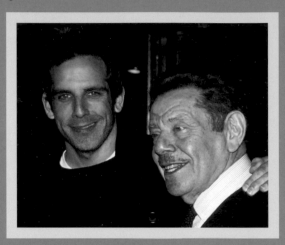

Jerry & Ben
Stiller

Gerald Isaac 'Jerry' Stiller (8 June 1927, USA) is best known as a comedian thanks to his portrayals of Frank Costanza in *Seinfeld* and of Arthur Spooner in the sitcom *The King of Queens*. He formed the legendary duo *Stiller and Meara* with his wife in the 60s. More recently, he has appeared in films such as *Hairspray*, *Anchorman* and *The Heartbreak Kid*.
Benjamin Edward 'Ben' Stiller (30 November 1965, USA) got his first opportunity with *Saturday Night Live*, made *the Ben Stiller Show* and subsequently got into the film business. In 1994, he made his directorial debut with *Reality Bites* and has since played in, written, directed and/or produced over 50 popular comedies such as *There's Something About Mary*, *Meet the Parents* and *Zoolander*.
Father & son: Ben and his father appear together in over 11 films, including *Heavyweights* and *The Heartbreak Kid*. • Ben regularly portrayed a younger version of his father's character in the television show *King of Queens*. • In 2010, Ben created the internet series *Stiller & Meara* starring his parents.
The Stiller family: Ben's mother Anne Meara is an actress. His sister Amy is a stand up comedian and an actress. The Stillers regularly appear in productions together.

Gerald Isaac "Jerry" Stiller (8 juin 1927, États-Unis) est un acteur comique, célèbre avant tout pour les rôles de Frank Costanza dans "Seinfeld" et d'Arthur Spooner dans "Un Gars du Queens". Il forma avec sa femme le duo légendaire Stiller & Meara dans les années 60. Plus récemment, il a joué dans *Hairspray*, *Présentateur vedette : la légende de Ron Burgundy* et *Les Femmes de ses rêves*.
Benjamin Edward "Ben" Stiller (30 novembre 1965, États-Unis) fait ses débuts de comédien à la télévision dans le "*Saturday Night Live*". Il anime ensuite le "*Ben Stiller Show*" avant d'entamer une carrière cinématographique. Il est aujourd'hui acteur (*Mary à tout prix*, *Mon Beau-Père et moi*, *Zoolander*), scénariste, réalisateur et producteur.
Père & fils : Père et fils ont partagé l'affiche de 11 films, dont *La Colo des gourmands* et *Les Femmes de ses rêves*. • Dans "Un Gars du Queens", Ben a régulièrement interprété le personnage d'Arthur Spooner jeune. • Ben a créé en 2010 la web série "Stiller & Meara", qui met en scène ses parents.
La famille Stiller : La mère de Ben, Anne Meara, ainsi que sa sœur, Amy, sont toutes les deux actrices. Les Stiller se donnent régulièrement la réplique dans diverses productions.

Gerald Isaac 'Jerry' Stiller (8 juni 1927, VSA) is als komiek nog het best gekend dankzij de rollen van Frank Costanza in Seinfeld en van Arthur Spooner in de sitcom *The King of Queens*. Met zijn vrouw vormde hij in de jaren 60 het legendarische duo *Stiller and Meara*. Meer recentelijk speelde hij in films als *Hairspray*, *Anchorman* en *The Heartbreak Kid*.
Benjamin Edward 'Ben' Stiller (30 november 1965, VSA) kreeg zijn eerste kans bij *Saturday Night Live*, maakte de *Ben Stiller Show* en rolde daarna de filmwereld in. In '94 maakte hij zijn regiedebuut met *Reality Bites* en sindsdien speelde hij mee in, schreef hij, regisseerde hij en/of produceerde hij ruim 50 populaire komedies zoals *There's Something About Mary*, *Meet the Parents* en *Zoolander*.
Vader & zoon: Ben en zijn vader stonden samen in minstens 11 films, zoals *Heavyweights* en *The Heartbreak Kid*. • In de tv-show *King of Queens* speelde Ben regelmatig een jongere versie van zijn vaders personage. • Ben creëerde in 2010 de internetserie *Stiller & Meara* rond zijn ouders.
De familie Stiller: Bens moeder Anne Meara is een actrice. Zijn zus Amy is komedienne en actrice. De Stillers treden regelmatig samen aan in producties.

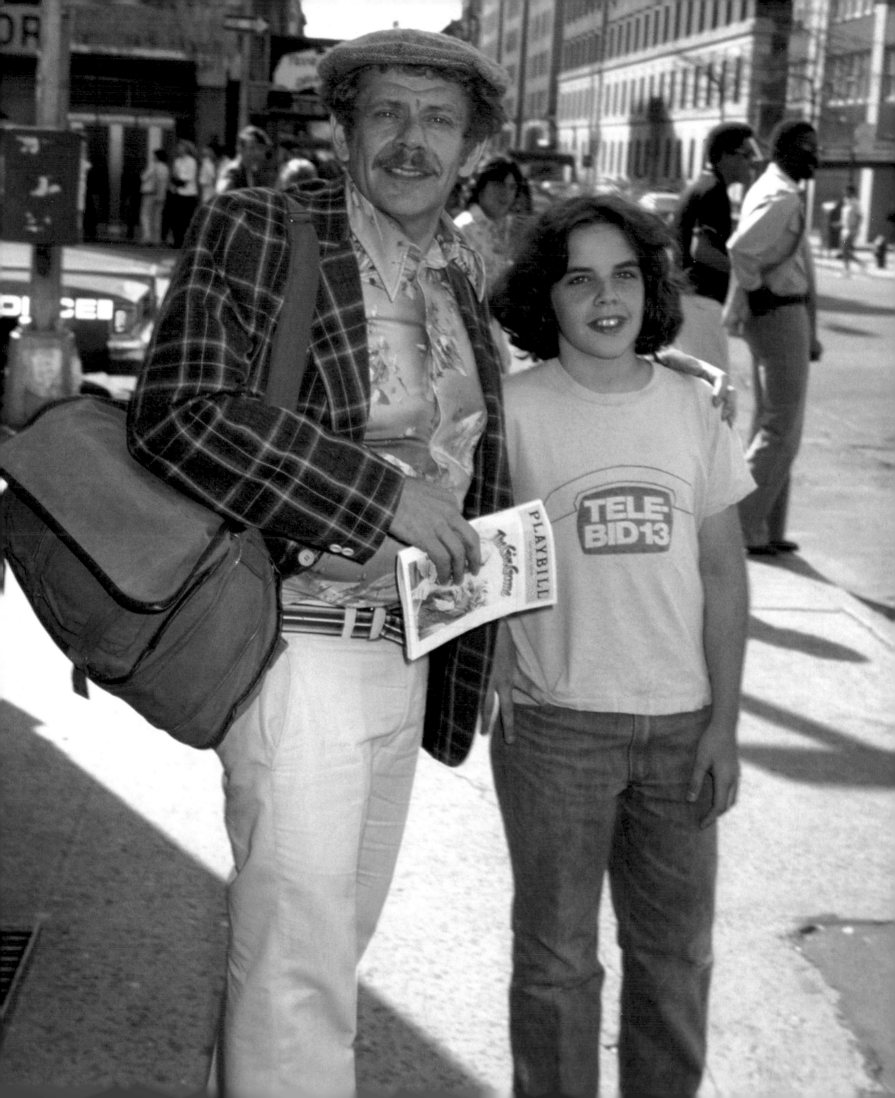

"Noble fathers have noble children."

Euripides (ca 480 BC-406 BC),
Greek tragedian

Coco
Sting & Sumner

Gordon Matthew Thomas Sumner (2 October 1951, Great Britain) conquered the world with the band The Police at the end of the 70s with songs such as *Every Breath You Take*, *Roxanne* and *Message in a Bottle*. After the band split in 1985, he started focusing on solo work, writing film music (like *Leaving Las Vegas*), ecological activism and a career in acting (*Dune*, *Penty*).
Eliot Paulina 'Coco' Sumner (30 July 1990, Great Britain) signed a record deal at the age of seventeen. In 2010 her band I Blame Coco performed at several big European summer festivals including Glastonbury, Latitude Festival, Pukkelpop and Lowlands. Her debut album *The Constant* was released in October 2010. *Selfmachine* was an immediate hit.
Father & daughter: Coco's hoarse voice has the same timbre as Sting's. Their music is different but shares the same love for philosophical lyrics and melodic accessible pop. • In one of her first songs, *My Name Is A Stain*, Coco lashed out at her descent. • Coco rules out any collaborative projects. "I think my dad's cool but that won't happen. I don't think either of us could get away with that," she explained.
The Sumner family: Coco's mother Trudy Styler is an actress and producer. Her half-brother Joe is the singer of the band Fiction Plane.

Gordon Matthew Thomas Sumner (2 octobre 1951, Angleterre), alias Sting, conquiert le monde dans les années 70 avec le groupe *The Police* et les tubes "*Every Breath You Take*", "*Roxanne*" et "*Message in a Bottle*". Lorsque le groupe se sépare en 1985, Sting entame une carrière solo, compose des musiques de films (notamment pour *Leaving Las Vegas*), milite pour l'écologie et s'essaie au cinéma (*Dune*, *Plenty*).
Eliot Paulina "Coco" Sumner (30 juillet 1990, Angleterre) signe un contrat avec une maison de disques à l'âge de 17 ans. Elle se produit en 2010 dans quelques grands festivals d'été (Glastonbury, Latitude Festival, Pukkelpop et Lowlands) avec son groupe *I Blame Coco*. Son premier opus, *The Constant*, sort en octobre 2010 et le titre "*Selfmachine*" devient immédiatement un tube.
Père & fille : Coco et son père ont le même timbre de voix. Leur musique est différente, mais leurs chansons traduisent un même attrait pour les textes philosophiques et les mélodies pop accessibles. • Dans le titre "*My Name Is A Stain*", Coco critique ses origines.
La famille Sumner : La mère de Coco, Trudy Styler, est actrice et productrice. Son demi-frère, Joe, est le chanteur du groupe *Fiction Plane*.

Gordon Matthew Thomas Sumner (2 oktober 1951, Groot-Brittannië) veroverde eind jaren 70 de wereld met The Police dankzij nummers als *Every Breath You Take*, *Roxanne* en *Message in a Bottle*. Na de split van de groep in '85 begon hij zich te richten op solowerk, het schrijven van filmmuziek (o.a. voor *Leaving Las Vegas*), ecologisch activisme en zijn acteercarrière (*Dune*, *Penty*).
Eliot Paulina 'Coco' Sumner (30 juli 1990, Groot-Brittannië) kreeg op haar zeventiende een platencontract en bezocht samen met haar band I Blame Coco in de zomer van 2010 enkele grote Europese zomerfestivals als Glastonbury, Latitude Festival, Pukkelpop en Lowlands. Haar debuutalbum, *The Constant*, kwam uit in oktober 2010. *Selfmachine* werd meteen een hit.
Vader & dochter: Coco's hese stem heeft hetzelfde timbre als die van Sting. Hoewel hun muziek verschilt, vertonen hun songs eenzelfde voorliefde voor filosofische teksten en melodisch toegankelijke pop. • In een van haar eerste nummers, *My Name Is A Stain*, geeft Coco af op haar afkomst. • Coco sluit samenwerkingsprojecten uit: "Ik vind mijn pa cool, maar dat zal niet gebeuren".
De familie Sumner: Coco's moeder, Trudy Styler, is actrice en producer. Haar halfbroer Joe is zanger van de band Fiction Plane.

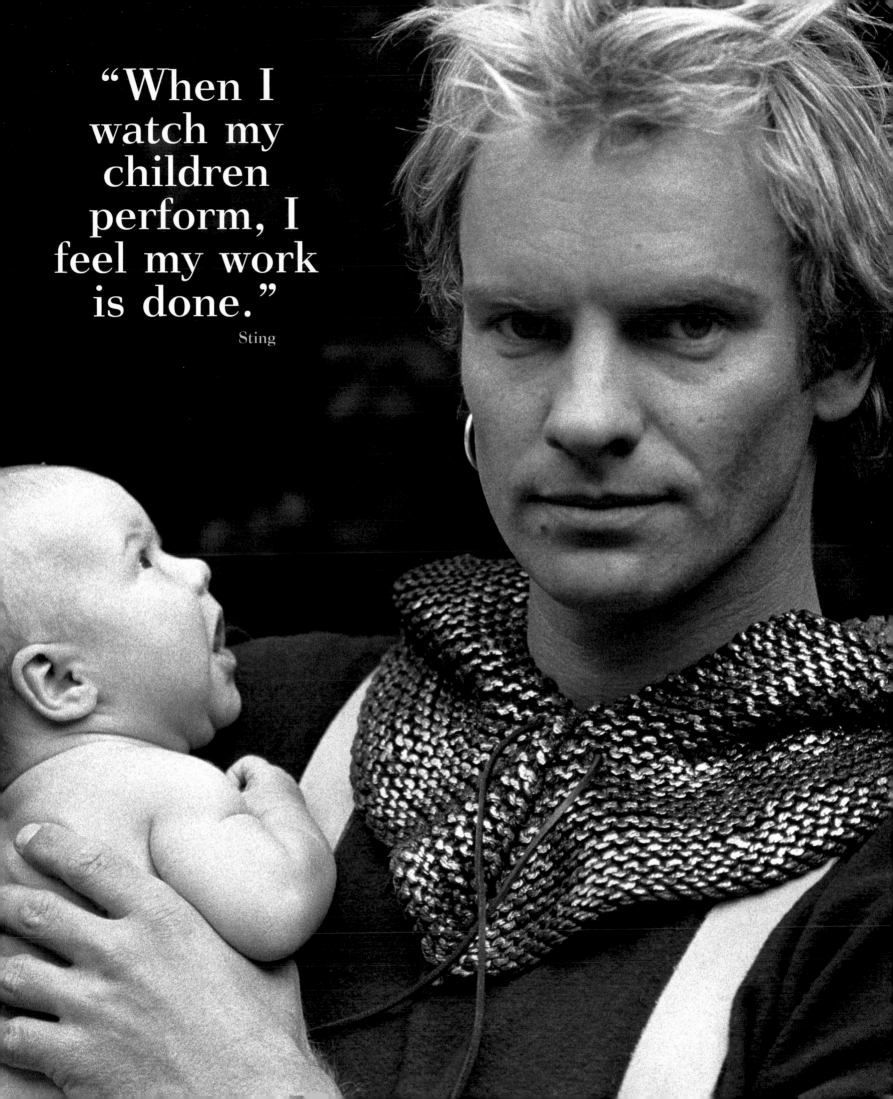

"When I watch my children perform, I feel my work is done."

Sting

Donald & Kiefer
Sutherland

Donald McNichol Sutherland (17 July 1935, Canada) is a successful character actor who, since the beginning of the 60s, has appeared in over 100 productions, including war films like *The Dirty Dozen*, *Kelly's Heroes* and *M*A*S*H*, and popular films like *Klute*, *Invasion of the Body Snatchers* and *Ordinary People*. More recently, he has appeared in the television series *Dirty Sexy Money*.

Kiefer William Frederick Dempsey George Rufus Sutherland (21 December 1966, Great Britain) made his debut in *Stand By Me* and since then has portrayed roles in around 70 films, including *The Lost Boys*, *A Few Good Men*, *Young Guns* and *The Three Musketeers*. He is currently best known for his part in the television series *24*.

Father & son: Donald named his son after Warren Kiefer, the director who gave him his first film role. • Kiefer starred with Donald in his first film *Max Dugan Returns* and in *A Time to Kill*. • In 2009, Kiefer received a star on the Hollywood Walk of Fame, one year before his father. • Kiefer inherited the Sutherland chin and piercing blue eyes.

The Sutherland family: Kiefer has a twin sister Rachel. His mother Shirley Douglas is a Canadian theatre actress and his half-brother Angus Redford recently made his debut in the acting industry.

Donald McNicol Sutherland (17 juillet 1935, Canada) a tourné dans plus de 100 longs-métrages en 50 ans de carrière, dont un grand nombre de films de guerre (*Les Douze Salopards*, *De l'or pour les braves*, *M*A*S*H*) et des films populaires (*Klute*, *L'Invasion des profanateurs*, *Des Gens comme les autres*). Plus récemment, on l'a vu dans la série "*Dirty Sexy Money*".

Kiefer William Frederick Dempsey George Rufus Sutherland (21 décembre 1966, Angleterre) tourne pour la première fois dans *Stand By Me* et a aujourd'hui plus de 70 films à son actif, dont *The Lost Boys*, *Des Hommes d'honneur*, *Young Guns* et *Les Trois Mousquetaires*. Son rôle le plus célèbre est aujourd'hui celui de Jack Bauer dans la série "24 heures chrono".

Père & fils : Donald prénomma son fils en l'honneur de Warren Kiefer, le réalisateur qui lui avait donné son premier rôle. • Kiefer et Donald ont partagé l'affiche de *Max Dugan Returns* et du *Droit de tuer*. • Kiefer a son étoile sur Hollywood Boulevard depuis 2009, son père depuis 2010. • Kiefer a hérité du menton et des yeux bleus des Sutherland.

La famille Sutherland : Kiefer a une sœur jumelle, Rachel. Sa mère, Shirley Douglas, est comédienne, et son demi-frère, Angus Redford, vient de faire ses débuts au cinéma.

Donald McNichol Sutherland (17 juli 1935, Canada) is een succesvolle karakteracteur die sinds begin jaren 60 meespeelde in ruim 100 producties, waaronder oorlogsfilms als *The Dirty Dozen*, *Kelly's Heroes* en *M*A*S*H*, en populaire prenten als *Klute*, *Invasion of the Body Snatchers* en *Ordinary People*. Meer recentelijk was hij te zien in de tv-serie *Dirty Sexy Money*.

Kiefer William Frederick Dempsey George Rufus Sutherland (21 december 1966, Groot-Brittannië) debuteerde in *Stand By Me* en vertolkte sindsdien rollen in ongeveer 70 films, waaronder *The Lost Boys*, *A Few Good Men*, *Young Guns* en *The Three Musketeers*. Momenteel is hij nog het gekendst voor zijn rol in de tv-serie *24*.

Vader & zoon: Donald vernoemde zijn zoon naar Warren Kiefer, de regisseur die hem zijn eerste filmrol gaf. • Kiefer speelde naast Donald in zijn eerste film *Max Dugan Returns* en in *A Time to Kill*. • Kiefer kreeg in 2009 een ster op de Hollywood Walk of Fame, een jaar vóór zijn vader er een kreeg. • Kiefer erfde de Sutherland-kin en doordringende blauwe ogen.

De familie Sutherland: Kiefer heeft een tweelingzus, Rachel. Zijn moeder Shirley Douglas is een Canadese theateractrice, zijn halfbroer Angus Redford zette onlangs zijn eerste stappen in de acteerindustrie.

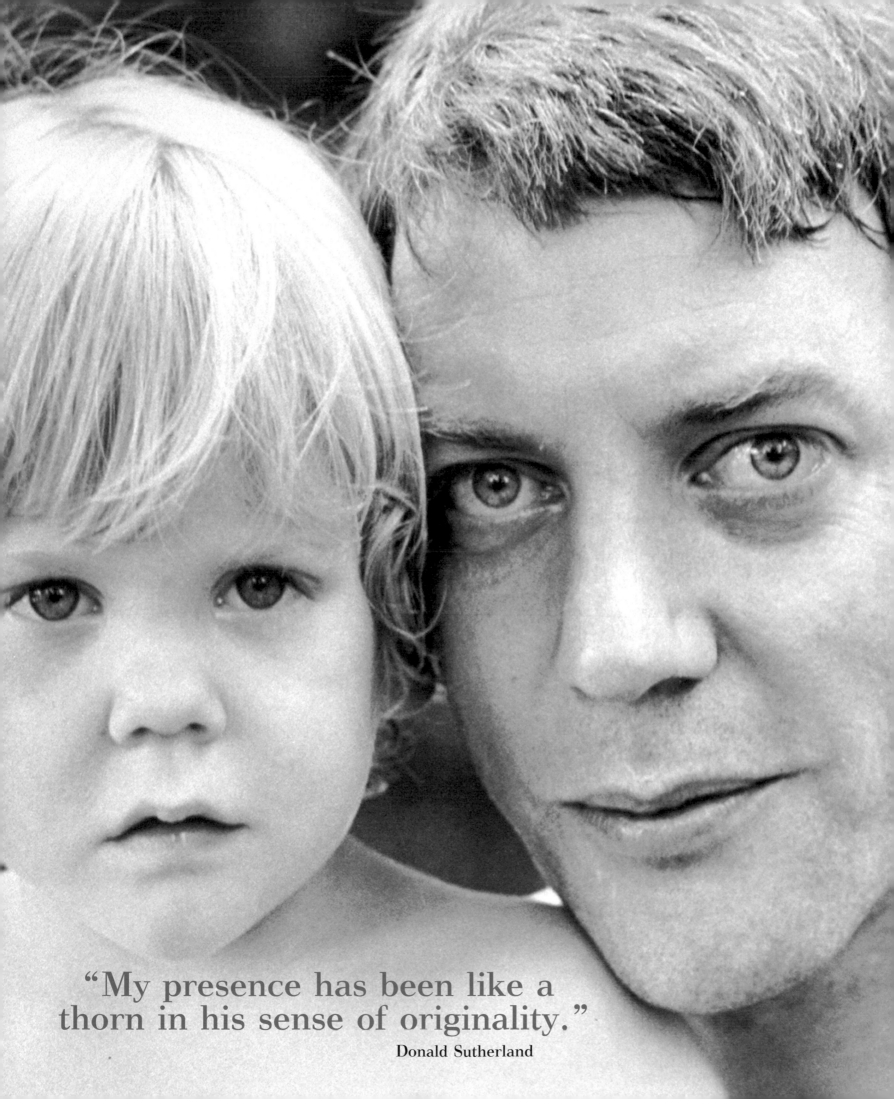

"My presence has been like a
thorn in his sense of originality."
Donald Sutherland

Steven & Liv
Tyler

Steven Victor Tallarico (26 March 1948, USA) was successful in the 70s as the singer of Aerosmith with songs such as *Dream On* and *Walk This Way*. After the band members had overcome their addictions, they pocketed a new generation with songs like *Love in an Elevator*, *Janie's Got a Gun*, *I Don't Want to Miss a Thing* and *Livin' on The Edge*.
Liv Rundgren Tyler (1 July 1977, USA) started her career as a model but appeared in successful films such as *Stealing Beauty*, *That Thing You Do* and *Heavy* by the age of twenty. She became world famous thanks to blockbusters like *Armageddon* and *The Lord of the Rings*.
Father & daughter: For years, Liv thought that Todd Rundgren was her biological father, but when the physical resemblance between Steven and his 11-year-old daughter Mia Tyler became so apparent, mother Bebe Buell told the truth. Liv promptly changed her name from Rundgren to Tyler. • Liv made her acting debut in 1994 when she appeared in the immensely popular Aerosmith clip *Crazy*. • Aerosmith provided the theme song for Liv's film *Armageddon*.
The Tyler family: Liv's half-sister, model and designer Mia Tyler has also appeared in several films.

Steven Victor Tallarico (26 mars 1948, États-Unis) et son groupe *Aerosmith* ont caracolé en tête des hit-parades dans les années 70 avec des tubes comme "*Dream On*" et "*Walk This Way*". À la fin des années 80, le groupe renoue avec le succès et séduit une nouvelle génération de fans avec "*Love in an Elevator*", "*Janie's Got a Gun*", "*I Don't Want to Miss a Thing*" et "*Livin' on The Edge*".
Liv Rundgren Tyler (1er juillet 1977, États-Unis) débute sa carrière comme mannequin avant de tourner dans des films comme *Beauté volée*, *That Thing You Do!* ou *Heavy*. Elle devient mondialement célèbre grâce à sa participation dans de grosses productions hollywoodiennes telles que *Armageddon* ou *Le Seigneur des anneaux*.
Père & fille : Liv pensa longtemps que Todd Rundgren était son père biologique ; quand la ressemblance physique de sa fille de 11 ans, Mia Tyler, avec Steven devint incontestable, Bebe Buell avoua la vérité. Liv prit alors le nom de Tyler. • Liv a joué en 1994 dans le célèbre clip d'*Aerosmith*, "*Crazy*". • *Aerosmith* a interprété la chanson-thème du film *Armageddon*.
La famille Tyler : La demi-sœur de Liv, le mannequin et designer Mia Tyler, a également tourné quelques films.

Steven Victor Tallarico (26 maart 1948, VSA) scheerde in de jaren 70 hoge toppen als zanger van Aerosmith dankzij nummers als *Dream On* en *Walk This Way*. Nadat de groepsleden eind jaren 80 hun verslavingen overwonnen hadden, palmden ze een nieuwe generatie in met songs als *Love in an Elevator*, *Janie's Got a Gun*, *I Don't Want to Miss a Thing* en *Livin' on The Edge*.
Liv Rundgren Tyler (1 juli 1977, VSA) begon haar carrière als model maar had nog voor haar twintigste al meegespeeld in succesvolle films als *Stealing Beauty*, *That Thing You Do* en *Heavy*. Ze werd wereldberoemd dankzij kaskrakers als *Armageddon* en *The Lord of the Rings*.
Vader & dochter: Liv dacht jarenlang dat Todd Rundgren haar biologische vader was, maar toen de fysieke gelijkenis met Steven en zijn dochter Mia Tyler op haar elfde niet meer te ontkennen viel, gaf mama Bebe Buell de waarheid toe. Liv veranderde prompt haar achternaam van Rundgren in Tyler. • Liv maakte in '94 haar acteerdebuut in de immens populaire Aerosmith-clip *Crazy*. • Aerosmith leverde de themasong voor Livs film *Armageddon*.
De familie Tyler: Livs halfzus, model en ontwerpster Mia Tyler speelde ook mee in een paar films.

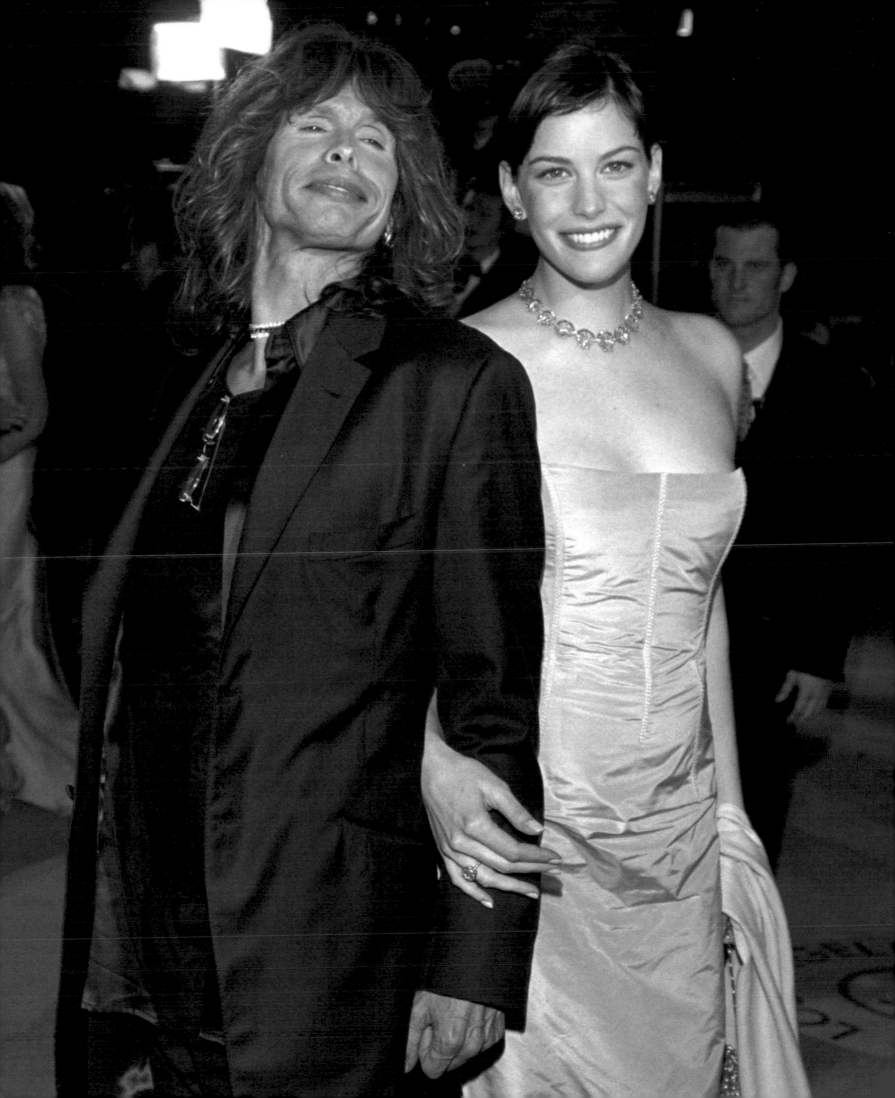

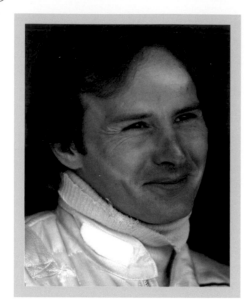 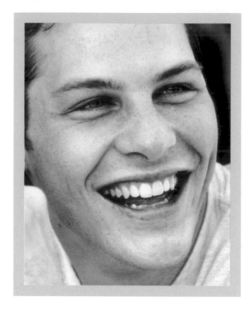

Gilles & Jacques
Villeneuve

Joseph Gilles Henri Villeneuve (18 January 1950 - 8 May 1982, Canada) learned the trade by participating in snowmobile and Formula Atlantic races. He made his Formula 1 debut in 1977 and won his first race in Montreal the following season. A year later, he finished in second place in the World Championship. Everyone believed he had a brilliant racing future ahead of him when he died in a crash at the Zolder circuit in Belgium.

Jacques Joseph Charles Villeneuve (9 April 1971, Canada) is the third driver to succeed in winning the F1 Championship, the CART Championship and the Indianapolis 500. Furthermore, he is the first Canadian to win the Formula 1 Championship and the Indianapolis 500.

Father & son: They travelled from circuit to circuit like gypsies in a mobile home because Gilles wanted his family nearby. F1 president Bernie Ecclestone wanted to give F1 a more elitist image and often tried to chase them away. • Barely four years after his father died, Jacques started begging his mother to allow him to race as well. • In 1993 Jacques won a race on the Canadian circuit named after his father.

The Villeneuve family: Jacques Villeneuve Sr., Gilles's brother, is also a racing driver.

Joseph Gilles Henri Villeneuve (18 janvier 1950 - 8 mai 1982, Canada) débute sa carrière de pilote par des épreuves de motoneige et de Formule Atlantic. En 1977, il passe en Formule 1 et remporte sa première victoire la saison suivante au Grand Prix de Montréal. Un an plus tard, il se classe second au championnat du monde. Pilote de génie en pleine ascension, il décède à l'âge de 32 ans dans un terrible accident sur le circuit belge de Zolder, en 1982.

Jacques Joseph Charles Villeneuve (9 avril 1971, Canada) est le troisième pilote à remporter à la fois le championnat du monde de F1, le championnat CART et les 500 miles d'Indianapolis. Il est le premier canadien à avoir gagné un titre de champion du monde de Formule 1 et les mythiques 500 miles d'Indianapolis.

Père & fils : Gilles aimait avoir sa famille auprès de lui ; celle-ci le suivait donc sur les circuits. • 4 ans après le décès de son père, Jacques suppliait sa mère de le laisser devenir pilote. • Jacques remporta en 1993 une course créée en l'honneur de son père sur le circuit canadien.

La famille Villeneuve : Jacques Villeneuve Sr., le frère de Gilles, fut également pilote automobile.

Joseph Gilles Henri Villeneuve (18 januari 1950 - 8 mei 1982, Canada) leerde racen tijdens sneeuwmobiel- en Formule Atlantic-races. In '77 maakte hij zijn Formule 1-debuut en het volgende seizoen behaalde hij zijn eerste overwinning tijdens de GP van Montreal. Een jaar later werd hij tweede in het wereldkampioenschap. Iedereen dacht dat hij een schitterende racetoekomst tegemoet ging tot hij omkwam bij een crash op het circuit van Zolder in België.

Jacques Joseph Charles Villeneuve (9 april 1971, Canada) is de derde racer ooit die erin slaagde zowel het F1-kampioenschap, CART-kampioenschap als Indianapolis 500 te winnen en de eerste Canadees die het Formule 1-kampioenschap en de Indianapolis 500 won.

Vader & zoon: Omdat Gilles zijn gezin in de buurt wou hebben, reisden ze als zigeuners in een mobilhome van circuit naar circuit. F1-baas Bernie Ecclestone wilde het F1 een meer elitair imago geven en probeerde hen geregeld weg te jagen. • Amper vier jaar nadat zijn vader omkwam, begon Jacques zijn moeder te smeken om ook te mogen racen. • Jacques won in 1993 een race op het Canadese circuit dat naar zijn vader vernoemd werd.

De familie Villeneuve: Jacques Villeneuve Sr., broer van Gilles, is ook een racepiloot.

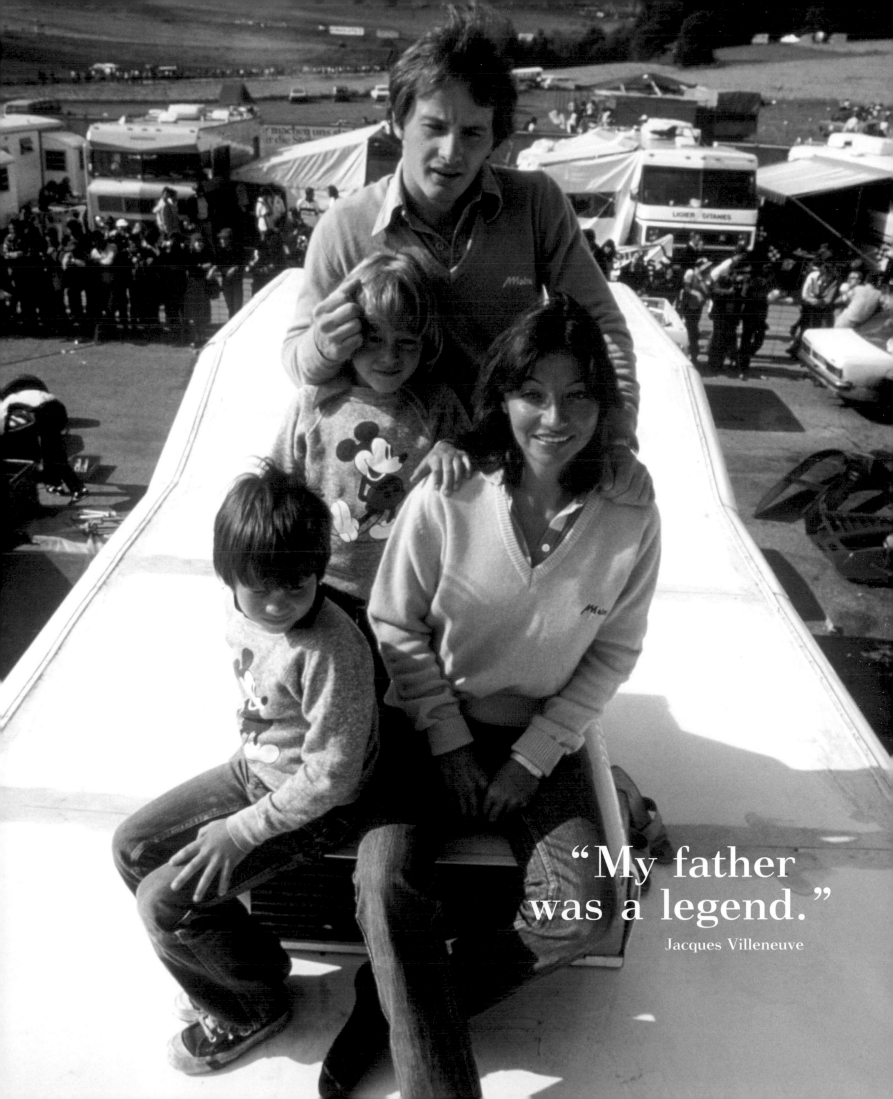

"My father
was a legend."
Jacques Villeneuve

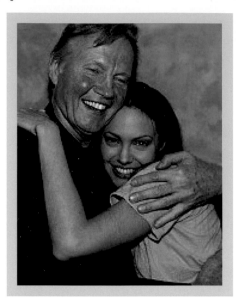

Jon

Voight & Jolie

Angelina

Jon Voight (29 December 1938, USA) gained recognition in the 60s with his role in *Midnight Cowboy* and won an Oscar for *Coming Home* in 1978. He became a respected character actor thanks to films like *Catch-22*, *Deliverance*, *The Odessa File*, *The Champ* and *National Treasure*.
Angelina Jolie (4 June 1975, USA) achieved fame with *Gia*, won an Oscar for *Girl, Interrupted* and became a superstar thanks to *Lara Croft: Tomb Raider*. She went on to star in one blockbuster after another, including *Mr. & Mrs. Smith*, *A Mighty Heart*, *Wanted* and *Changeling*. She attracted media attention for her turbulent love life, her six (both her own and adopted) children and her humanitarian work.
Father & daughter: Her father left the family when Angelina was six months old. • Their relationship was strained due to his statements about her 'psychic problems'. Jolie even had the surname Voight removed from her legal name. • However, they made up long enough to play father and daughter in *Lara Croft: Tomb Raider* in 2001. A new reconciliation followed in 2010.
The Voight family: Angelina's brother James Haven is an actor and director. Her mother Marcheline Bertrand was an actress and model.

Jon Voight (29 décembre 1938, États-Unis) fut révélé dans les années 60 avec le film *Macadam Cowboy* et reçut un Oscar en 1978 pour *Le Retour*. Il exprima ses talents d'acteur dans *Catch-22*, *Délivrance*, *Le Dossier Odessa*, *Le Champion* et *Benjamin Gates et le trésor des Templiers*.
Angelina Jolie (4 juin 1975, États-Unis) fut remarquée dans le téléfilm *Femme de rêve* et remporta un Oscar pour *Une Vie volée*. Le blockbuster *Lara Croft:Tomb Raider* fit d'elle une superstar. Elle enchaîna ensuite de gros succès au box-office (*Mr. & Mrs. Smith*, *Un Cœur invaincu*, *L'Échange*). Sa vie privée tumultueuse, sa famille nombreuse et son engagement humanitaire en font une des cibles favorites des tabloïds.
Père & fille : Jon abandonna sa famille quand Angelina avait 6 mois. • Leurs relations furent longtemps tumultueuses. Jon confia qu'Angelina avait des "problèmes mentaux" et Angelina changea légalement son nom de famille en "Jolie". • Ils jouèrent toutefois ensemble en 2001 dans *Lara Croft: Tomb Raider* et se réconcilièrent en 2010.
La famille Voight : Le frère d'Angelina, James Haven, est acteur et réalisateur. Sa mère, Marcheline Bertrand, était actrice et mannequin.

Jon Voight (29 december 1938, VSA) wekte in de jaren 60 aandacht met zijn rol in *Midnight Cowboy* en kreeg in '78 een Oscar voor *Coming Home*. Hij groeide uit tot een gerespecteerd karakteracteur dankzij films als *Catch-22*, *Deliverance*, *The Odessa File*, *The Champ* en *National Treasure*.
Angelina Jolie (4 juni 1975, VSA) gooide hoge ogen met *Gia*, won een Oscar voor *Girl, Interrupted* en werd een superster dankzij *Lara Croft: Tomb Raider*. Daarna rijgde ze de kassuccessen aan elkaar, waaronder *Mr. & Mrs. Smith*, *A Mighty Heart*, *Wanted* en *Changeling*.
Privé kwam ze vooral in het nieuws door haar turbulente liefdesleven, haar zes (eigen en geadopteerde) kinderen en haar humanitair werk.
Vader & dochter: Toen Angelina zes maanden was, verliet haar vader het gezin. • Lange tijd was hun relatie verzuurd naar aanleiding van zijn uitspraken in de pers over haar 'psychische problemen'. Jolie liet zelfs de familienaam Voight uit haar wettelijke naam verwijderen. • Toch legden ze het in 2001 lang genoeg bij om vader en dochter te spelen in *Lara Croft: Tomb Raider*. In 2010 volgde een nieuwe verzoening.
De familie: Angelina's broer James Haven is acteur en regisseur. Haar moeder Marcheline Bertrand was actrice en fotomodel.

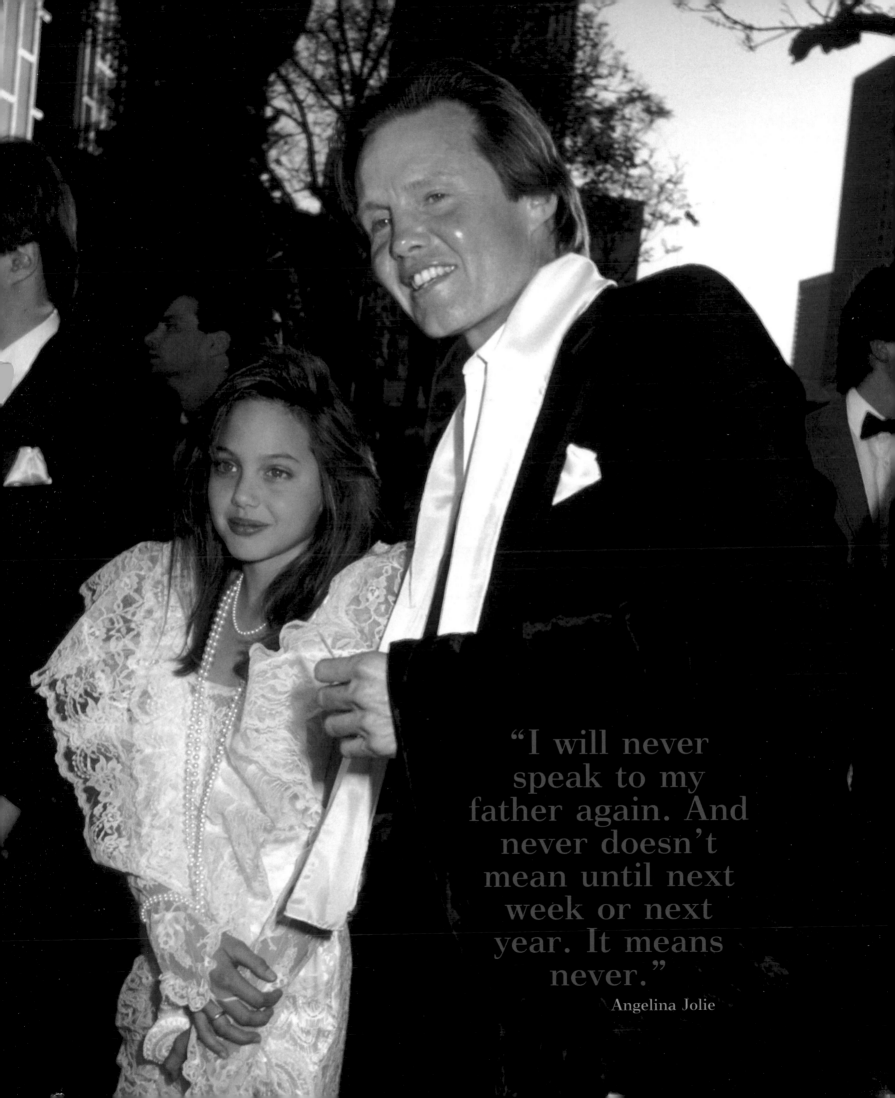

"I will never speak to my father again. And never doesn't mean until next week or next year. It means never."

Angelina Jolie

Loudon & Rufus
Wainwright

Loudon Snowden Wainwright III (5 September 1946, USA) is a folk singer and songwriter who has released over twenty albums, including *Dead Skunk*. He also had small roles in television series and films like *M*A*S*H* and *Big Fish*.
Rufus McGarrigle Wainwright (22 July 1973, USA) began playing the piano at the age of six, struggled with his homosexuality in his teens and, at the age of 23, started producing albums that were a theatrical mix of pop, opera, cabaret and Broadway musicals. He also played some minor film roles and worked on soundtracks. Some of his famous songs are *Dinner at Eight* and *Cigarettes and Chocolate Milk*.
Father & son: Rufus appeared in his father's songs *Rufus is a Tit Man* and *A Father and a Son*. He wrote *Dinner at Eight* following an argument he had with Louden. • Rufus covered his father's song *One Man Guy*. • Loudon and Rufus both appeared in the film *The Aviator*.
The Wainwright-McGarrigle family: Loudon's sister Sloane and two of his daughters, Martha and Lucy, are also singers. • After their parents' divorce, Rufus and Martha performed with their mother Kate and her sister Martha under the name The MacGarrigle Sisters & Family.

Loudon Snowden Wainwright III (5 septembre 1946, États-Unis), chanteur-compositeur de folk, a sorti une vingtaine d'albums, dont *Dead Skunk*. Il a joué des petits rôles dans des séries et des films comme *M*A*S*H* et *Big Fish*.
Rufus McGarrigle Wainwright (22 juillet 1973, États-Unis) commence à jouer du piano à l'âge de 6 ans. Il est l'auteur d'albums se voulant un mélange de pop, d'opéra, de cabaret et de comédies musicales, avec notamment les morceaux "*Dinner at Eight*" et "*Cigarettes and Chocolate Milk*". Il a interprété des petits rôles au cinéma et composé des musiques de films.
Père & fils : Les chansons de Loudon "*Rufus is a Tit Man*" et "*A Father and a Son*" font allusion à son fils. Rufus composa "*Dinner at Eight*" après une dispute avec Loudon. • Rufus reprit la chanson de son père "*One Man Guy*". • Loudon et Rufus ont tous les deux joué dans le film *Aviator*.
La famille Wainwright-McGarrigle : La sœur de Loudon, Sloane, et deux de ses filles, Martha et Lucy, sont chanteuses. • Après le divorce de leurs parents, Rufus et Martha ont chanté avec leur mère Kate sous le nom de scène *The MacGarrigle Sisters & Family*.

Loudon Snowden Wainwright III (5 september 1946, VSA) is een folkzanger en -liedjesschrijver met ruim twintig albums op zijn naam, waaronder *Dead Skunk*. Hij speelde ook kleine rolletjes in tv-series en films, zoals *M*A*S*H* en *Big Fish*.
Rufus McGarrigle Wainwright (22 juli 1973, VSA) begon op zijn zesde met pianospelen, worstelde in zijn tienerjaren met zijn homoseksualiteit en begon vanaf zijn 23e albums te produceren die een theatrale mix boden van pop, opera, cabaret en Broadway musicals. Daarnaast speelde hij enkele kleine filmrollen en schreef hij mee aan soundtracks. Bekende nummers zijn *Dinner at Eight* en *Cigarettes and Chocolate Milk*.
Vader & zoon: Rufus dook op in zijn vaders nummers *Rufus is a Tit Man* en *A Father and a Son*. Zelf schreef hij *Dinner at Eight* naar aanleiding van een ruzie met Loudon. • Rufus coverde zijn vaders liedje *One Man Guy*. • Loudon en Rufus traden beide aan in de film *The Aviator*.
De familie Wainwright-McGarrigle: Ook Loudons zus Sloane en twee van zijn dochters, Martha en Lucy, zijn zangeressen. • Na de scheiding van hun ouders zongen Rufus en Martha mee met hun moeder Kate en haar zus Martha onder de naam The MacGarrigle Sisters & Family.

> **"There's still a side of me that wants to conquer him in a certain way."**
>
> Rufus Wainwright

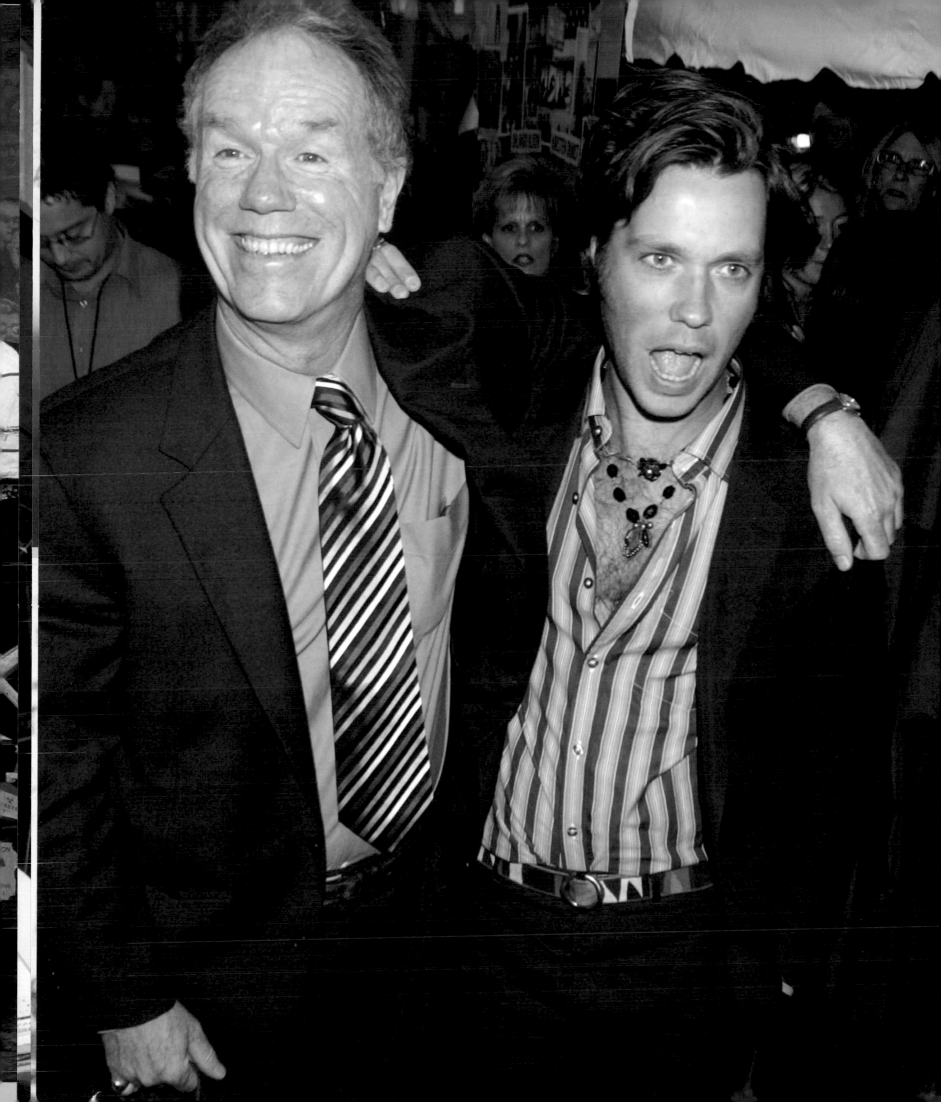

"By the time
a man realizes
that maybe his
father was right,
he usually has a
son who thinks
he's wrong."

Charles Wadsworth
(born 1929), American pianist

QUOTES ENGLISH

PAGE 57
"He also has some of the football qualities of my wife Danny, and those are nothing to boast about"
Johan Cruijff

PAGE 64
"If Jenne is convinced that he has a unique story to tell, there will be a day when he's no longer 'the son of'."
Jan Decleir

PAGE 67
"I once read: 'It is hard being Alain Delon's son.' 'It is also hard', I replied, 'being the father of the son of Alain Delon'."
Alain Delon

PAGE 68
"Other parents would think: 'My child is on tv, he or she will become famous.' He'd rather have said: 'My daughter is a lawyer'."
Linda De Mol

PAGE 70
My childhood was poor but happy, and then we became rich and all the problems concerning my father's fame have begun."
Guillaume Depardieu

PAGE 79
"I started playing the saxophone in order to get closer to my dad."
Candy Dulfer

PAGE 81
"And the faults of the fathers will fall onto the children way until the third and fourth generation."
Alexandre Dumas père
(Le Capitaine Paul, 1838)

PAGE 82
"Thomas is the best duet I've ever made with Françoise."
Jacques Dutronc

PAGE 139
"Who am I to stop him from racing a bicycle?"
Brandon Lee (1965-1993)

PAGE 143
"Un homme sait quand il vieillit, car il commence à ressembler à son père."
Gabriel Garcia Marquez, auteur colombien

PAGE 144
"In former days, as a footballer, I had no nerves. Now, as a father, I have nerves as never before."
Roger Lukaku

PAGE 155
"Who am I to stop him from racing a bicycle?"
Eddy Merckx

PAGE 185
"When I started doing the same job as my father, we started talking. But not before."
Davy Sardou

CITATIONS FRANÇAIS

COUVERTURE
"La pire infortune qui puisse arriver à un homme ordinaire, c'est d'avoir un père extraordinaire."
Austin O'Malley (1858-1932), auteur américain

PAGE 4
"Avoir un père célèbre signifie que, pour faire vos preuves, il vous faudra travailler trois fois plus qu'une personne lambda."
Frank Sinatra

PAGE 7
"Mon père a peut-être été le plus grand des boxeurs, mais il ne fut pas le meilleur des pères."
Laila Ali

PAGE 8
"Je pense que si quelqu'un nous lit dans cinquante ou cent ans, la ressemblance de notre écriture n'en semblera que plus évidente."
Kingsley Amis

PAGE 15
"Mon père était souvent fâché quand je lui ressemblais."
Lillian Hellman (1905-1984), Dramaturge américain

PAGE 18
"Il était impossible de supporter cette comparaison. Il était tout simplement trop bon."
Stephan Beckenbauer

PAGE 20
Mon père disait toujours : 'Ma fille fera de la politique. Ma fille deviendra Premier ministre'. Mais ce n'est pas ce que je voulais faire."
Benazir Bhutto (1953-2007)

PAGE 23
"Chaque père devrait se rappeler qu'un jour son fils suivra son exemple plutôt que ses conseils."
Anonyme

PAGE 30
"Zowie Bowie, c'était tout simplement irrésistible ! Il pouvait toujours changer de prénom par la suite."
David Bowie

PAGE 36
Interviewer : "Votre père, Tim Buckley, avait un peu le même sens de l'abandon, n'est-ce pas ?" Jeff Buckley : "Oui – il m'a abandonné."
Jeff Buckley (1966-1997)

PAGE 39
(à propos de la victoire électorale de son fils) : "Vous vous souvenez du jour où votre enfant est rentré à la maison avec un A – et que vous vous étiez persuadé qu'il allait échouer ? C'est exactement cela."
George H. W. Bush

PAGE 41
"Mon père ne fut pas un bon à rien. Après tout, il fut tout de même le père d'un président des États-Unis."
Harry S. Truman (1884-1972), 33e président des États-Unis.

PAGE 47
"Je lui ai dit : 'George, pour l'amour de Dieu, ne joue pas acteur'. Et la moralité de l'histoire est : il faut toujours écouter son père."
Nick Clooney

PAGE 51
"Très tôt, j'ai ressenti le besoin de dire 'Je suis comme je suis et il est comme il est'. Mais avec les années, j'ai réalisé que je n'avais pas besoin de rappeler ce genre de choses en permanence."
Jason Connery

PAGE 55
"De nombreux cinéastes remettent leurs films à mon père, parce qu'il a toujours de bonnes idées et des remarques à formuler. Il aurait fait un bon professeur."
Sofia Coppola

PAGE 57
"Elle possède aussi quelques-unes des qualités footballistique de ma femme, Danny, sans parler du reste."
Johan Cruijff

PAGE 59
"Je n'avais aucun amour propre lorsque j'étais enfant. J'étais la fille d'une célébrité et, dans ce cas là, on vous confisque tout ce que vous êtes."
Jamie Lee Curtis

PAGE 61
"Je rêvais d'être normale."
Jamie Lee Curtis

PAGE 64
"Si Jenne est absolument convaincu d'avoir une histoire singulière à raconter, viendra le jour où il ne sera plus le fils de."
Jan Decleir

PAGE 68
"D'autres parents penseraient : 'Mon enfant est à la télévision, il est célèbre'. Lui aurait préféré dire : 'Ma fille est licenciée en droit'."
Linda De Mol

PAGE 72
"Mon père est un maître, moi je ne suis qu'un peintre du dimanche."
Christian De Sica

PAGE 77
"Si j'avais su quelle personnalité Michael allait devenir, j'aurais été plus gentil avec lui quand il était enfant."
Kirk Douglas

PAGE 79
"Je me suis mise à jouer du saxophone pour me rapprocher encore plus de mon père."
Candy Dulfer

PAGE 85
"Venez mères et pères de partout dans le pays Et ne critiquez pas ce que vous ne pouvez pas comprendre. Vos fils et vos filles sont au-delà de vos ordres. Votre vieille route est en train de vieillir rapidement. Ne restez pas sur la nouvelle si vous ne pouvez pas nous aider. Car les temps sont en train de changer."
Bob Dylan

PAGE 88
"Quand quelqu'un dit 'Ça, c'est quelque chose que ton père aurait fait', c'est un immense compliment."
Dale Jr. Earnhardt

PAGE 101
"Il est très rare que les fils ressemblent à leur père : la plupart d'entre-eux sont pires,et quelques-uns seulement sont meilleurs."
Homère (env. XVIIIe siècle av. J.-C.), auteur grec

PAGE 110
"Si je continue à répondre aux mêmes questions concernant mon travail avec lui dans dix ans, je vais être déçu."
Colin Hanks

PAGE 117
"Mon père ne m'a pas dit comment je devais vivre ; il vivait et m'enjoignais de le regarder faire."
Clarence Budington Kelland (1881-1964), Auteur américain

PAGE 125
"Être le fils de quelqu'un d'autre vous rendrait ordinaire."
Enrique Iglesias

PAGE 130
"Je sens que si j'écris comme Joseph King, il se peut que je ne veuille pas écrire de fictions populaires ; tandis que si j'écris comme Joe Hill, je peux écrire tout ce que j'ai toujours voulu écrire."
Joe Hill

PAGE 132
"J'ai grandi très vite, et pourtant, une part de moi-même est toujours habitée par l'enfant en demande d'une figure paternelle."
Nastassja Kinski

PAGE 135
"Il y aura toujours une lutte entre un père et un fils, car tandis que l'un cherche à asseoir son autorité, l'autre entend affirmer son indépendance."
Will Smith

PAGE 139
"Ce doit être dans les gènes, ou alors parce que j'ai trop regardé ses films quand j'étais gosse."
Brandon Lee (1965-1993)

PAGE 143
"Un homme sait quand il

PAGE 144
"Avant, comme footballeur, je n'étais pas nerveux. Maintenant, en tant que père, je le suis d'autant plus."
Roger Lukaku

PAGE 147
"Le fils devient le père et le père devient le fils."
Superman dans Superman Returns (2006)

PAGE 148
"Plus j'évolue en tant qu'artiste, plus je pense que je deviens l'artiste qu'était mon père."
Ziggy Marley

PAGE 153
"J'ai dû me battre énormément dans ma vie pour acquérir mon indépendance."
Stella McCartney

PAGE 155
"Qui suis-je pour l'empêcher de courir !"
Eddy Merckx

PAGE 157
"Tous les enfants vivent dans l'ombre de leurs parents, et jusqu'à un certain âge dans la plupart des cas."
James Murdoch

PAGE 159
"La pire infortune qui puisse arriver à un homme ordinaire, c'est d'avoir un père extraordinaire."
Austin O'Malley (1858-1932), auteur américain

PAGE 160
"Mon père était un homme d'État, je suis une femme politique. Mon père était un Saint, pas moi."
Indira Gandhi

PAGE 162
"Il m'a réellement aimée, jusqu'à ce que j'attire davantage l'attention que lui. Après, il m'a détestée."
Tatum O'Neal

PAGE 164
"Il ne fait pas l'ombre d'un doute que la dépendance est une maladie. On a cela dans les gènes."
Kelly Osbourne

PAGE 168
"Mon fils est bien meilleur que je ne l'ai été."
Nelson Piquet

PAGE 173
"Luke, je suis ton père !"
Dark Vador dans Star Wars épisode V : L'Empire contre-attaque (1980)

PAGE 177
"Être la fille d'Elvis Presley représente une énorme pression. Cela a toujours été un fardeau dans ma vie."
Lisa Marie Presley

PAGE 181
"Oubliez le fait d'avoir survécu à 40 années de carrière musicale. Survivre 27 ans à Nicole Richie a été un combat de tous les instants."
Lionel Richie

PAGE 188
"Même s'il n'avait pas été mon fils, il aurait été mon meilleur ami."
Martin Sheen (à propos de Charlie)

PAGE 192
"Cet enfant est plus gai que je ne l'étais à son âge. Mais bon, il faut dire qu'il m'a comme père !"
Will Smith

PAGE 197
"J'ai su très tôt que j'étais la fille d'Aaron Spelling, car les gens autour de moi se comportaient de manière différente."
Tori Spelling

PAGE 199
(juste après la naissance de Zak) "Je ne laisserai

PAGE 203
"Les pères nobles ont de nobles enfants."
Euripide (env. 480 av. J.-C. -406 av. J.-C.), auteur tragique grec

PAGE 205
"Quand je vois mes enfants sur scène, je sens que j'ai bien fait mon travail."
Sting

PAGE 207
"Ma présence a été comme une épine dans son sens de l'originalité."
Donald Sutherland

PAGE 211
"Mon père était une légende."
Jacques Villeneuve

PAGE 212
"Je ne reparlerai plus jamais à mon père. Et jamais ne veut pas dire la semaine prochaine ou l'année prochaine. Cela veut dire jamais."
Angelina Jolie

PAGE 214
"D'une certaine manière, il y a toujours une part de moi qui cherche à le conquérir."
Rufus Wainwright

PAGE 218
"La première chose à faire si vous souhaitez avoir des enfants sympa, c'est de leur parler comme à des êtres humains et non comme s'ils étaient votre propriété."
Zappa

PAGE 223
"Au moment où un homme réalise que son père avait peut-être raison, il a généralement un fils qui pense de lui qu'il a tort."
Charles Wadsworth, pianiste américain

QUOTES DUTCH

COVER
"De ergste tegenvaller die een gewone man kan overkomen is een buitengewone vader hebben."
Austin O'Malley (1858-1932), Amerikaans auteur

PAGE 4
"Een beroemde vader hebben betekent dat je drie keer harder moet werken en je te bewijzen dan de eerste de beste die binnenkomt."
Frank Sinatra

PAGE 7
""Mijn vader was misschien wel de beste bokser, maar hij was zeker niet de beste vader."
Laila Ali

PAGE 8
"Ik denk dat iemand die ons allebei over vijftig of honderd jaar leest, ons waarschijnlijk als hetzelfde soort schrijver zal zien."
Kingsley Amis

PAGE 15
"Mijn vader was vaak boos wanneer ik het meest zoals hij was."
Lillian Hellman (1905-1984), Amerikaans theaterauteur

PAGE 18
"Deze vergelijking volhouden was gewoon onmogelijk. Hij was gewoonweg te goed."
Stephan Beckenbauer

PAGE 20
"Mijn vader zei altijd: 'Mijn dochter gaat in de politiek. Mijn dochter wordt eerste minister', maar dat is niet wat ik wilde doen."
Benazir Bhutto (1953-2007)

PAGE 23
"Elke vader zou zichzelf voor ogen moeten houden dat zijn zoon op een dag zijn voorbeeld zal volgen in plaats van zijn raad."
Anoniem

PAGE 30
"Zowie Bowie was gewoon te mooi om te laten liggen! Hij kan het altijd nog veranderen."
David Bowie

PAGE 36
Interviewer: Je vader, Tim Buckley, had ook zo'n gevoel van verlatenheid over zich, nietwaar? Jeff Buckley: "Ja - hij verliet mij."
Jeff Buckley (1966-1997)

PAGE 39
(over de verkiezingsoverwinning van zijn zoon) "Weet je nog toen je kind thuiskwam met twee tienen - en jij dacht dat hij zou zakken. Het is precies hetzelfde."
George H. W. Bush

PAGE 47
"Ik zei tegen hem: 'George, in godsnaam, niet acteren. Word geen acteur.' En de moraal van het verhaal is: luister altijd naar je vader."
Nick Clooney

PAGE 51
"Ik voelde al vroeg dat ik moest zeggen 'Ik ben wie ik ben en hij is wie hij is.' Maar toen ik ouder werd, realiseerde ik me dat ik dat niet voortdurend hoefde te verkondigen."
Jason Connery

PAGE 55
"Veel jonge filmmakers brengen hun films naar mijn vader omdat hij altijd veel goede ideeën voor de montage heeft en opmerkingen geeft. Hij zou een goede filmleraar zijn."
Sofia Coppola

PAGE 57
"Hij heeft ook enkele van de voetbalkwaliteiten van mijn vrouw Danny, en die zijn nou niet om over naar huis te schrijven."
Johan Cruijff

PAGE 59
"Ik had nul zelfvertrouwen toen ik klein was. Ik was de dochter van een beroemdheid en op die manier wordt vrijwel alles van je afgepakt."
Jamie Lee Curtis

PAGE 61
"Ik droomde ervan om normaal te zijn."
Jamie Lee Curtis

PAGE 64
"Als Jenne er rotsvast van overtuigd is dat hij een uniek verhaal te vertellen heeft, komt er een dag dat hij niet langer de zoon is van."
Jan Decleir

PAGE 67
"Ik heb ergens gelezen: 'Het is moeilijk om de zoon van Alain Delon te zijn.' 'Het is ook moeilijk', heb ik geantwoord, 'om de vader van de zoon van Alain Delon te zijn'."
Alain Delon

PAGE 72
"Mijn vader is een meester, ik ben een zondagsschilder."
Christian De Sica

PAGE 77
"Als ik had geweten hoe populair Michael zou worden, dan zou ik vriendelijker tegen hem geweest zijn toen hij nog een kind was."
Kirk Douglas

PAGE 85
"Kom, vaders en moeders, kom hier en hoor toe Wij zoon jullie praatjes en wetten zo moe Je zoons en je dochters die haten gezag De moraal die verveelt ons al tijden En nu je op, als de wereld nu je niet mag Want er komen andere tijden"
Uit 'Er komen andere tijden'

PAGE 30
van Boudewijn de Groot, vertaling van 'The Times they are a-changin' van Bob Dylan

PAGE 88
"Als iemand zegt: 'Man, dat is iets wat jouw vader zou doen', dan is dat een enorm compliment."
Dale Jr. Earnhardt

PAGE 101
"Het is zelden zodat zonen hetzelfde zijn als hun vaders, de meesten zijn slechter, en enkelen zijn beter dan hun vaders."
Homerus (ca. 8ste eeuw VC) Grieks auteur

PAGE 110
"Als ik over 10 jaar nog altijd dezelfde vragen moet beantwoorden over de samenwerking met hem, dan zal ik teleurgesteld zijn."
Colin Hanks

PAGE 117
"Mijn vader vertelde me niet hoe ik moest leven, hij leefde en liet me toekijken hoe hij dat deed."
Clarence Budington Kelland (1881-1964), Amerikaans auteur

PAGE 125
"Iemands zoon zijn maakt je onorigineel."
Enrique Iglesias

PAGE 130
"Ik had het gevoel dat ik geen populaire fictie zou willen schrijven als ik zou schrijven als Joseph King maar als ik zou schrijven als Joe Hill, zou ik alles kunnen schrijven wat ik maar wou."
Joe Hill

PAGE 132
"Ik groeide heel snel op, maar toch is een deel van me altijd dat kind gebleven dat naar die vaderfiguur verlangde."
Nastassja Kinski

PAGE 135
"Er moet altijd een strijd zijn tussen vader en zoon, waarbij de ene naar macht streeft en de andere naar onafhankelijkheid."
Samuel Johnson (1709 -1784), Engels auteur

PAGE 139
"Ofwel zit het in de genen, ofwel heb ik als kind teveel van zijn films gezien."
Brandon Lee (1965-1993)

PAGE 143
"Een man weet wanneer hij oud wordt, omdat hij dan op zijn vader begint te lijken."
Gabriel Garcia Marquez, Colombiaans auteur

PAGE 147
"De zoon wordt de vader en de vader wordt de zoon."
Superman in Superman Returns (2006)

PAGE 148
"Hoe meer ik groei als artiest, hoe meer ik het gevoel heb dat ik op de artiest in mijn vader ga gelijken."
Ziggy Marley

PAGE 153
"Ik heb mijn hele leven hard gevochten om onafhankelijk te zijn."
Stella McCartney

PAGE 157
"Elk kind leeft in de schaduw van zijn ouders, vaak tot ze op flink gevorderde leeftijd zijn."
James Murdoch

PAGE 77
"De ergste tegenvaller die een gewone man kan overkomen is een buitengewone vader hebben."
Austin O'Malley (1858-1932), auteur américain

PAGE 160
"Mijn vader was een staatsman. Ik ben een politica. Mijn vader was een heilige. Ik niet."
Indira Gandhi

PAGE 162
"Hij hield echt van mij tot ik meer aandacht kreeg dan hij. Vanaf toen haatte hij me."
Tatum O'Neal

PAGE 164
"Ik twijfel er niet in het minst aan dat verslaving een ziekte is. Het zit in je genen."
Kelly Osbourne

PAGE 168
"Mijn zoon is veel beter dan ik ooit was."
Nelson Piquet

PAGE 173
"Luke, ik ben je vader!"
Dark Vador in Star Wars Episode V: The Empire Strikes Back (1980)

PAGE 177
"De dochter zijn van Elvis Presley brengt een hoop druk met zich mee. Het was een constante spanning in mijn leven."
Lisa Marie Presley

PAGE 181
"Vergeet dat 40 jaar overleven in de muziekbranche. Gewoon al 27 jaar Nicole Richie overleven was anderhalve strijd."
Lionel Richie

PAGE 188
"Zelfs als hij mijn zoon niet zou zijn, zou hij nog altijd mijn beste vriend zijn."
Martin Sheen (over Charlie)

PAGE 192
"Die kleine is grappiger dan ik op zijn leeftijd. Maar ja, hij had mij ook als vader."
Will Smith

PAGE 195
"Het is onmogelijk om goed te doen voor de hele wereld en zijn vader."
Jean de La Fontaine (1621 -1695), auteur français

PAGE 197
"Ik wist al vroeg dat ik de dochter was van Aaron Spelling, en dat de mensen rondom mij hierdoor anders deden."
Tori Spelling

PAGE 199
(onmiddellijk na zijn geboorte) "Ik laat niet toe dat Zak een drummer wordt!
Ringo Starr

PAGE 203
"Grootse vaders hebben grootse kinderen."
Euripides (ca 480 BC - 406 BC) Grieks tragedieschrijver

PAGE 205
"Als ik zie hoe mijn kinderen optreden, heb ik het gevoel dat mijn werk af is."
Sting

PAGE 207
"Mijn aanwezigheid was als een doorn in zijn gevoel voor originaliteit."
Donald Sutherland

PAGE 211
"Mijn vader was een legende."
Jacques Villeneuve

PAGE 212
"Ik zal nooit meer met mijn vader spreken. En nooit betekent niet tot volgende week of volgend jaar. Het betekent nooit."
Angelina Jolie

PAGE 214
"Er is nog altijd een deel van mij dat hem op de een of andere manier wil verslaan."
Rufus Wainwright

PAGE 218
"Het eerste wat je moet doen als je leuke kinderen wil opvoeden, is ermee praten alsof ze mensen zijn, en niet alsof ze eigendommen zijn."
Zappa

PAGE 223
"Op het moment dat een man zich realiseert dat zijn vader misschien gelijk had, heeft hij gewoonlijk een zoon die denkt dat hij verkeerd zit."
Charles Wadsworth (geboren 1929) Amerikaans pianist

...hael & Marco Andretti + John & Jennifer Aniston ...ette + Franz & Stephan Beckenbauer + Zulfikar Ali ...olan + Duncan Jones & David Bowie + Pierre, Claude ... & Sean Brosnan + Tim & Jeff Buckley + George Clijsters + Nick & George Clooney + Nat King & Natalie ...ola + Johan & Jordi Cruijff + Tony & Jamie Lee Curtis + ... & Anthony Delon + John Sr., John Jr. & Linda De Mol ...e Sica + Kirk & Michael Douglas + Willem & Willem Jr. ...e fils Dumas + Jacques & Thomas Dutronc + Sunil & ...Jr. Earnhardt + Clint & Alison Eastwood + Harry ...n Flynn + Henry & Jane Fonda + Peter & Bridget ...Alessandro Gassman + Rein & Richard Groenendaal ... & Christie Hefner + Graham & Damon Hill + Bobby & ...glesias + Maurice & Jean-Michel Jarre + Laurent Désiré ...King & Joe Hill + Klaus & Nastassja Kinski + Arthur ...Brandon Lee + John, Julian & Sean Lennon + Roger & ...Ziggy Marley + Tomáš Garrigue & Jan Masaryk + Paul ...mes Murdoch + Louis & Günther Neefs + Jawaharlal Nehru, ...ly Osbourne + Pablo & Paloma Picasso + Nelson & ...& Lisa Marie Presley + Michael & Vanessa Redgrave ...i + Michel & Davy Sardou + Ravi Shankar & Norah ...k & Nancy Sinatra + Will & Jaden Smith + Wlodi ...& Zak Starkey + Jerry & Ben Stiller + Sting & ...Tyler + Gilles & Jacques Villeneuve + Jon Voight & ...Andrew & Jamie Wyeth + Frank & Dweezil Zappa

Muhammad & Laila **Ali** + Martin & Kingsley **Amis** + Mario
Bernard & Delphine **Arnault** + Lewis, Rosanna & Patricia A
& Benazir **Bhutto** + Niels & Aage **Bohr** + Marc & Rob
& Alexandre **Brasseur** + Lloyd, Jeff & Beau **Bridges** + P
H.W.& George W. **Bush** + John & David **Carradine** + Lei &
Cole + Sean & Jason **Connery** + Francis Ford & Sofia C
Billie Ray & Miley **Cyrus** + Jan & Jenne **Decleir**
+ Gérard & Guillaume **Depardieu** + Vittorio & Christian
Drees + Hans & Candy **Dulfer** + Alexandre père & Ale
Sanya **Dutt** + Bob & Jakob **Dylan** + Ralph, Dale Sr. &
& Stefan **Everts** + Gaston & Marc **Eyskens** + Errol
Fonda + Serge & Charlotte **Gainsbourg** + Vitto
+ Johnny & David **Hallyday** + Tom & Colin **Hanks** +
Brett **Hull** + John & Anjelica **Huston** + Julio & Enric
& Joseph **Kabila** + John F. & John F. Jr. **Kennedy** + St
& Roger D. **Kornberg** + Lenny & Zoë **Kravitz** + Bru
Romelo **Lukaku** + Cesare & Paolo **Maldini** + Bo
& Stella **McCartney** + Eddy & Axel **Merckx** + Rupe
Indira & Rajiv **Gandhi** + Ryan & Tatum **O'Neal** + Ozzy
Nelson Jr. **Piquet** + Ferdinand & Ferry **Porsche** +
Lionel & Nicole **Richie** + Roberto & Isabella **Ross**
Jones + Martin & Charlie **Sheen**, Emilio **Estevez**
& Ebi **Smolarek** + Aaron & Tori **Spelling** + Ringo S
Coco **Sumner** + Donald & Kiefer **Sutherland** + Steven
Angelina **Jolie** + Loudon & Rufus **Wainwright**